How We Are
Photographing Britain
FROM THE 1840S TO THE PRESENT

How We Are
Photographing Britain
FROM THE 1840S TO THE PRESENT

Val Williams and Susan Bright

WITH ESSAYS BY
Gerry Badger and Martin Parr
Kevin Jackson

Tate Publishing

To Mike Reynolds
and Martha Meadow Williams-Peppiatt

First published 2007 by order of the Tate Trustees
by Tate Publishing, a division of Tate Enterprises Ltd,
Millbank, London SW1P 4RG
www.tate.org.uk/publishing

British Library Cataloguing in Publication Data
A catalogue record for this book is available from
the British Library

ISBN 978 185437 7142

20 04004 774

Distributed in the United States and Canada by
Harry N. Abrams, Inc., New York

Library of Congress Cataloging in Publication Data
Library of Congress Control Number: 2007920242

Designed by Philip Lewis
Printed and bound by Butler and Tanner, Ltd

FRONT COVER: Jason Evans, *Strictly* 1991 (detail), C-type
print, 19 × 19, Tate
Photograph by Jason Evans, styling by Simon Foxton,
Courtesy the photographer
BACK COVER: Alfred George Buckham, *Aerial View of
Edinburgh*, 1920, Gelatin silver print, 45.8 × 37.8, National
Galleries of Scotland
FRONTISPIECE: Fergus Heron, *Robin Hill Drive, Camberely
Surrey 1996* (detail) from the series *Charles Church Estates,*
1996–2006, C-type print, 50.8 × 61, Courtesy the artist

Measurements of artworks are given in centimetres,
height before width

Contents

Foreword 7

Introduction 8
VAL WILLIAMS AND SUSAN BRIGHT

Harking Back: Loss and Longing in Nineteenth-Century British Photography 10
SUSAN BRIGHT

Marks on the Flesh: Character, Costume and Performance in British Photography 16
VAL WILLIAMS

First Moves 25
1840–1900
VAL WILLIAMS AND SUSAN BRIGHT

Into the Twentieth Century 63
1900–1918
VAL WILLIAMS AND SUSAN BRIGHT

New Freedoms in Photography 81
1918–1945
VAL WILLIAMS AND SUSAN BRIGHT

The New Britain 107
1945–1969
VAL WILLIAMS AND SUSAN BRIGHT

The Urge to Document 137
1970–1990
VAL WILLIAMS AND SUSAN BRIGHT

Reflections on a Strange Country 160
1990–2007
VAL WILLIAMS AND SUSAN BRIGHT

Our Back Pages 190
KEVIN JACKSON

We are All Photographers Now 198
GERRY BADGER AND MARTIN PARR

Selected Biographies 208
List of Exhibited Works 224
Acknowledgements 235
Lenders to the Exhibition 236
Index 237
Credits 239

Foreword

The ubiquity of the photographic image in our daily lives in Britain constituted both the original motivation behind this exhibition and the sternest challenge in defining and shaping its content. No selection of photographs, however extensive, can fully relate the history of British photography from its beginnings to the present day, let alone explain how the fluid and elusive notion of Britishness has evolved with the (usually) unwitting collusion of photographers and their work. Yet a growing conviction that Tate Britain's exhibition programme should begin to embrace the medium of photography more fully led us irresistibly towards the idea of attempting a show with a relatively broad sweep – in terms of chronology, subject matter, practitioners – that might shed a little light on how the photographing of Britain, in its many guises, has played a role in the formation of our multi-faceted national identity. The result, Kevin Jackson succinctly suggests, is a kind of 'British family album', one of which we are rather proud.

I am indebted to the exhibition's lead curators Val Williams and Susan Bright for working with dedication to forge, from infinite possibilities, an exhibition that is at the same time substantial and highly focused. They have listened patiently to much in the way of suggestions and advice and deserve our warmest thanks for producing a show of notable originality and conviction. We are also very grateful to their fellow catalogue writers Gerry Badger, Martin Parr and Kevin Jackson. Special thanks are due to David Mellor for support and guidance on many fronts; to the University of the Arts London, Photography and the Archive Research Centre at the London College of Communication and many individuals there, notably Lorna Crabbe, Robin Silas Christian, Robert Pullen, Henrietta Shirley and Janice Hart; to the exhibition designers Softroom and the graphic designers Graphic Thought Facility; to Philip Lewis, the designer of this book, and the editorial and production team of Alice Chasey, Lillian Davies, Anne Low and Emma Woodiwiss; to the numerous private and public collections who have supported us, for example Michael Wilson, the Victoria & Albert Museum and the National Media Museum, Bradford; and above all to the many photographers and their families or representatives whose co-operation has been greatly appreciated.

Finally I would like to thank the Tate team behind the exhibition, led with authority and incomparable commitment by Carolyn Kerr, assisted by Heather Birchall and Sofia Karamani, and guided by Judith Nesbitt. Emma Dexter, Ian Warrell and Mike Phillips contributed invaluable expertise and advice throughout the development of the project and many other staff across the Tate organisation helped bring it to fruition, notably Christina Bagatavicius, Gillian Buttimer, Matthew Flintham, Mikei Hall, Sarah O'Reilly, Shuja Rahman, Owen Sherwood, Andy Shiel, Alice Teng and Piers Townsend. The project has been generously supported by Wallis Annenberg and the Annenberg Foundation, through the American Patrons of Tate with additional sponsorship in kind from John Jones, the official framers of *How We Are: Photographing Britain,* and from Panasonic. Tate is grateful to the Museum, Libraries and Archives Council for arranging indemnity cover on behalf of Her Majesty's Government

Stephen Deuchar
DIRECTOR, TATE BRITAIN

Chris Harrison, *Sites of Memory*, Sheerness, Kent 1997 (detail, see no. 125)

Introduction

The story of British photography, its acute observation of and reflection upon the people, the politics and the land of this country, is a compelling one. Unique and idiosyncratic, and peopled by remarkable characters and their visions, it is distinguished by its strong social conscience, a love of the ordinary, an intense curiosity and a constant need to record. Above all, it is a medium of melancholic grandeur, tinged with nostalgia, which seeks to memorialise the past.

The history of photography in Britain to date, though far from complete, has been constructed with both passion and prejudice. *How We Are: Photographing Britain* does not aim to be a social history of Britain or a definitive history of photography. Both are too large, complex and unwieldy to be addressed by a single event or publication. Nor does it presume to be a 'new history' of British photography because such an assumption would suggest that one already exists and needs to be overturned. But it is a bold, and we believe timely, intervention that contributes new knowledge and scholarly research to this remarkable visual narrative of British life. It makes links between practices and time periods to show that British photography is essentially cyclical; the inventors of the digital age are not so very different from the inventors of the nineteenth century. It supplies more, and hopefully vital, parts of the intricate puzzle that is the history of British photography and shows how photographers working in Britain have grappled with,

and celebrated, the notion of Britishness, the identity of which is constantly shifting.

The sheer diversity of British photography is yet to be fully acknowledged. Its applications are myriad, including the family album, the souvenir postcard, the studio portrait, the social document and the natural-history photograph. Over the history of the medium, photographers have been reporters, family historians, satirists and inventors. They have made their work as professionals and as amateurs, as doctors, ornithologists, suffragettes and gardeners. Often, the contribution of women photographers, and photographs by and about some of the many minority communities living in Britain, as well as the work of vernacular photo-graphers, has been overlooked. Furthermore, many of Britain's most important photographic collections were lost to the nation in the great photographic diaspora of the postwar period. Despite the magnificence of the Victoria & Albert Museum collection in London, and the wonderful idiosyncrasy and sheer genius of the work held in the Royal Photographic Society (now at the National Media Museum in Bradford), many archives remain undiscovered or under-investigated and much of the best of British photography resides in the United States.

Photography has had a somewhat perilous journey to 'respectability' and for some museums it is still difficult to grasp its multiplicity of uses and of

presentation. For institutions, it can be a problematic medium, since the usual rules of art history and connoisseurship do not apply. Its confinement to 'documentary', 'news' or 'record' status in the nineteenth and early twentieth centuries meant that most major British museums collected photography only in so far as it supported their holdings of painting and sculpture. Fortunately, other institutions, far removed from the museum establishment, nurtured fascinating and important archives, such as The Antony Wallace Collection at the British Association of Plastic Surgeons in London, which contains the pioneering work of photographer Percy Hennell (no. 60) and The Barnardo's Archive in London's East End, containing an astonishing record of the children cared for by the charity in the nineteenth century (nos. 9a and 9b).

How We Are: Photographing Britain presents an opportunity to revise the history of British photography, and to break down the barriers that have been constructed between the centuries in terms of photographic practice. For within the mass of work produced from the beginnings of photography in the 1840s to the present day, spanning reportage, fashion, portraiture and landscape, there are fascinating continuums: between the work of nineteenth-century street photographer John Thomson (no. 26) and that of contemporary social documentarists Euan Duff and the Exit Photography Group (nos. 92 and 109);

between Madame Yevonde's series of 'Goddesses', from the 1930s (no. 68), and Clare Strand's stage-set portraiture of the urban everyday (2002–3, no. 118); and between Roger Fenton's oriental studio of 1858 (no. 2), and Grace Lau's Chinese studio (2005, no. 136).

It could be said that photography only succeeds if it informs and inspires us to make our own personal, imaginative journeys. Every day in Britain thousands of photographs are posted on the internet by ordinary people, whose only desire is to communicate with a wider community. The snapshot has returned to photography at a critical moment, providing a democratic, independent counterbalance to the demands of the gallery and the collector, and offering a spontaneous, personal comment on a shifting and sometimes uneasy society.

VAL WILLIAMS AND SUSAN BRIGHT

Harking Back:
Loss and Longing in
Nineteenth-Century
British Photography

SUSAN BRIGHT

The more we consider these mid Victorians, the more we realise how many, including some of the most sensitively intelligent, were forced by the pressures of a materialist age to live out a world of fantasy in their daily lives.

DEREK HUDSON[1]

1 Derek Hudson, *Munby, Man of Two Worlds: the Life and Diaries of Arthur J. Munby 1828–1910*, London 1972, p.3.

An 'Englishman's home is his castle'; Britain is 'a green and pleasant land': these may be worn-out clichés, but they are not without an element of truth. The house-purchasing frenzy that has taken place during the last ten years, as well as deep-seated concerns over the conservation of green-belt areas, testify to the degree to which such truisms are engrained in the British psyche. In fact, they could be said to sum up much about Britain as a nation, as the recent outpouring of books on the subject of nationhood, which all concentrate on these traits, seems to confirm.[2]

Once we begin to think about what defines the nation, and how the nation describes itself through representations, then the complexities, contradictions and challenges of a British national identity come to the fore, as the historian Hugh Seton-Watson has outlined: 'I am driven to the conclusion that no "scientific definition" of the nation can be devised; yet the phenomenon has existed and exists.'[3] This frustrating lack of definition echoes the writing of the social historian Benedict Anderson. His *Imagined Communities*, first published in 1983, produced some of the most influential theories on nationhood. He claims that the idea of a nation is 'imagined', since 'the members of even the smallest nation will never know most of their fellow-members, meet them, or even hear of them, yet in the minds of each lives the image of their communion'.[4]

If we accept Anderson's theories , it would seem that what binds the British (or indeed any nation) together is not actual experience, but shared mental images; images that are reinforced by what we read and hear, and most importantly by what we see through representations in cinema, television, art, design or photography. Whether these images are 'true' or not is irrelevant. What becomes important is how they inform our concept of ourselves and our sense of national identity.

The photographs selected for this exhibition and its catalogue simultaneously reinforce, exaggerate and contradict this idea of a collective sense of national belonging. For example, there are images depicting the cut and thrust of industrial development during the nineteenth century, and thus reinforcing a sense of national pride. These are represented most obviously by the famous portrait of Isambard Kingdom Brunel posing casually by the chains of his steamship *Great Eastern* (1857). But in amongst such pictures is a plethora of images infused with a sense of

2 Examples include Julian Barnes, *England, England*, London 1998; A.A. Gill, *The Angry Island*, London 2005 and Jeremy Paxman, *The English: A Portrait of a People*, London 2002.

3 Hugh Seton-Watson, *Nation and States*, Boulder 1977, p.5.

4 Benedict Anderson, *Imagined Communities: Reflections on the Origin and Spread of Nationalism*, London and New York, Revised Edition 1991, p.6.

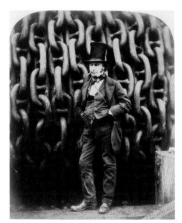

Pl. 22

longing that suggest a nation less confident about its identity – a nation obsessed with its past. The object of this longing may well be a figment of the imagination, for it is always shifting, always just out of reach. These images of the present, are infused, explicitly or implicitly, with a sense of melancholy. They are forever trapped in the 'real' world, unable to return to the fantasy of the past that the photographer so clearly evokes.

These nostalgic photographs were created for many different reasons: to document traditions believed to be disappearing, for example, or to illustrate albums and books. They also mirror picturesque parallels in painting as self-conscious art pieces. But nineteenth-century British photography did not always draw on traditions of romanticism and lyricism for their own sake in the way that painting of the period did. Instead, much of it was driven by a social conscience and a desire to reform. Parallels in subject matter are more likely to be found in the literature of the time than in art, perhaps because the structure of early British photography – like literature – was a fluid one, attracting a wider range of protagonists than the elite of the art academy. Photography relies less on money and connections for acceptance and success, than on passion, imagination, curiosity and desire.

Exemplary of this are the photographs diligently collected by Arthur J. Munby (1828–1910), who assembled a substantial and fascinating archive of images of nineteenth-century labouring women (see no. 21). Munby was a civil servant, diarist and minor poet. He first became interested in working women when studying law at Cambridge, as noted in the detailed diaries that he kept from 1859 to 1898.[5] These photographs, of which there are thousands, were often staged by Munby in the studios of the many photographers across the country whom he employed to take the pictures.[6] Pit girls were a particular favourite, dirtied for the camera, as well as milkmaids and fisherwomen. While the pictures are taken in an objective, non-judgemental way, and Munby's subjects must have been in some way complicit in his obsession (since they agreed to be photographed in their work clothes, when the norm was to pose in ones 'Sunday Best'), the quantity and repetition of this particular subject matter may seem uncomfortably domineering and fetishistic to contemporary eyes. The archive serves, however, to illustrate the huge discrepancies in the class system of the time, and acts as a vital social record of

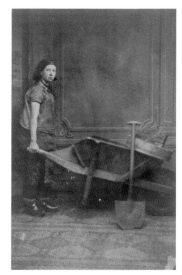

Pl. 21

5 His diaries number over sixty volumes, averaging 200 pages each. He also kept notebooks and wrote a biography of Hannah Cullwick. These are all held at Trinity College Library, Cambridge.
6 Munby used many photographers to take photographs of working women, these included R. Little of Wigan, Stoddarts of Margate, F.R. Wells at Hastings and Gilling of London.

Pl. 16

professions carried out by women in the mid-nineteenth century, which otherwise would have been lost forever.

Photography in the nineteenth century became a lucrative profession for many; photographs held mass popular appeal, especially when technology increased their accessibility. Magic-lantern shows and itinerant photographers travelled the country, as did the 'new tourists' eager for souvenirs. Francis Bedford (1816–94) is best known for his numerous views of Britain, most notably Wales, the West Country, Warwickshire and Stratford-upon-Avon. These places were regarded as areas of outstanding natural beauty, and on the whole were already established tourist attractions. *Black's Picturesque Tourist and Road and Railway Guide Book through England and Wales*, published in 1851, mentions most of the locations that Bedford chose to photograph, which indicates that he was well aware of the commercial value of his pictures. His work shows an Arcadian Britain of ivy-clad ruins – an attempt to hang onto the idea of Romantic enchantment and rural tranquillity in a country that was being radically changed by the advancements of the Industrial Revolution. Bedford's photographs served as reminders of a lost past, already imprinted in the nation's psyche by the writings of William Gilpin and the paintings of J. M. W. Turner, and were intended to reinforce a national sense of pride.

Benjamin Brecknell Turner (1815–94) is best known for his photographs of rural scenes, which he recorded with virtuoso skill in the 1850s (see no. 4). These large-scale prints show the ancient rhythms of the British countryside throughout the seasons, as well as the various types of rural architecture. Although he also recorded the Crystal Palace, that emblem of Victorian progress, in 1852, his rural scenes celebrate the traditional farming methods that were under threat from such progress. It is hard to imagine that the Industrial Revolution was about to change the landscape of Britain forever, transforming the economy of rural Britain from one based on manual labour, as seen in these photographs, to one dominated by manufacturing with the harnessing of the power of steam. Turner's images of rural Britain pay homage to their historic and Romantic locations, and show nothing of the huge upheavals that were taking place. In these complex compositions, it is as if the ghosts of the past have been given a final resting place before modern life takes over.

Pl. 25

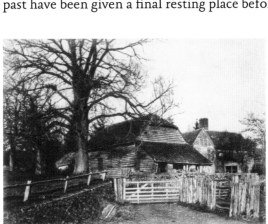

Pl. 4

This desire to memoralise the past manifested itself on different levels –
not only as nostalgia for Arcadia but also for an intensely personal past.
Gold lockets or bracelets containing a daguerreotype of a loved one,
were a reminder of the intimate relationship between the wearer and
the people represented, and were signifiers of loss as well as love. The
addition of a lock of hair, it has been argued, 'can be understood as a
vernacular commentary on ... the strengths and limitations of photog-
raphy as a representational apparatus'.[7] Such objects, which now seem
almost ghoulish, offer a conduit to mourning, a tangible parallel to the
daguerreotype's slippage between negative and positive, between life
and death. On one level, as items of adornment, such objects seem self-
explanatory; on another, they are emotionally complex and melancholy.

7 G. Batchen, *Forget Me Not, Photography and Remembrance*, Princeton 2004.

Queen Victoria came to the throne in 1837, the same year that Louis
Jacques Mandé Daguerre succeeded in establishing the first photographic
process,[8] and was a keen advocator of photography. Her long and
dramatic mourning of her husband Albert was played out for the public
in front of the camera, most pointedly in the cabinet card celebrating
her Diamond Jubilee in June 1897, taken by the photographic studio
Gunn & Stuart. Here, she wears her wedding veil and clutches in her
left hand a small photograph of the Prince Consort. On her right arm
is a bracelet bearing the handsome profile of her lost love, carefully
positioned for the camera lest the public should forget the importance
of Albert to her reign.

8 The daguerreotype was not publicly announced until 1839.

The urge to record and document increased as a new century loomed.
Established values and systems were deemed to be disappearing as the
Queen weakened. Prince Edward represented the dawning of a new
age – one that many felt was decadent and immoral. In July 1897, Sir
Benjamin Stone (1838–1914)[9] announced the formation of the National
Photographic Record Association, which comprised over 5,000 images of
exceptional quality, depicting monuments and other buildings, antiquities,
folk customs and people of historic interest (see no. 34). The results are
extraordinary, showing a nation uncomfortable and self conscious as
they are not yet at ease with the presence of the camera. The motives
behind such image-making were twofold: 'Primarily, a concern to record
for posterity the appearance of a conservative version of England with
traditions that were threatened or apparently doomed. Secondly, the

9 Sir Benjamin Stone was an industrialist, Member of Parliament and collector based in Birmingham.

Pl. 29

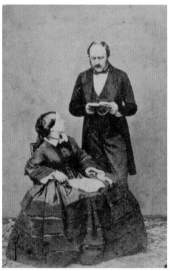

Pl. 7

10 M. Barnes, *A Record of England: Sir Benjamin Stone & The National Photographic Record Association, 1897–1910*, London 2006, p.5.

subjects selected implied an exercise in galvanising local pride and establishing a sense of national identity, [and] law and order by attempting to depict the traces of history both directly and tangentially.'[10]

As we look back at these images, now so removed from contemporary life, we feel an unavoidable sense of nostalgia. This is the inevitable double language of photography: there is the intention with which the photograph is taken, and the interpretation of those who look at it subsequently. But what we see here, is a Britain that was already nostalgic, desperate to capture disappearing customs, loved ones, an idealised landscape or dying professions. It is as if the photographers themselves believed that what was disappearing was somehow better, or purer, than the present and that by photographing it, something might be captured for a world so eager to progress that it was casting off what had made it great. Despite the apparent objectivity of such a vast project, there is a sense of loss lying at its heart, and of a country's affection for the ordinary. Here, photography has given the everyday a grandeur that only a love of tradition and the past could produce.

So is this desire to preserve the past a typically British trait? Perhaps. Common 'knowledge' and stereotypical beliefs would confirm that Britain still regards itself as a nation 'going to the dogs', or harking back to the 'good old days'. But, more significantly, what these shared images show is an 'imagined community' indulging in a complex interaction between past and present, and bound together by nostalgia and melancholy. In spite of the objectivity promised by one of the nineteenth century's greatest inventions, British photographers of that era relied just as much on fantasy and imagination to establish a sense of national belonging and community, as they do in contemporary culture.

Pl. 26

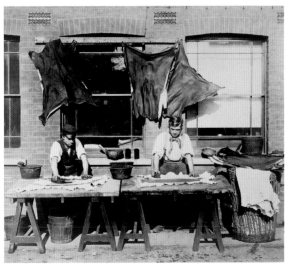

Pl. 23

Marks on the Flesh: Character, Costume and Performance in British Photography

VAL WILLIAMS

'I'd been reading about the history of the dandies, and at that time there was also a big raga thing going on ... a lot of sportswear, a lot of conspicuous consumption labels. Things that white people just wouldn't wear ... The syntax was completely upside down ... it was a new vision of Britain. We were trying to break stereotypes.'[1]

1 Jason Evans in conversation with the author, February 1998.

When Sir Benjamin Stone's volume of photographs *Festivals and Customs* was published in 1906, Michael MacDonagh declared in the book's introduction: 'The work will depict … all kinds of customs and festivals, even some of those which take place only once or twice in a lifetime, and will carry the mind in rapid succession to quaint old Knutsford, historic Lichfield … and many another spot. Thus it will bring before the vision with actuality and clearness some phases of our national life of which few of us can hope to be eyewitnesses.'[2]

2 *Sir Benjamin Stone's Pictures: Records of National Life and History*, London 1906, p.vii.

Stone's photographs, which were to influence photographers for many years after the publication of *Festivals and Customs*, mined a rich seam of English folk culture. Laconic posing, straight faces, costumed rituals, all emerge as part of some outlandish past. The Fool and Robin Hood, taking part in the Horn Dance at Abbots Bromley (no. 34), are clearly village people dressed up for the event. A little ill at ease and unaccustomed to the camera's eye, they pose with trepidation.

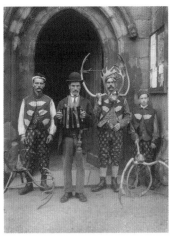

Pl. 34

Some seventy years later, young British documentary photographer Homer Sykes published *Once a Year: Some Traditional British Customs*. Though the subject matter was often the same as Stone's, Sykes was photographing at a moment when British identity was far less firmly anchored than when Stone made his survey. Sykes' feasts and fairs were set, not against the background of old England, but firmly within a 1970s landscape of small towns and transforming villages (see no. 97). His participants wore flared trousers and tank tops, Zapata moustaches and miniskirts. The England Sykes portrayed was bleak and rain-swept, caught at a moment between an old way of life and a new; black and white, but a thousand shades of grey. Sykes' Morris Men (at Bampton, Oxfordshire, on a Spring Bank Holiday Monday) are cheerful youths, their hair long and bushy, and seem aware of the absurdity of their activity, halfway between modernity and antiquity. Being photographed was not the ordeal that it would have been for their great-grandfathers. Sykes' strategy of juxtaposing arcane costumes and characters from British folklore with the blandness of 1970s Britain resulted in a visual *tour de force*, combining satire and reverence.

Notions of character and costume have pervaded British photography from its beginnings to the present day. The philanthropist Dr Barnardo was castigated when it was learned that he had colluded

Pl. 97

with the photographer Thomas Barnes to dress in rags the children brought to London orphanages to create the moving 'before and after' portraits that became, for a time, a central plank in Barnardo's publicity campaigns (see nos. 9a and 9b). As one of his main accusers, the Reverend George Reynolds remarked, in 1876: 'He is not satisfied with taking them as they really are, but he tears their clothes, so as to make them appear worse than they really are. They are also taken in purely fictitious positions. A lad named Fletcher is taken with a shoeblack's box upon his back, although he never was a shoeblack.'[3]

In another corner of the British Isles, nineteenth-century photographer John Thomas made studio portraits of women in Welsh national costume (see no. 18). He may well have been simply chronicling the costume of the day, but the photographs, distanced from us by over a century, emerge as theatre, bringing to mind memories of out-of-register colour postcards of the 1950s, souvenirs from an exotic land. Portraits commissioned from a variety of photographers by Arthur Munby (an employee of the Ecclesiastical Commissioners and fanatical devotee of working women) illustrate the ability of photography to reveal secrets and obsessions, to create scenarios of desire emerging from a finely wrought tableau of costume and props (see no. 21). In his diaries, Munby describes some of these sessions. One evening, he came across a dust woman near Westminster Bridge. 'She was a stout Irish lass of two and twenty, with big muddy boots and a ragged cotton frock looped up over a grey kirtle … Her arms, which were strong and full, were bare; but she carried a man's heavy corduroy jacket over her shoulder – a filthy thing, black with coaldust. She put on her jacket at my desire, and sat down, holding her tin dinner-can before her; and when I had posed her thus – which I did with my gloves on, seeing how dirty she was – the lens was uncovered.'[4] Munby was also fascinated by female circus performers – Tottie, the nineteenth-century wirewalker and equestrienne, is the complete Victorian lady until we notice the wild hair and the whip. Other members of her circus family pose in outlandish knickers and sleek tights, bringing all the erotic strength of the arena to their straight-faced posing.

While Munby was unashamed in his fascination for 'otherness', Dr Hugh Welch Diamond made claims for scientific objectivity when

3 Quoted in Lloyd and Wagner, *The Camera and Dr Barnardo*, National Portrait Gallery, n.d., p.12.

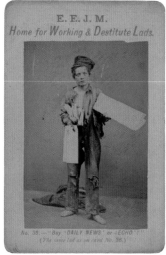

Pl. 9A

4 Quoted from Arthur Munby's diaries (n.d.) in Michael Hiley, *Victorian Working Women*, Cambridge 1979, p.79.

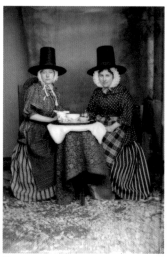

Pl. 18

taking his series of portraits of psychiatric patients (see no. 10). Like Barnardo and Munby, Diamond was well aware of the importance of dress and pose: 'One incidental effect of these artistic amusements is to draw the attention of the patients themselves to their own costume … and this direction of their notice may lead to salutary results. In the case in question, the patient made some objection to her own dress … made it a condition of her sitting quiet that she should be represented with a book in her hand.'[5] Even Lena Connell, distinguished photographer of the Suffragettes, used the studio as theatre; these militant women, who sat before her camera, emerge from her photographs as scholarly, solemn, deep in contemplation, steeped in intellect (see no. 48).

In her extended series of family albums, artist and photographer Vanessa Bell documented a community that was underpinned by the fantastical and the opaque. The characters that inhabited the anarchic world of her Sussex farmhouse were actors on the complicated stage of family life, dressing up and playing. In the small snapshots that she produced over several decades, Duncan Grant emerges as a bare-breasted Spanish dancer, Angelica Bell is swathed in queen's robes, and an anonymous pantomime horse blunders through a performance of *A Midsummer Night's Dream* (no. 49). 'I feel', Vanessa confided to her son Quentin, 'that the subject matter of a photograph should be a little absurd'.[6]

Far from the playfulness and aestheticism of Bloomsbury, postwar immigrants came to the Belle Vue studios in Bradford and to Harry Jacobs' shop in south London, posing for a photograph to send home, to show evidence of the beneficence of the mother country (see nos. 00 and 00). In the Belle Vue archive, men stand covered with pound notes or proudly in possession of a radio; a young woman looks dignified in a nurse's uniform. Harry Jacobs' generations of black south Londoners stand against the studio's background of country scenes, dressed in their best, turned out for the camera.

When the photographer Percy Hennell photographed the damaged faces and bodies of soldiers and civilians injured in the Second World War, he departed altogether from the kind of war photography that had been familiar to the British public. Hennell, a member of a prominent family of London silversmiths and employed as a photographer by the Metal Box Company, was seconded, through the Office of War

5 John Conolly, *The Physiognomy of Insanity*, Medical Times and Gazette 1858. Quoted in Sander L. Gilman (ed.), *The Face of Madness: Hugh W. Diamond and the Origin of Psychiatric Photography*, New Jersey 1976, p.10.

6 Quoted in Quentin Bell and Angelica Garnett, *Vanessa Bell's Family Album*, London 1981, p.10.

19

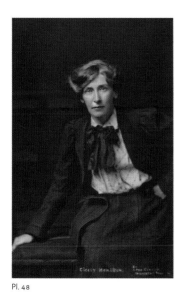

Pl. 48

PL. 91

Information, to record the work of plastic surgeons. Confronted with severely wounded and disfigured patients, he made photographs that were both dispassionate and heroic in their pitiless and often painful attention to detail (see no. 60). These images, together with Hennell's documentary portraits of women workers in the Second World War[7] (see no. 78) and his study of a decaying English farmhouse,[8] (see no. 55) are central to our understanding of British photography and its concern with appearance – the visual texture of people, things and the landscape.

When documentarist Tony Ray-Jones returned to England in the mid-1960s after an extended stay, studying and photographing in the United States, he began work on a project to document 'the English'. Published posthumously in 1974 as *A Day Off*, the series was intended to 'communicate something of the spirit and mentality of the English, their habits and their way of life, the ironies that exist in the way they do things, partly through tradition and partly through the nature of their environment'(see no. 95).[9] Though Ray-Jones had modelled his photographic practice on the new wave of documentarists emerging in the United States (Gary Winogrand, Diane Arbus and the earlier Robert Frank), his subject matter could hardly have been more different. The England that Ray-Jones discovered lacked the jarring juxtapositions of Frank's road trip across America, or the freakishness of Arbus' New York, and exuded a wistful melancholy and a wry sense of the bizarre. Ray-Jones drew inspiration from a copy of Stone's *Festivals and Customs*[10] and from Roy Christian's *Old English Customs.*[11] But photographers were not alone in discovering a new interest in English ritual. The popularity of English folk music, spearheaded by Ewan McColl and Peggy Seeger in the 1950s, the revival of interest in 'ordinary' English life, popularised by initiatives such as Charles Parker and Ewan McColl's radio ballads (1957–64) and the growth of oral history, were all manifestations of an increasing interest in the notion of 'Everyman'.

As we have seen, character and costume have dominated British photography from its early history to the present day. When the music hall *artiste* Vesta Tilley posed for a series of postcards, dressed in a variety of male costumes, she performed for perpetuity (see no. 35). Her image, jaunty as a sailor, dapper as a lad about town, became popular currency, expressing a particularly British interest in difference and ambiguity –

7 Percy Hennell, *British Women Go to War*, London, undated.
8 See Percy Hennell, *English Farmhouse and its Neighbourhood*, London 1948.

9 Tony Ray-Jones in *Creative Camera*, 1968. Quoted by Russell Roberts in *Tony Ray-Jones*, National Museum of Photography, Bradford 2004, p.13.

10 Published London MCMVI.
11 Published London 1972.

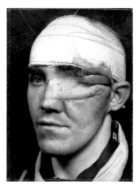

Pl. 60

Pl. 95

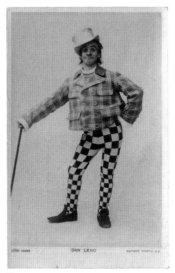

Pl. 36

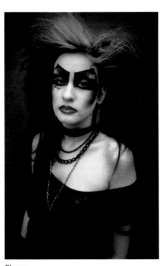

Pl. 101

encompassing notions of performance that would inform British photography throughout the twentieth and into the twenty-first centuries. There is mournfulness as well as humour in these photographs, as there is in a series of postcards of Dan Leno, comic hero, downcast and rubber-faced (no. 36), and in photographs of the Huline brothers, made in studios throughout Europe (no. 19).

When Daniel Meadows made a journey around Britain in the Free Photographic Omnibus in the early 1970s, inviting citizens to have their portraits taken, he produced a document which, three decades later, is a distinctive record of how we were (see no. 98). Teenaged girls stand together against an urban background in wide-lapelled jackets of polyester and synthetic tweed; tartan shirts were popular in Barrow-in-Furness, stripy tank tops in Southampton. All the young people look older than they really were, groups of likely lads and girls waiting for the future, indifferent to the past.

How different the world looked when Derek Ridgers photographed the London clubbing scene from the late 1970s until the early 1980s (see no. 101). He found *poseurs* on a par with Leno, Vesta Tilley and the Hulines, captured the fey and the beautiful, made-up fairies and clowns, Harlequins and Columbines. This new youth generation had mined both the present and the past to construct these extraordinary costumes. While Meadows' subjects revealed themselves as gauche, inhibited and curious, Ridgers's young men and women inhabited the camera's gaze as performers in a very particular arena. But it was the ordinariness that he glimpsed in these costumed characters that makes his photographs so powerful – the people he photographed wore beauty like a mask. The worlds that Ridgers photographed were small ones, peopled by young men and women who were captivated by the idea of image. His photographs do not search souls, they look at surfaces; these are not so much portraits as documents. He chronicled a very particular kind of theatre, a series of highly wrought performances played out on impromptu urban stages. His subjects knew the codes of photography, knew not to smile or gesticulate – they were always still, needing to be recorded, longing for celebrity. Ridgers's photographs captured the transitory nature of culture, a fleeting glimpse into what arrives, passes and is gone.

Dressed and choreographed, too, were the young men photographed

Pl. 98

by Jason Evans for his July 1991 fashion spread *Strictly* in the pioneering style magazine *i-D* (see no. 123). Styled by Simon Foxton, *Strictly* consisted of ten photographs of young black men in suburban locations, and propelled fashion photography into a new arena, in which it could discuss photography, race and sexuality. The clothes and locations were important because they were the vehicles for the discussion of a complex range of issues. 'I'd been reading about the history of the dandies, and at that time there was also a big raga thing going on … a lot of sportswear, a lot of conspicuous consumption labels. Things that white people just wouldn't wear … The syntax was completely upside down … it was a new vision of Britain. We were trying to break stereotypes.'[12] Evans both asserted and subverted the traits of fashion photography, using its artifice for his own ends, yet insisting on its 'ordinariness'.

Marks on the flesh, characters in costume, the most intense of rituals played out in half-forgotten corners, dressing up, going out, performing: these are the adaptations of body and spirit in the face of the onslaughts of change. Photographers have been close observers of a multitude of histories, linked by a perverse kind of national identity. The vibrancy and power of photography to observe, to take notice, to be curious, is indeed remarkable. Photography has a way of defying punditry, of flying in the face of propaganda, politics and pomposity. A series of photographs of British personalities made by staff photographers of the *Daily Herald* in the 1950s – Frankie Howerd, Bruce Forsyth (no. 87), Diana Dors, Tommy Cooper, Hattie Jacques – tell us as much about who we are, as does the most solemn social documentary. At the same time that the *Herald*'s photographers were tailing their celebrity subjects, cultural commentator Richard Hoggart wrote despairingly, 'We are a democracy whose working people are exchanging their birthright for a mass of pin-ups.'[13] But perhaps that was what we wanted all along.

12 See note 1.

13 *The Uses of Literacy*, London 1957.

Pl. 87

OPPOSITE
Albrecht Tübke, from the series *Citizens*, 2003 (see no. 134)

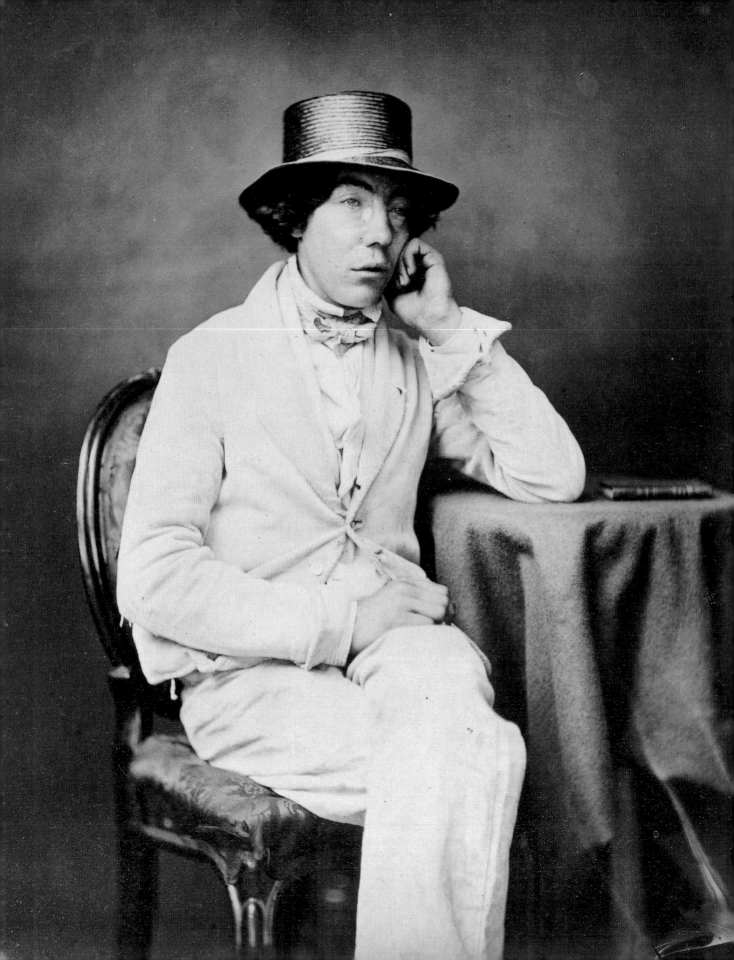

First Moves

The structure of early British photography was a flexible one, attracting inventors, eccentrics and reformers. Originally practised by wealthy amateurs, photography soon developed into a lucrative profession as its technology became more accessible and popular demand for photographs grew.

By the mid-nineteenth century, photography was used for a multitude of purposes, from plant studies to rural landscapes, from private family albums to portraits of the Royal Family. By the second half of the century, photographers such as Julia Margaret Cameron and Roger Fenton were making works that looked closely at British identity (see nos. 5 and 2). Fenton's elegiac studies of ruined abbeys and his still lifes of flowers and fruit, fur and feathers, were the visual embodiment of Britishness, with its contrasting notions of loss and plenty, a narrative that can be observed throughout the history of photography in Britain.

During photography's infancy, Britain was undergoing a radical shift from a predominantly rural economy to one that would be dominated by new economic concerns and social flux. While photographers chronicled the great technological achievements of the period, they were equally fascinated by poverty and street life in the increasingly populated cities of Britain. The philanthropist, Dr Barnardo, employed photographers to chronicle the London children admitted to his Homes, and was an early user of photography as propaganda, collaborating with

photographer Thomas Barnes to produce studio portraits that showed the transformation of children from ragged urchins to industrious apprentices (see nos. 9a and 9b).

W. Clayton of Tredegar, who in 1865 took a series of photographs of pit-head girls in South Wales, became one of the first photographers to satisfy the needs of the collector. Arthur Munby collected images assiduously and assembled a substantial (and fascinating) archive of photographs of nineteenth-century labouring women (see no. 21). Photography's association with the mysterious, the fetishistic and the erotic has continued to this day.

Women were active practitioners, as well as participants, in the new medium of photography throughout the second half of the century. Julia Margaret Cameron and Kate Gough produced remarkable portraits, often of family members and close associates, creating fascinating scenarios within the contexts of the domestic and the familiar (see nos. 5 and 14). As the century progressed, women were among the most energetic and skilled studio photographers operating in Britain, seeing photography as a means to independence and an outlet for creativity.

The nineteenth-century photographic scene was crowded with idiosyncratic, innovative photographers including Anna Atkins, who made the first photographically illustrated book in 1843 (see no. 1). Even in this early period, photographers used the vehicle of the book to present their work, with John Thomson's *Street Life in*

1840–1900

Photographer unknown, Ragged School Album, Casebook of London boys from the Ragged School Union admitted to a collecting centre for assisted emigrants to Canada, c. 1860 (detail, see no. 11)

London (1877) ,with a text by Adolphe Smith, announcing photography's ability to influence public thinking far beyond the confines of the salon or the photographic society.

These early years of photography saw technical innovation at its height. The daguerreotype, a positive photographic process introduced in 1839, gave photographers the possibility of producing an image, but not of reproducing it. In 1841, William Henry Fox Talbot introduced the calotype system, which enabled a positive salt print to be produced from a negative process that took place within the camera, and both art and amateur photographers used this technique until the late 1850s. Two major technological advances in photography after the 1840s dictated the ways in which the medium would be used in the future: the albumen print, invented in 1850, and the wet-plate collodion process, invented by Frederick Scott Archer in 1851. These processes, free of the patent restrictions imposed by Fox Talbot, allowed photographs to be produced more cheaply, bringing photography within the range of many more people, both as practitioners and as consumers.

By the 1860s, as technology was refined and photography ceased to be confined to the wealthy enthusiast and the inventor, the medium had begun to assert its own commercial potential. Stereoscopic photographs presented the public with a portable theatre, in which subjects ' came alive' and challenged the two-dimensionality of the photographic image. The popularity of the portrait studio and the production of *cartes-de-visite* (small photographs mounted on card) and cabinet photographs allowed ordinary people not only to commission portraits of themselves and their families, but also to collect photographs of public personalities and royalty. The development of photomechanical processes, such as the Woodburytype, enabled photographically illustrated books to be produced, including *Street Life in London* and T. & R. Annan and Sons' *Old Closes and Streets of Glasgow*, produced in 1870 using the carbon-printing process.

Nineteenth-century photographers were impelled by curiosity, by the desire to innovate and by social zeal. Dr Hugh Welch Diamond's photographs of asylum patients showed photography being used for what might now seem somewhat questionable scientific investigation (no. 10). Equally interesting is the multitude of photographic records produced during these years, such as the emigration albums prepared by the administrators of a Ragged School , a remarkable record of extraordinary events and social policies (no. 11). The photographs of children made by Lewis Carroll have continued to engage audiences since the time of their making (see no. 12) and, as attitudes to society change, have posed important questions about the photographer's responsibility to the subject that continue to engage critical and public attention.

Although photographers of this period travelled widely, and important bodies of work were produced in the far-flung lands of the Empire, British photographers, in the main, documented the people and the land of the home country. Through their work, a partial and inevitably personal history of Britain in the second half of the nineteenth century can be perceived.

Britain was a country of contrasts, from the fishing communities portrayed by Hill & Adamson and Frank Meadow Sutcliffe (nos. 16 and 29) to the grim realities of Scottish housing conditions documented by Thomas Annan (no. 24). John Thomas' extensive series of Welsh women in costume shows an intense desire to examine the outward manifestations of national identity (no. 18), while in the photographs of scenic locations produced by Francis Frith (no. 25), we see a burgeoning interest in the picturesque that would, in the twentieth century, become manifest in a plethora of publications extolling the virtues of the British landscape. Nineteenth-century photography shows us that Britain was a land of trees, meadows and rivers, and also of factories, asylums and slums. It reveals that we were as interested in celebrity then as we are today, as shocked by poverty and as fascinated by family, politics, work and fashion.

The delight in looking back at images made in these early years of photography lies very much in their potential to hold up a mirror to the past. Photographs of the 1897 Devonshire House Ball, made by the Lafayette Studios (no. 20), give us an entrée into the fantastical world of nineteenth-century dressing up. Photographs of the clowns known as the Huline brothers are a ghostly glimpse into nineteenth-century show business (no. 19). We know, from Robert Howlett's portrait of 1851, that Isambard Kingdom Brunel was a somewhat louche dandy, bristling with masculinity (no. 22). Through this plethora of photographs, we glimpse something of who we were, and gather clues as to who we are.

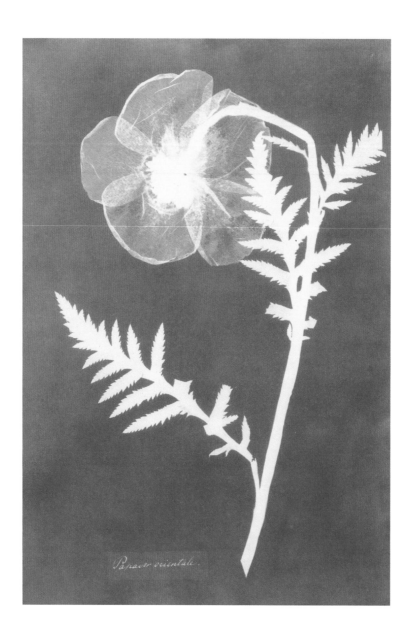

1 Anna Atkins, *Papaver orientale* (*Poppy*) from
Algae: Cyanotype Impressions 1843–54 1854
Cyanotype print, 35.2 × 24.1,
V&A Images/Victoria and Albert Museum

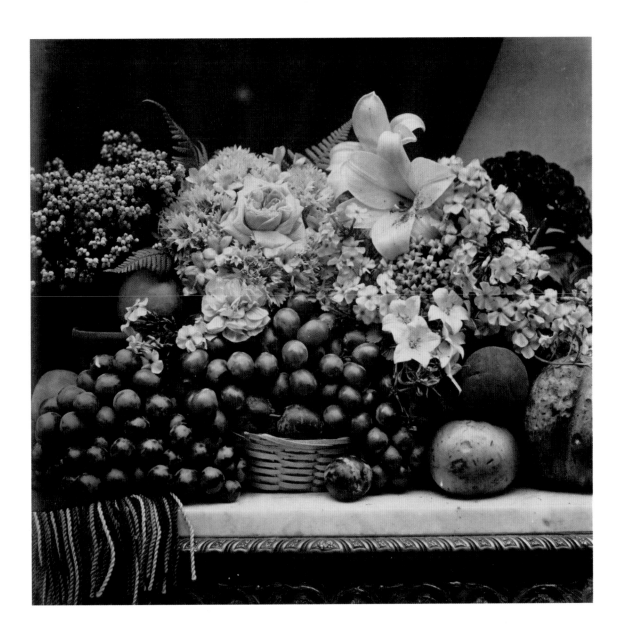

2 Roger Fenton, *Flowers and Fruit*, c.1860
Albumen silver print, 34.2 × 42.7,
NMeM/Science & Society Picture Library

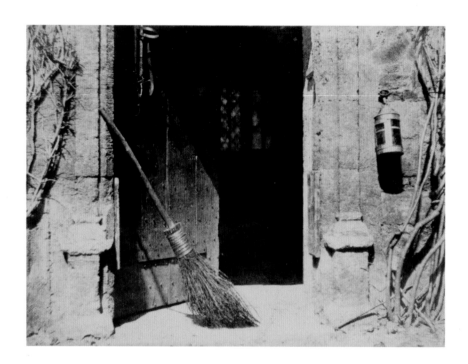

3 William Henry Fox Talbot, *The Open Door*, 1844
Salt print, 14.3 × 19.3, NMeM/Science & Society Picture Library

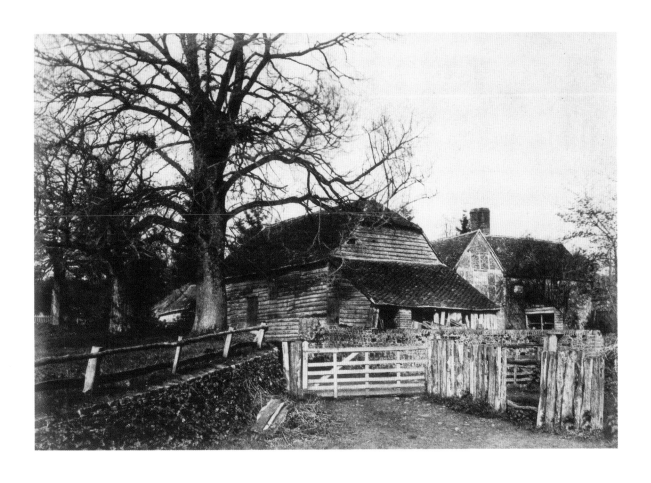

4 Benjamin Brecknell Turner, *At Compton Surrey*, Albumen print,
27 × 38.6, V&A Images/Victoria and Albert Museum
[not exhibited]

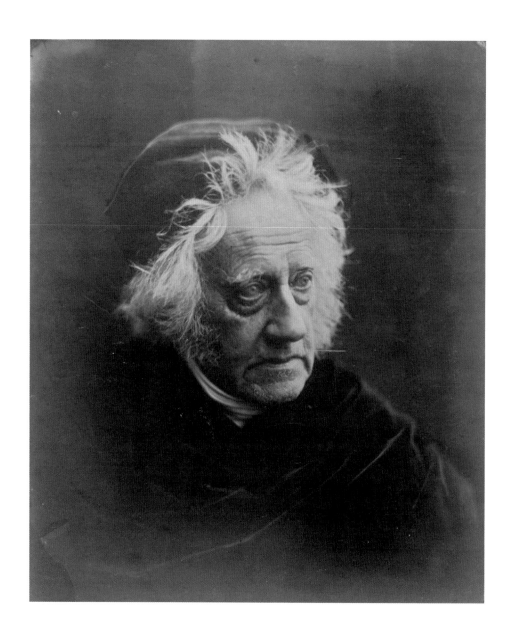

5 Julia Margaret Cameron, *Sir John Frederick William Herschel*, 1867
Albumen print, 27.9 × 22.7, NMeM/Science & Society Picture Library

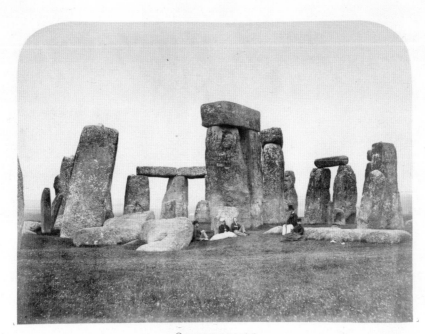

STONEHENGE.

VIEW FROM SOUTH WEST.

Photographed by the Ordnance Survey Department, Colonel Sir Henry James R.E. F.R.S. &c Director
1867.

6 Colonel Sir Henry James, *Plans and Photographs of Stonehenge, and
of Turusachan in the Island of Lewis; with notes relating to the Druids
and Sketches of Cromlechs in Ireland by Colonel Sir Henry James*, 1868
Albumen print, 17.3 × 23.6, Guildhall Library, City of London

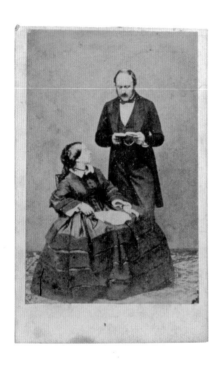

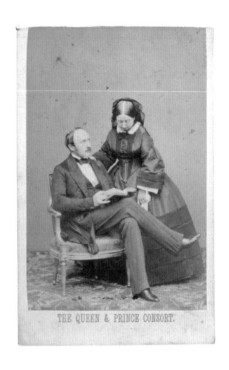

THE QUEEN & PRINCE CONSORT.

7 John Jabez Edwin Mayall, Queen *Victoria; Prince Albert
of Saxe-Coburg-Gotha*, 15 May 1860
Albumen silver print, *carte-de-visite*, 8.4 × 5.5, National Portrait Gallery, London

8 Richard Cockle Lucas, *Richard Cockle Lucas as a Hopeful Lover; Richard Cockle Lucas as a Disappointed One,* c.1858
Albumen *carte-de-visite,* 9.1 × 6.1, National Portrait Gallery, London

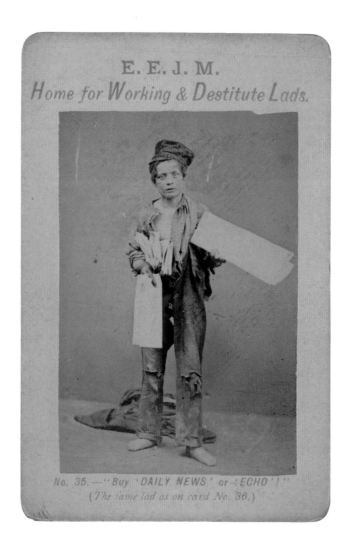

9a and 9b Thomas John Barnes, *Barnardo Before and After Picture*, c.1872
Albumen silver print cabinet cards, 8.1 × 5.7, Barnardo's Photographic Archive

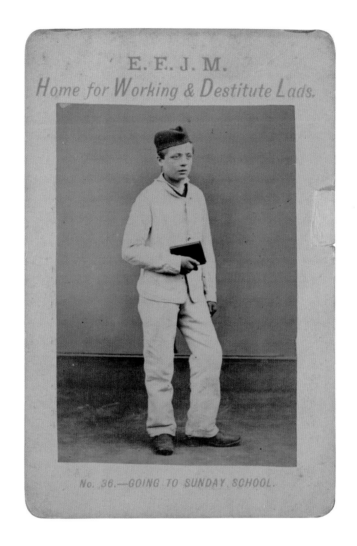

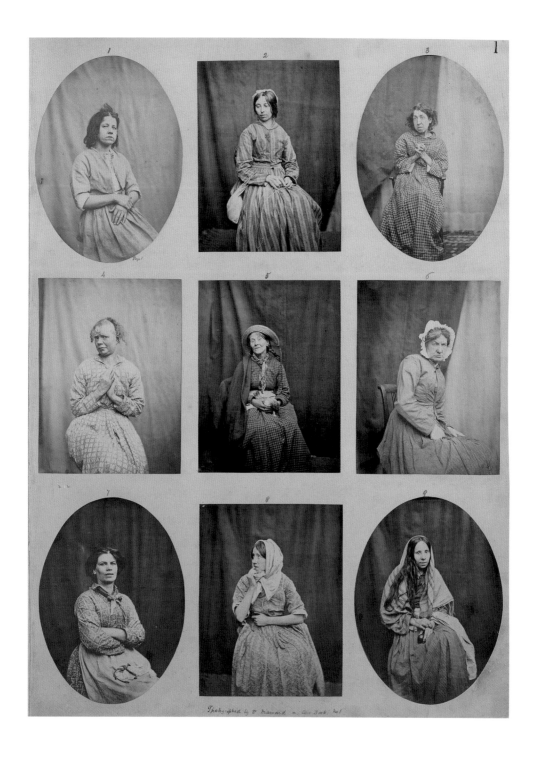

10 Hugh Diamond, *Photographs of Psychiatric Patients*, 1870s
18 Albumen silver prints, Mounted 91 × 70, Royal Society of Medicine

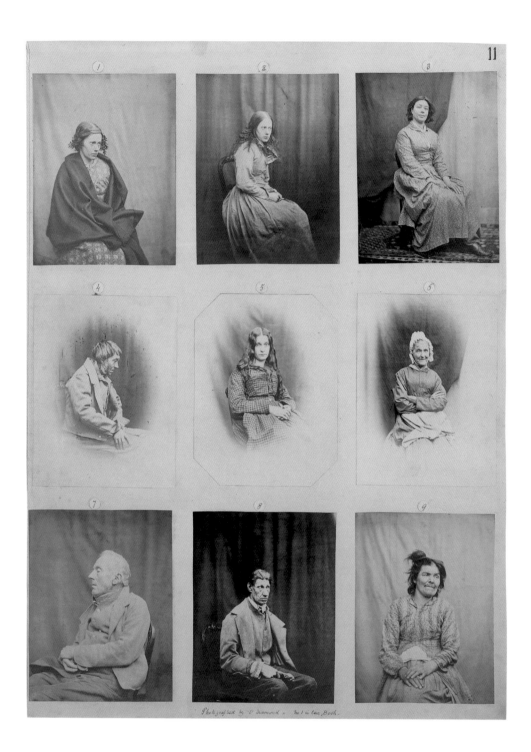

Photographed by H. Diamond at Surrey Coun. Asyl. Book.

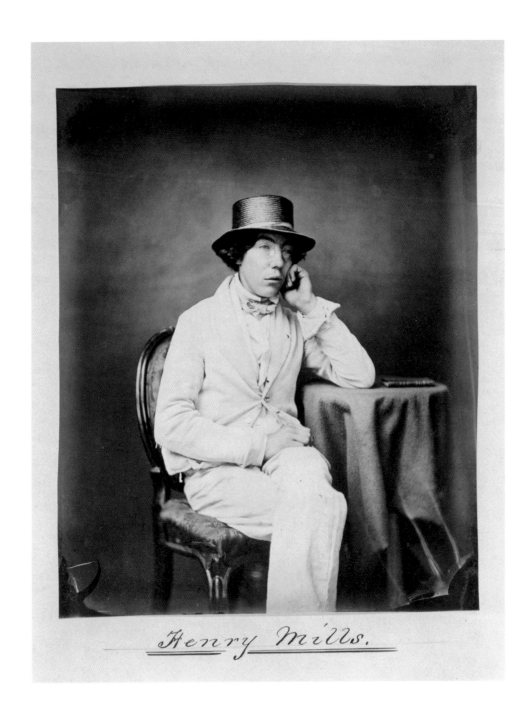

Henry Mills.

11 Photographer unknown, Ragged School Album, Casebook of London
boys from the Ragged School Union admitted to a collecting centre for
assisted emigrants to Canada, c.1860
Saltpaper prints, Image: 11.8 × 14.4, Closed album 27. 5 × 22,
Guildhall Library, City of London

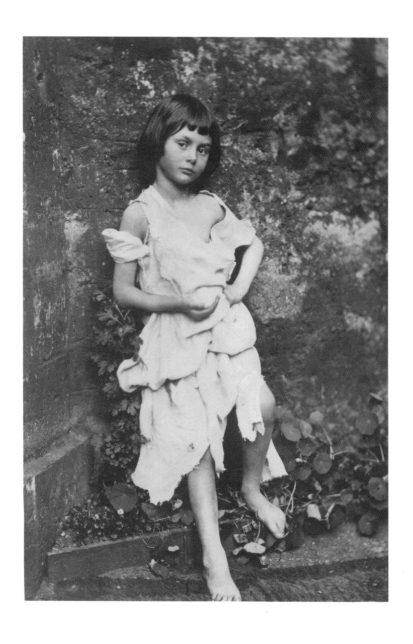

12 Lewis Carroll, *Alice Liddell as 'The Beggar Maid'*, c.1859
Albumen silver print from glass negative, 16.3 × 10.9, The Metropolitan
Museum of Art New York, Gilman Collection, Gift of The Howard
Gillman Foundation, 2005
[not exhibited]

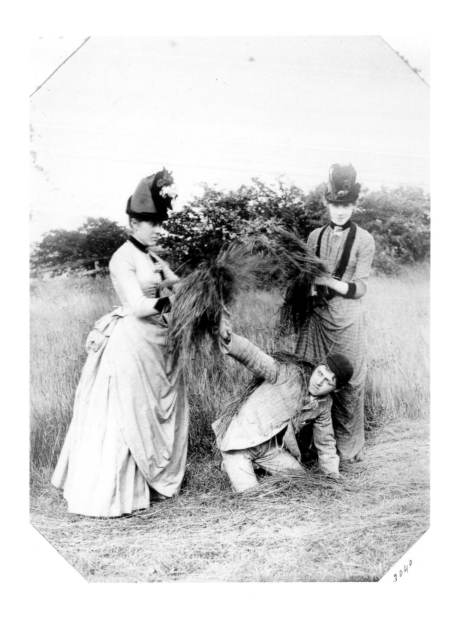

13 Walter D Welford, Scenes at Elmwood and Haycroft Farms,
Harlesden, Middlesex June 1888, *Ye George, ye Marye, and ye Stanleye
didde playe alle ye hyde and seeke rounde ye haystacke,* 1888
From the Welford Album c. 1890
Albumen print, 15.4 × 20.2, Guildhall Library, City of London

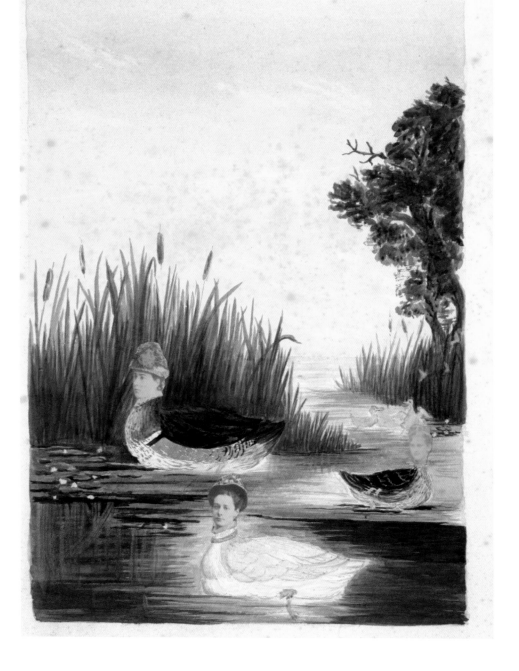

43

14 Kate Gough, *Kate Gough Album* open at *Royal Ducks*, c.1870
Collage, mixed media, 12.3 × 16.5, V&A Images/Victoria and Albert Museum

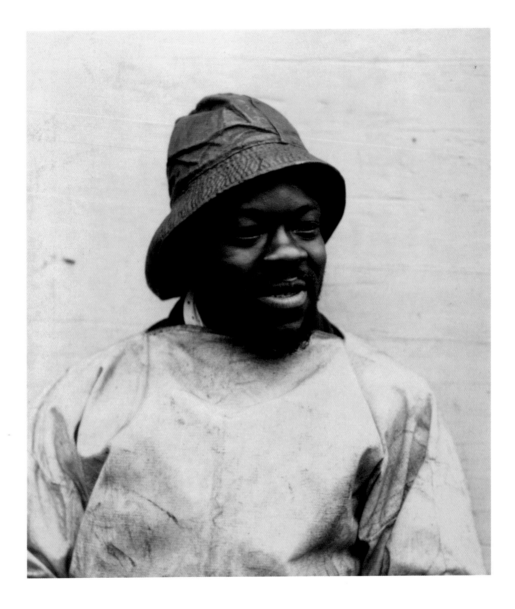

15 George Davison, *Portrait of a Fisherman*, c.1900
Gelatin silver print, 20.4 × 18.3, NMeM/Science & Society Picture Library

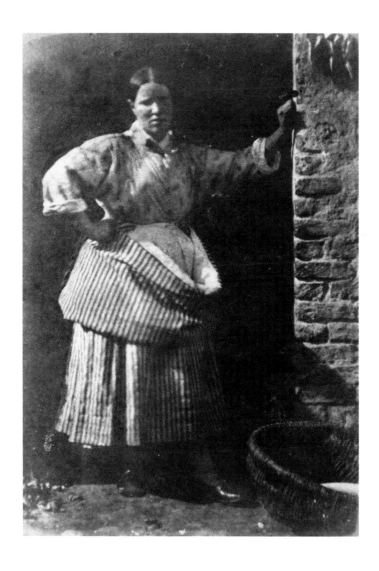

16 David Octavius Hill and Robert Adamson, *Newhaven Fishwife*, 1845
Salted paper print, 13.9 × 19.2, Wilson Centre for Photography

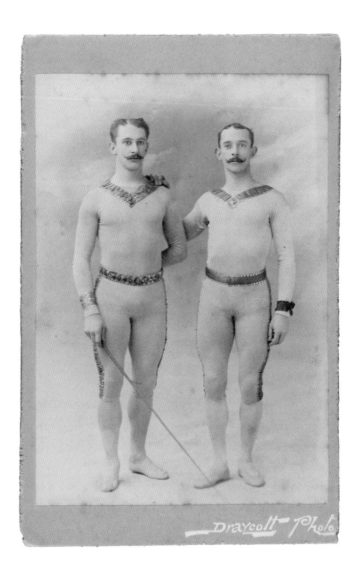

17 Draycott Photo, Alfred John and John Frederick Clarke, May 1892 Gelatin silver print, cabinet card, 17 × 11,Theatre Collections, Victoria & Albert Museum. Hippesley Cox Archive

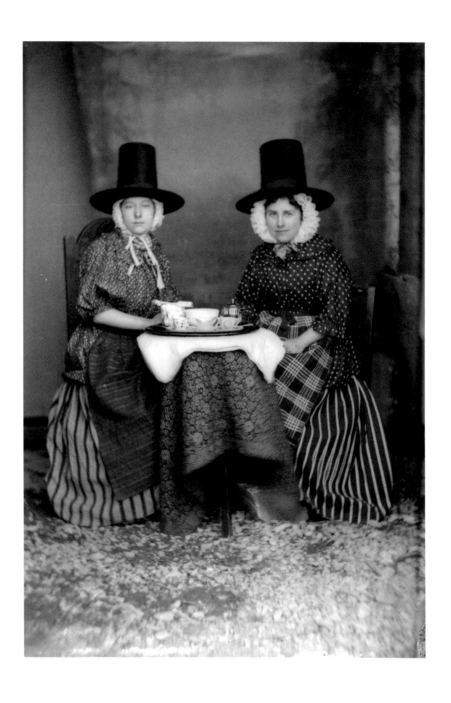

18 John Thomas, *Two women in Welsh National costume drinking tea*, c.1875
Modern black and white print from original negative, 59 × 49, By permission of
Llyfrgell Genedlaethol Cymru / The National Library of Wales

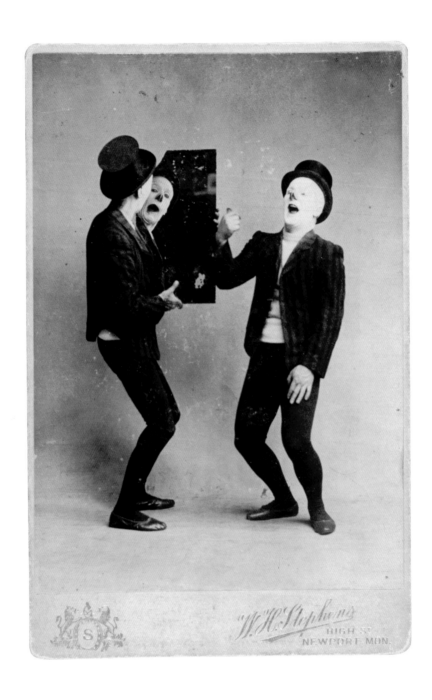

19 W.W. Stephens, *Huline Brothers*, c.1890
Albumen silver print cabinet card, 53.3 × 38.1, Theatre Collections,
Victoria & Albert Museum, Hippesley Cox Archive

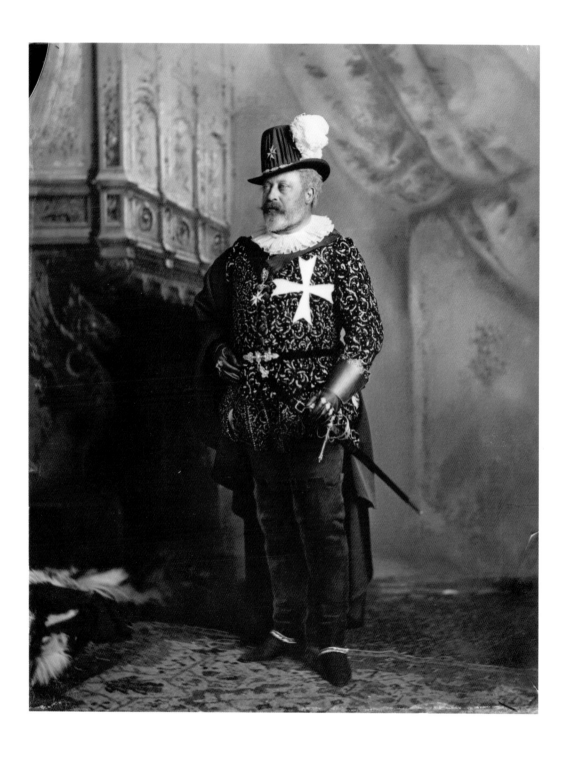

20 Lafayette, *King Edward VII dressed in costume of the Grand Prior
of the Order of St John of Jerusalem for the Devonshire House Ball*, 1897
Contact print on gold-toned printing out paper, 35.4 × 27.8, National
Portrait Gallery, London

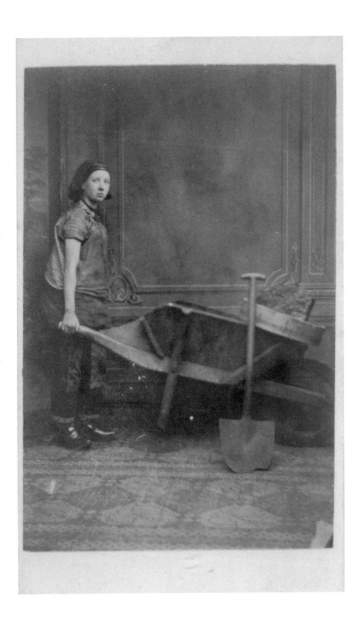

21 Richard Little, *Collier Girl with Spade and Wheelbarrow*, 1867
Carte-de-visite, 11 × 7, The Master and Fellows of Trinity College, Cambridge

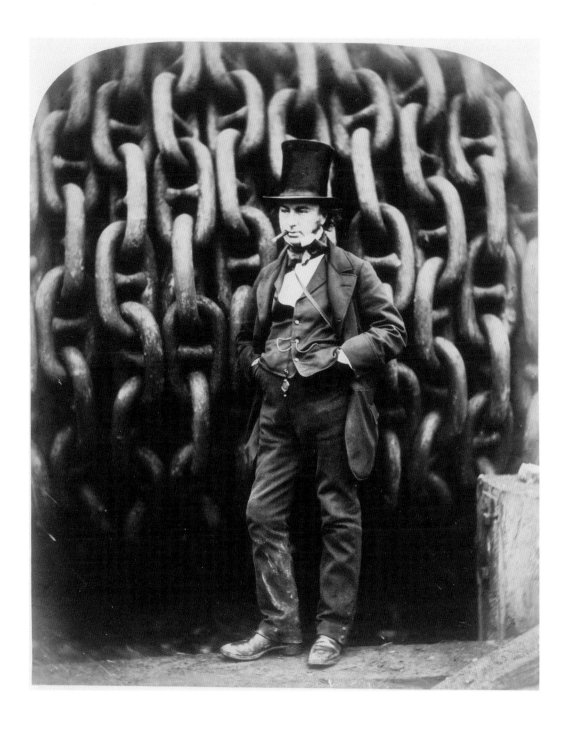

22 Robert Howlett, *Brunel Chains – I.K. Brunel by the Launching Chains
of the Great Eastern, Millwall, Isle of Dogs*, November 1851
Albumen silver print, 28.7 × 23.2, V&A Images/Victoria and Albert Museum

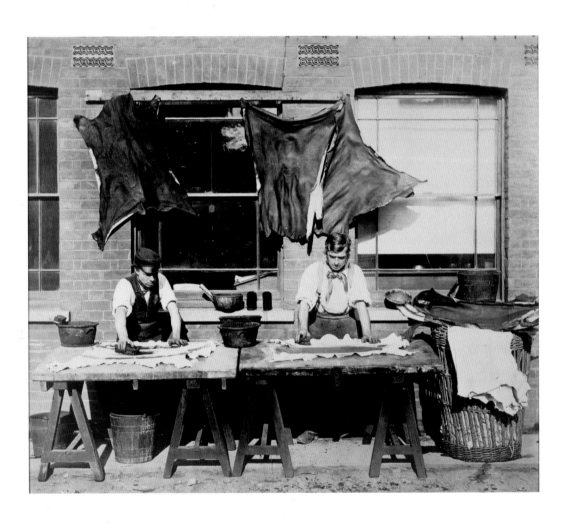

23 Geoffrey Bevington, Bevington and Sons, *Neckinger Mills tanning and leather finishing Factory*, 1861
Albumen silver print, 36.2 × 43, V&A Images/Victoria and Albert Museum

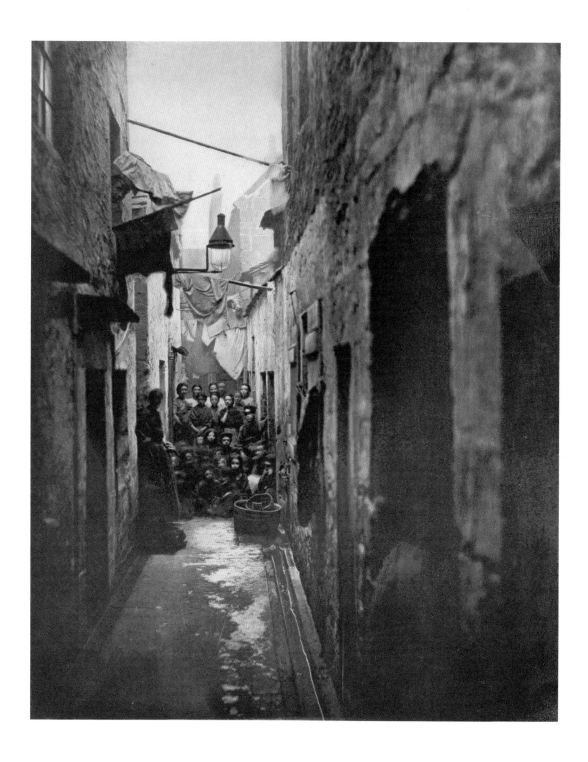

24 Thomas Annan, *Close No. 118 High Street* from the album *Glasgow City Improvement Trust Old Closes and Streets*, 1868–1899, (printed 1900)
Album, closed 56 × 43, V&A Images/Victoria and Albert Museum

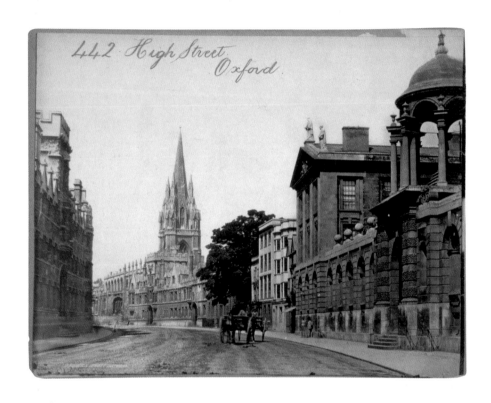

25 Frith Studios, *Oxford, High Street*, c.1865
Bromide print, 16.7 × 21. 6, V&A Images/Victoria and Albert Museum
[not exhibited]

26 John Thomson, *Recruiting Sergeants at Westminster*
from *Street Life in London*, 1877,
Woodburytype, 11.5 × 9, Guildhall Library, City of London

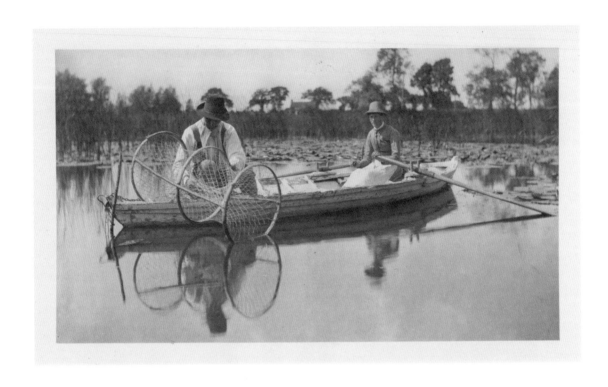

27 Peter Henry Emerson, *Setting the Bow Net*, 1886
Platinum print, 16.3 × 28.8, NMeM/Science & Society Picture Library

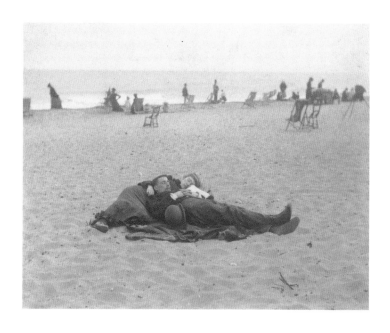

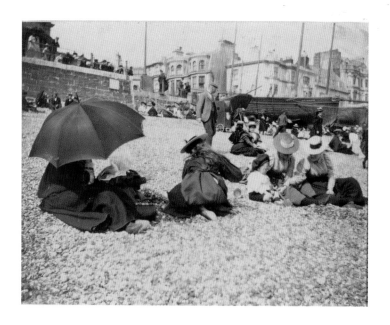

28 Paul Martin, *On Yarmouth Sands*, c.1892–5
Platinum print, 7.5 × 10, V&A Images/Victoria and Albert Museum

29 Frank Meadow Sutcliffe, *Families on the Beach*, c.1900
Gelatin silver print, 9.2 × 11.8, NMeM/Science & Society Picture Library

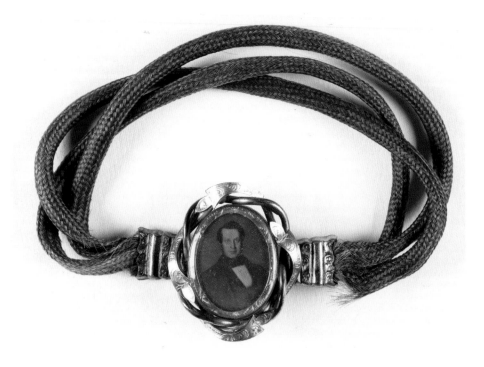

30 *Hair bracelet with portrait*, c.1860
Daguerreotype and hair, 1.8 × 1.6, NMeM/Science & Society Picture Library

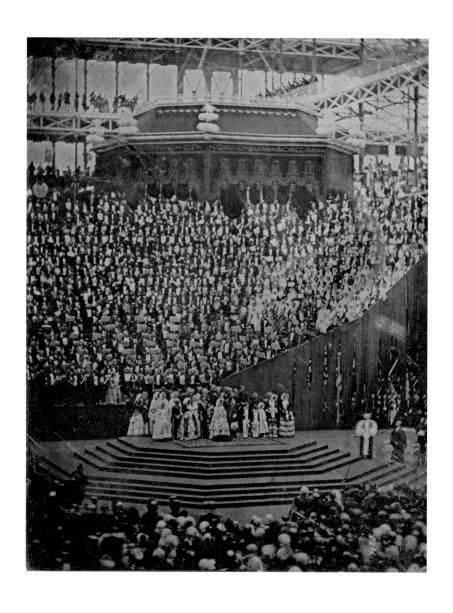

31 Phillip Henry Delamotte, *The Opening of The Crystal Palace at Sydenham
on the 10th of June,* 1854
Daguerreotype, 6.8 × 6, V&A Images/Victoria and Albert Museum

32 Robert Thompson Crawshay, *Turkish Bath*, c.1860
Cased ambrotype, approx. 10.7 × 8.1, V&A Images/Victoria and Albert Museum

33 William Edward Kilburn, *Hand-tinted portrait of a woman*, c.1850
Daguerreotype, 9.2 × 6.7, V&A Images/Victoria and Albert Museum

Into the Twentieth Century

By the turn of the century, the possibilities for photography were enormous. The studio movement had grown in strength, and photography had become a viable career for the middle classes, attracting many men and women who had customarily been excluded from the academy and the professions. Photography's gaze widened during these early years of the twentieth century and as the snapshot camera became increasingly popular, the making of photographs became increasingly available to a wide cross-section of the public. The British people grew accustomed to, and were hungry for, the photographic image.

The period leading up to the First World War was a time of immense change in British life, a time of social ferment and a concurrent growth of social mobility. Photography recorded a nation at a crossroads, and not only did photographers, as always, record change; they also sought to memorialise the past. Benjamin Stone's documentation of British customs and festivals preserved for posterity a nation still permeated by folklore (no. 34); his photographs, both purposeful and stark, later became a touchstone for documentary photographers.

While photographers of the nineteenth century had generally viewed the British countryside as a site of pastoral perfection, turn-of-the-century photographers, aware of the changing nature of British rural life, began to document its patterns and pursuits. Yorkshire museum curator Oxley Grabham produced photographs of life in the countryside, which, unlike the idealised rural tableaux made by Peter Henry Emerson in the nineteenth century, documented the arcane and ritualistic nature of rural communities. From dancing bears to a festoon of cats' tails and a beached whale paraded through a village (no. 37), Grabham's photographs give an indication of photography's ability to scrutinise the rural as well as to analyse the urban.

These first two decades of the new century also saw a new objectivity emerging from photography. The remarkable photographs of flowers, fruit and vegetables made by Charles Jones, a gardener at various English private estates, illustrate not only that photography was increasingly attracted to 'ordinary' subjects, but also that photographers could flourish outside the commercial, professional and art spheres (see no. 40). If Jones' view of nature was an objective, scientific gaze, then Agnes Warburg (a founding member of the Royal Photographic Society's Pictorialist group, and an early experimentalist in the Raydex and autochrome processes) was altogether more romantic (no. 49). Faced with a nation approaching modernity, the Pictorialists created through their photography a picture of a nation redolent with 'old' values. Many of those values were epitomised by nature tamed – the garden, the still life, the vase of flowers. Just as American photographer Alvin Langdon Coburn and the German Otto Pfenniger saw Britain's cities and

63

1900–1918

Alvin Langdon Coburn, *Leicester Square, London*
c. 1909 (detail, see no. 44)

seaside as idyllic and pleasure-filled (nos. 43 and 44), all depicted through the soft-focus lens of Pictorialism, so another group of photographers prepared to document change and dissent.

Women's lives became an intense focus of interest as the Suffragette movement gathered pace and women became politically active and socially involved. Photographers such as Lena Connell and Norah Smyth were members of the movement, Connell as a studio photographer and Smyth as a documentarist. Connell (who became an inspiration to later women portraitists, including Madame Yevonde) produced intense and dignified studio portraits of leading women campaigners, used in suffragette publicity campaigns (no. 48). Smyth, founder with Sylvia Pankhurst of the East London Federation of Suffragettes, used her camera to record the living conditions of women and children in the East End of London, documenting also the pioneering social and educational work of the ELFS and its later contribution to the war effort (see no. 38). The press photographer Christina Broom made important records of suffragette activity, documenting its public presence through photographs of marches and fairs (no. 46). Photography showed its sinister side, too, and continued to perform as a means of social record and surveillance, as can be seen in a sheet of photographs of 'known militant suffragettes' produced for the Criminal Records Office in 1912 (no. 45).

The growing popularity of music hall and circus provided an ideal arena for photographers, and during these early years of the century, the relationship between photography and celebrity was cemented. Photographs of circus performers, and music-hall stars like Vesta Tilley and Dan Leno (nos. 35 and 36), were sold as cartes-de-visite and cabinet photographs and, in large numbers, as photographic postcards, to a public hungry for glamour and entertainment. Photographers also realised that performers, with their highly developed notion of self-image, were ideal subjects.

Postcards, which often pictured local and personal events, as well as famous people, historic buildings and sublime landscapes, became a popular means of communication and the bearing of news. From the dramatic to the mundane, photographic postcards pictured disasters, from mining accidents to storm damage and crime scenes, while at the same time providing a vehicle for 'ordinary' news – a soldier in uniform, an engaged couple, a new home. Postcard production was an important form of income for small local photographic studios but was also highly lucrative for companies such as James Valentine and Sons of Dundee, whose business developed from the mass production of albumen prints for the tourist market in the 1880s to large-scale postcard production in the twentieth century.

As photographic technology became increasingly accessible, so family photographs, often in the form

of the new 'snapshot', became increasingly popular. The family album was a means not only of preserving domestic memories, but as an outlet for creativity and experimentation. The use of the snapshot camera (a Kodak Cat. 2) by Queen Alexandra, and the making by the Queen and her daughter Princess Victoria of a series of family albums, popularised the practice, particularly with women, who were (as they had been in the nineteenth century) often the makers and guardians of albums. The artist Vanessa Bell chronicled her family in snapshots from 1900 until 1952 (see no. 49). Her sister Virginia Woolf and other members of the Bloomsbury set were also enthusiastic photographers.

The great-nieces of Julia Margaret Cameron, both Bell and Woolf had a sophisticated appreciation of photography. Bell's family photographs, processed and printed at her local chemist's shop, often feature complex tableaux and disguises. Dressing up and play-acting, which is a constant strand throughout British photography, was as important in this context as it had been throughout the nineteenth century. Idiosyncratic family albums and collections, such as the Sassoon album in the archives of the Rothschild Collection in the City of London, are a common feature of British archives and are remarkable for their complexity (no. 42). Through these photographs, we glimpse the intimacy of family life played out against the background of Britain at peace, a mere four years before the First World War, which was to inflict permanent and catastrophic change.

From 1914 to 1918 and beyond, photographers, both amateur and professional, documented the First World War and its consequences. When an anonymous photographer documented a group of maimed servicemen before and after the fitting of new limbs, the importance of photography at the home front emerged as immense (no. 47). The sense of nationhood, which had been so prominent in the golden summer that preceded it, was challenged and damaged. Like photography, it would never be the same again.

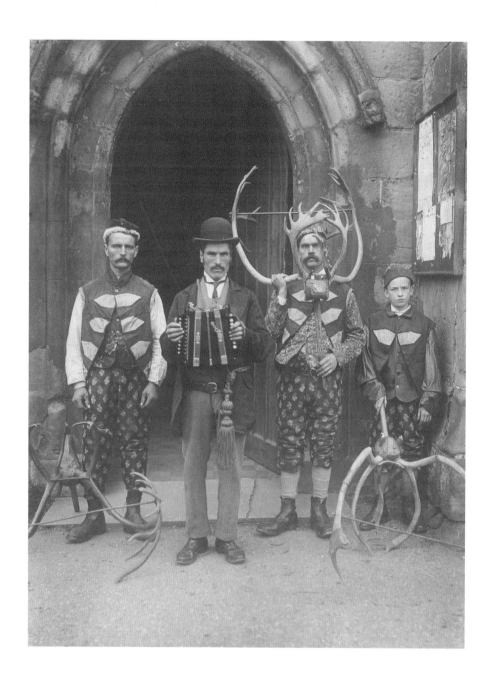

34 Benjamin Stone, *The Horn Dance, Abbot's Bromley, Four of the Performers*, 1899
Platinum print, 25.4 × 20.3, Birmingham Library & Archive Services

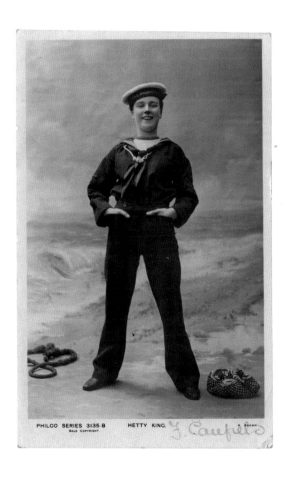

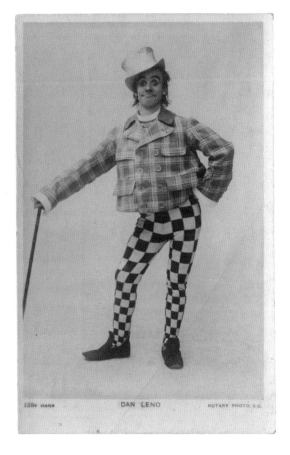

35 The Draycott Galleries, published by Philco Publishing Co, *Vesta Tilley,* c.1912
Bromide postcard print, approx. **19.8** × **7.3,** Private Collection, Surrey

36 Hana, published by Rotary Photo Co., *Dan Leno in the 1894 production of Dick
Whittington*, Undated
Bromide postcard print, approx. **13.8** × **8.8,** Private Collection, Surrey

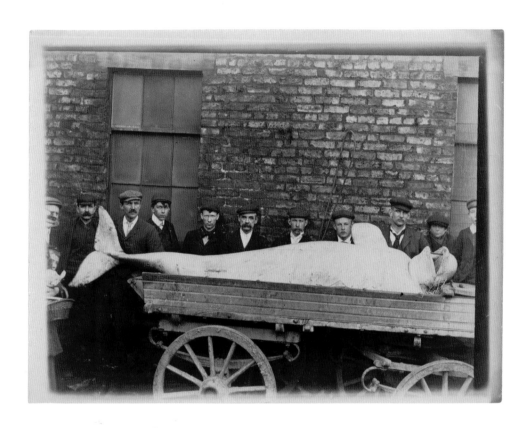

37 Oxley Grabham, *White Whale shot in the river near York*, c.1910
Gelatin silver print, 7.3 × 9.5 cm, NMeM/Science & Society Picture Library

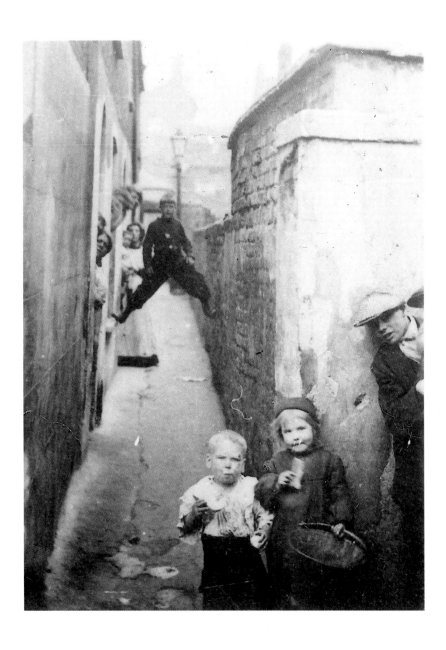

38 Norah Smyth, *Bromley Children, for the Women's Dreadnought*, 1914
Digital scan of original negative, By Permission of People's History Museum

39 Agnes Warburg, *Brighter, London*, undated
Three colour carbro print, 18.2 × 23.3, NMeM/Science & Society Picture Library

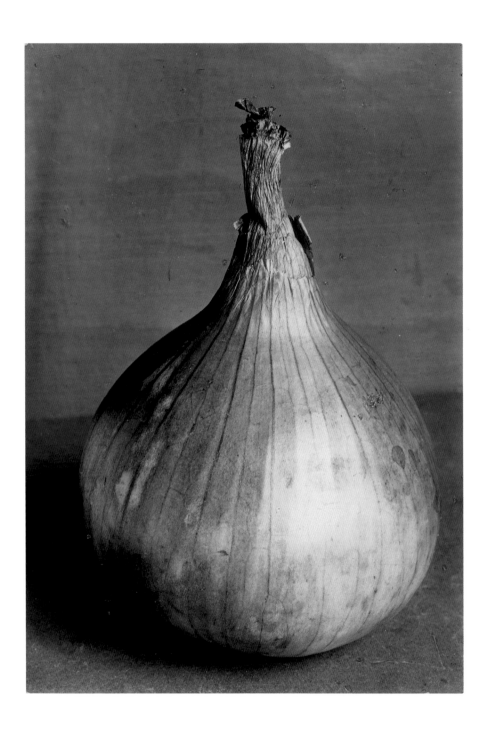

40 Charles Jones, *Onion Brown Globe*, c.1910
Gold-toned gelatin silver print, 48.5 × 35.5, Sexton Collection,
London in conjunction with Thames & Hudson

41 Photographer unknown, postcard 1900–1918, 82 × 133, Martin Parr

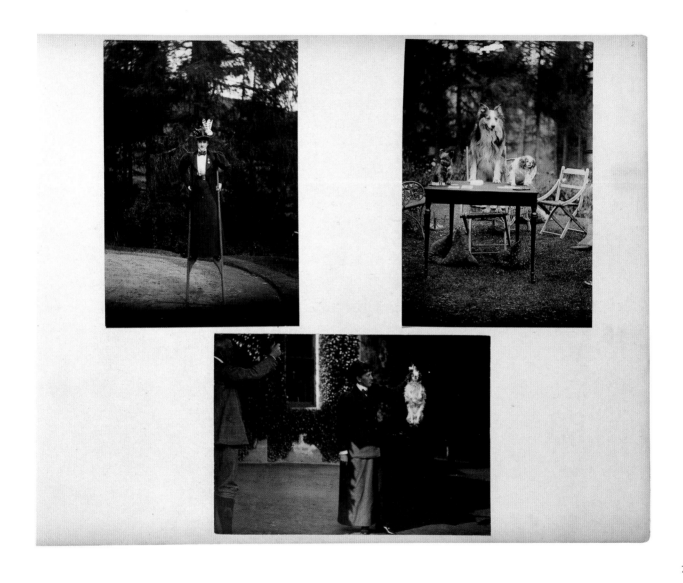

42 Sassoon Family Album, c.1900
Black and white photographs, process unknown, Closed album,
28 × 38, Rothschild Archive, London

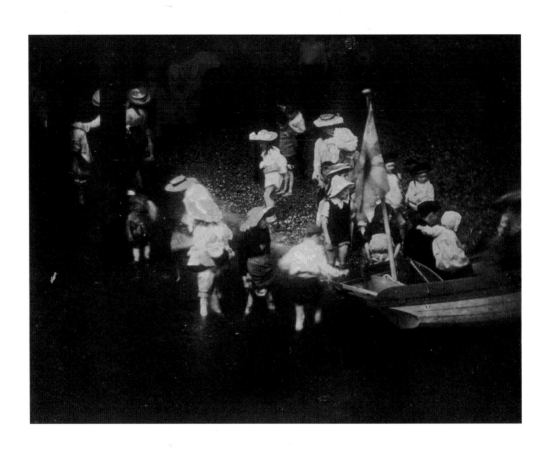

43 Otto Pfenninger, *Figures Around a Boat August 1906*, 1906
Three colour carbon print, 13.3 × 17.5, NMeM/Science & Society Picture Library

44 Alvin Langdon Coburn, *Leicester Square*, London c.1909
Photogravure, 20 × 14.5, NMeM/Science & Society Picture Library

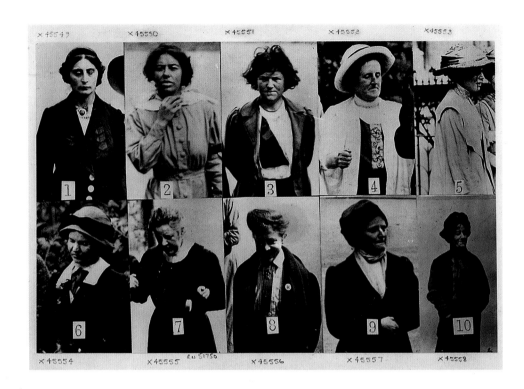
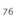

ig.	Name.	Year born	Height Ft. In.	Eyes	Hair.	C.R.O. Number	Crime
1	Scott Margaret	1888	5. 3	Blue.	D.Brown.	S.168279	Damage.
2	Hockin Olive.	1881	5. 3½	Brown	Brown	S.169280	Conspiry.
3	McFarlane Margaret	1888	5. 1	Hazel	Brown	S.168518	Damage
4	Wyau Mary @ Nellie Taylor.	1864	5. 1	Brown	Brown	S.168705	Damage
5	Bell Annie @ Hannah Booth and Elizabeth Bell.	1874	5.6½	Blue	Lt.Brn.	S.165769	Damage
6	Short Jane @ Rachel Peace.	1882	5. 3	Blue	Brown	S.168517	Arson
7	Ansell Gertrude Mary	-	5. 4	Grey	Tg.Grey	S.169570	Damage
8	Brindley Maud	1866	5. 3	Grey	Grey	S.167057	Damage
9	Oates Verity	-	5. 0	Brown	Brown	S.172313	Damage
10	Manesta Evelyn	1888	5. 2	Grey	Fair	S.166692	Damage

45 Surveillance Photograph issued by Criminal Record Office,
Photograph of Known Militant Suffragettes, 1912
Bromide print, 38.1 × 30.5, National Portrait Gallery, London

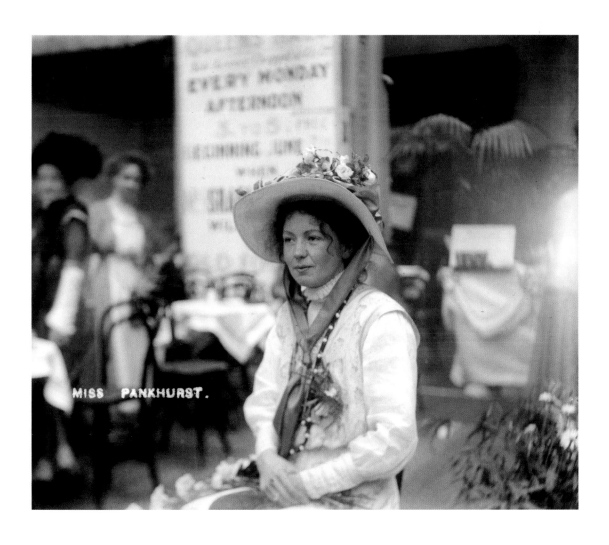

MISS PANKHURST.

46 Christina Broom, *Christabel Pankhurst at the*
International Suffragette Fair, Chelsea 1912, 1912
Modern gelatin silver print from original negative, 25.4 × 30.5,
Museum of London

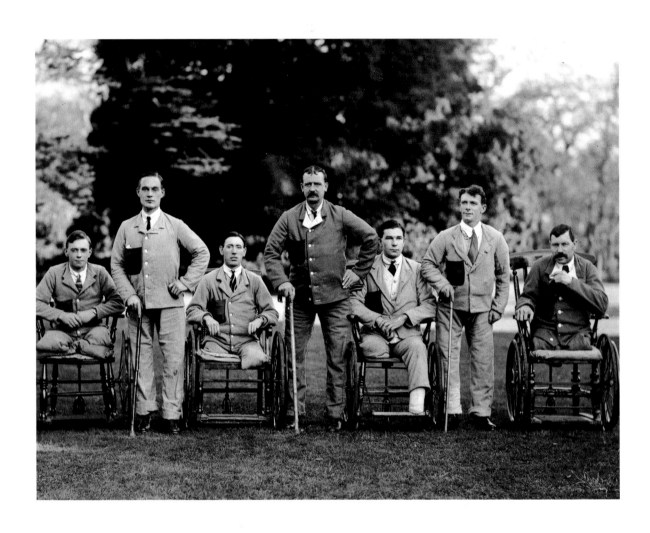

47 Photographer unknown, British Red Cross, *Legless Servicemen fitted with
artificial limbs at Queen Mary's Hosptial, Roehampton January 1918,* 1918
Modern gelatin silver print from original negative, 30.5 × 40.6,
Imperial War Museum, London

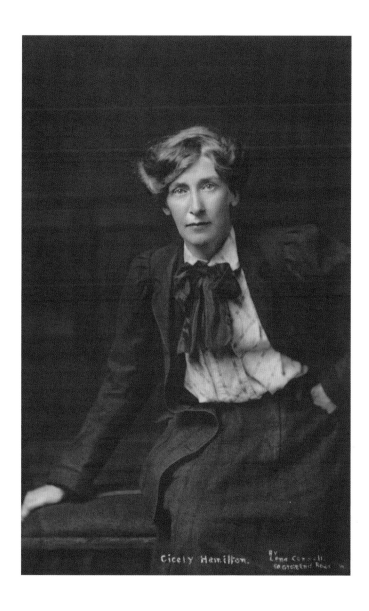

48 Lena Connell, *Cicely Mary Hamilton*, 1912
Matt gelatin silver print, 13.5 × 8.3, National Portrait Gallery, London

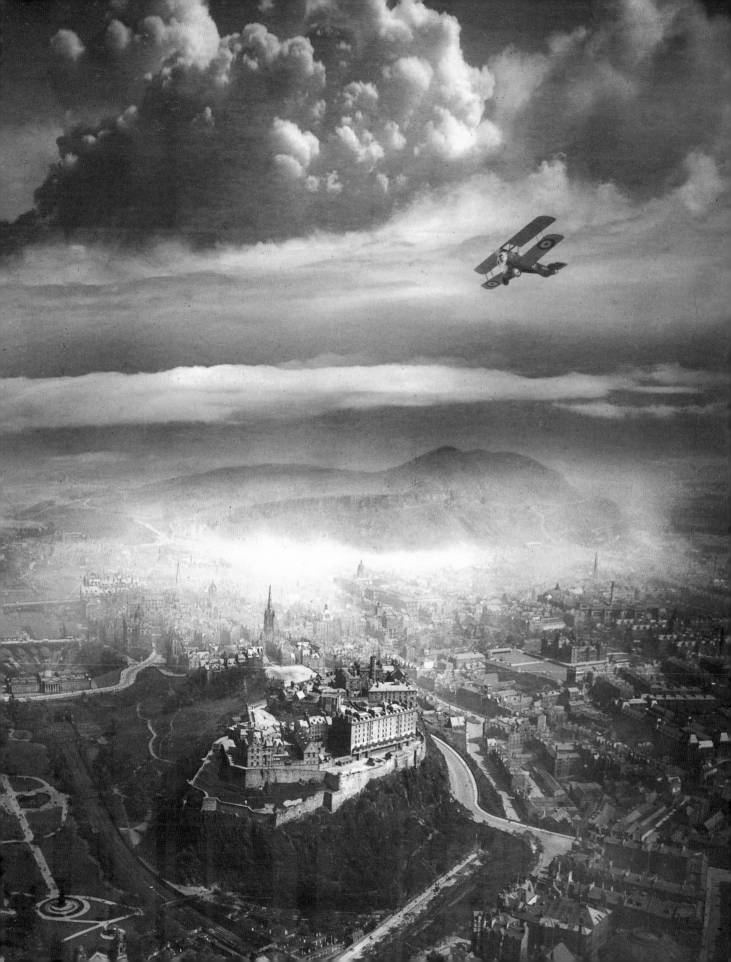

New Freedoms in Photography

The interwar years saw an explosion of new techniques in photography and new ways of seeing. The growth of advertising and public relations, the arrival in Britain of émigré photographers, the exposure in London of avant-garde work from Europe through foreign publications (accessed via Zwemmers' bookshop) and the embrace of modernism by photographers caused a surge of innovatory work. The outbreak of the Second World War changed the course of British photography, presenting both opportunities and obstacles. Some, like the society portraitist Cecil Beaton and the colour pioneer John Hinde, made important work during the war (see nos. 58 and 62); others, such as John Havinden and Barbara Ker-Seymer (nos. 56 and 52), saw their studio practices collapse as materials became scarce and austerity became the order of the day. Yet others, like Winifred Casson (no. 61), simply disappeared. The years from 1918 to 1945 were remarkable for photography, full of energy, enthusiasm, inventiveness and change.

Madame Yevonde, Winifred Casson, Angus McBean, Helen Muspratt, Barbara Ker-Seymer, Peter Rose Pulham and John Havinden (nos. 68, 61, 65, 55 ,52 ,54, 56), together with émigré photographers such as Edith Suschitzky (later Tudor-Hart) and Wolf Suschitzky (nos. 63 and 69), brought a new vitality to British photography. From this period, remarkable bodies of work emerged: Yevonde's *Goddesses and Others* in the mid-1930s (no. 68), Beaton's portraits of the English avant-garde (no. 58),

Casson's solarized still lifes and prtraits (no. 61), Havinden's modernist photographs for advertising and industry (no. 56), Ker-Seymer's portraits of London bohemia (no. 52), and Peter Rose Pulham's sublime experimentalist fashion photography (no. 54).

The photographic album was still an important repository of memory – Vanessa Bell continued to document her family throughout the period, while in *Dick's Book of Photos* 1939, artist Keith Vaughan compiled thirty-four photographs in a handmade album recording a sunlit summer on the beach at Pagham on the eve of the Second World War (no. 51). The work was dedicated to his brother Richard, who was killed in action in 1940.

Although everyone with access to a snapshot camera could now make photographs, studios continued to prosper. The studio portraitists, with their lights, props, retouchers and high-definition plate cameras, created highly crafted (and frequently embellished) portraits for public and private consumption. Like the theatre photographers who preceded him, Angus McBean gave the British public photographs of the celebrated and the talented, often wreathed in a particularly British 'surrealism' (no. 65). Studio portraitists of the 1920s and 1930s ranged from photographers such as Dorothy Wilding and Madame Yevonde, who catered for high-society and show-business clients (nos. 66 and 68), to rural photographers such as George Garland, whose clientele ranged from farm workers and soldiers to babies,

81

1918–1945

Captain Alfred George Buckham,
Aerial View of Edinburgh , c.1920
(detail, see no. 57)

servants and shopkeepers. Garland's photography, with its quiet honesty, gives us a fascinating and unique document of one small corner of England (see no. 50).

The 1930s saw great changes in photography. In terms of technological innovation, the availability of the miniature camera from the early 1930s gave photographers the ability to capture real life at speed. As a means of social documentation, photography was viewed by some as a tool for change. Many photographers were impelled by political conviction – Edith Tudor-Hart, like Norah Smyth before her, was a campaigner for radical causes (no. 63). A member of the Workers' Film and Photo League, Tudor-Hart contributed photographs to books such as *Working Class Wives* by Margery Spring Rice (1939) and to publications from the legendary Left Book Club. Helen Muspratt, who, with Lettice Ramsey, ran the Ramsey and Muspratt portrait studio in Cambridge in the 1930s, was a life-long socialist as well as one of Britain's most innovative studio photographers, working with techniques (including solarisation) that had been brought to Britain on a wave of European innovation (no. 55).

Professional photojournalism expanded with the growing popularity of illustrated magazines, and *Picture Post* became required reading across Britain, satisfying the public's hunger for the 'slice of life' photo story. During the Second World War, photojournalist Bert Hardy produced for *Picture Post* many photo stories that extolled the fortitude of the British under fire (no. 70).

Humphrey Spender (working under the pseudonym of Lensman for the *Daily Mirror*) documented British life throughout the 1930s, his series on the Jarrow Hunger Marchers symbolising a decade of poverty and protest (no. 64). Bill Brandt also produced work for picture magazines, as well as for books such as *The English at Home* (1936), which, in richly toned gravure, portrayed Britain as an austere nation of social extremes (no. 34).

The interwar years saw one of the most significant advances in the technology of photography since its invention – the emergence of colour. Photographers had been experimenting with colour since the beginning of the century, but the processes then available were cumbersome, expensive and extremely time consuming. By the 1930s, a new wave of photographers was experimenting with colour. John Havinden, who was producing photographs for advertising agencies, had used the Dufay process during the 1930s, though his practice remained rooted in high-quality black-and-white work (no. 56). It was the pioneering and commercially astute studio portraitist Madame Yevonde who noted the improvements in colour technology made by Dr D. A. Spencer and his company Colour Photographs. Yevonde became one of the first to exploit the Vivex process, a complex procedure using three negatives and colour filters with special lighting. The results were spectacular, producing prints that were bright, rich and almost luminous. The colour was so saturated that the photographs

took on a quality more familiar in the cinema than in photography (no. 68).

Another photographer who took up the challenge of colour with enthusiasm was John Hinde. Hinde began experimenting with colour while still a schoolboy in the early 1930s, encountering the Paget process through his local chemist's shop. When he embarked on a career in photography in London in the mid-1930s, he adopted Duxachrome before moving on to the Carbro process. He made his first significant experiments in colour with photographs for a series of books on British garden plants, but it was his wartime series, *Citizens in War – and After* 1945 (no. 62) that gave him the opportunity to make one of the first series of colour documentary photographs in Britain. Hinde was a truly remarkable photographer. *Citizens in War – and After* combined photojournalistic instinct and the ad-man's eye for a seductive scene with high craftsmanship and a passion for colour. Looking at Hinde's photographs, we see a war that we know in black and white becoming vivid with colour – fire burns intense orange, the dress of a Civil Defence worker is bright crimson, pink faces are scorched with black soot, an evacuee wears her best blue coat. At a time when colour photography was rejected by the serious photography 'establishment', Hinde proved that its impact and power could be enormous.

The Second World War saw another significant photographer working in colour: Percy Hennell, a member of a family of prominent British silversmiths and cousin of the artist Thomas Hennell, who worked as a photographer at the Metal Box Company in London before his secondment to the Office of War Information. As part of his war work, Hennell photographed reconstructive facial surgery performed on victims of war at London hospitals (no. 60). When he photographed these patients, his observation was unflinching yet reverent. In his book *British Women Go to War* (undated), with text by J.B. Priestley, Hennell achieved a photographic tour de force, picturing women undertaking many different kinds of war work, from farming to making torpedoes (no. 60). Hennell's gaze was intense – he saw both ordinariness and glamour in the women he photographed. The nation that he portrayed was damaged, yet fully capable of recovery.

During this period of immense social and political significance, Britain was a nation of extremes: violence and glamour, poverty and affluence. From the secret gardens of the south of England to the war-damaged faces of Londoners, from high bohemia to hungry men marching, from Edith Sitwell to a Sussex villager, British photographers captured it all, a timely witness in remarkable times.

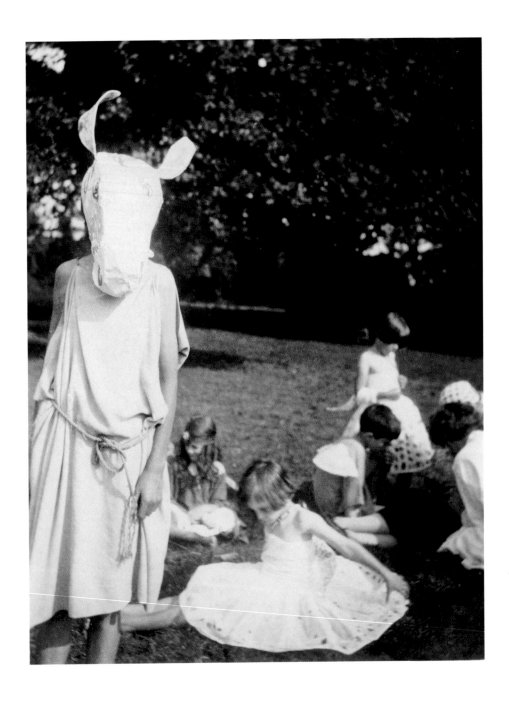

49 Vanessa Bell, *Summer School 'A Midsummer Night's Dream'*, 1928
Gelatin silver print, 8.9 × 10.2, Courtesy Tate Archive

50 George Garland Studio, *Duchesne Child*, April 1942
Modern gelatin silver print from original negative, 40.6 × 50.8,
Private Collection, London

51 Keith Vaughan, *Dick's Book of Photos*, Young Man, 1939
Gelatin silver print, 25.2 × 28.5, University of Wales, Aberystwyth

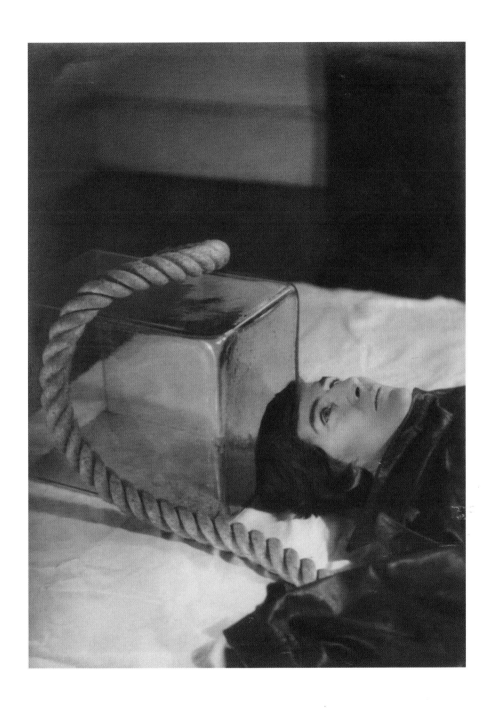

52 Barbara Ker-Seymer and John Banting, *Alix Strachey,* 1930s
Bromide print, 30.4 × 21.4, National Portrait Gallery, London

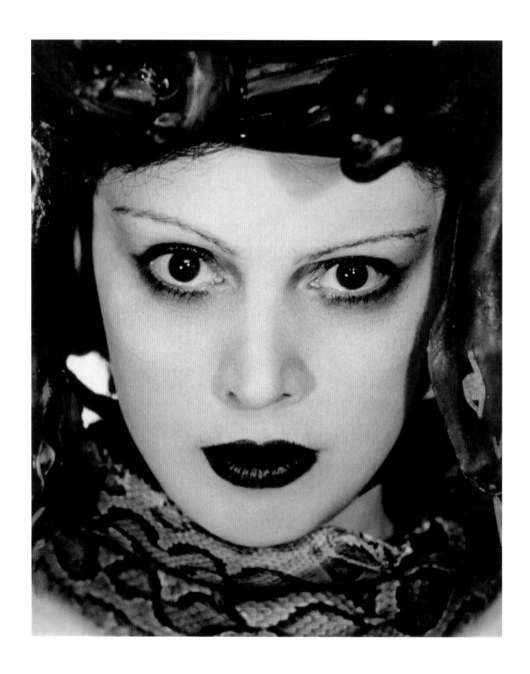

53 Madame Yevonde (Yevonde Middleton), *Mrs Edward Mayer as the
Medusa* from *Goddesses*, March 1935
Vivex colour print, 36.2 × 29.7, NMeM/Science & Society Picture Library

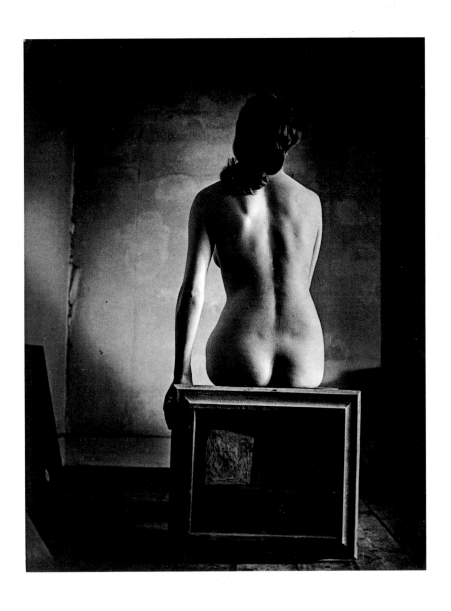

54 Peter Rose Pullham, *Nude Study of Theodra Fitzgibbon*, London, 1942
Gelatin silver print, 24.5 × 19.3, Private Collection, London

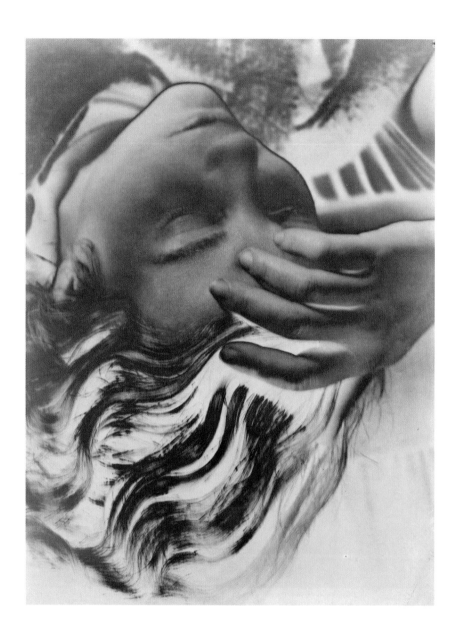

55 Helen Muspratt, *Eileen Agar*, c.1935
Gelatin silver print, 21 × 16, Private Collection, London

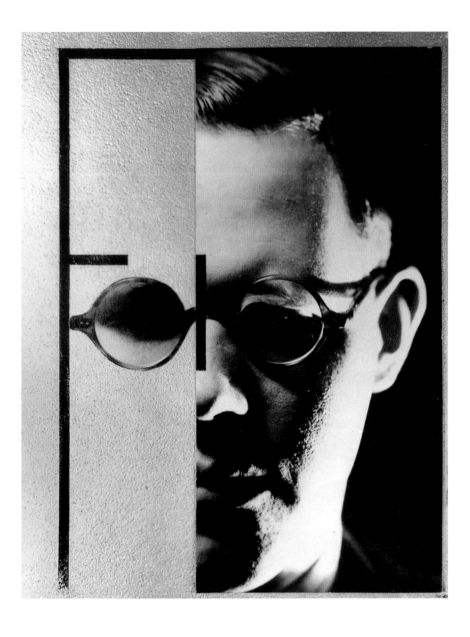

56 John Havinden, *John Havinden*, 1930
Bromide print, 25.4 × 20.3, National Portrait Gallery, London

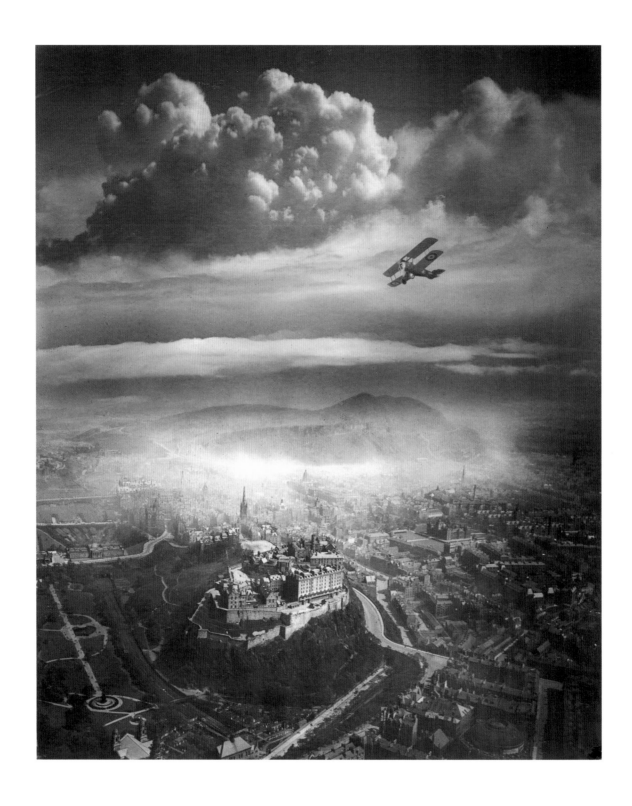

57 Captain Alfred George Buckham, *Aerial View of Edinburgh*, c.1920
Gelatin silver print, 45.8 × 37.8, Scottish National Portrait Gallery, Edinburgh

58 Cecil Beaton, *The Western Campanili of St Paul's Cathedral seen through
a Victorian shop front*, c.1940–41
Gelatin silver print, 20.4 × 19.5, Cecil Beaton Studio Archive, Sotheby's

59 Percy Hennell, from the book *British Women Go to War*, undated
19 × 25, Collins Publishers, London

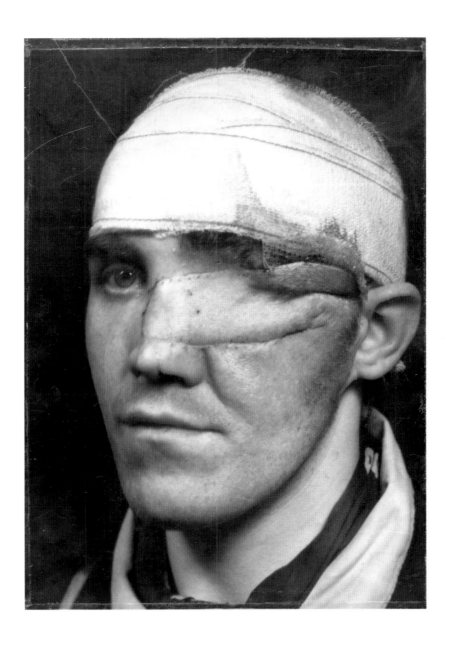

60 Percy Hennell, *Wartime injury of the left eye which has been removed and*
replaced with a flap of skin taken from the scalp or forehead which is bandaged, Undated
Colour print made from three negatives exposed synchronously in a one-shot
camera incorporating tri-chromatic filters, 19 × 14, Antony Wallace Archive,
British Association of Plastic Reconstructive and Aesthetic Surgeons at the
Royal College of Surgeons, London

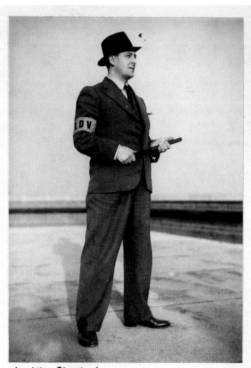

As We Started...

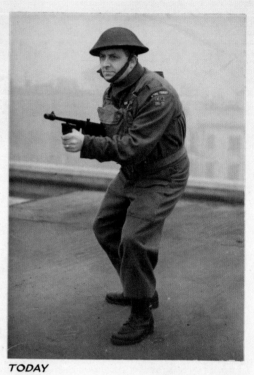

TODAY

61 Photographer unknown, *Kemsley House (C) Company 5th City of London*
Bn. Home Guard, c.1940
Silver gelatin prints, 25 × 30, Guildhall Library, London

62 John Hinde, *A Member of the Warden's Service Fitting a Gas Mask, 1944*
From the book *Citizens in War – And After*, Harrap London 1944, 1945
3 Colour carbon print, 21.5 × 16.5, NMeM/Science & Society Picture Library

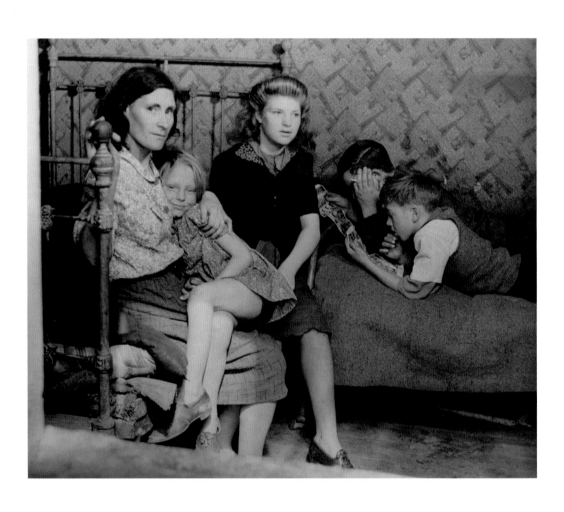

63 Edith Tudor-Hart, *London Family*, 1936
Gelatin silver print, 19.6 × 24, NMeM/Science & Society Picture Library

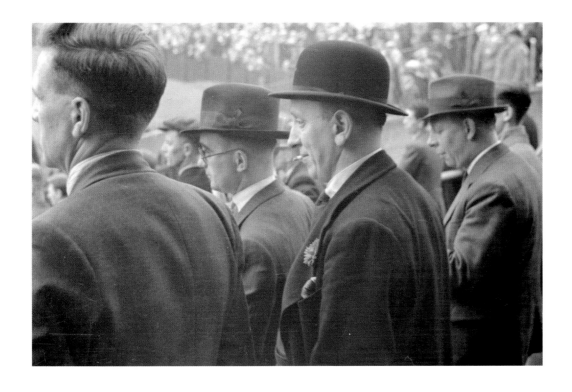

64 Humphrey Spender, *Work Town People: Photographs from Northern England* (*sport*): *Football spectators – Bolton Wanderers at home*, 1937
Gelatin silver print, 19 × 12, Bolton Museum and Art Gallery
[not exhibited]

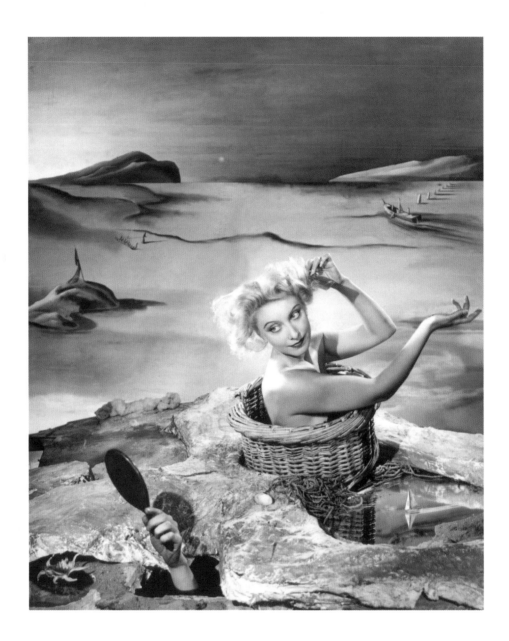

65 Angus McBean, *Frances Day*, 1938
Gelatin silver print, 30.5 × 25.4, Angus Mcbean Photograph,
Copyright © Harvard Theatre Collection

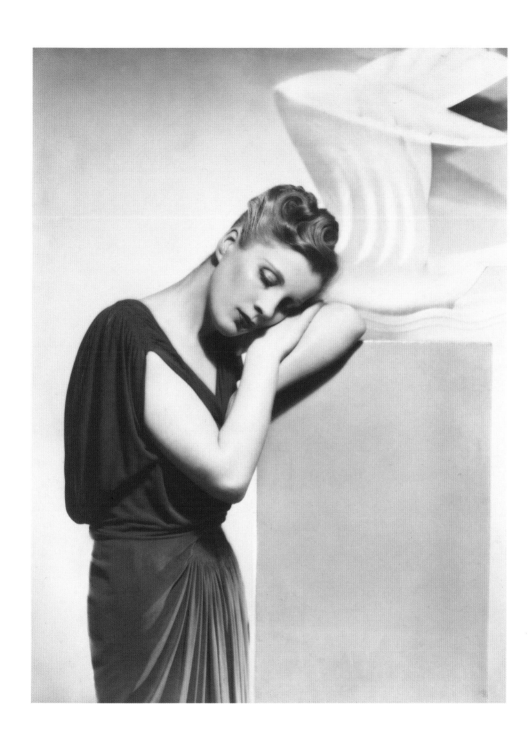

66 Dorothy Wilding, *Diana Wynyard*, 1937
Chlorobromide print, 43.3 × 33.3, National Portrait Gallery, London

67 Winifred Casson, *Still Life*, c.1935
Solarised silver gelatin print made with the technical assistance of
Somerset Murray, 24.0 × 23.8, Private Collection London.

68 Edward McKnight-Kauffer, *Camelia and Hand*, c.1935
Gelatin silver print, 28.2 × 23.8, Private Collection, London

69 Wolfgang Suschitzky, *Man outside Foyles, Charing Cross Road,* c.1936
Gelatin silver print, 30.5 × 40.6, Courtesy the artist
[not exhibited]

70 Bert Hardy, *The Man who Dresses the Elephant*, 1948
Gelatin silver print, 24 × 16, Cuming Museum, London Borough of Southwark

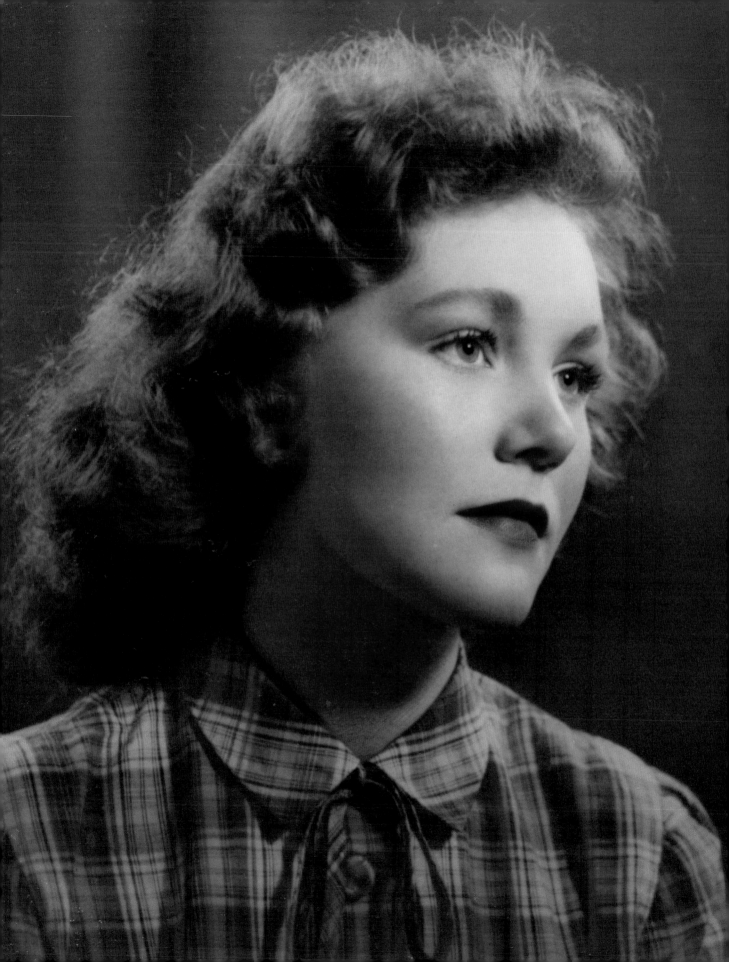

The New Britain

Postwar Britain held huge opportunities for photographers. Publications, as established as *Vogue* and as new as the *Sunday Times* and *Observer* magazines, demanded a constant flow of images. Book production, released from wartime constraints, increased significantly. Documentarists including Eve Arnold, Nigel Henderson, David Hurn, Roger Mayne and Grace Robertson, (see nos. 84, 85 and 89) were productive during these years, but equally so were lesser-known figures such as Shirley Baker, who produced colour photography of living conditions in the urban contexts of Manchester and Salford in the mid-1960s (no. 72). Euan Duff's photographs, published in *How We Are* (1971), picture Britain as a dour, dark and pessimistic place on the cusp of change (no. 92).

Fashion photography thrived in the postwar years as the industry emerged from the restrictions of war. Norman Parkinson, in his photographs for British *Vogue*, created a vision of 'Englishness' in which British women were seen as tailored, elegant and resolute (no. 96), while David Bailey chronicled the movers and shakers of fashion and pop (no. 86). Tony Ray-Jones introduced new ideas about documentary photography and influenced generations of photographers to come (no. 95). He saw Britain through Americanised eyes, a nation of odd juxtapositions and ambiguous encounters, challenging the *Picture Post* view of Britain, and seeking out eccentricity and a kind of abjectness.

The portrait studio flourished on the high street, giving, yet again, opportunities to carve out careers based around local interests and demands. Dorothy Bohm's Studio Alexander (no. 71) attracted Mancunian academe, as well as brides and babies, while Tony Walker's Belle Vue studio in Bradford (no. 90) and Harry Jacobs's studio in south London (no. 91) catered for recent immigrants to Britain, providing photographs that would make their tenuous foothold in the mother country seem stronger and more permanent.

The 1950s saw the growth of domestic-advice books, which paved the way to better cookery, better homes and better lives. Publications such as *The Good Housekeeping Guide to Colour Cookery* (1967) (no. 76) showed the women whose mothers had built torpedoes and plotted the course of enemy planes, how to make Scandinavian salad, Spanish paella and pineapple pieces on sticks. The emergent package-tour industry meant that Britons were travelling, glimpsing other cultures and trying appetising cuisines. A fast-improving economy fuelled an aspiration to better things. The release from long working hours, and from slums to new housing estates, meant that gardening and interior decoration, once the province of the well to do, were within everyone's reach. Photographically illustrated books were there to help – notably, the Rose Annual with its visions of the perfect British bloom (no. 75), and Constance Spry's volumes on flower arranging.

Celebrity and show business were as important as

1945–1969

71 Dorothy Bohm, *A Manchester Girl, Studio Alexander,* 1947
Hand-tinted gelatin silver print, 25.4 × 20.3,
Courtesy Dorothy Bohm Archive

they had always been to the British public, and images taken by the *Daily Herald* press photographers during the early 1960s gave extra sparkle to the stars of British light entertainment, such as Hattie Jacques, Frankie Howerd, Norman Wisdom and Tommy Cooper. **(see no. 87)**.

Throughout the post-war years, British photography was threaded through with the romance of landscape. Edwin Smith was active throughout the 1950s and 60s, making photographs of a Britain that was dark, secret and essentially melancholic **(no. 77)**. Like John Hinde, Smith had trained as an architect, and he was also an admirer of the work of Paul Nash, whose simple, sculptural representations of trees, gardens and plant forms appealed to his purist vision. Smith's view of Britain was in sharp contrast to work being made to satisfy a new hunger for photographs of British beauty spots, made in clear, bright colour.

Interest in British heritage, from village life to vernacular buildings and the rural landscape, was intense during the postwar decades. In May 1945, *Picture Post* published across two pages a photograph of a river fringed by ancient willows. The picture was captioned: 'One Of The Things We Have Been Fighting For: The Well-Loved Peace and Quiet Of The English Countryside'. For a country that had been so endangered, and whose cities had been so damaged, the time-honoured ritual of the English village, and the peace and sublimity of the countryside, came to symbolise all that was good about the nation. Growing prosperity among the working and middle classes made family excursions and holidays within Britain possible. The increasing ownership of family cars led to greater personal mobility. No longer tied to timetables and railway stations, the British could now venture out into the wild. From the 1950s to the 1970s, Batsford, David and Charles, Thames & Hudson and Country Life all published many illustrated books examining traditional British life. Batsford's series The British Heritage in Colour comprised fourteen volumes with titles such as *Shakespeare's Country*, *Old Inns of England* and *English Lakeland*.

Important writers on the countryside and heritage began to make an appearance. For example, the poet Geoffrey Grigson, at the suggestion of the artist John Piper, co-authored *An English Farmhouse and its Neighbourhood* (1948) with photographer Percy Hennell **(see no. 78)**. The book extolled the virtues of vernacular building techniques and warned against the dangers posed to this heritage: 'On the farms, life and amenities given in the past seem, at best, to be held; not so much is added, little is renewed, much is patched, much is slipping away, decaying, vanishing.' (p.28.)

Hennell's photographs had also made an appearance in the *About Britain Guides*, published for the Festival of Britain and edited by Grigson, with contributions by (amongst others) W. G. Hoskins. Hoskins, an Oxford academic, had published his seminal book *The Making of*

the English Landscape in 1955 **(no. 73)**. A new interest in local history, combined with the eloquence of Hoskins' exploration of the social history of the land, made his books unexpectedly popular. His photographs of the disappeared villages of England, obliterated by plague and poverty, prefigured many later landscape photographers who would define Britain through fragments and absences. Likewise, the photographs collected by J.K.S St Joseph in *The Coast of England and Wales* (with a text by J. A. Steers) pictured an island of lonely magnificence, unpeopled, ethereal **(see no. 81)**.

In the 1950s and 60s, the public needed not only to be guided around the sights and spectacles of England, but also to collect keepsakes of their visits. The Country Life Picture Books performed this function perfectly. They were high quality, well printed and beautifully illustrated by some of Britain's best-known and productive landscape photographers. W. A. Poucher, a perfumier whose obsession with mountains resulted in a series of books that depicted upland Britain **(no. 83)**, was a regular contributor to the Country Life series, as were E. A. Bowness, Geoffrey N. Wright, Kenneth Scowen and A. F. Kersting. The 1961 *Country Life Picture Book of the Lake District in Colour* **(no. 74)** showed a landscape humanised by country inns, ramblers, farmsteads and village settlements. Long derided as 'chocolate box', these photographs are perhaps the most enduring testament we have to the reawakening of the British

public to their rural heritage. In the photographs of Scowen, Bowness and Wright the landscape of Britain emerges from the darkness of war, sunlit and at peace.

The phenomenon of the souvenir picture postcard continued unabated and became an integral part of everyone's holiday. Butlin's holiday camps, which attracted thousands of working people every year, produced folders of souvenir photographs for their departing guests.

When writing about the farmhouse that he and Hennell had discovered in the south of England, Grigson noted the presence of owls in the crumbling ruin of a barn. But it was another observer of the rural, photographer Eric Hosking, who produced in July 1948 one of the most enduring symbols of British rural life: his study of a barn owl carrying food for its young **(no. 82)**. Hosking, a regular contributor to, and photography director of, the Collins New Naturalist series, was committed to popularising natural history, as expressed by naturalist James Fisher in 1942: 'After this war, ordinary people are going to have a better time than they have had; they are going to get about more … many will get the opportunity, hitherto sought in vain, of watching wild creatures and making discoveries about them.' (Quoted in Stephen Moss, 'Country Life', *Guardian*, 16 December 2006.)

Hosking's Barn Owl series can be seen as a tribute to British values – to the fliers who had played such an important part in the winning of the Second World War,

to the probity of rural life and the nobility (and ferocity) of nature. He brought the secret life of birds into the nation's living rooms, inspiring thousands of young naturalists, and playing an important part in the environmentalist cause.

The popularity of fashion photography and photojournalism, and the impact of agencies, such as Magnum Photos, encouraged photographers to see themselves as more than simply providers of images to the press. Magnum photographers, working mainly on commission, documented urban Britain in the tradition of Henri Cartier-Bresson, one of the agency's founder members, capturing pictures of everyday life, searching out the conundrums of a society caught in the crossfire between old and new. Photography was increasingly seen as a

way to change the world, often through the conduit of publications such as the *Sunday Times* magazine, the *Observer* magazine and *New Society*. The emerging discipline of sociology gave photographers the academic impetus to use their work as a means of social reform: Willmott and Young's *Family and Kinship in East London* (1961) was well known to many photographers of the period, as was Albert A. Cohen's *Delinquent Boys* (1955). Robert Smithies travelled to Tottenham in north London to photograph the new phenomenon of the Mods for his employers at the *Guardian*, who were acutely aware of the emergence of a new youth culture (no. 93). In the years to come, many photographers made the portrayal of youth culture a central part of their photographic practice.

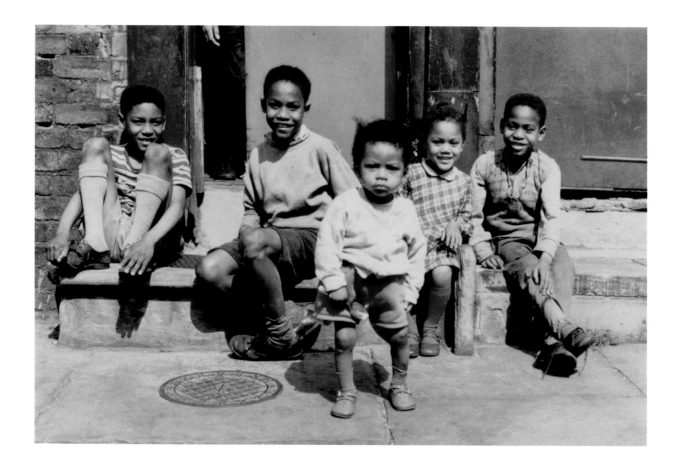

72 Shirley Baker, *Hulme, 1965*, 1965
C-type print, 25.4 × 20.3, Courtesy the artist

73 W.G. Hoskins, *The Making of the English Landscape*,
Hodder & Stoughton Ltd, London, 1955, 17.5 × 22

74 Country Life, *Picture Book of the Lake District in Colour,*
Country Life Ltd London, first published 1961, book, 25 × 43

'BIRMINGHAM POST' (H.T.)
'Queen Elizabeth' × 'Wendy Cussons'
Raised by Watkins Roses Ltd
TRIAL GROUND CERTIFICATE 1968
See page 184

114

75 The Rose Annual, The National Rose Society of Great Britain,
St. Albans, Herfordshire, 1969
Book plates, approx. 15.3 × 7.6

23. Cheese Savouries and Titbits

76 Photographer unknown, Good Housekeeping Colour Cookery, 1967
24.5 3 19, Courtesy National Magazine Company Ltd.

77 Edwin Smith, *Tresco Abbey Gardens, Isles of Scilly, "Dasylirion"* c.1950
Gelatin silver print, 25.4 × 20.3, RIBA Library Photographs Collection

PLATE 24.

78 Percy Hennell and Geoffrey Grigson, *An English Farmhouse,*
Max Parrish & Co Ltd, London 1948, book, 23.5 × 17.5

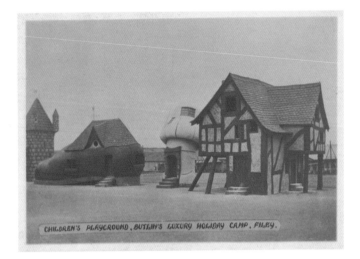

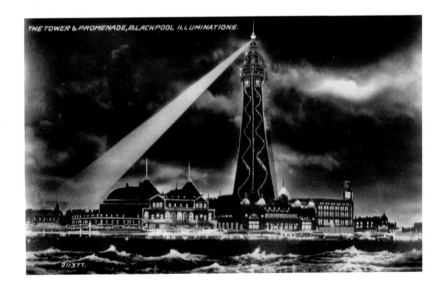

79 Photographer unknown, Souvenir photographs from
Butlins Holiday Camp, Filey mid 1950s
5.08 × 7.62, Private Collection

80 Photographer unknown, The Tower and Promenade,
Blackpool Illuminations, c.1955
postcard, 7.5 × 15, Published by Valentines & Son, London
Private Collection

81 *Old Harry Point*, 1958
Gelatin silver print, approx. 25.4 × 20.3, Cambridge University Collection of
Air Photographs. Black and white reproduction from colour original.

82 Eric Hosking, *Barn Owl, 1948*
Gelatin silver print, 25.4 × 20.3, The Eric Hosking Trust

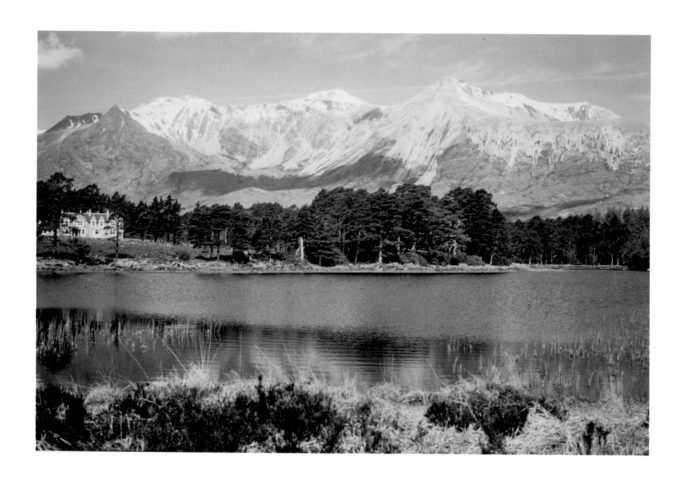

83 Walter Arthur Poucher, *Torridon – Beine Eigha from Loch Conlin*
Colour print, 24.8 × 37.7, NMeM/Science & Society Picture Library

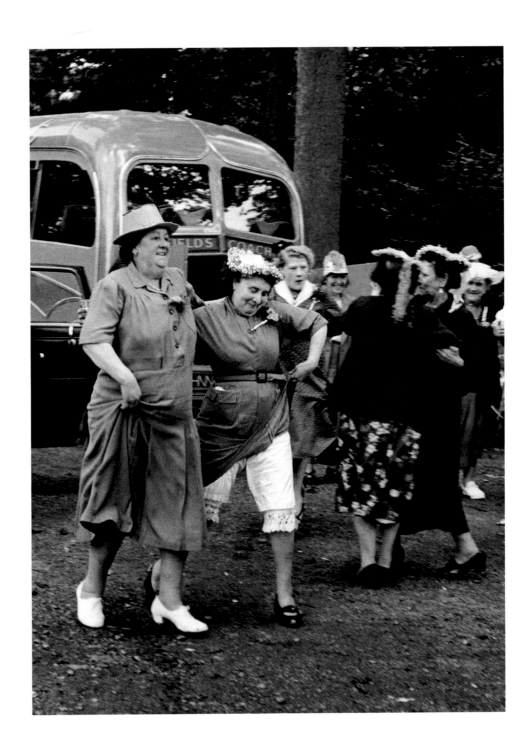

84 Grace Robertson, *Dancing on the Green, London Women's Pub Outing*, 1954
Gelatin silver print, 34 × 35, Courtesy the artist

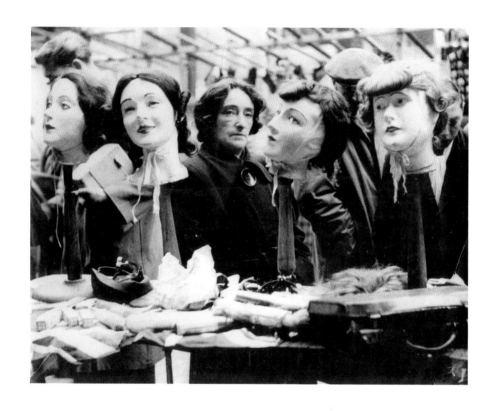

85 Nigel Henderson, *Wig Stall, Petticoat Lane*, 1952
Gelatin silver print, 20.2 × 25.6, Mayor Gallery, London

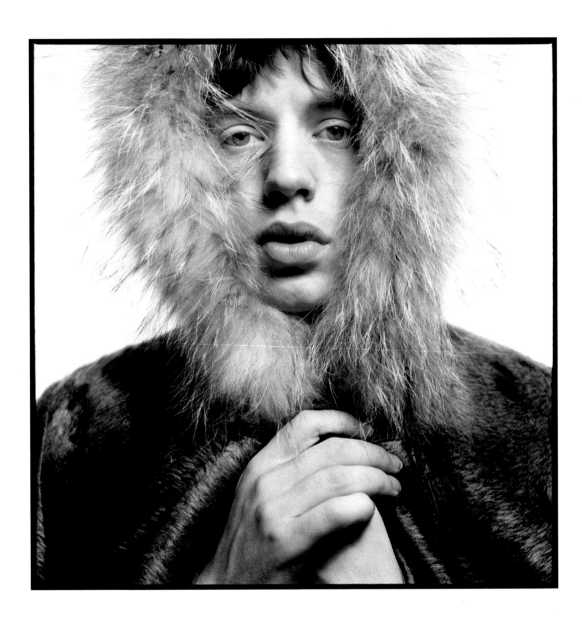

124

86 David Bailey, *Mick Jagger* from *Box of Pin Ups*, 1964
Gelatin silver print, 36.9 × 32, Courtesy the artist

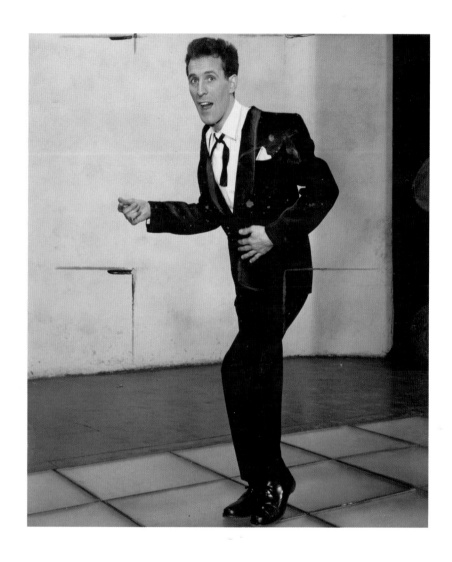

87 Photographer unknown, *Daily Herald Archive: Bruce Forsyth*, 1958
Gelatin silver print, 22 × 18.9, NMeM/Science & Society Picture Library

88 Leonard Freed, *Theatre Zoo, London*, c.1960
Gelatin silver print, 38, × 25.4, Leonard Freed / Magnum Photos
This photograph represents a series of photographs from the Magnum
Archive by David Hurn, George Rodger, Eve Arnold and Sergio Larrain.

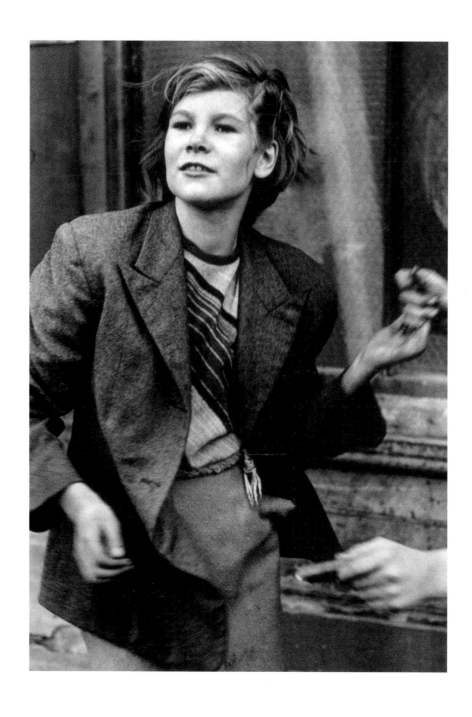

89 Roger Mayne, from the series *Southam Street*, 1956-61
Gelatin silver print, 36 × 27.2, Courtesy the artist and
V&A Images/Victoria and Albert Museum

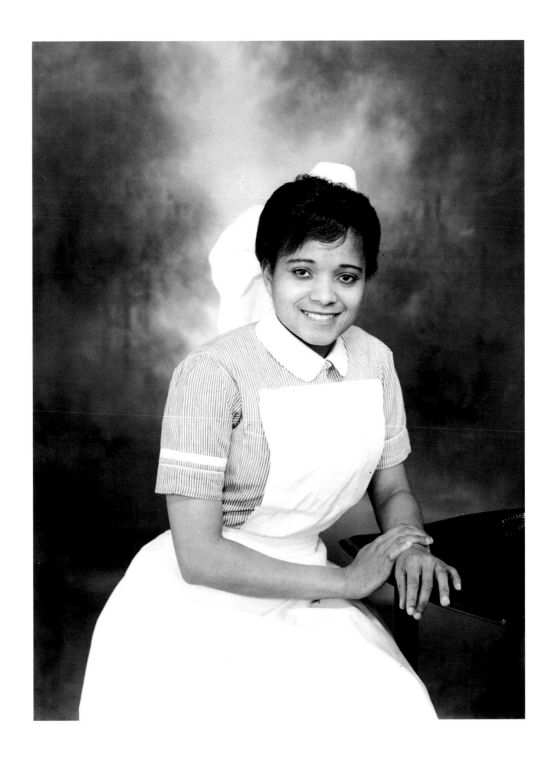

90 Tony Walker, Belle View Studio, Bradford, *Young Nurse in her Uniform*, 1950
Modern gelatin print from original negative, 25.4 × 20.3, Bradford Museum,
Galleries and Heritage

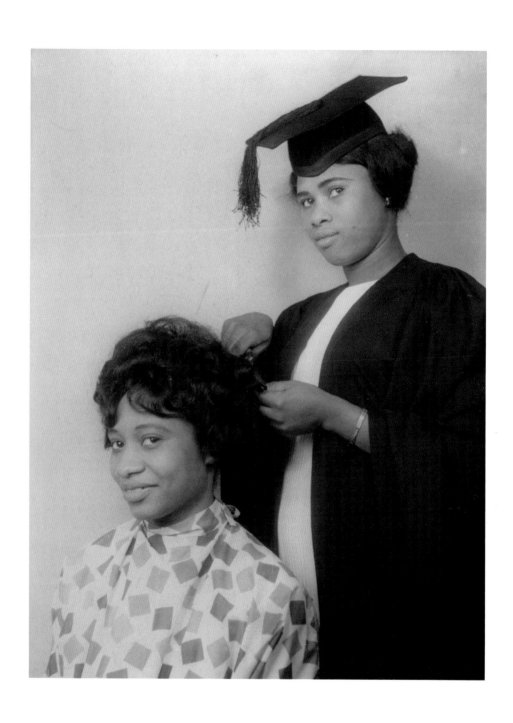

91 Harry Jacobs, Anonymous portrait photograph, c.1970
Gelatin silver print, 20.8 × 16, London Borough of Lambeth,
Archives Department

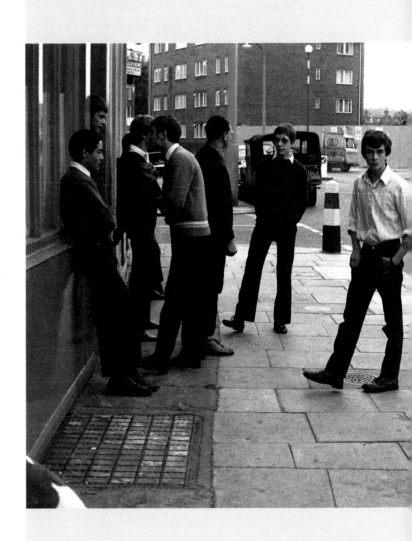

92 Euan Duff, *How We Are*, London 1965
book, 26.4 × 18.4

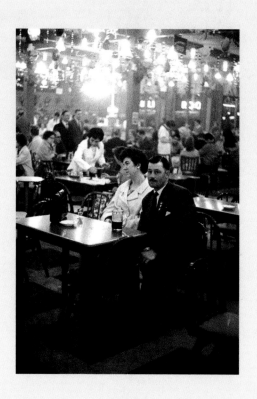

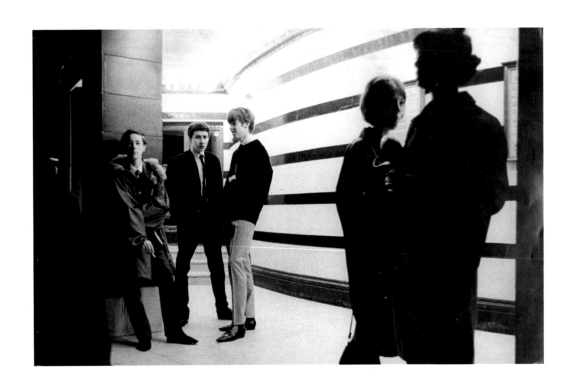

93 Robert Smithes, *The Modists*, c.1967
Gelatin silver print, 32.5 × 21.3, The Guardian

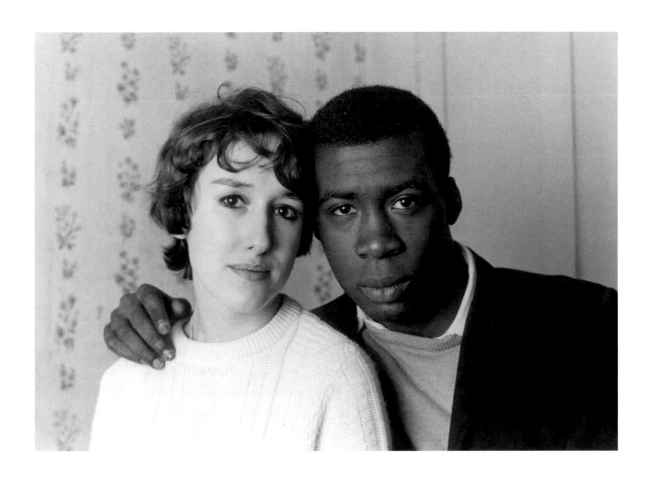

94 Charlie Phillips, *Notting Hill Couple*, 1967
Gelatin silver print, 27.1 × 39.4
Courtesy the artist and Akehurst Creative Management

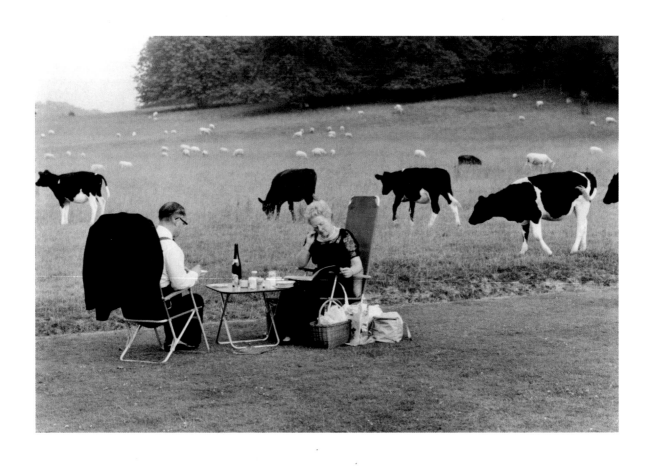

95 Tony Ray Jones, *Glyndebourne*, 1967
Gelatin silver print, 17.8 × 26.7, NMeM/Science & Society Picture Library

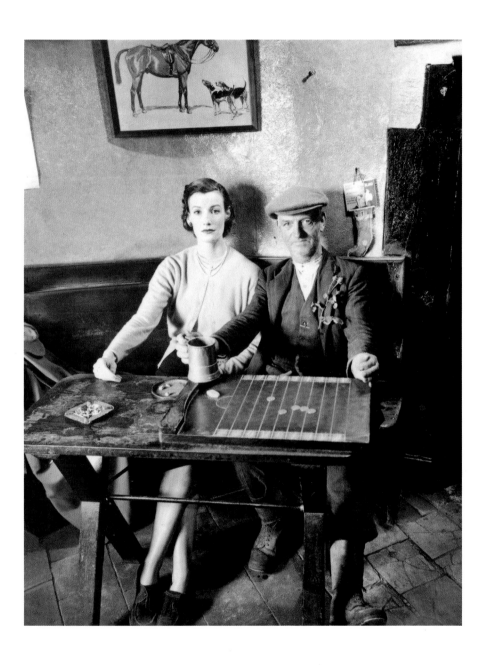

96 Norman Parkinson, *Wenda in a hand-knit cashmere twinset,*
the public bar, Hobnails Inn, Wasbourne 1951, 1951
Gelatin silver print, 37.7 × 28.8, Courtesy Eric Franck Fine Art and
the Norman Parkinson Archive, London

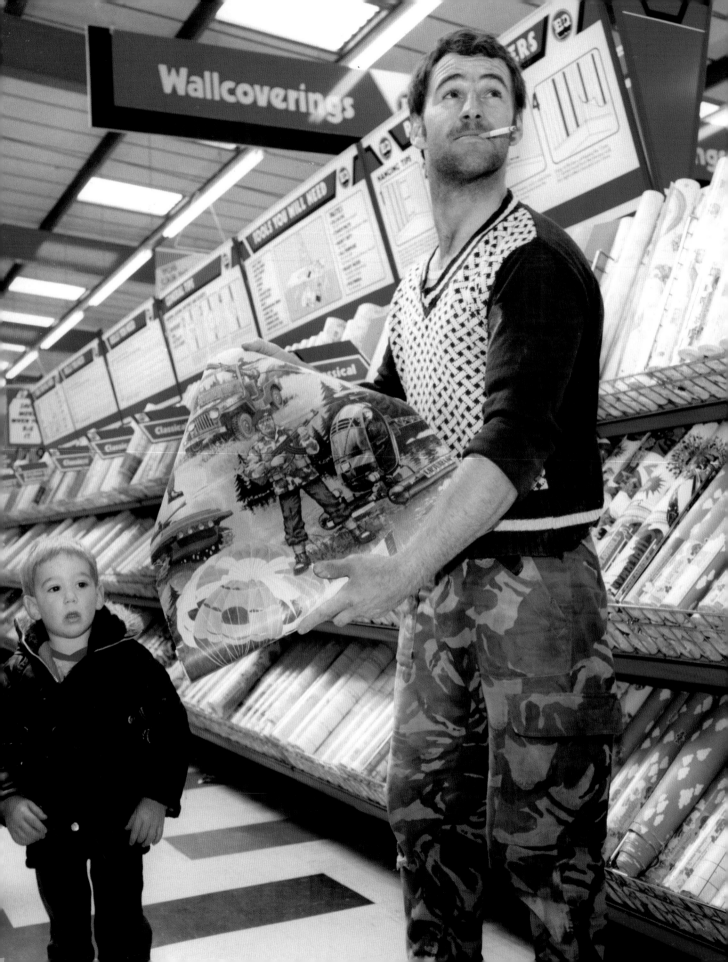

The Urge to Document

In the 1970s, photography in Britain underwent a sea change. Although facets of 'Britishness', such as social deprivation, the city and working-class life, which had attracted photographers during the postwar years, continued to be familiar subject matter, emerging photographers comprehensively rejected the idea of a British idyll so persuasively projected in the colour photographs of the 1950s and 60s. Documentary photographers of the 1970s worked in colour only from commercial necessity. The Britain of this decade was photographed in black and white and emerged as idiosyncratic, frayed at the edges, socially unequal. Photography became increasingly politically conscious and socially engaged.

Even landscape photography found a political edge. The photographer John Davies, in his photographs of industrial Britain, stood in direct opposition to his predecessors, who had pictured a Britain bathed in light and infused with notions of value. Davies' landscapes were by contrast dark and pessimistic (no. 115).

Documentary photographers became increasingly curious about Britain and the British. Nancy Hellebrand's series *Londoners* explored the secret world of London's bedsitter-land (no. 99), while in the early 1970s, Homer Sykes made a comprehensive record of British customs. In *Once A Year: Some Traditional British Customs* (London 1977, no. 97) Sykes takes us into the richly rewarding territory of the semi-rural, of pub culture and arcane Britishness. At around the same time that Sykes was photographing horn dancers and firecakers in the countryside, Peter Mitchell was constructing a detailed document of the houses, shops and people of Leeds (no. 107). One of the very few documentarists working with colour in the 1970s, Mitchell compiled an intimate diary of a city facing change, yet still rooted in the past.

'Community' became a byword for young photographers of the 1970s. The East End collective The Half Moon Photography Workshop was based around the principle that photography could, and should, be an instrument of social change. Its radical photo magazine *Camerawork* discussed photography's relationship with politics, history, feminism, race and representation. In the late 1970s and the 1980s, these debates became fierce, and significant bodies of work emerged from them. The 1977 'Lewisham' issue of *Camerawork* contained photographs of the protests in south London against the National Front taken by young photojournalists including Peter Marlow, who was later to join the Magnum agency. In 1981, the Open University published *Survival Programmes*, a survey of Britain's inner cities based on photographs made in the 1970s by the Exit Photography Group (Nicholas Battye, Paul Trevor and Chris Steele-Perkins). Exit's photographs were raw, challenging yet also hopeful. They showed people kicking against adversity rather than submitting to it.

137

1970–1990

Paul Reas, *Military Wallpaper. B&Q, Newport,* from *I Can Help,* 1988 (detail, see no. 103)

While publications such as the *Sunday Times* Magazine presented the deprived as inert under the burden of poverty and bad housing, Exit, with its unfailing belief in the power of community, produced images that asserted a belief in the power of people to rise above their circumstances (see no. 109). Horace Ové and Vanley Burke took the same attitude in their photographs of Britain's black community, portraying a sense of identity that reinforced the image presented in the studio photographs made by Harry Jacobs throughout this period (see nos. 111, 100 and 91).

Women photographers, so active in the interwar years, were noticeable by their absence in this new photographic landscape. Jane Bown, an *Observer* photojournalist, was an exception, and one of only a small number of women prominent in mainstream photographic production (no. 116). Women photographers found it equally difficult to penetrate the clubbish camaraderie of the independent movement of photographers emerging from the new Polytechnics.

Emerging documentarist Daniel Meadows, touring Britain in a double-decker bus remodelled to house living quarters, darkroom and photographic equipment, made photographs of anyone who chose to pose in his Free Photographic Studio (no. 98). The results were remarkable, as 'ordinary' people presented themselves to the camera, proudly displaying both costume and character. Likewise, in Chris Killip's work on the northeast of England, there is an energy and vitality that defies any notion of the abject (no. 110).

Britain in the 1980s was defined by the rise of the political Right. For some, 'Thatcherism' represented the abnegation of the state's responsibility, greed and social carelessness. For others, it opened up new avenues for personal improvement and social mobility. For photographers, it brought endless possibilities. Martin Parr, who had spent much of the 1970s documenting the gentle rhythms of life in West Yorkshire and Ireland, and who began to photograph in colour at the beginning of the 1980s (no. 104) explained: 'In *The Cost of Living*, I was examining my own position as, first off, a middle-class person, and secondly as a person who has flourished in a political climate that I feel somewhat opposed to but none the less have done very well out of thank you, and thirdly, my own guilt about being a relatively affluent person in modern Britain.' (Quoted in Val Williams, *Martin Parr*, London 2002, p.209.)

The use of colour in British documentary photography gave us a new vision of the nation. Parr's coruscating fable of middle-class life in middle Britain took its place alongside other pioneering photo series, including Paul Graham's depiction of life on the road in *A1: The Great North Road,* published in 1983 (no. 108), Anna Fox's rumbustious account of office life in *Workstations* (1988, no. 102) and Tom Wood's riotous portrayal of a night in the life of a New Brighton night club in *Looking For Love*

1989 (no. 12). In 1987, Martin Pover documented changing lifestyles and aspirations in the Essex suburb of Harold Hill (no. 106), and the following year, Paul Reas made an acerbic examination of consumerism in the chaotic world of shopping pictured in *I Can Help* 1988 (no.103). Photographers were interested in a new kind of Britishness, which they caricatured vividly, and critically, in bright colour. The melancholy, which had so characterised British documentary photography in the 1960s and 70s, was replaced by sardonic comedy.

But colour was not only for comedy. Paul Seawright's *Sectarian Murders* 1988 (no. 105) utilised a very modern methodology to investigate the sites of executions in Northern Ireland. Paul Graham's *A1: The Great North Road* 1983 (no. 108) portrayed isolated lives in desolate surroundings. Keith Arnatt explored the detritus of modern life in his *Objects from a Rubbish Tip* series 1989 (no. 114), while the eminent wildlife photographer Stephen Dalton ventured into the secret world of suburban gardens, where foxes gnaw on rubbish from an upturned bin and a rat jumps past a jumble of refuse (no. 113). If landscape and gardens were to have a place in this new photographic universe, then they would be despoiled spaces, makeshift killing places in areas of sectarian strife, carelessly landscaped peripheries, and an uneasy background to social change.

In the early 1980s, two newly launched style magazines – *i-D* and *The Face* – became the conduit for a new kind of photographer, who crossed the boundaries between fashion and documentary. In the late 1970s, Derek Ridgers began to photograph in London clubs. He was entranced by a new generation of style-makers. From Punks to New Romantics, he captured a vibrant moment in British culture, and broke the mould of documentary portraiture. Ridgers' subjects were triumphant waifs and strays, new and beautiful people, beyond the ordinary (no. 101).

A fresh appreciation of photography in the 1970s and 80s gave photographers the opportunity to work outside the traditional structures of photojournalism, portraiture and fashion. Enlightened museum curators, such as Mark Haworth-Booth at the Victoria & Albert Museum, supported photographers whose work was grounded in personal vision. The Arts Council of Great Britain, somewhat belatedly recognising photography as an art form, gave independent photographers the chance to make extended series of work and to publish them in short-run editions. An increasing interest in street fashion combined with the rise of style magazines provided a channel for experimental fashion photography and portraiture. Improvements in photography education encouraged students to think more widely about photographic representation and its multiple meanings. Self-made and self-directed, British photographers of the 1970s and 80s were confident, curious and challenging.

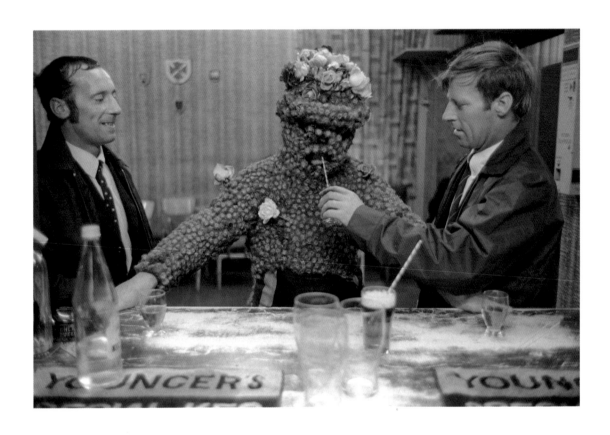

140

97 Homer Sykes, From the series *Once a Year: The Burry Man,*
South Queensferry, Lothian, Second Friday in August, 1971
Gelatin silver print, 30.4 × 40.6, Courtesy the artist

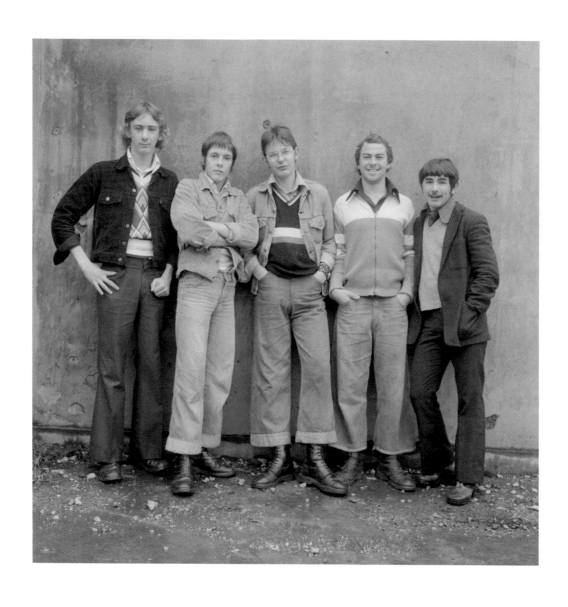

98 Daniel Meadows, From the Free Photographic Omnibus:
Brian Morgan, Martin Tebay, Paul McMillan, Phil Tickle, Mike Comish:
"Boot Boys" from Barrow-in-Furness, Cumbria, 1974
Gelatin silver print from 120 roll film, Dimensions variable,
Courtesy the artist

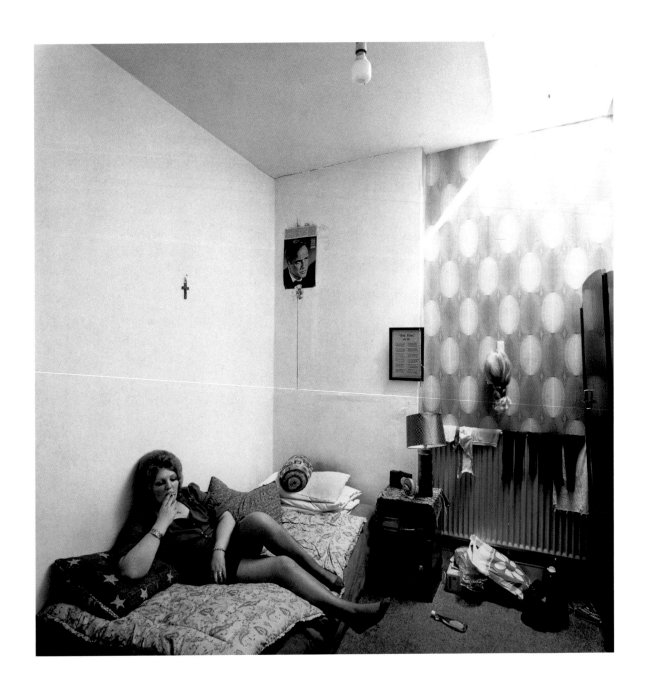

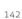

99 Nancy Hellebrand, *Marion in a Bed Sitter. Marion Reck,*
Shoot Up Hill July 1974, 1974
Gelatin silver print, 30 × 30, Courtesy the artist

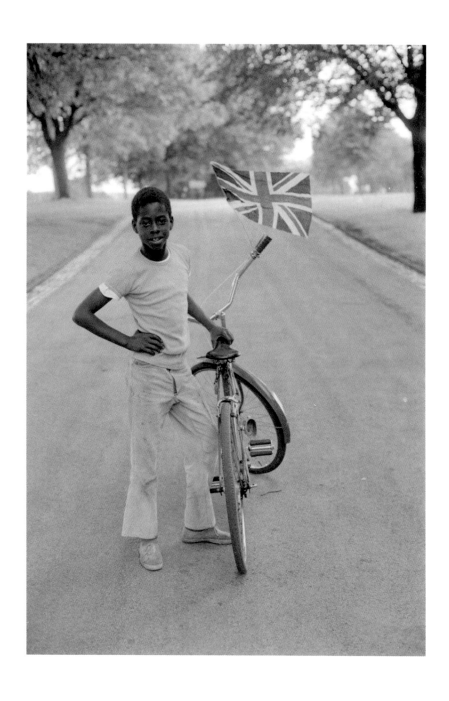

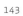

100 Vanley Burke, *Boy with Flag* c.1970–76
Gelatin silver print, 50.8 × 60.9, Courtesy the artist

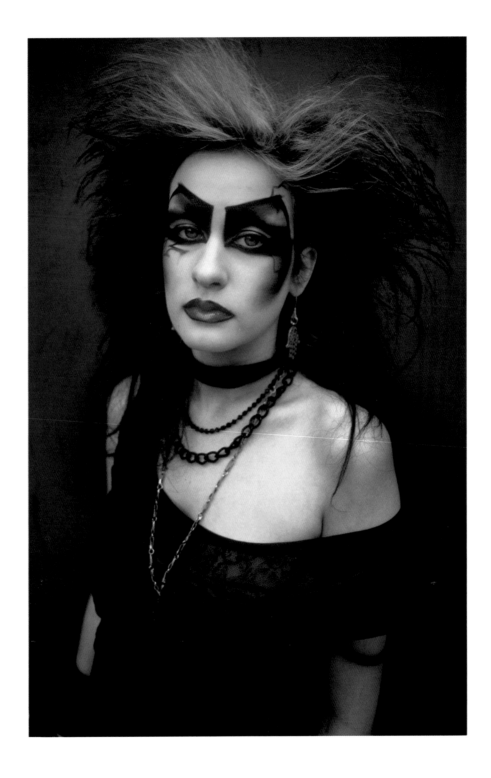

101 Derek Ridgers, *Kings Road '84*, from *Club and Street Portraits*, c.1985
Modern digital print from original negative, 1189 × 841, Courtesy the artist

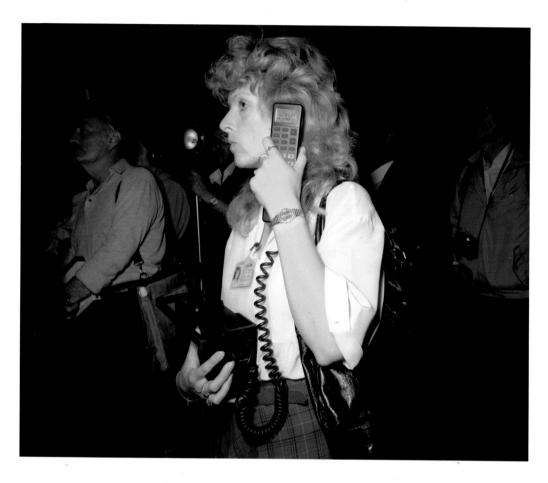

'If we don't foul up nobody can touch us'.

Computer Weekly 1987

102 Anna Fox, *If we don't foul up nobody can touch us*, from *Workstations*, 1988
C-type colour print with text, 45.5 × 55.5, Courtesy the artist, originally
commissioned by Camerawork Gallery and the Museum of London.

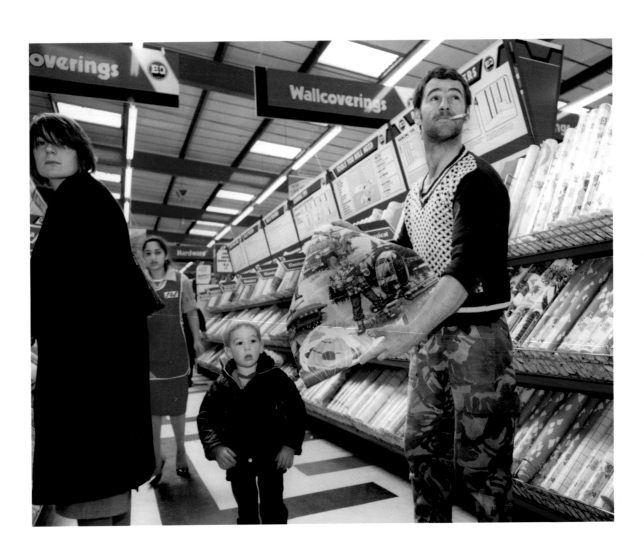

103 Paul Reas, *Military Wallpaper. B&Q, Newport*, from *I Can Help*, 1988
C-type print, 49.6 × 59.8, Courtesy the artist

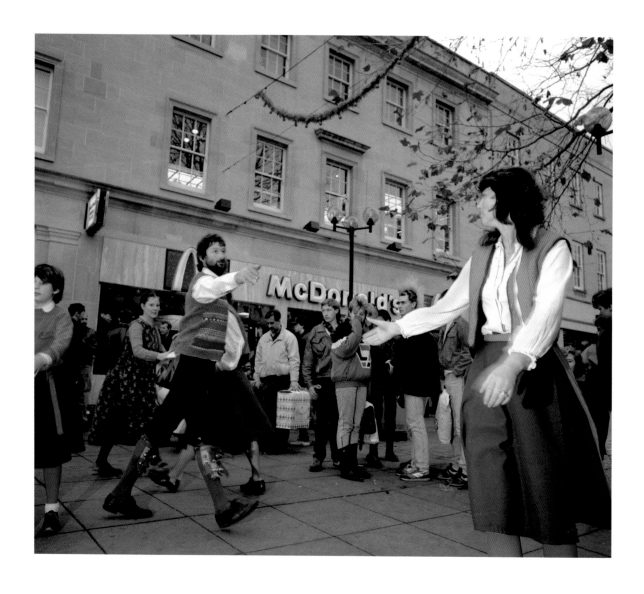

104 Martin Parr, *Morris Dancers* from *The Cost of Living*, 1988
C-type print, 42.5 × 52, Courtesy Martin Parr/Magnum Photos

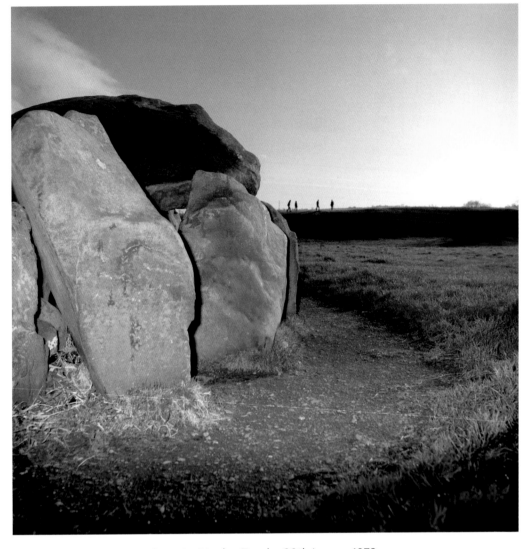

Sectarian Murder: Tuesday 30th January 1973,
Northern Ireland, 1988

'The car travelled to a deserted tourist spot known as the Giants Ring.
The 14 year old boy was made to kneel on the grass verge,
his anorak was pulled over his head, then he was shot at close range,
dying instantly.'

105 Paul Seawright, C-type print, 50.8 × 50.8
Courtesy Kerlin Gallery, Dublin

OPPOSITE
106 Martin Pover, *Harold Hill* 1987
C-type prints, 50.8 × 40.6, Courtesy the artist

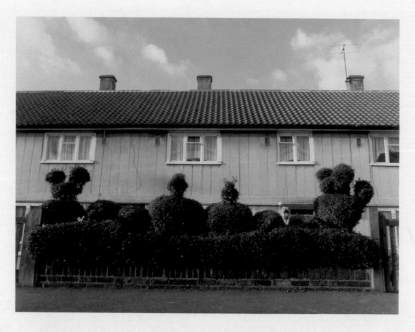

MRS OSTERBERG and **GRAND-DAUGHTER EDENHALL GLEN**

Mrs Osterberg was bombed out of Stepney and has lived in this house for thirty-six years. She moved here form a Nissan hut in the Mile End Road, and is still a council tenant. "All my friends around here have been here all the time".

"There were no pavements when we moved in, just a load of mud from all the building. We thought it was everso big – children were running around upstairs all day".

"My husband died two-and-a-half years ago. He used to sit at the front door watching me do the hedge. There's four tortoises and two birds. All the children around here know them and give them all names".

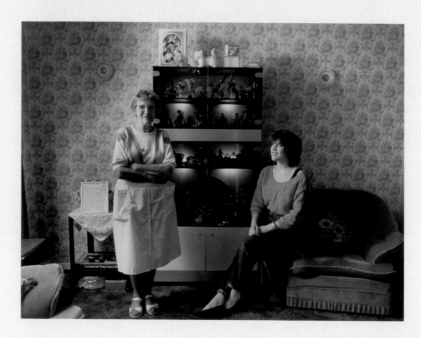

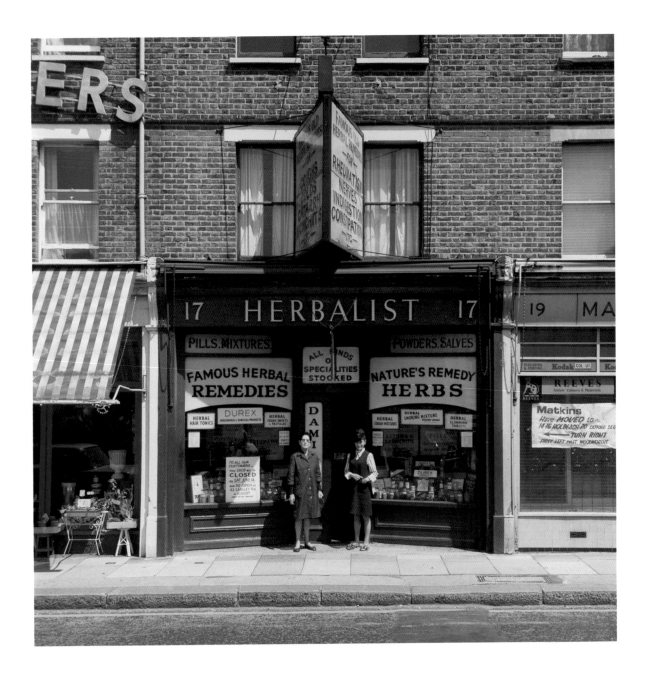

107 Peter Mitchell, *Mrs. McArthy & her daughter. Saturday 7 June 1975.*
Noon. Sangley Road, London S E 6. Not only nature's remedy but also purveyors
of 'certain things' in the discreet manner from the 1979 exhibition 'A New
Refutation of the Viking 4 Space Mission' 1975
Resin coated c-type print, 50.8 × 40.6, Courtesy the artist

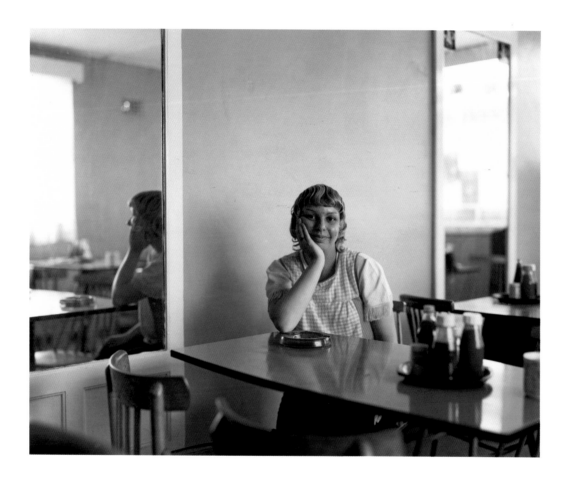

108 Paul Graham, *Plate 11, Café Waitress, John's Café, Sandy Bedforshire,*
May 1982 from *A1 The Great North Road*, 1983
Colour coupler print, 19.4 × 24.2, The artist, courtesy of Anthony Reynolds Gallery

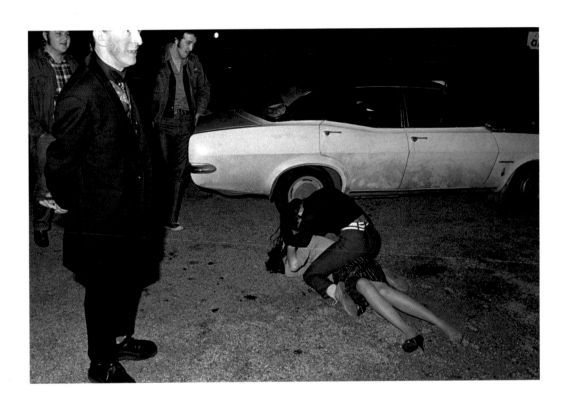

109 Exit Photography Group, Chris Steele-Perkins, *Outside the White Hart,
Tottenham*, 1977, from *Survival Programmes in Britain's Inner Cities*
Gelatin silver print, 23.5 × 35.5, Courtesy the artist

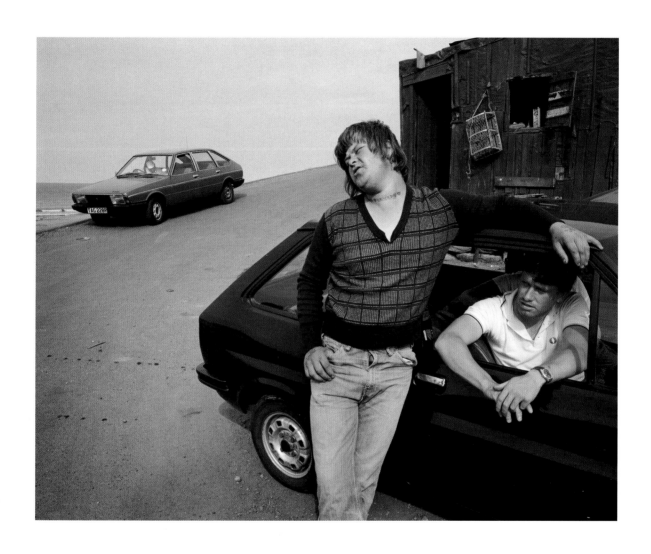

110 Chris Killip, *Bever, Skinningrove, North Yorkshire*, 1980
Gelatin silver print, 95 × 114.5, Courtesy the artist

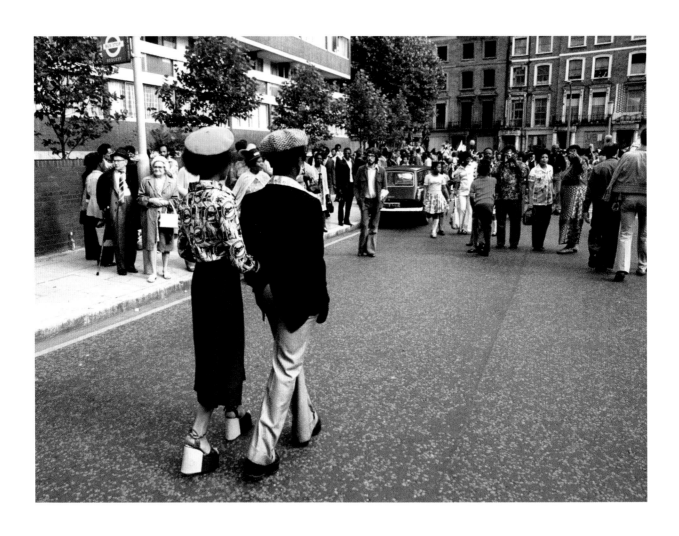

154

111 Horace Ové, *Walking Proud* c.1970
Giclee print, 44 × 61, Courtesy the artist

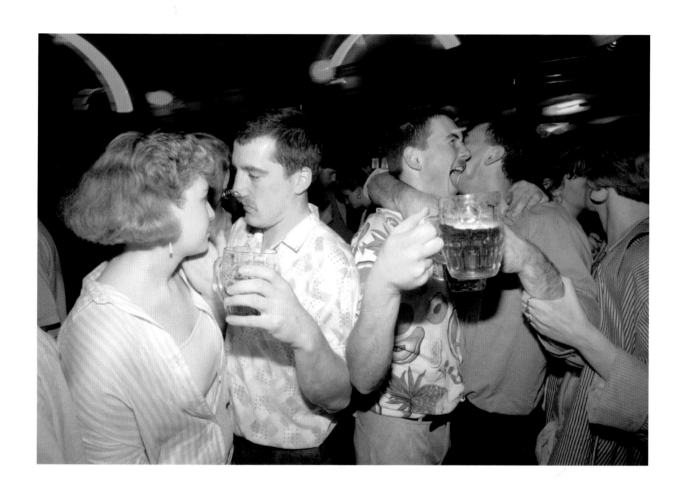

112 Tom Wood, *Bottlenose, Chelsea Reach*, 1985, from *Looking for Love, 1985–6*
C-type print, 39.3 × 58.4, Courtesy the artist

113 Stephen Dalton, *Brown Rat (Rattus norvegicus) leaping from dustbin*, 1983
R-type print, 30.3 × 47, Stephen Dalton/NHPA/Photoshot

114 Keith Arnatt, *Pictures from a Rubbish Tip*, 1988
C-type print, 50.5 × 60.1, Courtesy the artist

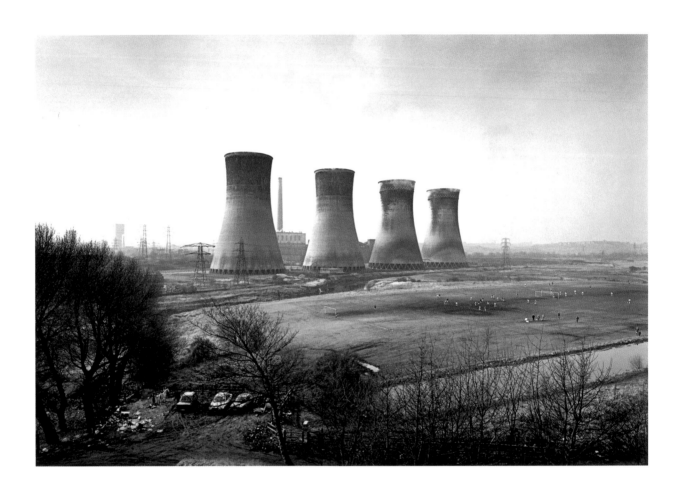

115 John Davies, *Agecroft Power Station, Salford, England, 1983*, 1983
Gelatin silver print, 25.5 × 37.5, Courtesy the artist and V&A Images/
Victoria and Albert Museum

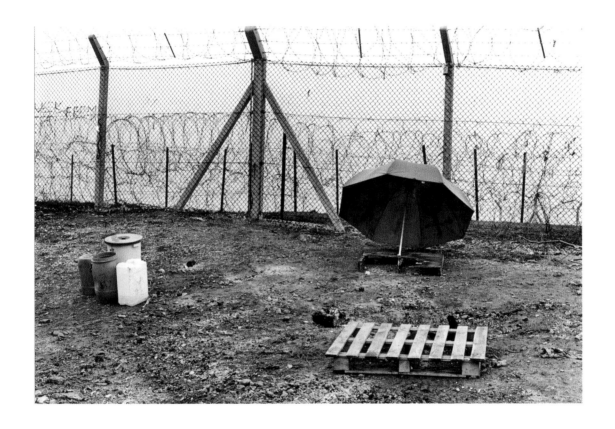

116 Jane Bown, *After the Eviction, 29 March 1984* from *Greenham Common,* 1984
Gelatin silver print, 19.9 × 29.9, The Guardian/Jane Bown 1984

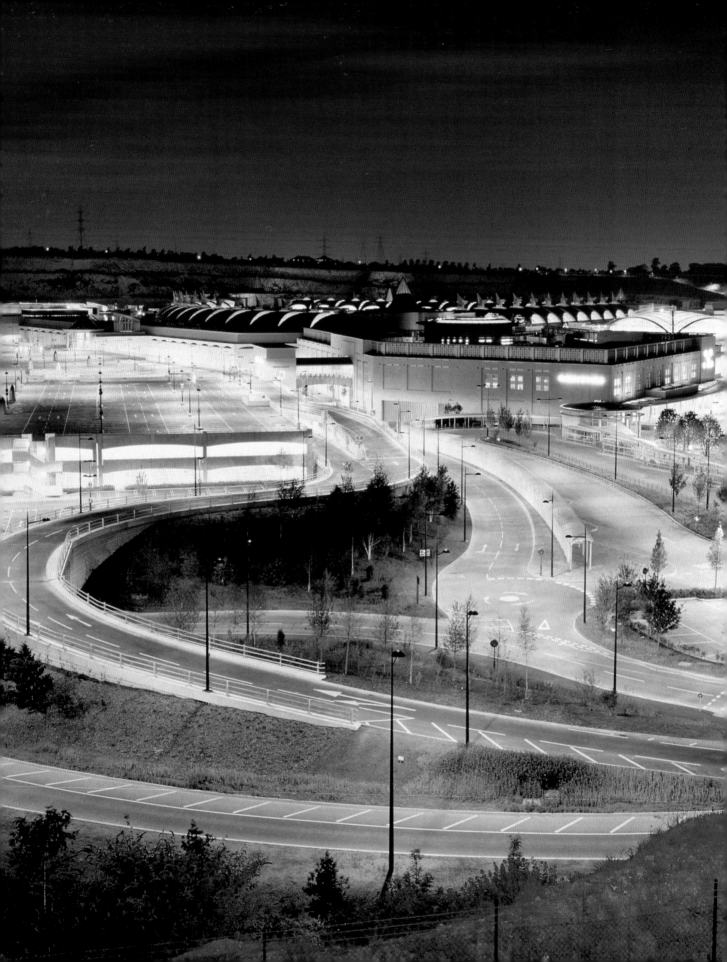

Reflections on a Strange Country

From the early 1990s, photography in Britain began to diversify. A growing interest in street fashion and art photography, together with a continuing interest in documentary photography and photojournalism, produced bodies of work that presented very different views of life in Britain. Developments in the 1980s had given British photographers freedom to experiment. Debates on the ethics of representation, which had dominated the decade, gave way to an energised photography that was directed by new interest from the art market and from advertising. As demand for traditional story-telling photojournalism began to decline, documentary photographers looked towards art commissions and small-scale book publishing as outlets for their work. Increased commitment to research within art and design education meant that photographers, who hitherto had been forced to work in the commercial sphere or to rely on grants and commissions, could now undertake practice-based research within a university context. At the same time, highly academicised photographic practice, which had become popular in the 1980s, was seen increasingly as overly theoretical and stylistically cumbersome. David Trainer, in his memorable black-and-white documentary of an 'ordinary' Britain (see no. 119) appears to reference earlier photographers such as Bill Brandt, Diane Arbus and Edwin Smith, but from the early 1990s, this methodology was replaced almost completely by work in colour, which challenged the notion of documentary 'reality'.

A new kind of fashion photography presented an image of Britain seen through a prism of style and fiction. Although style magazines such as *The Face* and *i-D* had prospered in Britain during the 1980s, encouraging talented photographers such as Derek Ridgers (no. 101), the early 1990s saw an explosion of documentary fashion photography and fruitful partnerships between photographers and stylists. Photographers such as Elaine Constantine (see *Mosh* 1997, no. 122) and Jason Evans (see *Strictly* 1991, no. 123) began to colonise the London scene, rejecting the dense styling that had characterised 1980s fashion photography and opting instead for photographs of 'real life'. Neither Evans nor Constantine saw themselves as 'fashion photographers' – Constantine's inspiration came from the work of 1980s documentarists such as Chris Killip, whose dark, dramatic photographs of life in the northeast of England might have seemed to be the antithesis of fashion's glamour (no. 110).

A growing awareness of environmental issues and continuing discussions about lifestyle informed the work of a number of photographers: Clive Landen, as seen in *Familiar British Wildlife* 1993 (no. 141); Fergus Heron, in his sardonically perfect study of executive housing, *Charles Church Houses* 2005–7 (no. 140); and David Spero, in his ongoing exploration of alternative communities in England and Wales, *Settlements* 2004–6 (no. 126). Dan Holdsworth's survey of the marginal landscapes of the city, *A Machine for Living* 1999 (no. 130), expressed the

161

1990–2007

Dan Holdsworth, *A Machine for Living: Untitled* 1999
(detail, see no. 130)

interests of many young photographers of the period, who challenged conventional landscape photography. Jonathan Olley's documentation of our crumbling coastline, *Sea Walls* 2003 (no. 124), forewarns of disasters yet to come, while Jem Southam, in his ongoing series *The Pond at Upton Pyne* 1996–2001 (no. 117), is more hopeful, reflecting on the continuity of nature. In his *Travellers* series 1996–8 (no. 127), Tom Hunter makes a light-filled survey of young nomads, while American photographer (and sometime British resident) Susan Lipper, in her survey of the hinterlands of West Sussex entitled *Bed and Breakfast* 1998 (no. 138), gives us glimpses of a bland yet threatening semi-rural landscape.

The studio portrait, long since out of fashion, saw a renaissance. Eileen Perrier, in her home studio portraits of the Ghanaian community in London 1997–2004 (no. 132), used photography to explore her identity as a young black British woman. Like Clare Strand in *Gone Astray* 2002–3 (no. 118) and Grace Lau in *Hastings: Summer, 2005 – An Archive* 2005 (no. 136), she both subverts and pays homage to photography's enduring past. Strand's work, made during an artist's residency in Clerkenwell, portrays young urban men and women as maimed and lost amongst the miasma of the city. Lau's collaborative project, with residents and visitors to the Sussex resort of Hastings, examines multicultural Britain against the background of her Chinese heritage. In Zed Nelson's photographs of beauty queens, *Love Me* 2006 (no. 133), the notion of 'studio perfection' is called into question; these young women are flawed and vulnerable, every blemish exposed.

In 2006, Douglas Abuelo, an emerging photojournalist, set out to photograph the conditions of London's homeless people. A study of habitat, the sleeping places that the homeless have made their own, *Where They Sleep* 2006 (no. 120) is set against the backdrop of a scratched and grafitti-ed London. The city, encased by concrete and coded with the incoherent messages of the street, is cold and damaged, facing crisis. In Nigel Shafran's *Charity Shops* 2001–2 (no. 128), the discarded objects of the city gather, forlorn dresses hang in a hasty semblance of display. Aspiration is no more, and only the gleaners remain, sorting through the detritus of the dead and the forgotten.

The German photographer Albrecht Tübke, resident in London during the late 1990s, portrayed London's citizens using the methodology he had employed earlier for his serene and resonant survey of Dalliendorf, the village where he was brought up. From the flamboyant to the ordinary, Tübke's Londoners are not 'types' but rather an intriguing collection of individuals, caught for a moment in their urban journey (see *Citizens* 2003, no. 134).

Richard Primrose, documentarist, is equally fascinated by journeys. In *NightBus* 2005 (no. 135), people traverse the darkened city, each with their own story. Primrose uses photography and commentary to construct a

picture of 'ordinary' life, rendered extraordinary by disclosure. In *NightBus*, the photographer becomes the central character, his laconic soundtrack emerging as melancholic comedy. Comedic, too, is Stephen Bull's *Meeting Hazel Stokes* 1997– (no. 137), a collection of snapshots of theatre usherette Hazel Stokes, posing with minor celebrities backstage at a provincial repertory theatre. Stokes wants to be famous, if only vicariously, and Bull, in his careful collection, editing and presentation of these photographs, becomes the ringmaster of vernacular photography.

The recording of war has been a constant strand in British photography, and contemporary photographers have challenged traditional conflict reportage. The war memorials photographed by Chris Harrison in *Sites of Memory* 1997 (no. 135) are dwarfed by symbols of the modern age – roads, supermarkets, and housing developments. Sarah Pickering, in her documentation of a city of facades, built to train police to cope with extreme situations (*Public Order* 2002–5, no. 129), photographs a fiction of trauma. The sublime nature of Simon Norfolk's Scottish landscapes 2006 (no. 131) is undermined by the ways in which they are used by the military, while Alistair Thain's monumental portraits of soldiers 2005 (no. 121), made immediately after a training exercise, show young men exhausted, stressed, staring through and past the camera. These photographs are a grim comment on a shifting and uneasy society.

Photographers have moved around this strange country in which we live, observing, collecting, making fictions from facts, facts from fictions. Their view is an enigmatic one; the old certainties of photography have disappeared. Penny Klepuszewska's photographs (see *Living Arrangements* 2006, no. 139) are of something real, yet something imagined, rooted in her own experience, yet travelling beyond it.

Photographing Britain is a complex endeavour – one that tells stories about the self, about other people, about the contradictory nature of life on this small island. These photographers, and the narratives they construct, provide a very partial view of Britain, its people, its landscape, its obsessions and its crises. The vision of photographers is by its nature artful, skewed and selective; they show us a Britain that they want us to see. They are picaresque narrators on a grand scale.

117 Jem Southam, *The Pond at Upton Pyne, December 1996*, 1996
Diptych, Chromogenic dye coupler print, 34.25 × 27, Courtesy the artist

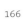

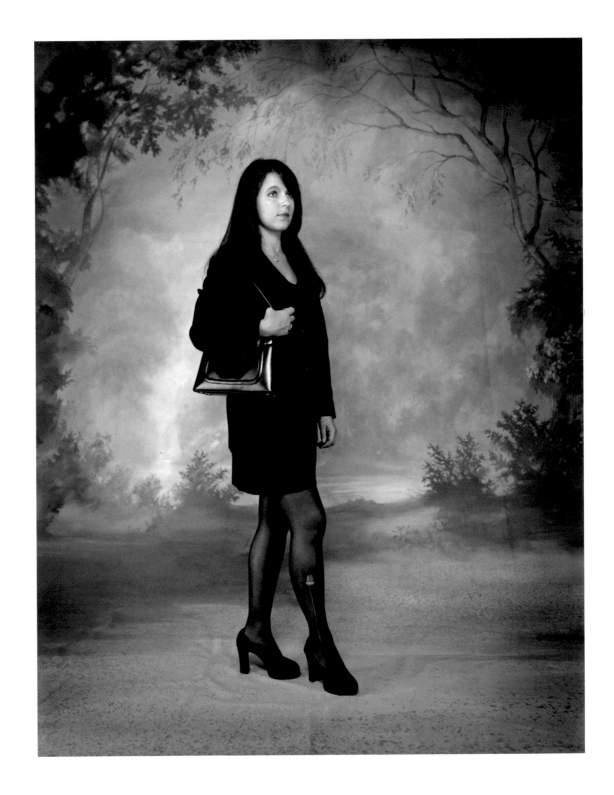

118 Clare Strand, *Gone Astray, Portrait*, 2002–2003
Gelatin silver print, 124.5 × 99, Courtesy the artist

119 David Trainer, *Wanstead Flats London Easter Funfair,* 1991
Gelatin silver print, 37 × 37, Courtesy the artist

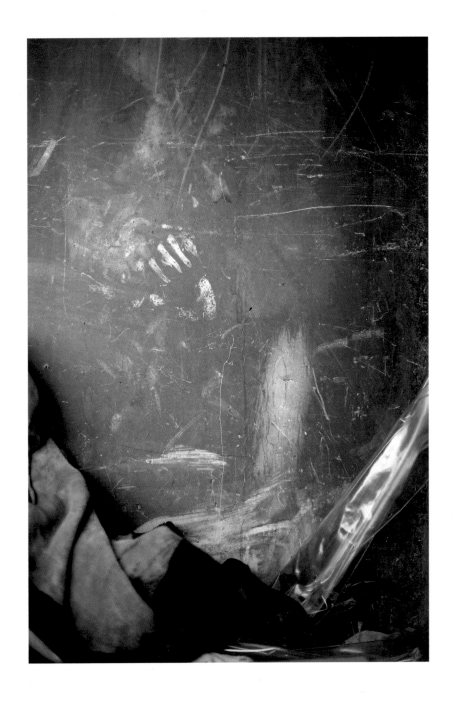

120 Douglas Abuelo, *Postcode – SE17 2UN*, from *Where They Sleep*, June 2006
Gelatin silver print, 91.4 × 76.2, Courtesy the artist

OPPOSITE
121 Alastair Thain, *Marine 2,* 2005
Chromogenic colour print, 300 × 200,
Courtesy the artist

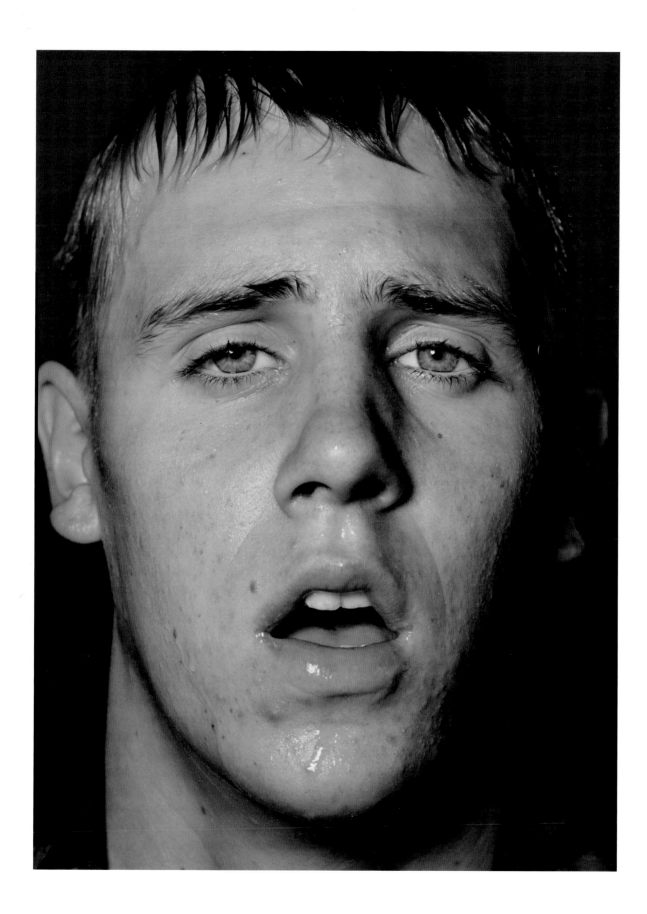

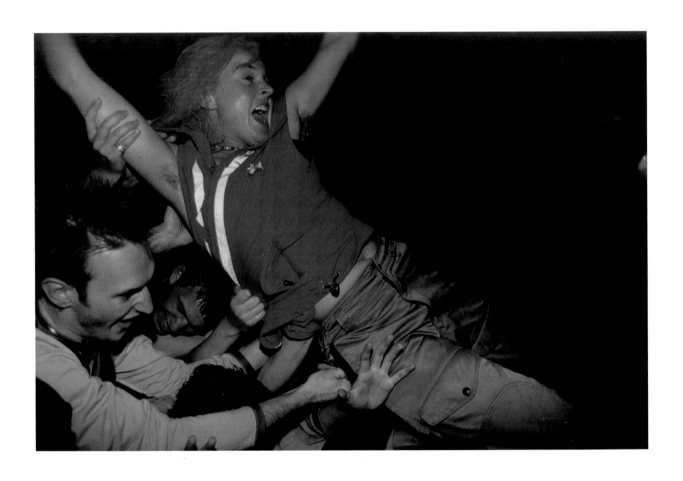

122 Elaine Constantine, *Mosh*, 1997
C-type print, 30.5 × 25.4, Courtesy the artist

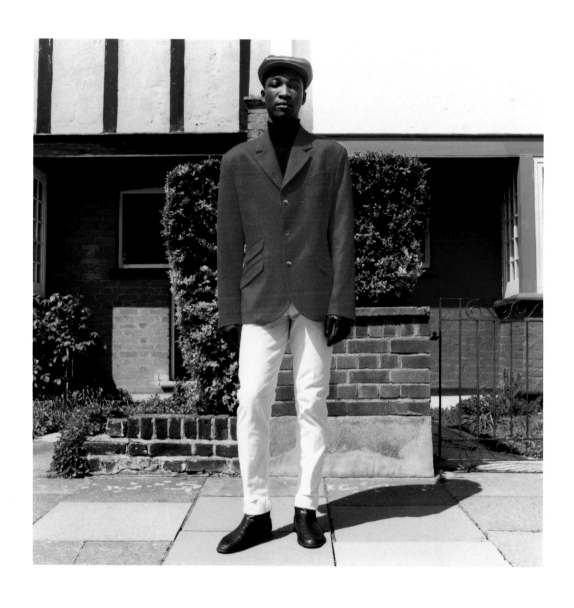

123 Jason Evans, *Strictly*, 1991
C-type print, 19 × 19
Photograph by Jason Evans, styling by Simon Foxton

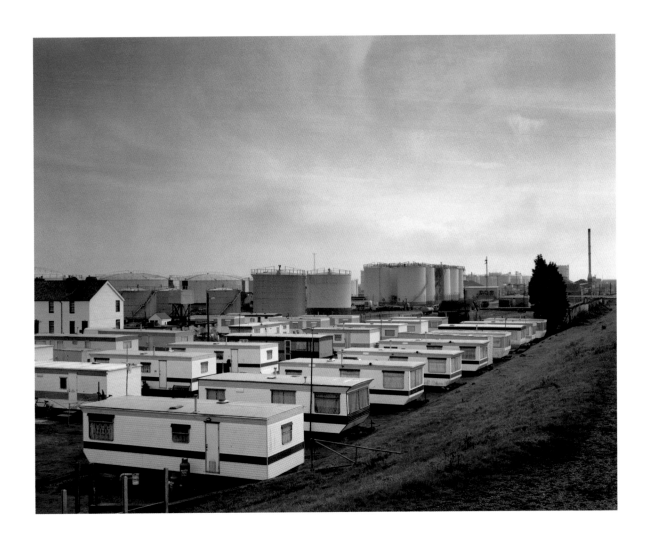

124 Jonathan Olley, *Oil storage depot and caravan site, Deadmans Point,*
Canvey Island, Essex, United Kingdom, from *Sea Walls*, 2003
Lambda print, 50.8 × 60.9, Courtesy the artist

125 Chris Harrison, *Sites of Memory, Sheerness, Kent*, 1997
Cibachrone print, 76.2 × 152.4, Courtesy the artist

126 David Spero, *Emma and John's Tir Ysbrydol* (*Spiritual Land*),
Brithdir Mawr, Pembrokeshire, October 2004, from *Settlements*, 2004–6
C-type print, 60.4 × 76, Courtesy the artist

127 Tom Hunter, *Traveller Series II*, 1996–8
Cibachrome print, 50.8 × 61 cm, Courtesy the artist

128 Nigel Shafran, *Relief fund for Romania charity shop, Kilburn*, 2002
C-type print, 58.5 × 74, Courtesy the artist

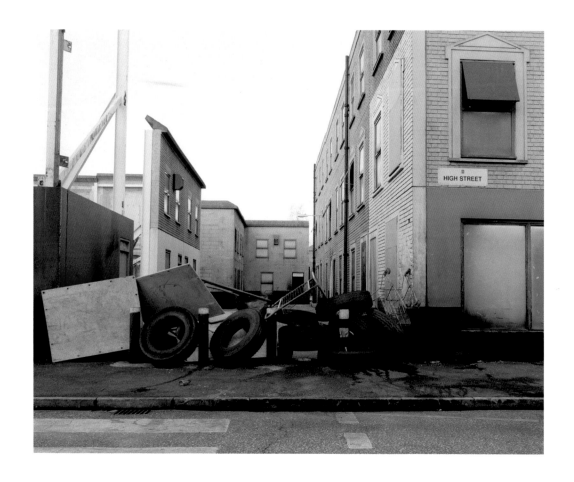

129 Sarah Pickering, *High Street Barricade 2002* from *Public Order*, 2002–5
C-type print, 30 × 37, Courtesy Daniel Cooney Fine Art, New York

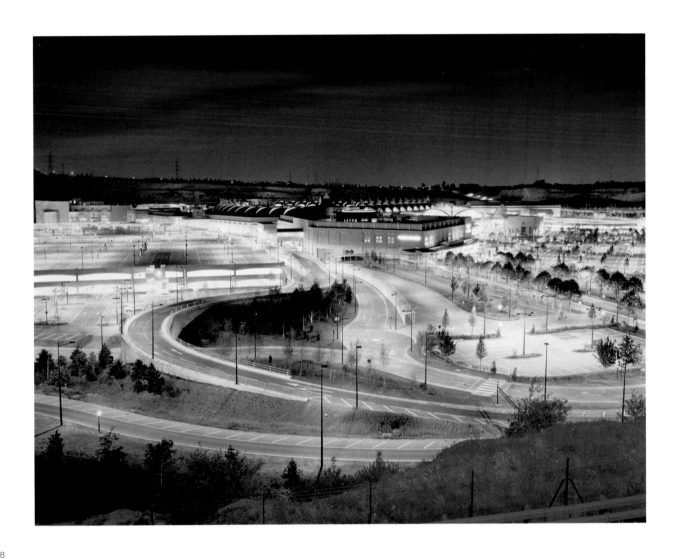

130 Dan Holdsworth, *A Machine for Living: Untitled*, 1999
C-type print, 92.5 × 114.5 cm, Tate

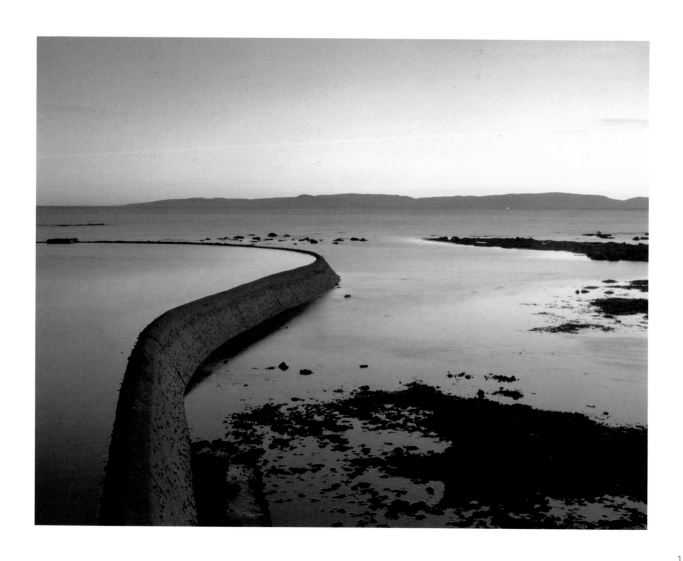

131 Simon Norfolk, *The 'Perisher' submairine-commander exercise area,*
between Ayrshire and Arran from *Military Landscapes,* 2006
Archival digital c-type print, 101.6 × 127, Courtesy the artist and Bonni
Benrubi Gallery, New York

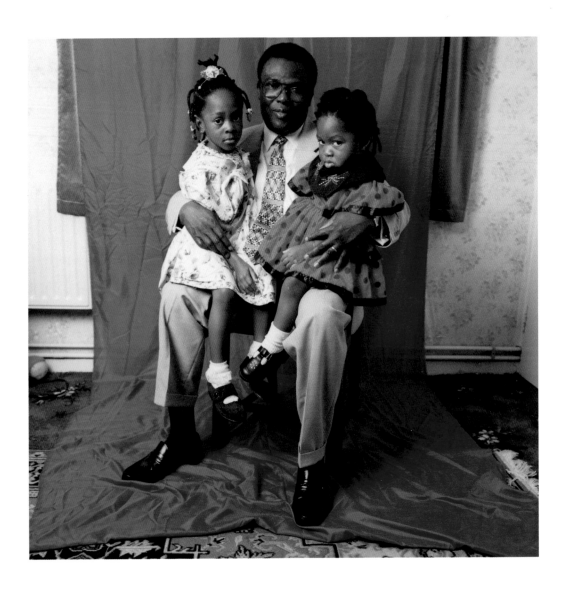

132 Eileen Perrier, *Untitled*, from *Red, Gold and Green*, 1997
C-type print, 30.5 × 40.6, Courtesy the artist. Commissioned by Autograph ABP

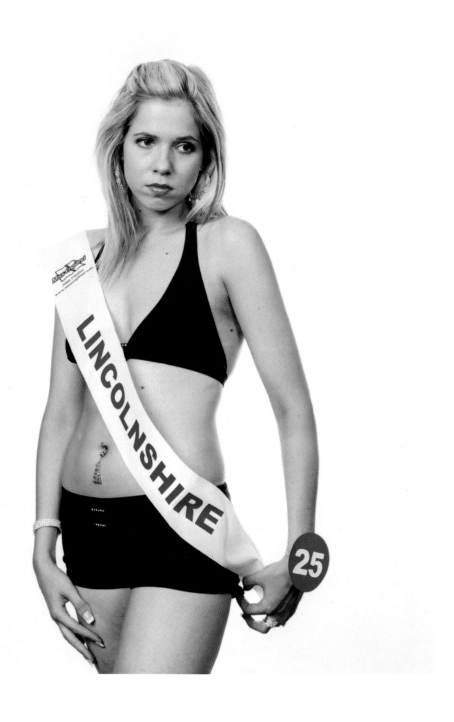

133 Zed Nelson, *Miss Lincolnshire*, from *Love Me*, 2006
C-type print, 73.5 × 60.5, Courtesy the artist

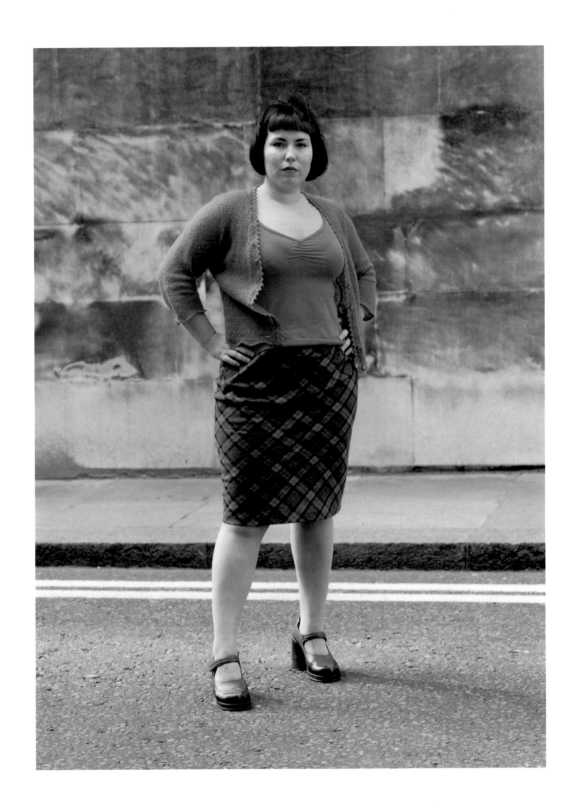

134 Albrecht Tübke, from the series *Citizens*, 2003
C-type print, 47 × 38, Courtesy Dogenhaus Galerie

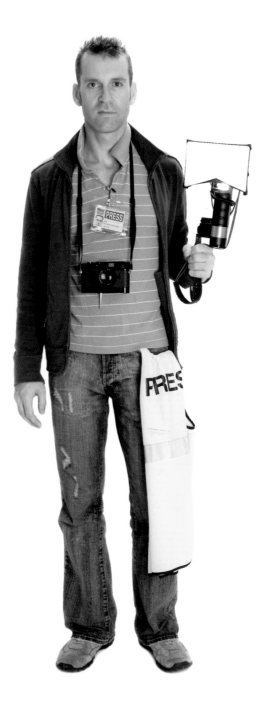

135 Richard Primrose, *The Nightbus Project*, 2005
Dimensions variable, Courtesy the artist

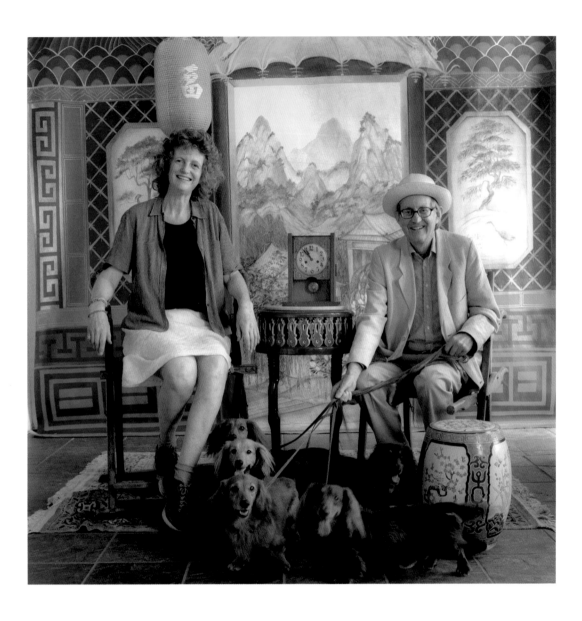

136 Grace Lau, *Archive of Hastings, Summer, 2005*, 2005
C-type print, 60.9 × 60.9, Courtesy the artist

137 Stephen Bull, *Lionel Blair Meeting Hazel Stokes*
from *Meeting Hazel Stokes*, c.1997
Digital image from c-type print, Dimensions variable,
Courtesy the artist

138 Susan Lipper, *Untitled* from *Bed and Breakfast*, 1998
C-type print, 21.1 × 25.9, Courtesy the artist. Commissioned by Photoworks UK

139 Penny Klepuszewska, *Living Arrangements*, 2006
Digital c-type print, 50.8 × 86.4, Courtesy the artist

140 Fergus Heron, *Robin Hill Drive, Camberely Surrey 1996*
from *Charles Church Estates,* 1996–2006
C-type print, 50.8 × 61, Courtesy the artist

141 Clive Landen, *Familiar British Wildlife, Erithacus Rubecula Melophilus* 1994
Digital image from c-type print, Dimensions variable, Courtesy the artist

Our Back Pages

KEVIN JACKSON

'We are ... obviously very different from the kind
of British people Orwell knew, and I fear he would
not have liked us very much – for our materialism,
our silliness, our failures of principle. But by the
time he had looked through this album to its very
last pages, Orwell's ghost would have been nodding
grimly. However little he might care for the look
of us, he would be too honest not to come to the
inevitable conclusion. We are family.'

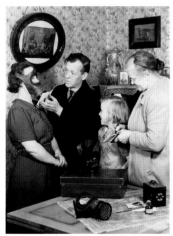

Pl. 62

In 1941, as the Luftwaffe's bombs rained down on London, George Orwell sat at his typewriter, chain-smoking, guzzling cup after cup of weak tea and tapping out the words of the single most influential essay ever written about British national identity, 'The Lion and the Unicorn'. It is a wonderful piece, pungent and poignant, and like so much of Orwell, a unique mixture of plain speaking and crankiness, intelligence and prejudice, cool horse sense and fervent sentiment. It has been inspiring readers for the last six decades, but also annoying many, not least for its suggestion that Britain might best be understood as a kind of family – a dysfunctional family (to use a recent term Orwell would have despised, had he ever met it), plagued with horrible inequalities and injustices, to be sure, but a family none the less.

'Family!?,' Orwell's critics shriek in horror, and proceed to pour scorn over the notion that a country so bursting with ill-concealed antagonism between rich and poor, young and old, north and south – let alone the friction between individual nations that have been yoked together in political Union – could ever reasonably be described as a family. (The witty French critic Roland Barthes made much the same point when he attacked a famous photographic exhibition entitled *The Family of Man*.[1]) There is a measure of justice in such objections, though not quite as much as received wisdom would have it. Orwell, a larger figure than any of his detractors, understood perfectly well that such divisions existed, as the full text of his essay made clear. And so long as we remember that 'family' is only a metaphor, we might sometimes find it a useful metaphor still.

The great British film-maker Humphrey Jennings – an admirer of Orwell's essay – certainly found it useful when he came to make his last film, a commission for the Festival of Britain in 1951: he called it *Family Portrait*, and stressed that the nation had always been at its best when it found ways to overcome its inner antagonisms. And if we find the word 'family' just a little too snug and cosy for our tastes, we might find reassurance in the fact that, in the ten years or so after Orwell wrote 'The Lion and the Unicorn', that chilliest of major philosophers Ludwig Wittgenstein (like Handel, an honorary Briton) spent agonised hours pondering the notion of 'family resemblances' – a phrase you will find throughout Orwell's piece.

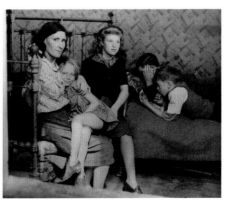

Pl. 38

So if we were to summon Orwell's ghost, and to hand him a catalogue of this fascinating exhibition, *How We Are: Photographing Britain*, he would immediately see it for what it is: a family album; a pictorial narrative of what our 'family' has been up to since the 1840s. There would be some surprises for him. For one thing, as the album responsibly registers, the family has grown a lot more diverse, culturally and ethnically, since about 1950. For another, the sisters, wives, mothers and daughters of Albion occupy a lot more space than they once did. A puritan, Orwell would probably have harrumphed at some of the cheap luxuries that have entered conspicuously into family life since the 1960s. In the end, though, he would have recognised how strangely continuous certain strands of the British experience and identity have been.

Is that to say, then, that this exhibition offers an objective history of Britain? Thank the Lord, no. Photography is a quotation from reality (and the art of photography, when it is practised as an art, requires a strong editorial sense as well as pictorial sensibility). A photographic exhibition is a quotation from quotations. The richer its partiality, the more likely it is to achieve moments of illumination. To judge by the aspects of Britishness Orwell discusses in 'The Lion and the Unicorn', he would have reacted most strongly to four of the strands that this show highlights.

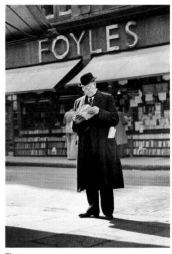

1. Poverty

Though other nations, particularly the United States of America, may still enjoy caricaturing us as an antiquated pack of effete aristocrats in white linen suits, or as even tighter-buttoned, tighter-lipped bourgeois in bowlers or stays (the film producers Merchant & Ivory grew prosperous by recycling these hand-me-down images), the family on show here can hardly be described as posh; they are not even comfortably off. Terms like 'destitute', 'skint' and 'crushed' would usually be closer to the mark. British photography was born in a decade of notorious economic woe – the so-called Hungry Forties – and it was almost inevitable that cameras, initially the property of the rich, should bear witness to that crisis and be turned on the poor. And the British poor have been with us ever since, photographically as well as in harsh reality.

Pl. 71

The curators of this exhibition have both recognised this fact and respected it, so that perhaps the single most striking thing about it is its fiercely democratic spirit. After an untypical initial flurry of Victorian royalty and worthies, this family album is mostly taken over by the workers, the unemployed and the outcast. Here the focus is not on those traditionally – and admirably – enshrined in our National Portrait Gallery, which was created with the express intention of inspiring Britons to high achievement by displaying those of our forebears who had been exceptional by birth or, better still, talent, courage and enterprise. Instead, this album sets out to throw retrospective light on that other side of the nation. But, as Bertolt Brecht slyly asked in one of his poems, 'Who built Thebes of the Seven Gates?'[2] Our unknown predecessors demand our attention as much as those of whom we sometimes brag.

Not only are there very few blue-bloods here, the few that do sneak in after Queen Victoria's death are viewed bleakly. There are, with one notable exception (see no. 87) no representatives of those professions who are commonly regarded as the architects of national greatness (including those from the profession of architecture). There are no scientists – no J. J. Thompson or Ernest Rutherford or Francis Crick or Stephen Hawking. After Julia Margaret Cameron's Tennyson, almost no poets – no Thomas Hardy, W. H. Auden, T. S. Eliot or Philip Larkin, though Dame Edith Sitwell does poke her extraordinary nose into a witty study by Cecil Beaton (1928). After her Carlyle, no philosophers – no Bertrand Russell, no Sir Alfred Ayer, no Ludwig Wittgenstein. And after Robert Howlett's portrait of a cocky Isambard Kingdom Brunel 1851 (no. 22), no famous engineers or entrepreneurs. And perhaps the most striking absence of all for a nation that became (during the period of this exhibition, from the 1840s to the present day) the head of the largest military empire in history and then retreated – no admirals, no air vice marshals, and no generals. Not even T.E. Lawrence, the one British military leader who most peace-loving intellectuals feel they can safely respect.

On the other hand, there are plenty of regular fighting men (see Alastair Thain's *Marines* 2005, no. 121) as well as some fighting women, and not a few casualties of war (see *Legless Servicemen at St. Mary's Hospital, Roehampton* 1918, no. 47).

2 See Bertolt Brecht's poem, 'Questions from a Worker who Reads'.

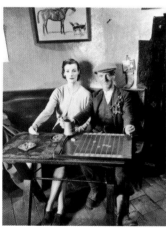

Pl. 96

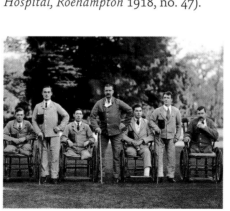

Pl. 47

But if poverty, and the question of How the Other Half Lives,[3] has been a constant theme in British photography, the motives and methods of its portraitists have varied considerably. The set of photographs of Barnardo Boys from the 1870s have the most lenten artistic aspirations, and are meant only to display a social ill and its remedy (nos. 9a and 9b); the portraits of the insane from roughly the same date were taken mainly for the advancement of science (no. 10); and the Munby portraits of working girls, taken just a few years earlier, smack of exercises in domestic anthropology, early anticipations of Mass Observation's work in the 1930s, though with a very different ideological perspective (no. 21). We can safely guess that all these photographers were high-minded, principled ladies and gentlemen; and yet time has rendered us more touchy about the balance of power between rich and poor, male and female, old and young, so that a faint whiff of the patronising, even the bullying, now hangs around these unassuming images.

That off-putting whiff starts to disperse as the camera becomes a tool cheap enough to pass into the hands of the masses themselves, and as some of the common people grow richer and less suitable as objects of well-intentioned pity. It is fascinating to watch the ways in which the subject matter of poverty mutates with changes in technology and outlook. In different hands, the camera variously preserves attitudes of anguished pity, of rage, of political solidarity, of disgust, of existential despair, or of raw shame that a rich nation can so harden its heart against its own citizens.

To follow these variations on the theme of deprivation would be one rewarding, if harrowing, path through this labyrinth. It might pass through the following landmarks: Norah Smyth's *Bromley Children* (no. 38), *Nurse Hobbes and the Malnourished Child*, or *A Home in Bow* (all 1914); Humphrey Spender's *Jarrow Hunger Marchers Approaching Trafalgar Square* 1936; Roger Mayne's Southam Street series (no. 89) ; Shirley Baker's Salford series (no. 72); and the Inner Cities series of the Exit Group (no. 109); Chris Killip's *Youth, Jarrow* 1977 and Douglas Abuelo's *Where They Sleep* (no. 120). Between them, these photographs offer up an epic narrative of British disenfranchisement.

Still, powerful as these dark notes are, they do not dominate our album to the extent of making it an unmitigated wallow in gloom. There is enormous vitality and festivity here, too, as well as creativity, appetite for

3 The phrase, 'How the Other Half Lives', entered our vocabulary with the publication of Jacob Riis' photographic studies of living conditions in New York slums in 1890.

Pl. 72

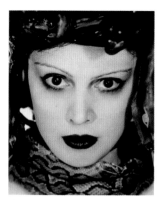

Pl. 68

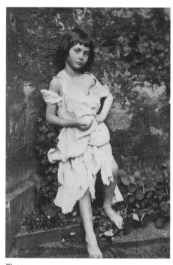

Pl. 12

pleasure, stylishness and – the one recognised English vice (or virtue?) that most citizens will admit to cheerfully rather than with a shudder – eccentricity. The next three Orwellian strands can be described much more succinctly.

2. Dressing Up

One pastime that unites both the classes and the generations in this family album is an enduring passion for adopting funny, pretty or exotic costumes. Julia Margaret Cameron loved to dress up her subjects as angels, monks or characters from Shakespeare, and although this side of her work is slightly down-played by the selection here, the theme is well represented by her fellow Victorians and her successors. Lewis Carroll, for example, dressed Alice Liddell as a 'beggar maid' (no. 12) (a portrait which reads all the more strangely in the company of so many pictures of genuinely poor children), and other girls and boys as Penelope Boothby[4] and St George.

Pictures from the 1870s of Welsh women in national costume represent the solemn rather than the frothy or fanciful aspect of dressing up (no. 18), but for the most part, unusual clothes are donned in the spirit of fantasy. This is illustrated by the portraits produced by the Lafayette Studio, such as that of Edward, Prince of Wales (1897, no.20), in rather comical Ruritanian finery, and Benjamin Stone's solemn records of English customs, including *The Fool and Robin Hood* and *Lichfield Greenhill, Bower, Display of Armour* and *The Sherborne Pageant*, all *c.*1900. More fully in the spirit of Julia Margaret Cameron's playful exercises are, in their different ways, *Vanessa Bell's Summer School, A Midsummer Night's Dream* (no. 49) ; Madame Yevonde's striking and flamboyant Goddesses series, from the mid-1930s (no. 68); Angus McBean's *Frances Day* (no. 65), and Homer Sykes's *Britannia Coconut Dancers* 1972. If none of these lifts your spirits, you may wish to consult a doctor.

3. The Entertainers

First cousins to the portraits of those who dress up for fun are those of people who dress up for a living: the professional entertainers, from the music hall crooners and clowns to the crowd-pleasing actors and musicians of the 1950s, 1960s and 1970s. And this is the one traditional British profession that has survived the curators' stern eyes – that of the stage:

a reasonable exception, since, as a visit to the National Portrait Gallery will soon show you, ours has always been a land of famous actors, singers and jongleurs, from James Burbage and Will Kempe, via Edmund Kean and Henry Irving to Jude Law and Keira Knightly.

The emphasis, as one would expect, is on those performers who were taken to heart by the masses; the sort that Orwell liked to write about. Not too many theatrical lords, then. No Gielguds and Richardsons, no Noel Coward or Gertrude Lawrence (and, strangely, no Chaplin, Crazy Gang or Flanagan and Allen); but the famous and not-so-famous headliners of that reputedly wonderful institution, the music hall. Here, then, from 1912 are shots of the enduringly celebrated Dan Leno, a performer whose power to reach audiences has been said to border on the supernatural: Leno as dapper fellow, Leno as village idiot, Leno in a pair of dazzling chessboard trousers that make him look half-clown, half Soviet poet. And here from the same year is one of our most beloved transvestites, Vesta Tilley, in a range of masculine get-ups, some of which might deceive the sharpest eye. These famous names are kept company by the less celebrated: the rum-looking Huline brothers from the 1890s (no. 19), as well as the equestrienne and wire-walker Tottie and the Clarke Brothers (no. 17). To look at these photographs is to catch a faint glimpse of a fairly recent culture that is now as lost to us as burned Carthage.

Entertainers step back from the forefront for a few decades, and then return with a vengeance in the 1950s and 1960s, with the likes of an impossibly young Bruce Forsyth (no. 87) and (one of the first true soap stars) Pat Phoenix. The pleasures of this section include what must be the least glamorous picture of Sean Connery ever taken, and one of the most glamorous portraits of John Lennon and Paul McCartney by David Bailey (1968).

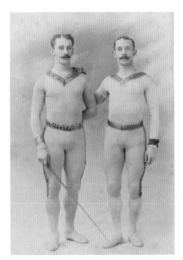

Pl. 17

4. Gardens, flowers and vegetables

Orwell was adamant on this point: one of the decisive tokens of British national identity was a love of flowers and a passion for gardening. So, with a few exceptions, such as the work of the Frith studios from the 1860s, or Alfred George Buckham's breathtakingly lovely aerial views from the 1920s, conventional landscape studies are not very strongly represented in this family album; but gardens, flowers and vegetables are. A charming

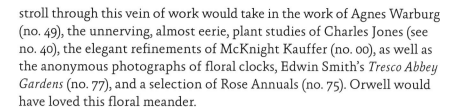

stroll through this vein of work would take in the work of Agnes Warburg (no. 49), the unnerving, almost eerie, plant studies of Charles Jones (see no. 40), the elegant refinements of McKnight Kauffer (no. 00), as well as the anonymous photographs of floral clocks, Edwin Smith's *Tresco Abbey Gardens* (no. 77), and a selection of Rose Annuals (no. 75). Orwell would have loved this floral meander.

*

There is obviously much here that does not fit so easily into these four categories. Orwell himself might well have added a fifth, calling it something like Seaside, since the British industrial working classes have traditionally taken themselves off to the coast for fun and frolics, leaving mountains, lakes and Giotto's frescos to the posher and less jolly classes. But we can guess that the four categories we have picked out for special attention – poverty, role-playing, entertainment and horticulture – would have appealed strongly to Orwell, partly because they lack the boast and swagger that are a persistent temptation when people are asked to describe their nation's defining character, and partly because they fit so well into his own vision of what Britishness meant: mildness of temper, a retreat from the public zone into the comfort of the purely personal, a fondness for small hobbies rather than grand art, and for vulgarity rather than uplift.

And, to end on a bleak note, a terrible willingness to turn a blind eye to the social ills that are (in some cases literally) right on our doorsteps. Orwell, socialist and patriot, felt that the only true remedy for this last trait would be a revolution – a revolution that would change Britain utterly, and yet leave it as recognisably the same as ever. The sort of revolution he had in mind never came; other types of change and upheaval came in its place. We are, almost all of us under the age of eighty, obviously very different from the kind of British people Orwell knew, and I fear he would not have liked us very much – for our materialism, our silliness, our failures of principle. But by the time he had looked through this album to its very last pages, Orwell's ghost would have been nodding grimly. However little he might care for the look of us, he would be too honest not to come to the inevitable conclusion. We are family.

Pl. 75

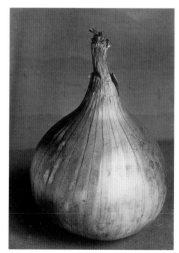

Pl. 40

We Are all Photographers Now: Popular Photographic Modes in Great Britain

GERRY BADGER AND MARTIN PARR

Photography has become a household word and a household want; is used alike by art and science, by love, business, and justice; is found in the most sumptuous saloon, and in the dingiest attic – in the solitude of the Highland cottage, and in the glare of the London gin-palace, in the pocket of the detective, in the cell of the convict, in the folio of the painter and architect, among the papers and patterns of the millowner and manufacturer, and on the cold brave breast on the battle-field.[1]

LADY ELIZABETH EASTLAKE, 1857

1 Lady Elizabeth Eastlake, in 'Photography', *London Quarterly Review*, April 1857, p.442.

From the beginning, photography was as much about communication as it was about art. It was as much a part of 'low' culture as it was of 'high' culture. Although some have always entertained ideas for the medium above its station, for most of its history its 'station' has been firmly within the compass of populist culture and popular illustration. For every photographer with an eye on artistic merit, there are hundreds, probably thousands, using the camera without any notion of art. As Walker Evans (paradoxically one of the great photo-artists) put it, most photographs stem from a simple desire 'to recognise and to boast'.[2]

2 Walker Evans, in 'The Snapshot', *Aperture*, vol.19, no.1, 1974, p.95.

The inventors of photography, and those who first organised and exploited it, came generally from the upper and middle classes, but photography itself soon became the people's medium. However, one of its accredited inventors, the Frenchman Louis Jacques Mandé Daguerre, was a showman and maker of popular panoramic spectacles, and consequently there was often a whiff of fairground disreputability about photographs of this period. Magic realism began here. A medium that captured a Miss Smith in her hirsute nakedness was always going to appeal to a wider audience than an artistically depilated and nude Ariadne.

Before the invention of photography, only those with the means to pay a painter could have their likenesses made. But within five years of the French government's magnanimous gift of the daguerreotype patent to the world (with the exception of 'perfidious Albion'), portrait studios for the people had proliferated. Richard Beard charged one guinea (the equivalent of £1.42 today) for a daguerreotype portrait taken in his Regent Street establishment in 1841, but by 1843 the cost had decreased to 12s 6d (62p), a substantial but not inordinate sum. By the mid-1840s, you could be photographed in such far-flung outposts of civilisation as Samoa or Fiji.

Photography's British inventor, William Henry Fox Talbot, made the tactical mistake of patenting his photographic system – the calotype – to prevent it from falling into the wrong, that is, lower class, hands. But in every other respect, he was responsible for both the spread and the democratisation of the medium. Firstly, he discovered a negative-positive technique, producing a matrix (the negative) from which any number of positive prints could be struck. Then he was instrumental in developing the photographically illustrated book, or 'photobook', another innovation that would result in the widespread dissemination of photographic images.

Pl. 3

To begin with, reproducibility was the problem. The daguerreotype was a unique image,[3] and while this did not limit its popularity, it hindered its long-term viability. The job of making prints using Fox Talbot's calotype was a time consuming and costly one. When the magazine *The Art Union* featured a Fox Talbot photograph in its May 1846 issue, some 7,000 photographs had to be printed from several negatives and pasted into each copy by hand.

For photography to become a mass medium, it was necessary to introduce mass production. Early cameras tended to be large and cumbersome. Enlarging negatives was virtually unknown and a print was the size of the negative from which it was derived. If you wanted a 16 × 20in print (about the largest practical size), you used a 16 × 20in negative. This presented a formidable prospect when glass negatives were introduced in 1853.[4]

But in late 1854 the French photographer André Adolphe Eugène Disdéri patented a way of taking a number of small, different photographs – usually eight – on a single large plate.[5] They could be printed in one operation, and then cut up and sold separately. The result was the *carte-de-visite* portrait, measuring around 4 ½ × 2 ½in (11.4 × 6.3cm) in size. It could be used as a calling card, with the sitter's portrait on the front and their personal information on the reverse. Or, if it was an image of a celebrated personage, it could be collected by the public. In England *carte-de-visite* portraits were taken of Queen Victoria and the Royal Family, as well as other eminent individuals. The American photographer John Jabez Edwin Mayall sold over 100,000 copies of his portraits of the Queen, so it was a lucrative business for a photographer if a famous person consented to sit for him. The French photographer Oliver François Xavier Sarony, who was based in Yorkshire, was reputed to be earning over £10,000 a year from his *cartes-de-visite*, when the average price for a card was a shilling (5p). Not only did this craze enable almost anyone to be immortalised by the camera, due to its low cost; it also marked the beginning of a popular interest in photographic images of celebrities that has continued unabated to this day.

The passion for *cartes-de-visite*, although extreme, represented just one of a number of instances during the nineteenth century when photography caught the public imagination. The first was the fashion for

3 A daguerreotype was a unique direct-positive image, produced on a highly polished silver halide coated copper plate, without the intermediate stage of a negative. After the plate had been exposed, the image was developed using mercury fumes.

4 In Fox Talbot's calotype, the light-sensitive silver salts were brushed on to writing paper. The surface texture of the resultant paper negative was incorporated into the image, producing a loss of sharpness and a grainy impression. Although it had a certain charm, this effect was seen as a fault compared to the daguerreotype's seamless fidelity. In 1851 Frederick Scott Archer published his collodion or wet-plate process. Collodion was a mixture of commercially available gun cotton, dissolved in ether or alcohol and iodide salts, a tensile, sticky, syrupy substance. This was applied evenly to a glass plate, which was then sensitised by immersion in a silver nitrate bath. The sensitised plate, while still damp, was exposed in the camera and then developed immediately before it could dry fully. Despite its obvious disadvantages – it was an extremely fiddly process – the collodion plate produced very detailed negatives with good tonal range, and quickly supplanted both the calotype and the daguerreotype. See note 6.

5 These smaller pictures, which required multiple exposures, were devised using a variety of methods. Some cameras had multiple lenses, to be exposed singly or as desired; others had a rotating back that moved each section of the plate into the correct position.

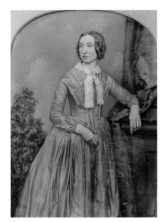

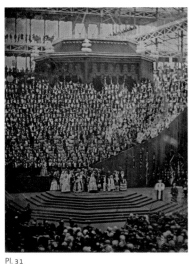

daguerreotypes, or 'daguerreomania'. Another was the market for three-dimensional images, or stereoscopic photography, which began in 1844 with the Scottish physicist Sir David Brewster's proposal for a refractive stereoscopic camera. The fashion for 'stereos' was a persistent one, and still has its devotees. Stereoscopic photography derived from the principle – known since the sixteenth century – that if two nearly identical images are placed side by side and viewed in a suitable instrument, a three-dimensional illusion is created. This, in effect, recreates the mechanism of human vision. Queen Victoria, on visiting the Great Exhibition in 1851, was impressed by the stereoscopic daguerreotypes of the Frenchman Jules Duboscq, which gave this photographic form a great boost. While these daguerreotypes were in demand, it was not until they became available as small albumen prints, pasted on a card mount, that their popularity really soared, much like the *carte-de-visite*.

In 1854 George Swan Nottage founded the London Stereoscopic Company for the purpose of mass-producing stereo cards. By 1856 the company had sold over 500,000 stereoscopes and their catalogue of titles numbered 10,000. The company, and other manufacturers of stereo cards, offered a wide range of imagery including architectural and landscape views, celebrity portraits, images of everyday life, humorous tableaux and anecdotal images. The latter might be considered the beginnings of reportage and news photography. Less reputably, indecent stereo cards ensured that those with a taste for such things could be titillated in three dimensions.

Between the mid-1840s and the 1880s photography – especially in Britain – advanced more rapidly than during any other period in its history. The most fundamental change – the introduction of the gelatin dry plate – occupied most of the 1870s. It was a development that was as significant as the current shift from film-based to digital photography. The dry plate marked photography's passage from a largely handcrafted industry to a mechanised, industrial process. Furthermore, it made it possible for the general populace to become photographers as well as consumers of photography.

Prior to the dry plate there was the wet plate, so-called because the photographer had to do everything – coat the plate, expose it and then develop it – while it was wet. Taking a wet-plate photograph necessitated

carrying around a portable darkroom and a case of noxious chemicals.[6] 6 See note 4.
It made location photography an especially tricky business. A viable dry-plate system became something of a Holy Grail for photo-scientists. In the *British Journal of Photography*, dated 8 September 1871, an English physician Dr Richard Leach Maddox described how he had produced a successful dry plate by using gelatin rather than collodion as the support medium for the plate's light-sensitive silver salts. This was the breakthrough, leading to plates that were not only prepared in advance and used dry, but were also much more light sensitive, enabling truly instantaneous photography.

The gelatin dry plate may be regarded as the start of modern photography, and the man behind much of it was an American, George Eastman. From 1879 to 1900 his company, Kodak of Rochester, New York, transformed photography with a series of inventions that took the medium from the professional or serious amateur and gave it to the man and woman in the street.

Beginning in 1880, with a company turning out dry plates on an industrial scale, Eastman went on to produce the first 'film', using a transparent cellulose base for the light-sensitive chemicals rather than glass. In 1888 the first Kodak camera was produced. It was a simple, basic, hand-held box, the forerunner of today's 'point and shoot' camera, loaded with enough film for a hundred exposures. Once the film had been taken, the camera was simply sent back to the company and the modestly sized prints arrived a few days later – together with the camera, reloaded with another film. 'You Press the Button, We Do the Rest' was the company's famous slogan, and soon the Kodak name could be seen emblazoned in neon in Piccadilly Circus (Kodak's first manufacturing plant outside America was opened in Harrow in 1891). For the first time, taking a photograph was as simple as blinking and the era of the family snapshot began in earnest. Most photographs taken from that point on arose from the desire to immortalise family and loved ones, and to make a record of shared lives – to confirm one's existence.

The popularity of photography as a mass medium was dependent as much upon its dissemination as upon technical innovation. Fox Talbot had invented the photobook in 1844,[7] but these early photobooks consisted of original prints pasted in by hand. Attention now turned to

7 Fox Talbot's *The Pencil of Nature*, published by Longman, Brown, Green & Longmans, London, in six volumes between 1844 and 1846, consisted of pasted-in calotype prints with letter-press commentaries. It is regarded generally as the first photobook. But some have argued that a woman, Anna Atkins, should be given the credit for this important innovation. The first volume of her *Photographs of British Algae: Cyanotype Impressions* (1843–53), consisting of cyanotype (blueprint) impressions of British plants, was ready a year before Talbot's book. But Mrs Atkins' book was privately distributed, rather than published for sale, and could therefore be regarded as an album rather than a fully fledged book. Also counting against her is the fact that the somewhat portentous *Pencil of Nature* has more of an epoch-making ring about it than *Photographs of British Algae*.

the development of photomechanical processes and the search for a way of reproducing photographs in ink on a printing press rather than by handcrafted chemical means.

The development of photomechanical processes, such as photogravure, collotype and Woodburytype, progressed steadily until the 1880s, when there was a quantum leap – halftone printing. Invented by an American, Frederick Eugene Ives, at the beginning of the decade, the halftone block enabled photographs and text to be printed simultaneously. The invention was to revolutionise the illustrated book and magazine. In 1887 the most successful British journal of the Victorian era adopted the process. Founded in 1842 by Herbert Ingram, the *Illustrated London News* had featured photographs from the beginning, but they were reproduced in the form of engravings made from prints. Roger Fenton's photographs of the Crimean War were reproduced in this way during the 1850s. The *Illustrated London News* now led the way in halftone printing, and the events of the day were reproduced in mass-circulation journals throughout Britain.

Another medium for bringing photographed events to a wide audience, yet on a personal level, was the postcard. Postcards had been in use since the 1860s, but the British postcard industry gained added impetus in September 1894, when the Post Office allowed picture postcards published by commercial manufacturers to be posted at the cheap rate of $\frac{1}{2}$d. As there were four postcard deliveries a day, a message posted in the morning could reach its destination by the afternoon. The postcard was the turn-of-the-century equivalent of e-mail. In 1902 the 'divided back' was introduced, whereby the address and message could be written on the reverse of the postcard, leaving the front free for the image. From then until the beginning of the First World War – a little over a decade – the British postcard enjoyed unprecedented success.

Companies like James Valentine of Dundee printed topographical views of the whole country, but postcards were also published locally by small-town photographers. They were produced either by halftone methods or as real photographic prints, on special bromide paper. They could be in black and white, sepia, hand-coloured or printed in colour and the range of subject matter was limited only by the imagination of the publisher. As well as views and portraits of celebrities, postcards

Pl. 41

were issued depicting local customs, modes of transport, fashion and news events. Postcards of disasters, such as train crashes or floods, were popular. In addition there were the so-called 'dirty postcards', distributed widely in Britain but always sold 'under the counter' and usually imported from sinful Europe.

After the First World War, the postcard's popularity abated somewhat, but photography, thanks to the introduction of better and faster printing machines, continued to develop as a mass medium. This was aided by the growth of another photographically based arrival – the cinema – and further technical improvements. In Germany, sophisticated cameras and lenses enabled photographers to work more quickly and unobtrusively than ever, freed from the constraints of the tripod. The chief tool of this new breed of photographer was the 35mm format camera, in the shape of the Leica, introduced by Oskar Barnack in 1925. Small and light, the Leica could take thirty-six pictures without the need to load a new film, an enormous advantage.[8]

Both taking photographs and printing them mechanically became easier, and photography was regarded as the modern communication medium par excellence. In the 1920s and 1930s, a multiplicity of magazines and journals used photography to illustrate all aspects of modern life. These publications (such as the *Berliner Illustrirte Zeitung* in Germany, *Vu* in France, *Life* in America and *Picture Post* in Britain) became the forum for photographs of every kind, whether made by journeymen professionals, committed documentarians, or those with artistic aspirations, and a new profession emerged to feed an insatiable demand for new and novel photographs – the photojournalist.

A novel way of presenting photographs was also introduced. The Leica was developed to accept motion-picture film, and magazine editors borrowed ideas from the film industry to create the picture essay – 'stories' laid out in still photographs. Many of these innovations were initiated in Germany, but following Hitler's rise to power, a number of the best photographers, designers and editors, being Jewish, left the country. One was the Hungarian Stefan Lorant, who became the first editor of the popular British illustrated magazine, *Picture Post*.[9]

Picture Post was founded in 1938. After six months its circulation reached 1,600,000 copies a week. Lorant was editor from 1938 to 1940,

8 The three main types of camera in professional use in the 1930s were the large-format plate camera, large, unwieldy cameras taking one sheet of film at a time; the medium-format rollfilm camera, such as the Rolleiflex, taking twelve 6 × 6cm negatives on a roll; and the small-format 35mm camera, taking thirty-six 24 × 36mm negatives on a roll. Basically, the photographer had the choice of trading the perfect technical quality but unwieldy nature of the large camera for the ease of use of the smaller camera, at the expense of image quality.

9 Among other German émigrés who worked for *Picture Post* were photographers Kurt Hutton and Felix Mann.

10 Hopkinson's socialist views were frequently in conflict with those of *Picture Post*'s owner, Edward G. Hulton, a supporter of the Conservative Party. This ultimately led to Hopkinson's dismissal in 1950, after he had published a feature about South Korea's ill-treatment of prisoners during the Korean War, written by James Cameron and with photographs by Bert Hardy. *Picture Post*, faced with declining sales, finally closed in 1957. Its photographic archive, a valuable documentary resource, was set up by Hulton as the Hulton Picture Library. Bought by the BBC in 1958 and incorporated into the Radio Times photo-archive, it was bought by Brian Deutsch in 1988. In 1996 the Hulton Deutsch Collection was bought by Getty Images for £8.6 million, and now operates under its original name, the Hulton Picture Library.

11 The *Sunday Times Magazine*, Britain's first 'colour supplement', was launched as the *Sunday Times Colour Section* on 4 February 1962. The *Observer Colour Supplement* first appeared on 6 September 1964.

12 For example, the half-frame camera had a negative exactly half the size of a 35mm negative, enabling the photographer to take seventy-two exposures on a single roll. It enjoyed a brief vogue in the 1960s. Much more significant was the Polaroid Land camera, introduced by Edwin Land in 1947, which produced an 'instant' picture as a result of incorporating developing agents within each photograph. Then in 1995 came the Advanced Photo System, which may represent film's last hurrah. The APS coats film with a transparent magnetic coating that relays digital information to the automatic printing machines, so enabling them to provide better prints.

13 The Kodachrome process produced a direct-positive piece of film, known as a 'slide' or a 'transparency'. Prints could be made from this, but the usual way of viewing transparencies was to project them onto a screen in a darkened room. In the printing world, nearly all colour reproductions were made from transparencies, which were generally of better quality than that achieved from prints. However, digital scans have gradually replaced transparencies for reproduction in the last five years or so.

when Tom Hopkinson took over the post. Under the socialist Hopkinson, *Picture Post* favoured committed socio-political journalism, and in January 1941 published its 'Plan for Britain'. The plan called for the kind of policies the Labour Party would introduce when they came to power in 1945 and the issue came to be regarded as a populist forerunner of the party's manifesto.[10]

After the Second World War, the sales of *Picture Post*, like those of many magazines, went into decline as a result of competition from a new mass medium – television. The market for hard-hitting photojournalism was revived for a time in the 1960s with the 'colour supplements' of the Sunday broadsheet newspapers,[11] but in general the thrust of photo-journalism in Britain (and elsewhere) has been towards niche publications. With television the main carrier of 'hard' news, most of these publications tend to concentrate on lifestyle features rather than socio-political issues. Photographers of a serious disposition have increasingly turned to the photobook as a medium, a niche market in itself.

The trend throughout the twentieth century was to make photography quicker, easier and less expensive for the snapshooting general public. The film format of choice, for those outside the professional ranks, was 35mm, though there were attempts (mostly short-lived) to introduce other formats, just as there had been in the nineteenth century.[12]

One lasting innovation was the general introduction of colour. Colour photography had been attempted from the very beginning, but the first practical, modern colour film, Kodachrome, was only introduced in 1936, and like that other pre-war invention, television, only blossomed after the Second World War. Kodachrome was a slide film,[13] and the phenomenon of being asked round to friends' houses to view their holiday transparencies through a projector became a feature of post-war British life. With the evolution of colour negative films, 'enprints' (standard-sized photographic prints) gradually replaced the 'tranny' in popularity.

The early years of the twenty-first century have witnessed the so-called 'digital revolution' in photography. Digital cameras do not use film but employ sensors to record the image as digitally encoded information, which can then be stored and edited on a computer and printed out in

various ways. This has been the biggest technical advance in photography since the dry plate, marking the beginning of the demise of film[14] and giving complete control to anyone who can master electronic image manipulation on a computer. In conjunction with new media, it has also completely revolutionised the distribution of photographs, enabling an image file to be sent anywhere in the world in an instant. For professionals, there are certain issues concerning quality of reproduction and copyright protection, but for amateurs the digital age makes photography simpler than it has ever been.

Cameras are also getting smaller, and are now incorporated into the ubiquitous mobile phone, with which users can take both still and moving pictures. This also has implications for professionals. News photographs are being taken on the spot by those unfortunate enough to be caught up in news events. The most vivid images of the London bombings on 7 July 2005, both film footage and still photographs, came from the phone cameras of victims.

On a happier note, more people are making and enjoying photographs than ever before. Some share them with family and friends; others find a wider audience on 'blog' websites. There is no doubt that a vast archive of snapshots of life in Britain during the early twenty-first century is being created at this very moment. How much will be retrievable is another question, but any photographer with the most rudimentary digital 'dark-room' – camera, computer and printer – has the capacity to experiment with the medium, make his or her own photobooks and distribute photographic images.

In a real sense, the digital revolution has returned us to Victorian photography's 'do it yourself' roots – with one important difference. Fox Talbot, father of British photography, and Anna Atkins, credited with being one of the first woman photographers, who made their photographs and albums in their comfortable country houses, were members of a minority, privileged class. In the 160 years or so since their day, photography has been thoroughly democratised. We are all photographers now.

14 For diehards and certain professional applications, film will probably continue to be used for some time. For amateurs and most professional uses, however, it looks as though, in the first years of the twenty-first century, digital cameras have already matched the quality of film and their manufacturers have achieved a critical mass in sales. Consequently many models of film camera are no longer produced.

142 Flickr, page shown Tom Hopwood, from www.flickr.com,
photosharing, website, launched 2004

Selected Biographies

BIOGRAPHIES COMPILED BY

Heather Birchall, Lorna Crabbe,
Jane Fletcher, Robert Pullen,
Robin Silas Christian, Nadim Sammam,
Sophie Spencer-Wood and
Hannah Vaughan

Douglas Abuelo 1969–

Originally from New York, and now based in Leipzig, Berlin and London, Abuelo has been working as a photographer for the past eight years, commissioned by national and international newspapers and magazines including *Der Spiegel*, *Focus*, *Time*, *Die Welt*, *Financial Times Deutschland*, *Leipziger Volkszeitung*, *Le Point*, *Max*, and *Neon*. Subjects include the Falash Mura in Ethiopia, the Vietnamese community in Leipzig, communities in northern Romania and drug addicts in Berlin. He has a MA in photojournalism and documentary photography from the London College of Communication.

Thomas Annan 1829–1887

Annan began his career as a lithographic writer and engraver on a local newspaper in Fife, and later moved to Glasgow taking a position in the lithographic establishment of Joseph Swan, producing illustrations for maps, books and topographical works. He set up a studio, T&R Annan and Sons Ltd, as a professional photographer in 1855, and founded a photographic printing works in Hamilton in 1859. By 1862 he had begun to establish a reputation for photographing works of art. In 1866, he purchased the carbon process patent rights for Scotland and in 1883 secured the British rights for photogravure. Between 1868 and 1871, he executed a commission from the City of Glasgow to photograph the slums of the old town before their demolition, later published in the book *Photographs of Old Closes and Streets of Glasgow taken 1868–1877* (1900). T&R Annan and Sons Ltd were official photographers at the Glasgow Exhibitions of 1888, 1901 and 1911, and received a Royal Warrant from Queen Victoria in 1889. Exhibitions include Photographic Society of Scotland, Edinburgh (1858 and 1864), The Photographic Society, Glasgow (1859), London Architectural Association (1861), London Photographic Society (1863) and The International Exhibition, Dublin (1865). Work was published in the *British Journal of Photography* and *Photographic News*. Collections include the Victoria and Albert Museum, National Portrait Gallery, London, The National Galleries of Scotland Collection and the Harry Ransom Humanities Research Center at the University of Texas at Austin. The Thomas Annan Collection of over 500 photographs is housed at the Mitchell Library, Glasgow.

Keith Arnatt 1930–

Born in Oxford, Arnatt studied at the Royal Academy Schools, London (1956–8), and later taught at Liverpool College of Art (1962-5), Manchester College of Art (1965-9) and Newport College Art (1969–90). Projects and solo exhibitions include the TV intervention *Self Burial* (1969) and *Walking the Dog*, Anthony D'Offay Gallery, London; Graves Art Gallery, Sheffield; Walker Art Gallery, Liverpool; John Hansard Gallery, University of Southampton and Chapter Arts Centre, Cardiff, Wales (1979) and *A.O.N.B. (Area of Outstanding Natural Beauty)* (1982-4). A retrospective exhibition of Arnatt's photographs entitled *I'm a Real Photographer* is to be held at the Photographers' Gallery in June 2007. Selected publications include *Walking the Dog* (1979), *Photography as Performance* (1986), *Pictures from a Rubbish Tip*, Photographers' Gallery (1988), *Rubbish and Recollections* (1989) and

One Foot Has Not Yet Reached The Next Street (1992). Collections include the Victoria and Albert Museum; National Media Museum, Bradford; Arts Council; Tate and the National Museum of Wales.

Eve Arnold 1913–

Born in Philadelphia, Pennsylvania, to Russian immigrant parents, Arnold began photographing while working at a photo-finishing plant in New York City in 1946, and then studied photography in 1948 with Alexey Brodovitch at the New School for Social Research in New York. She first became associated with Magnum Photos in 1951, and became a full member in 1957. She was based in the US during the 1950s and came to England in 1962. Her first major solo exhibition was at the Brooklyn Museum in 1980 when she also received the National Book Award for *In China*. In 1996, *Eve Arnold: In Retrospect* opened at the Barbican Art Gallery, London. In 1997, she was appointed to the advisory committee of the National Museum of Photography, Film & Television, Bradford (now known as National Media Museum). Publications include *The Unretouched Woman* (1976), *Flashback: The 50's* (1978), *In America* (1983), *Marilyn Monroe: An Appreciation* (1983), *All in a Day's Work* (1989), *The Great British* (1991), *In Retrospect* (1995) and *Magna Brava: Magnum's Women Photographers* (with Inge Morath, Susan Meiselas, Martine Franck and Marilyn Silverstone, 1999).

Anna Atkins (neé Children) 1799–1871

Atkins was a member of the Botanical Society of London. In 1841, she experimented with William Henry Fox Talbot's Calotype process producing images using a camera, but in 1842 she experimented with Sir John Frederick William Herschel's newly invented cyanotype process, in which images are produced by placing objects in contact with the sensitive paper and exposing to sunlight. She used this process to produce the first photographic book published in the UK, the three-volume set of the *British Algae: Cyanotype Impressions* (1843–53). During this 10-year period, 12 sets were produced, containing over 5,000 prints. Collections include the British Library, The Linnean Society of London, Victoria and Albert Museum and The New York Public Library.

David Bailey 1938–

Born in London, Bailey was self-taught in photography. He served in RAF in Malaysia 1948–53, and became assistant to photographer John French in 1959. He was employed by Vogue magazine from 1960 onwards, and freelanced for publications including *Daily Express*, *Sunday Times*, *Daily Telegraph*, *Elle* and *Glamour*. He has directed television commercials since 1966 and documentaries since 1968. Solo exhibitions include National Portrait Gallery, London (1971); Photographers' Gallery, London (1973); Victoria and Albert Museum (1983) and International Center of Photography, New York (1984); National Centre of Photography, Bath (1989); Barbican Art Gallery, London, (1999); National Museum of Photography, Film & Television, Bradford (now known as National Media Museum) (1999–2000); Moderna Museet, Stockholm (2000); City Art Museum, Helsinki (2000); Modern Art Museum, The Dean Gallery,

Edinburgh (2001); *14 Stations of the Cross* (with Damien Hirst) Gagosian Gallery, London (2004) and *Artists by David Bailey*, Gagosian Gallery (2004). Group exhibitions include *Floods of Light*, Photographers' Gallery (1982); *British Photography 1955–65*, Photographers' Gallery (1983) and *Shots of Style*, Victoria and Albert Museum (1985). Publications include *Box of Pin-Ups* (1964); *Goodbye Baby and Amen* (1969); *Beady Minces* (1974); *David Bailey's Trouble and Strife* (1980); *Black and White Memories* (1983); *David Bailey Photographs 1964–1983* (1984); *Imagine* (1985); *If We Shadows* (1992); *The Birth of the Cool*, (1999); *Models Close-Up* (1998) and *Chasing Rainbows* (2001).

Shirley Baker 1932–

Born in Salford, and brought up in Manchester, Baker studied Pure Photography at Manchester College of Technology and later took courses at London's Regent Street Polytechnic, the London College of Printing and the University of Derby. She has worked as an industrial photographer, a freelance writer and photographer on various magazines, books and newspapers, and has lectured at Salford College of Art and Manchester Polytechnic. Her images from the late 1960s and early 1970s of the communities of Salford and Manchester were first exhibited in *Here Yesterday, and Gone Tomorrow* at the Salford Art Gallery in 1986 and were published as *Street Photographs* (1989). She was later commissioned by The Lowry in Salford to revisit these locations and record both contrasts and continuities. These images were exhibited at the Lowry in 2000 and published as *Streets and Spaces* in (2000). She has made photographic projects for the Documentary Photography Archive, the Royal Manchester Children's Hospital and Viewpoint Gallery, and undertaken commissions for Manchester Airport and Cheshire Arts Services. Her work is regularly on display at the Print Room of the Photographers' Gallery, London.

Alexander Bassano 1829–1913

Bassano spent his early career helping in the studios of the painter Augustus Egg and the watercolourist and scene-painter William Beverly. He opened his first photographic studio at 57 Pratt Street, Camden Town, St Pancras (1851-2), later moving the studio to 72 Piccadilly (1869–80) and 25 Old Bond Street, where the firm was located until 1921. This studio was large enough to accommodate an 80-foot panoramic background scene mounted on rollers, which provided a variety of outdoor scenes and court backgrounds. Several of Bassano's photographs of Queen Victoria provided the basis for well-known paintings, including that by Benjamin Constant, which was shown at the Royal Academy in 1901. Bassano retired from active work in the studio c.1903, and the premises were extensively refurbished and modernised with electric lights and re-launched as Bassano Ltd, Royal Photographers. The National Portrait Gallery, London now owns more than 50,000 Bassano negatives. Collections include the National Portrait Gallery, London, Victoria and Albert Museum, Museum of London, The Women's Library and The Rothschild Archive, London.

Nicholas Battye 1950–2004

Australian born Nicholas Battye – poet, photographer and Naqshbandhi Sufi – moved to London before his 21st birthday where he became allied with photographers Chris Steele Perkins and Paul Trevor. From the home of the Half Moon Photography Workshop in the East End of London they worked on a local documentary project, culminating in the booklet *Down Wapping* (1974). In 1973, they formed the Exit Photography Group, and with the help of the Gulbenkian Foundation, extended their work to 'inner-urban areas' across the UK. The project took over six years to complete, and a selection of the work was shown at the Side Gallery, Newcastle in 1982 and the book, *Survival Programmes: In Britain's Inner Cities* was published later that year. The *Survival Programmes* archive is held in the archives of the London School of Economics.

Cecil Beaton 1904–1980

Born in Hampstead, London, Beaton's first photographs were of his sisters Nancy and Baba set in front of home-made sets. A trip to New York at the end of the 1920s lead to contracts for *Vogue*, *Vanity Fair* and *Harper's Bazaar*, publications that he worked for throughout his career. During the 1930s he took a portrait of Queen Elizabeth II, resulting in his appointment as official Royal Photographer. He was also the official photographer for the Ministry of Information during World War II. He illustrated a large number of books and was a prolific writer publishing his diaries and an early autobiography *Photobiography* (1951). He was also an illustrator, painter and costume designer, creating costumes and sets for many stage productions including productions of *Gigi* (1958) and *My Fair Lady* (1964). Selected solo exhibitions include Cooling Gallery (1930), National Portrait Gallery, London (1968), Sonnabend Gallery (1973) and Kodak House (1974). Selected publications include *Cecil Beaton's Scrap Book* (1937), *The Book of Beauty* (1938), *Cecil Beaton's New York* (1938) and *Personal Grata* (1953). He also wrote *British Photographers* (1944) and was co-author of a history of photography *The Magic Image* (1975).

Vanessa Bell (née Stephen) 1879–1961

Born in London, educated at home, Bell took drawing lessons from Ebenezer Cook before attending Sir Arthur Cope's art school in 1896. She studied painting at the Royal Academy in 1901, and moved to Bloomsbury with her sister Virginia and brothers Thoby and Adrian and associated with the artists, writers and intellectuals who would form the Bloomsbury Group. She married Clive Bell in 1907 and had two sons. She later had a daughter with the painter Duncan Grant with whom she lived for many years at Charleston in Sussex. She designed furniture, fabrics and ceramics for the Omega Workshop, (1913–19), and also contributed illustrations and design to Virginia and Leonard Woolfe's Hogarth Press. Exhibitions include Gallery of London Artist's Association (1927, 1930, 1931); Beaux Art Gallery (1932); Leicester Galleries (1935); Artists' International Association at the Whitechapel Art Gallery (1939); National Gallery, London (1942) and Tate Gallery (1948). Her photographs were included in the 1986 exhibition *The Other Observers: Women's Photography in Britain*

at the National Museum of Photography, Film & Television, Bradford (now known as National Media Museum). Collections include National Portrait Gallery, London; Courtauld Institute of Art, London; Tate; Ashmolean Museum, Oxford; Manchester City Art Gallery; National Gallery of Australia and the Pomona College Museum of Art, California. Her family photographs are housed in the Tate Archive. *Vanessa Bell's Family Album* was published in 1981.

Geoffrey Bevington 1838–1872

Bevington was a member of the family of Bevington & Sons, who owned leather tanning mills in Bermondsey, London. He was an amateur photographer and was awarded the Silver Cup of the Amateur Photographic Society. In 1861–2, Bevington took a series of photographs of the works at the Neckinger Mills, these were exhibited on the company's stand at the International Exhibition 1862. Collections include Victoria and Albert Museum.

Dorothy Bohm (neé Israelit) 1924–

Born in Konigsberg, East Prussia, Bohm moved to Lithuania before leaving for England in June 1939. In 1940–2, she studied photography at Manchester College of Technology, and worked in Samuel Taylor's portrait studio from 1942–5, undertaking a lecture tour of northern England. She opened Studio Alexander in Manchester in 1946, and in 1950, moved to London. In the 1950s and 1960s, she travelled extensively in Europe, Scandinavia and the USA. In 1971 she helped found the Photographers' Gallery in London and, for the next fifteen years, was its Associate Director. Exhibitions include *Four Photographers in Contrast*, Institute of Contemporary Arts, London (1969); Photographers' Gallery (1974); Il Diaframma, Milan (1976); Camden Arts Centre (1981); Museum of London (1997); Royal Photographic, Bath (1998) and Musée Carnavalet, Paris (2005). Publications include *World Observed* (1970), *A Celebration of London* (1984), *Egypt* (1989), *Venice* (1992), *Sixties* (1996), *Inside London* (2001) and *Un amour de Paris* (2005). Collections include Arts Council of Great Britain, Victoria and Albert Museum, Musée Carnvalet, Paris and The Israel Museum, Jerusalem.

Jane Bown 1925–

Born in Dorset, studied photography at Guildford School of Art, Surrey (1946–50). Joined *Observer* newspaper in 1949. In 1964, worked for three years on the *Observer Colour Magazine*. Her extensive photojournalism output includes series on gypsies, Greenham Common evictions, and in 2002, the Glastonbury Festival, and her sitters include Queen Elizabeth II, Jean Cocteau, Samuel Beckett, Björk, Sir John Betjeman and the Beatles. Her forthcoming publication *Unknown Bown* (2007) focuses on Bown's photojournalistic and social documentary output between the 1940s and 1960s. Exhibitions include *The Gentle Eye*, National Portrait Gallery, London (1980–1) and *Rock 1963–2003* (2003). Publications include *The Gentle Eye* (1980), *Women of Consequence* (1986), *Men of Consequence* (1987), *The Singular Cat* (1988), *Pillars of the Church* (1991), *Faces: The Creative Process Behind Great Portraits* (2000) and *Rock 1963–2003*

(2003). Collections include National Portrait Gallery, London and Palace of Westminster, London.

Edward Alan Bowness 1928–

Born in Great Langdale in the Lake District, Bowness studied at Manchester University, graduating in 1948 with a geography degree. He was a schoolmaster for thirty-five years. A self-taught photographer, he set up a small freelance business. His photographs have been used in calendars, books, postcards, brochures and advertising material and featured in *The Westmorland Gazette*, *Observer*, *Telegraph*, *Country Walking* and *The Great Outdoors*. Publications include *Country Life Picture Book of the Lake District* (1961), *The Lake District in Colour* (1979), *The Yorkshire Dales* (1999) and *Lake District* (2002). He was commissioned to provide one hundred new images of Lakeland for the Automobile Association in 1995. He has built his picture library to a total of around 10,000 images.

Bill (Hermann Wilhelm) Brandt 1904–1983

Born into an Anglo-German family in Hamburg, Brandt began his career apprenticed to a portrait photographer in Vienna in 1927. He worked in Man Ray's Paris studio (1929–30) before moving to London. His photographs of British society were published in *The English at Home* (1936) and *A Night in London* (1938). During this time he contributed to magazines such as *Lilliput* (1939–45), *Picture Post* and *Harper's Bazaar*. In 1940, he was commissioned by the Home Office and the National Buildings Record to document the underground bomb shelters of London. After World War II, he focussed on portraiture, landscape and the nude. In 1975, he curated *The Land* exhibition for the Victoria and Albert Museum. Exhibitions include Museum of Modern Art, New York (1948); Hayward Gallery, London (1970); Photographers' Gallery, London (1974); Moderna Museet, Stockholm (1978); Victoria and Albert Museum (1984) and Barbican Art Gallery, London (1993). Publications include *Bill Brandt: Camera in London* (1948), *Literary Britain* (1951), *Perspective of Nudes* (1961) and *Shadow of Light* (1966). Collections include English Heritage National Monuments Record, Victoria and Albert Museum, Imperial War Museum, Birmingham Central Library, National Portrait Gallery, London and the British Council Collection.

Christina Broom (née Livingstone) 1863–1939

Educated at Claremont, Margate, Broom was the official photographer of the Household Brigade, 1904–39. A supporter of the suffragette movement, she made many portraits of its leaders and events between 1908 and 1913. During the 1920s and 1930s Broom recorded London life, publishing her work in *The Illustrated London News, Tatler* and *Country Life*. Her work has been shown in exhibitions including *The Other Observers: Women's Photography in Britain*, National Museum of Photography, Film & Television, Bradford (now known as National Media Museum) (1986) and in the National Portrait Gallery's 1994 exhibition *Edwardian Women Photographers*. Collections include Museum of London, Imperial War

Museum, Chelsea Library, The Women's Library, National Portrait Gallery, London, St Paul's Cathedral, Architectural Archive and the Gernsheim Collection at the Harry Ransom Humanities Research Center at the University of Texas at Austin.

Captain Alfred George Buckham
1880–1956
First head of aerial reconnaissance for the Royal Navy in World War I, and later a Captain in the Royal Air Force, Buckham's aerial photographs are housed in collections which include the Scottish National Photographic Collection, the National Oceanic and Atmospheric Administration Photo Library, Washington and the US Naval Foundation, Washington. His images have been published in *Science Newsletter*, *Fortune*, *American Photographer* and the Scottish National Photographic Centre publication *Photography in Scotland* (2004). Exhibitions include the Royal Photographic Society 58th and 66th exhibitions (1913 and 1929), Camera Club, Adelphi (1929) and *The Fine Art of Photographs* (2001) at the National Portrait Gallery, Edinburgh.

Stephen Bull 1971–
Bull is an artist, writer and lecturer based in Brighton, England. He has exhibited at The Photographers' Gallery, London and as part of the *Shoreditch Photography Biennale*. Two books of his work have been published, *A Meeting With A Celebrity* (2004) and *Meeting Hazel Stokes* (2006). As well as essays for a number of books, he has written over fifty articles and reviews for magazines including *Art Review*, *Creative Camera*, *Photoworks* and *Source: The Photographic Review*. He is also the author of *Photography* in a series on Introductions to Media and Communications (to be published in 2008). Stephen is Course Leader for BA (Hons) Photography at The University of Portsmouth and has run courses at Tate Modern in Photography as Art, Photography and Celebrity and Photography and the City. He studied BA (Hons) Photography and MA Photography at The Surrey Institute of Art and Design, Farnham.

Vanley Burke 1951–
Burke moved to Birmingham from Jamaica in 1965, and two years later began to photograph the black community in Handsworth. He continues to chronicle this community today. His archive of photographs and ephemeral material documenting the cultural presence for African Caribbean communities is held at Birmingham Central Library. Exhibitions include *Handsworth From The Inside* at Ikon Gallery, Birmingham (1983); *No Time For Flowers*, Walsall Museum and Art Gallery (1991); *The Journey*, Walsall Museum and Art Gallery (1993); *Redemption Songs*, Birmingham Symphony Hall (2002) and *Sugar Coated Tears* at Wolverhampton Art Gallery and selected pubs, clubs, community centres, churches, schools and pool halls (2007). Publications include *Vanley Burke A Retrospective* (1993). Collections include Birmingham Central Library.

Julia Margaret Cameron (neé Pattle)
1815–1879
Born in Calcutta, Cameron was given a camera by her daughter in 1863, and by the following year she was a member of the Photographic Society of London (later The Royal Photographic Society). Living at Freshwater Bay on the Isle of Wight the subjects for her photographs included her neighbours and friends, such as Lord Alfred Tennyson, Thomas Carlyle, and her niece Julia. In 1864, she exhibited at the Photographic Society of Scotland and the Photographic Society, London, and in 1865 at the International Exhibition in Dublin. In 1875, Cameron and her family moved to Sri Lanka, where she continued to photograph. Collections include National Portrait Gallery, London; The Rothschild Archive, London; National Media Museum, Bradford; Victoria and Albert Museum and The J. Paul Getty Museum, Los Angeles.

Lewis Carroll (Charles Lutwidge Dodgson)
1832–1898
Carroll was educated in Oxford and awarded a BA in Mathematics. In 1856, he purchased a camera and began to photograph friends and family. He is particularly known for the photographs of the children of the Liddell family – Alice, Edith and Lorina (Ina). In the 1860s and 1870s he photographed eminent people such as Sir Frederick Gore Ouseley and Dante Gabriel Rossetti. Carroll is known as the author of *Alice's Adventures in Wonderland* (1865) and *Through the Looking-Glass* (1871). Collections include The Royal Photographic Society Collection at the National Media Museum, Bradford; National Portrait Gallery, London; Metropolitan Museum of Art, New York; Gernsheim Collection at the Harry Ransom Humanities Research Center at the University of Texas at Austin and the Princeton University Collection.

Winifred Casson 1908–1969
Casson trained with the photographer John Somerset Murray in London. Active for no more than five years during the late 1930s she exhibited at the Chelsea Arts Club (1935) and was included in *Photography Yearbook* (1936). Casson left London at the outbreak of World War II; any subsequent photographic work remains untraced. Collections include Gernsheim Collection at the Harry Ransom Humanities Research Center at the University of Texas at Austin.

Alvin Langdon Coburn 1882–1966
Born in Boston, Massachusetts. In 1899, Coburn's photographs were included in an exhibition at the Royal Photographic Society *The New School of American Photography*. In 1904, he worked in London photographing notable people including George Bernard Shaw, and in 1906, had a solo exhibition at the Royal Photographic Society, was subsequently invited to become a member. To produce his high quality photogravures, Coburn set up a press and studio in his home in Hammersmith, London in 1909. In 1918, he moved to Wales. In 1916, he invented 'vortographs', images created by an optical device attached to the camera lens – the Vortoscope'. In 1919, he became a Freemason and in 1952 attained the high office of Provincial Grand Master of the Mark Degree for North Wales. Published work includes *London*

(1909), *New York* (Foreword by H.G. Wells, 1910), *The Door in the Wall, and Other Stories* (by H.G. Wells, 1911), *Men of Mark* (1913), *Moor Park, Rickmansworth: a series of photographs* (1915) and *More Men of Mark* (1922). Collections include the Royal Photographic Society Collection at the National Media Museum, Bradford and George Eastman House International Museum of Photography and Film.

Lena Connell (née Beatrice Cundy)
1875–1949
Trained as an assistant photographer to her father F.H. Connell in 1891, in 1900, she opened her first studio at 3 Blenheim Place, St John's Wood, taking over the premises from her father. From 1901 to 1905 and again in 1910–11, she exhibited at the Royal Photographic Society's Annual Exhibition. In 1912, she was awarded a gold medal for her photograph *Portrait, untitled* by the *Professional Photographer* magazine. She specialised in portraiture, photographing notable people of the day including members of the suffragette movement, Edith Craig, Cicely Hamilton and Gladys Keevil – some were published as postcards and sold in aid of the Suffrage movement. Connell was a member of the Women's Social and Political Union. The work was published in *Tatler* (1920 and 1921) and *Sketch* (1922). In 1922, she decided to use her married name of Beatrice Cundy, and closed her studio at 12 Baker Street to concentrate on what the *British Journal of Photography* in a review of her 1928 and 1929 exhibitions at the Halcyon Club, London, termed 'at-home portraiture'. Collections include Museum of London; National Portrait Gallery, London; The British Library; The Women's Library; The Royal College of Music and McCord Museum, Canada.

Elaine Constantine 1965–
Born in Manchester, Constantine became interested in photography as a teenager. She freelanced for the magazine *Scooter Scene* and took City and Guilds course in photography. In 1992, she moved to London and became first assistant to Nick Knight. Her work has appeared in Italian, American and French *Vogue*, *The Face*, *W* magazine, *Sleazenation* and *Arena Homme Plus*, and she has supplied advertising and cover art for musicians including work for Texas, Moloko and St. Etienne. In 2002, she was commissioned by the Castlefield Gallery and made *Tea Dance*, a photographic series which focused on the tea dance culture of Manchester. Since her first solo show at Galerie 213, Paris (1998), her work has been shown in galleries and museums worldwide. Group exhibitions include *Look at Me: Fashion and Photography in Britain 1960 to present*, Kunsthal, Rotterdam, (1998); *Imperfect Beauty*, Victoria and Albert Museum (2000–1) and *Jam Tokyo-London*, Barbican Art Gallery, London (2001).

Robert Thompson Crawshay 1817–1879
Crawshay was the fourth 'Iron King' of the Cyfarthfa Iron Works, Merthyr Tydfil. He became a member of the (Royal) Photographic Society in 1867, and was elected to its Council in 1872. He mastered several photographic *genres*, including landscape, portraiture and tableaux. In 1873 and 1874, he offered cash prizes to encourage

large-scale portraits 'direct from life', stipulating the size of the glass negative and the dimensions of the face. Crawshay's scenes from a Turkish bath were most likely made at the home of his cousin, George. Details about their production and intended meaning, however, remain tantalisingly ambiguous. Collections include the Victoria and Albert Museum.

Stephen Dalton 1937–
Educated at the Regent Street Polytechnic, in the 1960s, Dalton worked as an industrial, commercial and promotional photographer. His interest in natural history began while studying photography. He is widely known for high-speed flash photography of insects while in flight – using self-designed custom flash units. Publications include *Honeybees from close up*, photographs by S. Dalton text by A. M. Dines (1968); *Borne on the Wind* (1975); *The Miracle of Flight* (1977); *Caught in Motion: high-speed nature photography* (1982) and the *Secret Life* series (1988).

John Davies 1949-
Born in Sedgefield, County Durham, England, Davies studied photography at Trent Polytechnic in Nottingham. He began an analysis of the 'wild and natural' landscapes of the British Isles in the mid-1970s, later published in *Mist Mountain Water Wind* (1985) and *Skylines* (1993). In 1981, he began a documentation of Britain published as *A Green & Pleasant Land* (1986). His work has been included in exhibitions at the Museum of Modern Art, New York; The Pompidou Centre, Paris; Royal Academy of Art and the Victoria and Albert Museum. During the mid-1980s, he worked in Western Europe on a variety of architectural and environmental projects, including three monographs commissioned and published in France: *Temps et Paysage* (2000), *Le Retour de la Nature* (2001) and *Seine Valley* (2001). In 2000, he began work on the Metropoli Project, investigating major post-industrial cities within the UK and culminating in an exhibition at Ffotogallery, Cardiff in 2004. In 2006, *The British Landscape* was published and accompanied a retrospective of this work at PhotoEspaña in Madrid and the National Media Museum, Bradford. Collections include Arts Council England; Bibliotheque Nationale, Paris; Museum of Modern Art, New York; National Library of Wales and National Media Museum, Bradford.

George Davison 1854–1930
Born in Lowestoft, England, Davison began his career as an audit clerk in London. He took up photography in his early thirties and began to develop his own style of photographic impressionism using a pinhole camera to achieve soft focus. In 1885, he was one of the first members of the London Camera Club, and in 1886 he joined the Photographic Society of London. Davison was involved in debates at the London Photographic Society (later the Royal Photographic Society) and later became a member of the Linked Ring. In 1889, he began working for the Kodak Company, appointed Deputy Manager of Kodak Limited in 1897, and Managing Director in 1900, a post he held until 1908. He remained a director at Kodak until 1913. Davison gave up photography in 1911 and from his home, Wern Fawr in North Wales, he

aided many socialist projects including the Central Labour House in London. Collections include the National Media Museum, Bradford.

Philip Henry Delamotte 1821–1889
Born at the Royal Military College, Sandhurst, Delamotte was a photographer, artist and teacher, becoming Professor of Fine Art at King's College, London in 1855. He photographed the Crystal Palace making two major series of work: *Photographic Views of the Progress of the Crystal Palace, Sydenham. Taken During the Progress of the Works, by Desire of the Directors* (1855) and after its reconstruction, *The Crystal Palace at Sydenham* (c.1858–9). Publications include *The Practice of Photography: A Manual for Students and Amateurs* (1853), *The Oxymel Process in Photography* (1856), *A Photographic Tour among the Abbeys of Yorkshire* (1856) and *The Sunbeam, A Photographic Magazine* (parts 1–6) (1857–61). Collections include English Heritage National Monuments Centre, Swindon; Swansea Library; Victoria and Albert Museum; The British Library; National Media Museum, Bradford and The University of Maryland.

W. & D. Downey active c.1860–1940
William (1829–1915) and Daniel (1831–1881) were initially active in Newcastle, and in the late 1860s moved to London establishing studios in Ebury Street at Nos. 61 (1872–1940), 51 (1879) and 57 (1880–90). They were known for portraits of Royalty, celebrities and actors of the day. In the 1860s, their photograph of the Princess of Wales and Princess Louise sold over 300,000 copies. In 1879 and 1890, they received Royal Warrants. Their publications include *The Cabinet Portrait Gallery* (1890–4). Collections include the National Portrait Gallery, London, Getty Images, and The Rothschild Archive, London.

Dr Hugh Welch Diamond 1809–1886
Diamond trained as a doctor but was to become one of the earliest exponents of photography. He used William Henry Fox Talbot's calotype process just three months after the announcement of its invention in 1841. In 1853, he became one of the founder members of the Photographic Society of London (later the Royal Photographic Society), and became the Society's Secretary and for ten years edited the *Photographic Journal*. Between 1848 and 1858, he made many calotypes documenting the facial expressions of patients suffering from mental disorders at the Surrey County Asylum, where he was Superintendent of the female department. These were exhibited in 1852 at the Society of Arts with the title *Types of Insanity*. In 1867, the Photographic Society acknowledged Diamond's long and successful labours as one of the principal pioneers of the photographic art and of his continuing endeavours for its advancement. Collections include the Royal Society of Medicine and National Portrait Gallery, London.

Euan Duff 1939–
Duff studied photography at the London School of Printing and Graphic Arts (1957–60) before working as a freelance photojournalist in London. He taught at Chelsea School of Art (1965-74), North East London Polytechnic (1974-8) and Trent

Polytechnic (1979-90). He wrote photographic criticism for the *Guardian* between 1972 and 1974 and published two books, *How We Are* (1971) and *Workless* (1975), a study of unemployment, produced in conjunction with the writer Dennis Marsden. His film *Janet & John – grow up* was produced by the British Film Institute in 1976. Duff's work has featured in *How We Are* (1979), a solo exhibition at the Institute of Contemporary Arts, London and *Through The Looking Glass* (1989), a retrospective of British photography since 1945 held at the Barbican Art Gallery, London. It was also the subject of the exhibition and conference *Archives from the New British Photography of the 70s: Euan Duff and Peter Mitchell* (2005) at the Gardner Arts Centre, Brighton. In 2002, Duff donated a large volume of work to the Mass Observation Archive at the University of Sussex.

Peter Henry Emerson 1856–1936
Born in Cuba, educated at Cambridge, Emerson gained a medical degree in 1885, and began making photographs in 1881. Publications include *Naturalistic Photography for Students of the Art* (1889) and *The Death of Naturalistic Photography* (1890). He also published books and portfolios of his photographs as photogravures or platinotype prints including *Life and Landscape on the Norfolk Broads* with T.F. Goodall (1887), *Pictures from Life in Field and Fen* (1887), *Idyls of the Norfolk Broads* (1887), *Pictures of East Anglian Life* (1888), *The Compleat Angler* by Izaak Walton (1888), *Wild Life on a Tidal Water* (1890), *On English Lagoons* (1893) and *Marsh Leaves* (1895). Collections include National Media Museum, Bradford; The British Library; Victoria and Albert Museum; George Eastman House International Museum of Photography and Film and The J. Paul Getty Museum, Los Angeles.

Jason Evans 1968–
Born in Wales, Evans studied at Sheffield City Polytechnic (1987–90), and acted as an assistant to Nick Knight in 1990, before going on to work predominantly for style magazines. He is often associated with the group of young photographers who brought fashion photography to the fore in the early 1990s. He worked as a freelance stylist and contributor to *i-D* magazine (1989–92), contributing editor to *i-D* (1992–3). Group exhibitions include *Tomorrow People*, i-D now, Palazzo Cosini, Florence (1992); *Expose Yourself*, Tannery Gallery, London (1994); *Teen*, Pierre Chevalier Gallery, Paris (1997); *Look at Me* (1998) and *Make Life Beautiful! The Dandy in Photography*, Brighton Museum (2003). He has had solo exhibitions at the American Museum of Snapshots, Portland, Oregon (1996) and Dean Clough Gallery, Halifax (1998). Web projects include *The Daily Nice* and *The New Scent*, and he was the author of *W'Happen* (1998). Evans teaches photography at University College for the Creative Arts at Farnham. Collections include Victoria and Albert Museum and Tate.

Roger Fenton 1819–1869
Educated at University College, London, in 1844 Fenton travelled to Paris as a pupil of the painter Michel-Martin Drolling. Returning to England c.1847, he studied with the painter Charles Lucy. In 1850, he exhibited the painting *The Letter to*

Mamma: What shall we write? at the Royal Academy. He was called to the bar in 1851. In 1852, he wrote the paper a *Proposal for the Formation of a Photographical Society* published in *The Chemist; a Monthly Journal of Philosophy, and of Chemistry applied to the Arts, Manufactures, Agriculture, and Medicine, and Record of Pharmacy.* In 1853, the Photographic Society of London (later the Royal Photographic Society) was formed: Fenton was a founder member. In 1854, he photographed Queen Victoria, Prince Albert and the royal children. In 1855, he travelled to the Crimea spending three months photographing war and military life. In 1855, photographs from the Crimea series were exhibited as *Photographic Pictures Taken in the Crimea* at the Gallery of the Water-Colour Society, London, and Thomas Agnew, the Manchester print-seller, published a set of the photographs as *Photographic Pictures of the Seat of War in the Crimea,* a series of three portfolios: *Scenery-Views of the Camps, Incidents of Camp Life-Groups of Figures* and *Historical Portraits* (1855). Although Fenton's popularity and reputation was high, despite continuing to photograph and exhibiting in the Photographic Society's annual exhibitions, and, in 1860, illustrating *Conway in the Stereoscope,* in 1862 he announced his retirement from photography and the Photographic Society of London. Collections include The Royal Collection, Windsor; Victoria and Albert Museum; National Media Museum, Bradford; National Portrait Gallery, London; The J. Paul Getty Museum, Los Angeles; Collection Centre Canadien d'Architecture, Canada and George Eastman House International Museum of Photography and Film.

Anna Fox 1961–
Studied at West Surrey College of Art and Design (1983–86), Fox made *Work Stations: Office Life in London* (1988) a commission by Camerawork and the Museum of London. Other projects include *The Village* (1992), *Friendly Fire* (1994), *Zwarte Piet* (1993–8) and *Pictures of Linda* (1983–2007). Artists' books include *Cockroach Diary* (2000), *My Mother's Cupboards and My Father's Words* (2000) and *Made in Europe* (2001–3). She taught at London College of Printing, Royal College of Art and is currently Head of BA Photography at University College for the Creative Arts, Farnham. Commissions include *Regeneration*, Site Gallery, Sheffield (1991); *La Retraite*, for ARPA and Caisse de Depots et Consignations, Paris (1994) and *Further Up in The Air*, Liverpool (2004). Solo exhibitions include Photographers' Gallery, London (1990) and Museum of Contemporary Photography, Chicago (2000). Collective exhibitions include *Through the Looking Glass,* Barbican Art Gallery (1989); *Warworks,* Victoria and Albert Museum (1995); *Interior Britannia,* Saidye Bronfman Centre, Montreal (1999); *New Natural History*, National Museum of Photography, Film & Television, Bradford (now known as National Media Museum) (1999); *From Tarzan to Rambo,* Tate Modern, London (2002) and *Centre for the Creative Universe: Liverpool and the Avant-Garde*, Tate Liverpool (2007). Publications include *Workstations* (1988), *Interior Britannia* (with Richard Billingham) (1999) and *Zwarte Piet* (with Mieke Bal, 2001). Collections include British Council Collection, Museum of London, Victoria and Albert Museum, National Media Museum, Bradford and Pompidou Centre, Paris.

William Henry Fox Talbot 1800–1877
Educated at Cambridge, Fox Talbot's interests included mathematics, astronomy, botany, etymology and science. He invented one of the first photographic processes. In 1832, he was elected as Member of Parliament for Chippenham. In 1834, he began work on the process which he announced as *Photogenic Drawing* in 1839. In 1841, he patented the *Calotype* process (or as it would be known as the *Talbotype*), the first in-camera negative process, which is the basis of photography today. In 1843, he opened the Reading Establishment, Reading, a studio and printing works, set up to print photographs, including Fox Talbot's part-work series *The Pencil of Nature* in 1844–6. In 1845, he issued *Sun Pictures of Scotland* (1846), containing 23 salt prints. In the 1850s, he moved away from photography to methods of reproducing images by ink on paper. In 1852, he patented the Photographic Engraving Process and in 1858 Photoglyphic Engraving – these would later be the basis of the photogravure process. Collections include the British Library; National Media Museum, Bradford; The J. Paul Getty Museum, Los Angeles and the Museum of Modern Art, New York.

Leonard Freed 1929–2006
Born in Brooklyn, New York to Jewish parents of Eastern European descent, Freed took up photography in 1953. In 1954, after trips through Europe and North Africa, he returned to the United States and studied at Alexey Brodovitch's 'design laboratory'. He moved to Amsterdam in 1958 and photographed the Jewish community. Working as a freelance photographer from 1961 onwards, Freed began to travel widely, photographing in America (1964–5), in Israel (1967–8), the Yom Kippur war in 1973 and, between 1972 and 1979, the New York City police department. He joined Magnum in 1972. Subjects of his work include the American civil rights movement, Asian immigration in England, North Sea oil development and Spain after Franco. Publications include Leonard Freed's Germany (1971), *Police Work* (1980) and *Leonard Freed: Photographs 1954–1990* (1992).

Francis Frith 1822–1898
Frith began his working life as an apprentice in a Sheffield cutlery firm, but from the mid-1850s became a photographer. In 1856, he embarked on one of three trips to the Middle East publishing the photographs that he made as stereoscopes and large-format prints. The success of this venture led to further commissions and his third trip resulted in the publication, *Egypt and Palestine Photographed and Described by Francis Frith* (1858–9). In 1859, he opened a printing establishment in Reigate, Surrey selling illustrated books and albumen prints. As the company of Francis Frith & Co., Frith staff photographers recorded the landscape, villages and towns of Great Britain. The Frith archive comprises over 400,000 negatives and prints, all taken between c.1870 and 1970. The company remained in business until 1971 when the archive was sold. Collections include Victoria and Albert Museum, Birmingham Central Library, National Maritime Museum and George Eastman House International Museum of Photography and Film.

George Garland 1900–1978
George Garland was brought up near Petworth in Sussex, and attended Midhurst Grammar School. He set up studio in Station Road, Petworth in the 1920s. In his early years as a photographer, he made photographs for society magazines including *Tatler*, but soon began to specialise in photographs of the Sussex countryside and rural pursuits which were published in *Farmer and Stockbreeder* and in national, regional and local newspapers. On his death he bequeathed his collection of 60,000 negatives to the Record Office. Garland's work became a subject of scrutiny when Photoworks launched its *Country Life* series, inviting photographers and artists to respond to his work. Participating artists included Chris Harrison, Joachim Schmid and Susan Lipper. Books on Garland include *Not Submitted Elsewhere*, Petworth, *The Winds of Change* and *The Men with Laughter in their Hearts,* all by Peter Jerrome and Jonathan Newdick. Collections include West Sussex Record Office.

Kate E. Gough (neé Rolls Hoare) 1856–1948
Active as a photographer between 1860s–1880s. Collections include the Victoria and Albert Museum.

Oxley Grabham 1864–1939
Keeper of the Yorkshire Museum from 1905–1919, Grabham was a well-known naturalist with specialist knowledge of zoology, ornithology and photography. He used photography to catalogue the museum collection and documented rural life at the turn of the twentieth century. He was elected an honorary member of the Yorkshire Philosophical Society in 1920. Publications include *British Mammals: Sixty Photographs from Life* (1907) and *Yorkshire Potteries, Pots and Potters* (1916). Collections include Science and Society Picture Library and the Royal Photographic Society.

Paul Graham 1956–
Born in Stafford, Graham completed his degree at Bristol University in 1978. He was a pioneer of new colour documentary in the 1980, and created bodies of work in a number of international sites, including Northern Ireland, England, Japan, America and Western Europe. Exhibitions include *A1 – The Great North Road*, Photographers' Gallery, London (1983); *Television Portraits*, Anthony Reynolds Gallery, London (1993), *Empty Heaven*, Kunstmuseum, Wolfsburg, Germany (1994), *End of an Age*, Scalo, New York (2000) and *American Night*, PS1 MoMA, New York (2003). Group exhibitions include *New British Photography*, Whitechapel Art Gallery, London (1987) and *Cruel and Tender*, Tate Modern, London (2002). Publications include *The Great North Road* (1983), *Beyond Caring* (1986), *Troubled Land* (1987), *New Europe* (1993), *Empty Heaven* (1995) and *American Night* (2003). Collections include Museum of Modern Art, New York; British Council Collection; Victoria and Albert Museum; National Media Museum, Bradford; Fotomuseum, Winterthur and Musée de la Photographie, Charleroi, Belgium.

Gunn and Stuart active 1888–1905
The partnership of Charles James Angel Isaac Gunn (1857–1927) and his brother-in-law William Slade Stuart (1858–1938) operated studios at 162 Sloane Square (1894–1905) and at 2 The Quadrant, Richmond (1888–1931). Collections include the National Portrait Gallery, London.

Bert Hardy 1913–1995
Hardy worked as a messenger, darkroom assistant and then as a photographer. In 1938, he worked as a freelance photographer and later as a staff photographer for *Picture Post*. In 1942, he was drafted into No.5 Army Film and Photographic Unit, and in 1944 covered the D-day Landings, the liberation of Paris and the concentration camps in Germany, in particular Bergen-Belsen. After the war he returned to *Picture Post* and covered many stories including the Korean and Vietnam wars as well as stories of London life. After *Picture Post* closed in 1957, Hardy worked for various magazines, *Lilliput*, *Farmer's Weekly*, *Eagle* and *Robin*, until 1959, when he concentrated on advertising work. Collections include The Cuming Museum, Getty Images, Imperial War Museum, Museum of London and Victoria and Albert Museum.

Chris Harrison 1967–
Harrison studied photography at Trent Polytechnic (1987–90) and the Royal College of Art (1997). Group exhibitions include *Shoreditch Photography Biennale*, London (1996) and *Arles Festival*, France (1998). Solo exhibitions include *Whatever Happened to Andra Patterson*, Zone Gallery, Newcastle (1993); *Noblesse Oblige*, Leconfield Hall, Petworth (1996); Imperial War Museum (1997), *Oriel Mostyn*, Llandudno, Wales (1998) and Brighton University Gallery (1999). Publications include *Under the Hood*, commissioned by the Viewpoint Photography Gallery, Salford (1994) and *Noblesse Oblige* (1996), published in the *Country Life* series by Photoworks in response to the George Garland Archive in Petworth.

John Havinden 1908–1987
In the 1920s, Havinden lived in France and then Australia, working as a commercial photographer. In 1929, he returned to England forming the Gretton Studios in 1930 to specialise in commercial and colour practice. Clients included HMV, the G.P.O., Monte Carlo and Standard Cars. From 1935 to 1942, Havinden worked as an advertising photographer, and in 1942 joined Strand Films. At the end of World War II, Havinden abandoned photography, moving into the antiques trade. In 1979, a retrospective of his work was shown at Impressions Gallery, York and in 1981, photographs were included in the Arts Council touring exhibition *Modern British Photography 1919–39*. Collections include National Portrait Gallery, London and Royal Institute of British Architects.

Nancy Hellebrand 1944–
Educated at the University of Southern California, in 1965 Hellebrand took photography classes with Alexey Brodovitch at New York University. She opened a studio and also taught photography in New York before moving to London in the late 1960s. Between 1971–4, Hellebrand studied photography under Bill Brandt and later published *Londoners at Home* (1974). Her work has been exhibited widely and has had solo shows at the National Portrait Gallery, London (1974), Light Gallery (1975), Paul Cava Gallery (1981), Pace/McGill (1984 and 1989), Pennsylvania Academy of Fine Arts (1985), Locks Gallery (2002) and Museum of the Southwest (2007). Collections include National Portrait Gallery, London; Museum of Modern Art, New York; Art Museum, Princeton University and Philadelphia Museum of Art.

Nigel Graeme Henderson 1917–1985
Educated at Stowe, Henderson took up painting, photography and collage. He worked as an assistant picture restorer at the National Gallery (1936–9) while moving on the fringes of the Surrealist movement and the Bloomsbury group. He was a pilot in RAF Coastal Command during the war; when de-mobbed he returned to art and studied at the Slade. In 1949–52, he produced a series of documentary photographs of East End life, moving to Essex in 1952 where he continued to paint and practice photojournalism and teach creative photography at the Central School. During the 1950s he was one of the founders of the Independent Group, with Eduardo Paolozzi and Richard Hamilton. He taught in Norwich from 1965. Exhibitions include *Parallel of Life and Art*, Institute of Contemporary Arts, London (1953); *This Is Tomorrow*, Whitechapel Art Gallery, London (1956); a solo exhibition at the ICA (1961); Anthony d'Offay Gallery (1977); Kettle's Yard, Cambridge and Serpentine Gallery (1983). Publications include *Photographs, Collages, Paintings* (1977) and *Heads I Win* (1992). Collections include Tate and National Portrait Gallery, London.

Percy Hennell 1911–c.1988
From the age of eleven, Hennell attended evening and weekend classes at St Martin's School of Art and in the early 1930s was employed as a commercial artist, working in a photographic studio in Great Portland Street, London. In 1938, he was appointed manager of the Metal Box Company Colour Photographic Department. Hennell became a pioneer of colour photography, his processes being used during World War II to record colour-coded German fuses and, from 1940, burns and plastic surgery cases at a number of Royal Air Force hospitals. Between 1941 and 1942, he accompanied Sir Harold Gilles on a lecture tour of North and South America on the subject colour photography. In 1944, he travelled to Naples to record casualties and conditions in air raid shelters, and in 1945 he photographed malnutrition and gangrene among British prisoners of war in Silesia. Hennell's photographs were used to illustrate numerous books on medicine, including *Fractures and Joint Injuries* (1940) and *The Principles and Art of Plastic Surgery* (1957). Collections include The Antony Wallace Collection at The Royal College of Surgeons England.

Fergus Heron 1972–
Heron studied Photography at the Surrey Institute of Art and Design (1997) and the Royal College of Art, London (2000) and now teaches at the University of Brighton. His photographic practice is concerned with the representation of landscape and architecture in relation to history, memory and perception. Exhibitions include *Together Again*, Pump House Gallery, London (2000); *Royal Collage*, Museum of Contemporary Art, Roskilde, Denmark (2001); *Dislocation*, K3, Zurich (2003); *Unravelling Photography*, Quay Arts, Isle of Wight (2006); *Forest Dreaming*, Centre for Contemporary Art and the Natural World, Exeter (2006). Publications include *Eventful: Photographic Time* (edited by Yve Lomax and Olivier Richon) (2000).

Hill and Adamson active 1843–1847
The partnership of David Octavius Hill (1802–1870) and Robert Adamson (1821–1848) was formed in 1843 and lasted until 1847. Hill, a painter, lithographer and a founder of the Royal Scottish Academy of Arts, decided to paint the members of the newly formed Free Protesting Church of Scotland (this painting is commonly known as the '*Disruption Painting*'). Hill required 400 portraits of the members to use as preparatory sketches to work from. Photography was considered to be the best method to accomplish this and Adamson, who had used the Calotype process since 1842, was one of Edinburgh's notable photographers. They did not limit themselves to this project, and their subjects included portraiture, architectural views, landscape and a series of portraits of the fishermen and women of Newhaven. They also published *A Series of Calotype Views of St. Andrews* (1846). Collections include National Portrait Gallery, London, Glasgow School of Art and George Eastman House International Museum of Photography and Film.

John Hinde 1916–1997
Born in Somerset, raised as a Quaker, Hinde began experimenting with photography as a schoolboy, setting up his own darkroom and subscribing to photography magazines. Trained as an architect in Bristol, he joined the Bristol Photographic Society, and in the mid-1930s, began to take both architectural and advertising photographs, at one time working with Edward McKnight-Kauffer. He became skilled in colour photography and specialised in location work, photographing plants for the *Plantsman* and author T.C. Mansfield, using the Duxachrome process. He was appointed as photography manager for the publisher Adprint. Publications include *Of Cabbages and Kings* (1945), *Citizens in War – and After* (with Stephen Spender, 1945), *The Small Canteen* (1947), *British Circus Life* (1948) and *Annuals in Colour and Cultivation* (1949). As a result of his assignment for *British Circus Life*, Hinde joined Chipperfield's Circus, and then operated his own circus company until 1955. That same year, he established the John Hinde Postcard Company in County Dublin, Ireland, employing a number of photographers to make high quality images for colour postcards. Hinde's archives are held at the Royal Photographic Society Collection at the National Media Museum, Bradford.

Dan Holdsworth 1974–
Holdsworth graduated from the London College of Printing in 1998, and now lives and works in Yorkshire. In 2005, a monograph *Dan Holdsworth* was published. His work also features in *Art Photography Now* (Susan Bright, 2005).

A recent collaboration with Paul Shepherd, *Geographics* opened at Middlesbrough Institute for Modern Art in 2007. Exhibitions include *The World in Itself,* Barbican Art Gallery, London (2001); Chelsea Kunstraum, Cologne (2002); The New Art Gallery, Walsall (2003) and National Maritime Museum, London (2006). Group exhibitions include *Photospin*, Photographers' Gallery, London (2000); *Looking With/Out*, Courtauld Institute of Art, London (2001) and *Spectacular City*, The Netherlands Architecture Institute, Rotterdam (2006). Collections include Tate; Government Art Collection, London; Victoria and Albert Museum and the Contemporary Art Society, London.

Eric Hosking 1905–1991

Born in London, Hosking's career spanned over sixty years. He is one of the world's most respected natural history photographers, publishing numerous books including *Birds of the Day* (1944), *Masterpieces of Bird Photography* (1947), *Bird Migrants* (1952), his biography *An Eye for a Bird* (1970) and *Eric Hosking's Birds: Fifty Years of Photographing Wildlife* (1979). For many years he travelled throughout the UK presenting lectures illustrated by slides. He was a founder member of the Hilbre Party, that met once a year on the Island of Hilbre for a week of intensive bird watching. He was a regular contributor to the Zoological Society of London's *Animal and Zoo* magazine in the 1940s and 1950s and a distinguished editor of the New Naturalist publications. A major retrospective exhibition of his vintage prints was shown at the Wildlife Art Gallery in Lavenham, Suffolk in 1993. He was the President of the Nature Photographic Society and Vice President of the British Ornithologists' Union, Royal Society for the Protection of Birds and the British Naturalists' Association, and Honorary President of the Royal Photographic Society. He received an OBE in 1977 for his natural history photography and work in conservation. Hosking lost an eye, in 1937, when he was attacked by an owl while photographing in Wales. The subsequent media attention catapulted him into the national consciousness and later inspired the title of his 1970 biography *An Eye for a Bird*. The book, prefaced by HRH Prince Phillip, was published in several editions.

W.G. Hoskins (William) 1908–1992

Born in Exeter, Devon, Hoskins was appointed lecturer in Commerce at University College Leicester in 1931, while teaching archaeology and local history in the evenings at Vaughan College. After the award of his doctorate, he was appointed Reader in English Local History. In 1948, he was a founder member of the Leicestershire Victoria County History Committee, and appointed honorary local editor of the Victoria County History publication. In 1952, he became Reader in Economic History at the University of Oxford. He was one of the founders of the Exeter Group (later the Exeter Civic Society) in 1960. He was the President of the Dartmoor Preservation Association from 1962–76. He was awarded an honorary Doctorate of Letters by the University of Exeter in 1974. He became the first professor of local history at the University of Leicester in 1965 where he founded the Department of English Local History (now the Centre for English Local History). He was awarded Fellowship of the British

Academy in 1969. In 1955 Hoskins published *The Making of the English Landscape* – a landscape history of England and a seminal text in that discipline and in local history. He wrote widely on the British landscape and popular historical guide-books including *Chilterns to Black Country* (1951), *East Midlands and the Peak* (1951), *Devon and its People* (1968) and *History from the Farm* (1970). He wrote and presented a BBC television series *The Landscape of England* in 1976.

Robert Howlett 1831–1858

In 1857, copies of Howlett's photographs of the construction and launch of Isambard Kingdom Brunel's steamship 'Great Eastern' were published in the *Illustrated Times*. His publications include *On the Various Methods of Printing Photographic Pictures on Paper* (1856). He exhibited at the Photographic Institution (1855), the Photographic Society's Annual Exhibitions (1856, 1857 and 1858) and Art Treasures, Manchester (1857). Collections include Victoria and Albert Museum, National Portrait Gallery, London, Institution of Civil Engineers and English Heritage National Monuments Record.

Tom Hunter 1965–

Born in Dorset, Hunter moved to Hackney in 1986. He graduated from the London College of Printing in 1994, and from the Royal College of Art in 1997, and is currently Research Fellow at the London College of Communication, where he also teaches. He first came to critical attention with *Persons Unknown* (1999). His most recent work, a series of narratives *Living in Hell and Other Stories* draws on scenes from East London and headlines from his local newspaper – *Hackney Gazette*. Exhibitions include *Portrait of Hackney*, Alba Gallery Café, London (1996); *Tom Hunter, Retrospective*, Photofusion Gallery, London (1997); *Persons Unknown and Travellers*, Alba Gallery Café, London (1997); *Life and Death in Hackney*, White Cube, London (2000); and *Living in Hell and Other Stories*, National Gallery, London (2005–6). Exhibited *Factory Built Homes* at *Shoreditch Photography Biennale* in 1998 as part of *The Artist and the Archive* programme. Group exhibitions include *Housing and Homeless*, The Candid Gallery, London (1998); *Modern Times*, Hasselblad Center, Gothenburg (2000); *Breathless! – Photography and Time*, Victoria and Albert Museum (2000); *Creative Quarters*, Museum of London (2001) and *Contemporary British Photography*, American Federation of the Arts, New York (2004–5). Publications include *Tom Hunter* (2003) and *Living in Hell and Other Stories* (2005). Collections include Victoria and Albert Museum; The National Gallery; Smithsonian Institution and Los Angeles County Museum of Art.

David Hurn 1934–

Self-taught photographer who began his career in 1955 as an assistant at the Reflex Agency, in 1956, Hurn made photo-reportage of the Hungarian revolution. He abandoned news reportage in favour of a personal approach to photography. He became associate member of Magnum in 1965 and a full member in 1967. In 1973, he set up the School of Documentary Photography in Newport, Wales. Exhibitions include *British Photography* (with Ian Berry and Tony Ray Jones), XYZ Fotografie Gallery, Belgium (1986) and *A Welsh Life*, touring

(2007). Publications include *David Hurn Photographs: 1956–76* (1979), *On Being A Photographer* (with Bill Jay, 1997) and *Wales: Land of My Father* (2000).

Harry Jacobs 1918–

Born in Stepney in East London, Jacobs served in the military between 1939–45. In 1945, he opened a jewellery business in Granville Arcade, Brixton Market. He became a portrait photographer in the 1950s, initially making photographs in sitters' homes, opening a studio in Landor Road, Stockwell in the early 1960s. He worked in black and white until 1975, often using hand-colouring. He operated the Harry Jacobs Studio until his retirement in 1999, when he sold his negatives to photographer Paul Ellis. The contents of the print archive (numbering 5,000 photographs) were taken into public ownership by Lambeth Archives. Since the closure of the studio, Jacobs's work has become a valued resource; photographs from the collection were shown at the Photographers' Gallery London (2002), the Fashion Space Gallery at London College of Fashion (2003), the Swiss Cottage Library Gallery and the Black Cultural Archives, Brixton (2004–5). Publications include *Twin Lens Reflex: the Portrait Photographs of Harry Jacobs and Bandele 'Tex' Ajetunmobli* (2004). Collections include London Borough of Lambeth Archives.

Sir Henry James 1803–1877

A notable surveyor, James was appointed to the Ordnance Survey in 1827 and, following a period working as an engineer in Portsmouth, became its Superintendent. In this role he advocated large-scale maps and, in 1855, built a studio in Southampton where he invented with others a technique called 'photozincography', which allowed maps to be produced at various scales. Being both economical and accurate, the process attracted widespread attention in Europe. In 1857, James was appointed Director of the Topographical and Statistical Department of the War Office. He continued to control the survey of Britain until 1875.

Charles Jones 1866–1959

Born in the north of England, Jones trained as a gardener and worked on a number of private estates. His gardening skills won him recognition in *The Gardener's Chronicle* (1905) but his photographic talent went unnoticed for another seventy-five years. Historian and collector Sean Sexton came across 500 of his gold toned silver gelatin prints at Bermondsey Market, London and through exhibitions and publications Jones is now as well-known for his photography as his gardening. The prints were made between 1900 and 1910 whilst he was head gardener at Ote Hall, in Sussex. No negatives remain as they were used as makeshift cloches to protect tender vegetables. After retirement, he moved to Lincolnshire and advertised his services in the magazine *Popular Gardening*.

Barbara Ker-Seymer

Ker-Seymer studied at Chelsea School of Art in the early 1920s alongside Edward Burra and William Chappell. In 1983, she illustrated the front cover

of *O, How the Wheel Becomes It* by Anthony Powell. Exhibitions include *One Hundred Years Ago*, National Portrait Gallery, London (2005) and *Dance to the Music of Time: The Life and Works of Anthony Powell*, Wallace Collection (2005). Collections include National Portrait Gallery, London and Rambert Dance Company Archive. A selection of her correspondence and papers are housed in the Tate Archive.

William Edward D. Kilburn 1818–1891
Kilburn opened his first portrait studio at 234 Regent Street (1845–55) and his second at 277 Regent Street (1855–63). In April 1848, he photographed the Chartist demonstration on Kennington Common, London; images were reproduced in *Illustrated London News* soon after, and the surviving daguerreotypes were purchased by Prince Albert. Kilburn also photographed members of the Royal Family. By 1881 he had retired from photography, and lived on the Isle of Wight until his death. Exhibitions include *Great Exhibition* (1851), Photographic Society annual exhibitions (1856 and 1860), *Art Treasures*, Manchester and the *International Exhibition* (1861). Collections include Victoria and Albert Museum; The Royal Collection, Windsor; National Portrait Gallery, London and The Rothschild Archive, London.

Chris Killip 1946–
Born in Douglas, Isle of Man, Killip moved to London in 1969 to work as a freelance photographer. He returned to his birthplace in 1970 and began a three-year photographic project. He photographed Huddersfield and Bury St Edmunds – an Arts Council of Great Britain commission for the exhibition *Two Views – Two Cities*. In 1976, he was founder of Newcastle-Upon-Tyne's Side Gallery where he worked as Gallery Director between 1977–9, and as Exhibition Curator until 1984. In 1985, Killip took part in the joint exhibition *Another Country* with Graham Smith at London's Serpentine Gallery. Further exhibitions include *Seacol*, Side Gallery, Newcastle-Upon-Tyne (1984); *Working at Pirelli*, Victoria and Albert Museum (1990); *The Last Art Show*, Bede Gallery, Jarrow (1996); *Chris Killip: Chris Killip Photographs, 1971–1996*, Manx Museum, Douglas, Isle of Man (1997) and *Sixty Photographs*, Old Post Office, Berlin (2000). Publications include *The Isle of Man: A Book about the Manx* (1980), *In Flagrante* (1988) and *The Pirelli Photographs* (2007). Collections include Museum of Modern Art, George Eastman House International Museum of Photography and Film, San Francisco Museum of Fine Arts and Victoria and Albert Museum. Killip now lives and works in the USA.

Penny Klepuszewska 1967
Klepuszewska participated in an exchange at the Academy of Fine Art in Lodz, Poland (2002), graduated from Nottingham Trent University in 2003 and studied for a MA from London College of Communication in 2006. In 2004, she exhibited *Made in Poland* at the Polish Cultural Institute in London. The more recent series *Living Arrangements* (2006) explores the life of an ageing population. Exhibitions include *Unfinished Works*, Miniatura Gallery, Poland (2005) and *End (Part 1) / Living*

Arrangements, Pickford's House Museum, Derby (2006). Group exhibitions include *Taken*, Surface Gallery, Nottingham (2003) and *For Sake or For Sale*, Homestead Gallery, London (2006). Collections include University of the Arts London.

Lafayette active 1880–1951
The first Lafayette studio was founded in Dublin in 1880 by James Stack Lauder (1853–1923) and was immediately successful. Lauder joined the Photographic Society (later the Royal Photographic Society) in 1884, and in 1885 took his first royal sitting on the occasion of Princess Alexandra's visit to Ireland. In 1887, he was awarded a Royal Warrant as 'Her Majesty's Photographer in Dublin'. Other branches of the studio were opened in Glasgow (1891), Manchester (1892), London (1897) and Belfast (1900). The London studio became the centre of the business and was located in various locations on New Bond Street. It was floated on the stock exchange in 1898. The firm went into voluntary liquidation in 1952. The National Portrait Gallery, London owns about 35,000 negatives from the 1920s–1950s and the Victoria and Albert Museum about 3500 plate and celluloid negatives 1885–1937. Collections include National Portrait Gallery, London, Victoria and Albert Museum and London Metropolitan Archives.

Clive Landen 1950–
Landen is Senior Lecturer in Documentary Photography at Newport School of Art, Media and Design. His images have been published in *Source* and *Urban Nature Magazine*. Exhibitions include Gallery of Photography, Dublin (1997); Hereford Photography Festival (2002); Holden Gallery, Manchester (2006) and Fondazione Studio Marangoni, Florence (2007). Publications include *From the Cradle to the Grave: Healthcare in the Community, Newport, Gwent* (1987), *Familiar British Wildlife* (1994) and *On the Bright Side of Life* (1997).

Sergio Larrain 1931–
Born in Santiago, Chile in 1931, Larrain took up photography in 1949. From 1949 –53, he studied forestry at the University of California at Berkeley, and then attended the University of Michigan at Ann Arbor before setting off on travels throughout Europe and the Middle East. He began work as a freelance photographer and staff photographer for Brazilian magazine *O Cruzeiro*, and in 1958, produced a body of photographs documenting London. In 1959, he became a Magnum associate, and a full member in 1961. He returned to Chile in 1961, came into contact with Bolivian guru Oscar Ichazo in 1968 and virtually gave up photography to pursue his study of Eastern culture and mysticism. Publications include *London 1958–59* (1998).

Grace Lau 1939–
Born in London, the daughter of a Chinese diplomatic family, Lau lived in China from 1945–9. She studied on the Documentary Photography course at Gwent College of Higher Education, Newport in 1992. Founder of Exposures, Association of Women Photographers, Lau was also a member of Signals Festival of Women Photographers Committee 1992–4. She is founder and

photographer for fetish magazine *Second Skin*, and her book *Adults in Wonderland* was published in 1997. Her work has featured on the covers of *Time Out* and *Paris-Match*. In 2005, she reproduced a nineteenth century Shanghai photographic portrait studio on Hastings seafront in East Sussex, and in 2006, she was invited to recreate this studio in the National Portrait Gallery, London. Other exhibitions include *She Wants*, Impressions Gallery, York and touring (2004). A forthcoming exhibition at Photofusion, London will include recent portraits and a selection of archival vintage prints from the Michael Wilson Collection.

Susan Lipper 1953–
Lipper studied at Yale University (1981–3) earning a Master of Fine Arts degree. Her major monograph *Grapevine* was published in 1994, and she published her second book, *trip* in 1999. She was commissioned to make *Bed and Breakfast* (2000) series by Photoworks as a response to the George Garland archive. Lipper's *Not Yet Titled Series* (1999–2004) explores themes of narrative and place. Exhibitions include Photographer's Gallery, London (1994); Arnolfini Gallery, Bristol (1994) and The Tang Teaching Museum and Art Gallery, New York (2004). Included in the group exhibition *Who's Looking at the Family?* Barbican Art Gallery, London (1993). Collections include National Portrait Gallery, London; Victoria and Albert Museum; Metropolitan Museum of Art, New York City; Center for Creative Photography, Arizona; Museum of Contemporary Art, Los Angeles and San Francisco Museum of Modern Art. She is based in New York City.

Richard Cockle Lucas 1800–1883
Born in Salisbury, apprenticed at the age of twelve to an uncle who was a cutler, Lucas entered the Royal Academy Schools in 1828. Between 1829 and 1859, he exhibited busts, medallions, portraits, wax reliefs and mythological groups at the Royal Academy. Commissioned sculptures of key figures include Dr Isaac Watts, Southampton; Sir Richard Hoare, Salisbury Cathedral and Dr Johnson, Lichfield. His album *50 Studies of Expressions* (1865), featuring *carte de visite* self-portraits posed as fictional characters in allegorical guises of virtue and vice, are held at George Eastman House International Museum of Photography and Film and National Portrait Gallery, London. Many of his etchings, wax reliefs and *cartes de visite* are also housed at National Portrait Gallery, London. Publications include *Remarks on the Parthenon* (1845), *Fac-similes of Nature [A Series of Coloured Impressions of Leaves, etc]* (1858) and *On the Mausoleum of Halicarnassus* (1858). A collection of his photographic studies and manuscripts are housed at the British Library.

Angus McBean 1904–1990
Celebrated British theatre photographer, McBean began a career as a theatre scenery designer and mask-maker before taking up photography. In 1935, he opened his own studio, and in 1937, created a series of 'surreal' portraits for *Sketch*. He closed his studio during World War II, but opened a larger studio in Covent Garden in 1945, subsequently becoming official photographer for the Royal Shakespeare Company, Royal Opera House,

Sadler's Wells and the Old Vic theatre (all London). In 1963, he photographed the Beatles for the front cover of the album *Please Please Me*. His first retrospective was held at Impressions Gallery, York (1977). He retired in the 1970s, but returned to photography in the 1980s with commissions for publications including British *Vogue*. Exhibitions include *Angus McBean: Portraits*, National Portrait Gallery, London (2006). Publications include *Shakespeare Memorial Theatre, 1948–1950: A photographic record* (1951), *Angus McBean* (with Adrian Woodhouse, 1982) and *Vivien: A Love Affair in Camera* (1989). Collections include National Portrait Gallery, London and National Media Museum, Bradford.

Edward McKnight-Kauffer 1890–1954
Born in Montana in the USA, McKnight-Kauffer came to London in 1914, where he worked for the London Transport Board and for the Great Western Railway, later becoming a member of both Wyndham Lewis's Group X and the Cumberland Market Group. He was primarily known as a graphic designer, and quickly gained a reputation for his influential poster designs, theatre costumes, carpets and textiles. The bold, machine-like style he developed during the 1920s served to elevate the status of commercial design. In 1940, he moved from London to New York.

Paul Augustus Martin 1864–1944
Born in Herbeuville, France, Martin came to Britain with his family in 1870 as a refugee from the Franco-Prussian War. Employed as a wood engraver's apprentice, he would copy artists' sketches and photographs onto wood blocks for reproduction in newspapers and magazines. In 1884, Martin took up photography, using a variety of cameras including the Fallowfield Facile (or 'detective') camera. These cameras, disguised as a parcel, allowed him to record scenes of everyday life unnoticed. With Harry Gordon Dorrett, he operated the Dorrett and Martin photographic studio at 16 Bellevue Road, Tooting (1899–1926) and 60 Strand, Westminster (1901–1908). In 1888, he became a member of the West Surrey Amateur Photographic Society. Collections include the Museum of London, Victoria and Albert Museum and the Harry Ransom Humanities Research Center at the University of Texas at Austin.

John Jabez Edwin Mayall 1813–1901
Mayall opened his first studio at 1 Lowther Arcade in the Strand in 1847–55 and advertised as 'Professor Highschool'. He ran other studios in London until 1885, and in Brighton until 1901. In the 1850s, Mayall was granted permission to photograph the British Royal Family, initially producing daguerreotypes and later *cartes de visite*. In 1860, Queen Victoria gave him permission to publish these in the *Royal Album* containing 14 portraits of herself, Prince Albert and their children. The demand for photographs of the Royal family was immense, especially after Prince Albert's death in 1861, at which time it is reported that Mayall's portraits of Queen Victoria were being sold in the '100,000s'. In 1853, Mayall patented 'Crayon daguerreotypes' a device to help soften the sharp image of the daguerreotype. Mayall was a member of the Photographic Society,

Fellow of the Chemical Society and the Royal Microscopical Society. Collections include the National Portrait Gallery, London; The Royal Collection, Windsor; Victoria and Albert Museum and The J. Paul Getty Museum, Los Angeles.

Roger Mayne 1929–
Born in Cambridge, Mayne studied Chemistry at Balliol College, Oxford and became interested in photographic processing. On graduating in 1951, he contributed to *Picture Post* and was an occasional stills photographer. In the early 1950s, he made photographic portraits of residents of St Ives, Cornwall. He had solo shows of portraits at the Institute of Contemporary Arts, London and George Eastman House International Museum of Photography and Film (1960). He photographed the street culture of Southam Street, London (1956–61), and in the 1960s, moved into colour photography, working abroad and publishing work in *Sunday Times* and *Observer* magazines. Exhibitions include AIA Gallery, London (1959); Photographers' Gallery (1974); Victoria and Albert Museum (1986); Tate Britain (2004); National Portrait Gallery, London (2004) and Tate Liverpool (2006). Publications include *Things Being Various* (1970); *Devon: A Shell Guide* (1975), co-written with his wife, playwright Ann Jellicoe; *Street Photographs of Roger Mayne* (1986) and *Roger Mayne Photographs* (2001). Collections include National Portrait Gallery, London and Victoria and Albert Museum.

Daniel Meadows 1952–
Born in Gloucestershire, England, Meadows studied at Manchester Polytechnic from 1970. Notable projects from that time include collaborations with Martin Parr – *Butlin's by the Sea* in Yorkshire (1972) and *June Street* in Salford (1973). Meadows toured England in the Free Photographic Omnibus (1973–4), and *Living Like This – Around Britain In The Seventies* was published in 1975. He taught alongside David Hurn on the Documentary Photography course at Newport's School of Art and Design. From 1994, Meadows has taught Photography and New Media at Cardiff University's School of Journalism, Media and Cultural Studies. Exhibitions include Institute of Contemporary Arts, London (1975), Photographers' Gallery, London (1987), Royal Photographic Society, Bath (1996) and Viewpoint Gallery, Salford (1997). In 2001, he took the idea of digital storytelling to the BBC, where he was creative director of the award-winning *Capture Wales*. His books include *Set Pieces – Being About Film Stills Mostly* (1993), *National Portraits – Photographs From The 1970s* (Val Williams, 1997), *Nattering in Paradise* (1998) and *The Bus* (2001). He was awarded his PhD in 2005.

Peter Mitchell 1943–
Born in Salford, Mitchell studied graphic design at Hornsea College of Art, London, and has lived and worked in Leeds since 1972. Exhibitions include *An Impression of the Yorkshire City of Leeds,* Leeds City Art Gallery (1975); *We Are All Heroes of Today,* Serpentine Art Gallery, London (1977); *A New Refutation of the Viking 4 Space Mission,* Impressions Gallery, York (1979) and *We Build it Here,* Mercer Art Gallery, Harrogate (1999). Mitchell is currently working on *LS7 4DX Leeds Annals of a Life*

Threatening Postcode, a meditation on the wake of the twentieth century and the destiny of cities.

Helen Muspratt 1907–2001
Born in India, Muspratt came to England as a child and quickly developed a fascination with photography. Following her training at the Regent Street Polytechnic in London, she worked for a photographer in Frinton, Essex and in 1929 opened a studio in Swanage. There she developed her distinctive style of portrait photography and began to experiment with new processes, notably solarization. In the 1930s, Muspratt opened a studio in Cambridge with Lettice Ramsey, and later moved to Oxford where the partnership, Ramsey and Muspratt, prospered. A committed socialist, Muspratt made an extensive photographic record of the Soviet Union, and documented deprivation among the mining communities of South Wales. Muspratt's work was included in the exhibition *The Other Observers: Women's Photography in Britain*, National Museum of Photography, Film & Television, Bradford (now known as National Media Museum) (1986), where her work is also held in the collection.

Arthur J. Munby 1828–1910
Born in Clifton near York, educated at St Peter's School, York and Trinity College, Cambridge, Munby read for the bar and was a solicitor for the Ecclesiastical Commissions Office until 1888. He taught Latin at the Working Man's College (1860–70) and was a published poet. He was a talented amateur photographer and a Fellow of the Society of Arts. His interest in working women was acquired at Cambridge, and references dominate diaries which he kept from 1859–98. He befriended working women including the 'pit brow wenches' in Lancashire, 'tip girls' in South Wales and 'flither lasses' at Farnborough Cliffs, recording their lives and commissioning photographs of them. He met Hannah Cullwick a 'maid of all work' in 1854; they married secretly in Clerkenwell, London in 1873. The diaries and letters of Munby and Cullwick as well as Munby's photograph collection are held at Trinity College, Cambridge. Exhibitions include *Coal: British Mining in Art 1680–1980*, Science Museum, London (1983). Publications include *Vestigia Retrorsum: The Roslyn Series (poems) Volume IV* (1891); *Munby: Man of Two Worlds: The Life and Diaries of Arthur J. Munby 1828–1910* (1972) and *Victorian Working Women: Portraits From Life* (1980).

Zed Nelson 1965–
Nelson studied at Westminster University (1985–8) graduating with a BA (Hons) in Photography, and gained attention for photographs depicting scenes of political and social breakdown in Somalia in 1992. He worked as freelance photographer for British magazines, and in 2000, published *Gun Nation* – a collection of photographs and writings reflecting on America's relationship with firearms. Other subjects have included the Ku Klux Klan, Afghanistan, and the Beauty Industry. Nelson was recently featured in the book *The World's Top Photographers: Photojournalism* (2006). Exhibitions include Newseum, New York (1999); Westzone Gallery, London (2000); Oksnehallen, Denmark,

Copenhagen (2001) and Kulturhuset, Stockholm, Sweden (2002). Group exhibitions include *Internationale Fototage*, Herten, Germany (2001); *International Biennial of Photography*, Turin, Italy (2002) and *Caught in the Crossfire*, Salle des fêtes de Gentilly, Paris (simultaneously in venues in Pretoria, India, New York, San Paulo and London, 2006). Publications include *Gun Nation* (2000). Collections include Victoria and Albert Museum.

Simon Norfolk 1963–
Born in Lagos, Nigeria, Norfolk studied Philosophy and Sociology at the Universities of Oxford and Bristol. From 1990 to 1994, he was staff photographer for *Living Marxism*. In 1994, abandoned photojournalism in favour of landscape photography. His first book, *For Most Of It I Have No Words*, which documented sites of twentieth-century genocide, was published in 1998. Other publications include *Afghanistan: Chronotopia* (2002), *Afghanistan* (2003) and *Bleed* (2005). His work appears regularly in the *New York Times* and *Guardian Weekend*. *For Most Of It I Have No Words* was exhibited at The Imperial War Museum, London; Nederlands Foto Instituut; Holocaust Museum, Houston; Belfast Exposed; McBride Fine Art, Antwerp; Bonni Benrubi Gallery, New York; Los Angeles County Museum of Art and Wolverhampton Art Gallery. Collections include the Thessaloniki Museum of Photography, Greece and the National Museum of Contemporary Art, Korea.

Jonathan Olley 1967–
Born in London, Olley studied Fine Art and Design at Chelsea School of Art (1985–7), followed by the post-graduate course in Photography at the Newport School of Documentary Photography (1987–9). Shortly afterwards, he began working as a freelance photographer, supplying the international press (including *Boston Globe*, *Paris Match*, *Guardian*) with news photographs. He has exhibited at the Photographers' Gallery, London; World Press Photo; The Institute of Contemporary Arts, London; Letterkenny Arts Centre, Ireland; Picture House Centre for Photography, Leicester; *Festival Du Photoreportage*, France and *Noorderlicht Photo Festival*, Groningen. His work features in the book *Kosovo* (1999). Collections include the Public Records Office and Imperial War Museum, London.

Horace Ové 1939–
Born in Trinidad and Tobago, Ové practices painting, photography and filmmaking. His photographs focus on 'capturing the reality of moment in people's lives' as well as exploring abstraction and surreal images from the real world. His photographic work has appeared in several exhibitions including *Breaking Loose,* Photographers' Gallery, London and *Farewell to the Flesh*, Cornerhouse, Manchester (1987). In 2001, he was invited to exhibit his works in *Recontres de la Photographie* in Bamako, Mali, alongside another photographers from the African Diaspora. In 2004, he had a major British touring exhibition of his work entitled *Pressure*. Ové has had retrospectives at the Barbican, The British Film Institute, University of California Los Angeles and the University of Tuebingen, Germany. He has also exhibited at the National Portrait Gallery, London, Victoria and Albert Museum, Whitechapel Art Gallery and Tate

Liverpool. Horace's film *Dream to Change the World* (2005) was shown at the 2005 *Pan African Festival* in Los Angeles, at the Street Level Photoworks gallery in Glasgow and most recently at The Royal Festival Hall, London (2007).

Norman Parkinson 1913–1990
Parkinson attended Westminster School before being apprenticed to Court photographers Speaight and Sons Ltd in 1931. In 1934, he opened a studio with Norman Kibblewhite, and from 1935 to 1940 worked for *Harper's Bazaar* and *The Bystander*. In 1937, he photographed unemployed miners and families in South Wales and toured Britain photographing 'traditional types'. During World War II, Parkinson concentrated on farming and made photographs for the Air Ministry. From 1942 to 1960, he worked for British *Vogue* before becoming Associate Contributing Editor of *Queen* magazine, and joining *Town & Country* magazine in 1978. In 1963, Parkinson moved to Tobago. As well as fashion, he is known for his portraits of the Royal Family. Exhibitions include *Venice Biennale Photographic Exhibition* (1957); Jaeger House (1960); Photographers' Gallery, London (1979); National Portrait Gallery, London (1981); International Center of Photography, New York (1983); Staley Wise Gallery, New York (2005); *Portraits in Fashion*, National Portrait Gallery, London (2004) and a British Arts Council exhibition at the Moscow International Festival (2007). Publications include *Sisters Under the Skin* (1978), *Photographs by Norman Parkinson* (1981), *Norman Parkinson* (1987) and *Norman Parkinson: Portraits in Fashion* (2004). Collections include National Portrait Gallery, London and the Harry Ransom Humanities Research Center at the University of Texas at Austin.

Martin Parr 1952–
Parr studied at Manchester Polytechnic (1970–3). In 1972, he made the project *Love Cubes,* and two collaborations with Daniel Meadows, *June Street* (a recording of a Salford terraced street) and *Butlins by the Sea*. His project *Home Sweet Home* was shown at the Polytechnic in 1973, then at Impressions Gallery, York (1974). In 1974, Parr moved to Yorkshire previewing *Beauty Spots* at Impressions Gallery, York (1976). In 1980, he moved to live in Northwest Ireland – images from this time are collected in the series *Bad Weather* (1982), *Abandoned Morris Minors of the west of Ireland* (1982) and *A Fair Day* (1984). *The Last Resort* (1986) documented day-trippers to New Brighton, and was shown at the Serpentine Gallery (1986). In 1988, Parr joined Magnum Photos. *Martin Parr Photoworks 1971–2000* opened in 2002 at London's Barbican Gallery. He was Guest Curator for the Arles Festival (2004). Exhibitions include *Three Perspectives on Photography*, Hayward Gallery, London (1979); *The Non-Conformists*, Camera Work, London (1981); *Bad Weather*, Photographers' Gallery, London (1982); *The Cost of Living*, Royal Photographic Society, Bath (1989); *Signs of the Times*, Janet Borden, New York (1992); *Autoportrait*, Tom Blau Gallery, London (2000) and *Cruel and Tender*, Tate Modern, London (2002). Publications include *The Cost of Living* (1989), *Sign of the Times* (1992), *From A–B* (1994), *Small World* (1995), *Boring Postcards* (1999), *Common Sense* (1999), *Think of England* (2000) and *Martin Parr* (Val Williams,

2002). Parr is also editor of *Our True Intent Is All For Your Delight* (2002), *Lodz Ghetto* (with Timothy Pruss, 2004) and *The Photobook: A History – vol.1* (2004) and *vol.II* (2006) – both with Gerry Badger. Collections include Arts Council of Great Britain; Victoria and Albert Museum; Tate; Museum of Modern Art, Tokyo; Museum of Modern Art, New York and Kodak, France.

Eileen Perrier 1974–
Perrier studied photography at the Surrey Institute of Art and Design (1993-6) and at the Royal College of Art, London, (1998–2000). Selected group exhibitions include *Brixton Studio*, The Photographers' Gallery, London (2002); *Envol*, Oxo Tower, London (2002); *Drawing with Light*, Angel Row Gallery, Nottingham (2003) and *Africa Remix*, Hayward Gallery (2005). Solo exhibitions include *Shoreditch Photography Biennale* (1996); The Centre of Attention, London (2001); *Grace*, London Underground, Piccadilly Circus (2002); *6 – 8* and *Found*, Space Gallery, London (2004) and *Embrace*, Gasworks, London (2004). Her work has been published in *Creative Camera, Tank,* and *Creative Review*. Monograph publications include *Eileen Perrier* (1999).

Otto Pfenninger c.1855–
Pfenninger was born in Switzerland. Between 1898–1903, he was also known as O.P. Suisse, and worked as a studio portrait photographer for Lombardi and Co., at 79 West Street, Brighton. Pfenninger experimented with colour photography, and by 1906 had devised a process capable of taking colour photographs, although its complexity limited its commercial viability. In 1921, Pfenninger published *Byepaths of Colour Photography*, which explained the method of making colour negatives. He also exhibited at the Royal Photographic Society's Annual Exhibition in 1904. Collections include The Royal Photographic Society Collection at the National Media Museum, Bradford.

Charlie Phillips 1944–
Phillips was born in Jamaica and came to London in 1956, initially producing photographs for magazines including *Harper's Bazaar*, *Life* and Italian *Vogue*. Throughout the 1960s, he used his camera to capture aspects of urban life in Notting Hill, and the shifts taking place in the cultural landscape, including racial integration and the birth of Carnival. He also photographed iconic black figures, including Muhammad Ali, Teddy Taylor and Omar Sherif. Phillips spent the early 1970s in Italy as a paparazzi photographer, but more recently he has photographed a series of black funerals in London. His work was exhibited, alongside that of Armet Francis and Neil Kenlock, in *Roots to Reckoning*, Museum of London (2006). Mike Phillips' publication, *Notting Hill in the Sixties* (1991), is illustrated with photographs by Charlie Phillips.

Sarah Pickering 1972–
Born in Durham, Pickering graduated from the Royal College of Art, London, with a MA in Photography in 2005. Her work has been displayed in *East International*, Norwich (2005) and at the Museum of Contemporary Photography, Chicago

(2006). She has exhibited in London, Paris, Italy, New York and Mexico. Her photographs have featured in publications such as the *Washington Post*, *Portfolio*, *Cabinet* and the *New York Sun*, and are included in the anthology on contemporary photography, *Vitamin Ph* (2006).

Walter Arthur Poucher 1891–1988

Sometimes called William Arthur Poucher, he was one of the leading English mountain photographers and guidebook writers in the years following World War II. He was also a leading researcher on the chemistry of perfumes at Yardley. His 1923 monograph *Perfumes, Cosmetics and Soaps* has been revised and reprinted over the years and is now in its tenth edition. Publications include *The Magic of Skye* (1949), *The Lakeland Peaks* (1960), *The Welsh Peaks* (1962), *The Scottish Peaks* (1965) and *The Peak and Pennines* (1966). Later volumes of these works, updated in consultation with his son, John, are still in print. Collections include the Royal Photographic Society Collection at the National Media Museum, Bradford.

Martin Pover 1948–

Pover studied photography at Polytechnic of Central London, and has taught photography since 1973, initially at the Slade School of Fine Art and at the University College for the Creative Arts. His photographs have been shown at the Victoria and Albert Museum as part of the *Household Choices* exhibition (1990), and in *Uneasy Spaces* at the Washington Square East Galleries, New York (2006). From 2003, Pover has been working on a series of photographs of contemporary zoos, titled *I Carceri*.

Richard Primrose 1968–

Primrose earned his MA in Photojournalism and Documentary Photography at the London College of Communication. His lifelong passion for photography began at the age of seven, when he won a Kodak camera in a raffle. His professional career as a wedding and portrait photographer with an East London studio began in 1994, and he later photographed families on council estates throughout Southeast England. In 2005, Primrose completed *The Nightbus Project*, the first photography work designed exclusively for Apple's video iPod.

Peter Rose Pulham 1910–1956

Pulham studied at the Architectural Association School of Architecture (1927–8) and at Worcester College, Oxford, prior to embarking on a successful photographic career, receiving regular commissions for *Harper's Bazaar*. In 1938, after visiting Paris and being drawn to the Surrealist movement, Pulham decided to give up photography to concentrate on painting. He held solo exhibitions at Redfern Gallery (1947) and Hanover Gallery (1950). In 1952, his work was included in *Recent Trends in Realist Painting* at London's Institute of Contemporary Arts. Pulham lived in France from 1949.

(Holroyd) Anthony Ray-Jones 1941–1972

Born in Wokey, Somerset, Ray-Jones attended London College of Printing where he studied Graphic Design (1957–61). He was awarded a scholarship to Yale University School of Art, Connecticut (1962) for a graduate Design programme. During his final year, Ray-Jones joined Brodovitch's 'Design Laboratory' in New York. In 1964, he again joined Brodovitch as Associate Art Director of the influential photographic magazine *Sky*. Ray-Jones returned to Britain in 1965. Selected exhibitions include Institute of Contemporary Arts, London (1969); *Personal Views*, an Arts Council Exhibition of contemporary British Photography (1970) and San Francisco Museum of Art (1972). In 1971, he returned to America and was a Visiting Lecturer at the San Francisco Art Institute. *A Day off – an English Journal* was published posthumously (1974). The National Museum of Photography, Film & Television, Bradford (now known as National Media Museum) acquired the entire Ray-Jones archive in 1993, and mounted a retrospective exhibition in 2004.

Paul Reas 1955–

Reas was born in Bradford, and trained at Newport School of Art. Until recently, he taught at Brighton University, is now Senior Lecturer in Documentary Photography at the University of Wales, Newport. His work has been included in numerous solo and group exhibitions in Britain and Europe, including a solo exhibition at Photographers' Gallery London (1985 and 1993). Group exhibitions include *Through the Looking Glass*, Barbican Art Gallery (1989); *Documentary Dilemmas*, British Council Touring (1993); *Who's Looking at the Family?*, Barbican Art Gallery (1994); *A Gentle Madness*, National Museum of Photography, Film & Television, Bradford (now known as National Media Museum) (2004) and *The House in the Middle*, Towner Art Gallery, Eastbourne (2004). Publications include *Flogging a Dead Horse* (1993) and *I Can Help* (1988).

Derek Ridgers 1950–

Born in Chiswick, West London, Ridgers studied graphic design at Ealing Art School (1967–71) before spending ten years as an art director for various London advertising agencies. He became a freelance photographer in 1982 and has since worked for, among others, *The Face*, *Time Out*, *Sunday Telegraph*, *New Music Express*, *Independent on Sunday* and *Loaded*. His work has appeared in exhibitions including *Punk Portraits*, Institute of Contemporary Arts, London (1978); *Skinheads*, Chenil Studio Gallery, London (1980); *The Kiss*, Photographers' Gallery, London (1982) and *One Man Show*, City Centre Art Gallery, Dublin (1990). Group exhibitions include *British Photographers*, Thames Valley University, London (1997); *Look at Me: Fashion and Photography in Britain 1960 to present*, Kunsthal, Rotterdam, (1998); *Queer Nation*, Elms Lesters Gallery, London (2002) and *Very Public Art*, Selfridges / Britart (2003). Publications include *When We Were Young - Derek Ridgers: Club and Street Portraits 1978–1987* (Val Williams, 2004) and *Stare: Portraits from the Endless Night* (2006). Collections include National Portrait Gallery, London.

Grace Robertson 1930–

Robertson began taking photographs in 1947, initially working with Simon Guttman, and producing photographs for Report Agency. She began working with *Picture Post* magazine and continued until its closure in 1957, after which she taught in primary schools from the late 1960s. In 1986, she was included in the National Museum of Photography's exhibition *The Other Observers: Women's Photography in Britain* and in the eponymous Virago book by Val Williams. In 1990, she made photographs for Channel 4 TV series *Picking Oakum* and in the early 1990s made work about men and women in their nineties, exhibited at the Royal National Theatre, London. Solo shows include *1989*, Zelda Cheatle Gallery, London (1990); Cathleen Ewing Gallery, Washington D.C. and National Gallery of Wales (1994) and University of Brighton (1995). Publications include *Grace Robertson: Picture Post Photographer* (1989) and *A Sympathtic Eye* (2002). Collections include the National Gallery of Australia, Scottish National Portrait Gallery, London, Victoria and Albert Museum and National Media Museum, Bradford.

George Rodger 1908–1995

Rodger was born in Hale, Cheshire, and after studying at St Bedes College, served in the Merchant Navy until 1929, travelling the world and taking pictures as an *aide-mémoire*. He began his professional photographic career with the BBC in 1936 and in 1939 joined the Black Star Agency, for which he photographed the effects of the Blitz in London and Coventry. These images appeared in *Picture Post*, and he was subsequently hired as a war correspondent and photographer for *Life* magazine. Rodger travelled widely, documenting World War II in Europe, Africa and Asia. He was present at the liberation of Paris and at the German surrender at Lüneberg. Rodger is as well known for his documentation of Africa, and the nomadic tribes of the Nuba and Masai, as for his domestic coverage of the Blitz. He established the renowned co-operative agency Magnum Photos with Robert Capa, Henri Cartier-Bresson and David 'Chim' Seymour in 1947. Extremely successful during his lifetime, Rodger was the subject of many publications and his work was exhibited in galleries in Tokyo, New York, Switzerland, Spain, London, Paris and Sydney. He was made Honorary Fellow of the Royal Photographic Society in 1993.

J.K.S. St Joseph–1994

Former Head of Archaeology with the Scottish Royal Commission, St Joseph's pioneering work revolutionised archaeological data and advanced knowledge of aerial photography. He held many posts at the University of Cambridge including Curator in Aerial Photography (1948–62), Director in Aerial Photography (1962–80) and Professor of Aerial Photographic Studies (1973–80). He stressed the technological and economic interpretation of facts registered on photographs, resulting in the recognition of new classification criteria. Photographs became objects of analysis (equivalent to written sources and maps) and not mere illustrations. He was made a Fellow of the British Academy in 1978 and was later awarded the CBE.

Kenneth Scowen (dates unknown)
Scowen was Fellow of the Institute of Incorporated Photography, and Fellow of the Royal Photographic Society, where he was a member of the Pictorial Group. Publications include *Scotland in Colour* (1961), *London in Colour* (1964), *Ireland in Colour* (1966), *The Batsford Colour Book of Ireland* (1966), *Portrait of the Cotswolds* (1971), *London in Pictures* (1973), *Walking in England* (1976), *Peel's England* (1977), *Unknown England* (1980) and *The Wisely Book of Gardening* (1983). He contributed to issues of *The Countryman*. A selection of his unbound pictorial work is held at the British Library.

Paul Seawright 1965–
Born in Belfast, Northern Ireland, Seawright studied at University of Ulster and West Surrey College of Art and Design. He is Professor of Photography at the University of Ulster and was formerly Dean of Newport School of Art Media and Design at the University of Wales, Newport. Selected exhibitions include Photographers' Gallery, London (1991 and 1995); The International Center of Photography, New York (1992); Cornerhouse, Manchester (1994); Ffotogallery, Cardiff (1996); Centre of Photography, University of Salamanca, Spain (2000); Hasselblad Centre, Gothenberg, Sweden (2001); *Hidden*, Imperial War Museum, London and Irish Museum of Modern Art, Dublin (2003) and *Hidden*, Rena Bransten Gallery, San Francisco (2004). Included in the group exhibitions *Different Stories*, Nederlands Foto Instituut, Rotterdam (1994) and *Lie of the Land*, Gallery of Photography, Dublin (1996–7). Seawright represented Wales in the 2003 *Venice Biennale*. Publications include *Inside Information* (1995), *Paul Seawright* (2001), *The Forest* (2001) and *Hidden* (2003). Collections include Art Institute of Chicago, San Francisco Museum of Modern Art, Imperial War Museum, National Museum of Wales and the Irish Museum of Modern Art.

Nigel Shafran 1964-
Shafran worked as assistant to commercial still-life photographers in London (1982–4), and was a freelance photography assistant in New York City (1984–6). In 2002, he was included in the British Council touring exhibition *Reality Check,* Moderna Galerija, Ljubljana, Slovenia. Exhibitions include *New Colour, Arles Festival* (1989); *A Positive View*, Saatchi Gallery, London (1994); *London Show*, Zwemmers Fine Photography Gallery, London (1994); *Route to my Darkroom*, Photographers' Gallery Printroom (1997); *Bench*, Photographers' Gallery, London (1997); *Look at Me: Fashion and Photography in Britain 1960 to present,* Kunsthal, Rotterdam (1998) and *Blue Suburban Skies*, Photographers' Gallery, London (1999). Publications include *Ruthbook* (1995), *Dad's Office* (1999) and *Edited Photographs 1992–2004* (David Chandler 2004). Collections include the Victoria and Albert Museum.

Edwin Smith 1912–1971
Trained as an architect, Smith was also a prolific artist, producing countless drawings, watercolour and oil paintings, woodcuts and linocuts throughout his life. He began wood-engraving in 1934, and worked in this medium until 1939, after

which he continued to make linocuts. From 1935, he began to take photographs professionally, and his work featured in books primarily covering the landscape and architecture of Britain, often produced in partnership with his wife, the artist and author Olive Cook. Photography publications include *English Villages* (1963), *The English Garden* (1966) and posthumously, *English Parish Churches* (1976), *Sacheverell Sitwell's England* (1976), *The English House Through Seven Centuries* (1984) and *English Cottages and Farmhouses* (1985). His woodcut and linocut publications include *A Clowder of Cats* (1946), *A Small World* (1969), a short book of engraving produced in an edition of thirty two copies, and *Edwin Smith – Cuts* (1992). Exhibitions include Royal Institute of British Architects (1985) and *Record and Revelation*, Impressions Gallery and Fry Gallery, Essex (1989). Following Olive Cook's death in 2002, Smith's archive, including 60,000 negatives, now rests with the Royal Institute of British Architects in London.

Robert Smithies 1934–2006
Smithies joined *Manchester Evening News* at age of 16, initially running errands in the Photographic department. In 1955, he joined the *Guardian* as the newspaper's third staff photographer, training under Tom Studdart. In 1966, he also worked as a crossword setter for the *Guardian* under the pseudonym 'Bunthorne'. He worked for the paper until 1974 covering assignments worldwide. His photographs often depicted English scenes that he would later describe as 'the disappearing world of the North West'. His series included *Manchester Housing* and *Manchester 'Slums', Manchester Streets* and *English Prisons* (executed in the 1950s). Smithies also worked as a television news editor and presenter for Granada between 1974 and 1994. His work was included in a show of six *Guardian* staff photographers at Impressions Gallery, York (1973), and is scheduled to be included in *100 Years of Guardian Photographers*, Lowry Centre, Manchester (2008).

Norah Smyth 1874–1962
A supporter of the Suffragette Movement, Smyth's photographs document the work of the East London Federation of Suffragettes between 1914 and 1918. Smyth was an active member of the Federation, working and living with Sylvia Pankhurst in a house in Bow, London, the centre of the Federation's activities. During World War I she also worked with Pankhurst to open the Mother's Arms day nursery for East End children. Many of her photographs, often representing poverty and the exploitation of labour, were published in the Federation's newspaper, the *Women's Dreadnought* (later the *Worker's Dreadnought*). By the early 1930s, Smyth had returned to her family in Florence, where she worked as a secretary, though she continued to correspond with Pankhurst until her death. Her work was shown in the 1986 exhibition *The Other Observers: Women's Photography in Britain* at the National Museum of Photography, Film & Television, Bradford (now known as National Media Museum).

Jem Southam 1950–
Educated at the London College of Printing, Southam works predominantly in the southwest

region of England. Since 1981, Southam's photographic work has developed through the following main series: *Bristol City Docks* (1977–84), *Paintings of West Cornwall* (1982–6), *The Red River* (1982–87), *The Raft of Carrots* (1992), *The Shape of Time: Rockfalls, Rivermouths and Ponds* (2000), *The Pond at Upton Pyne* (2002) and *The Painter's Pool* (2004). Exhibitions include *The Shape of Time*, Photographers' Gallery (2003); *The Painters Pool*, Room, Bristol (2004); *From a Distance: An Industrial Landscape in Cornwall*, Tate St Ives (2005) and *Path to a Picture*, Victoria and Albert Museum (2006). Collections include Victoria and Albert Museum, British Council Collection and the Government Art Collection.

Humphrey Spender 1910–2005
Spender studied History of Art at the University of Freiburg-im-Breisgau (1927–8), and a year later began a course at the Architectural Association (1929–34). After qualifying, he operated a portrait and commercial photography studio in London with Bill Edmiston and received commissions for the *Architectural Press, Vogue* and *Harper's Bazaar*. In 1937, he became a member of the pioneering research organisation, Mass Observation, and took a series of photographs of the daily life in Bolton and Blackpool, entitled *Worktown* (1937–9). From 1936–8, he worked for the *Daily Mirror* under the byline 'Lensman'. In 1938, Spender began a series of commissions for *Picture Post*, and from 1941–5 he acted as the official photographer for the British War Office, London. Spender was later appointed to the Textiles Department of the Royal College of Art, London and abandoned professional photography.

David Spero 1963–
Spero studied photography at the Royal College of Art, London. Exhibitions include *Breathless! Photography and Time*, Victoria and Albert Museum (2000); *The Art of the Garden*, Tate Britain, London (2004); *Photo España*, Madrid (2005) and *Settlements*, Photographers' Gallery, London (2005–6). Collections include British Council Collection, Citigroup Bank Collection and Victoria and Albert Museum.

Chris Steele Perkins 1947–
Perkins moved to England from Burma with his father at the age of two. He studied at Christ's Hospital, then at University of Newcastle-upon-Tyne, graduating in 1970. He worked as a freelance photographer, and moved to London in 1971. Apart from a trip to Bangladesh in 1973, he worked mainly in Britain documenting urban poverty and sub-cultures. In 1975, he began working with the Exit Photography Group, a collective dealing with social problems in British cities, a collaboration which culminated in the publication of the book *Survival Programmes* (1982). In 1979, he completed his first solo book, *The Teds* (1979), and joined Magnum Photos where he worked extensively in the developing world, in particular, Africa, Central America and Lebanon. Perkins published *The Pleasure Principle* in 1989, an exploration of Britain in the 1980s. In 2000, he published *Afghanistan*, the result of four trips over the course of four years. After marrying his second wife, Perkins embarked on a long-term photographic exploration of Japan

publishing his first book of that work, *Fuji*, in 2001. A highly personal diary of 2001, *Echoes*, was published in 2003, and the second of his Japanese books, *Tokyo Love Hello,* in 2006. Perkins continues to work in Britain documenting rural life in Durham, which will be published as *Northern Exposures* in 2007.

Sir (John) Benjamin Stone 1838–1914

Born in Aston, Birmingham, the son of a local glass manufacturer, Stone succeeded to the business after the death of his father. He became a local Conservative politician, founder of the Birmingham Conservative Association and MP for Birmingham East (1895–1909). Stone was a member of the Coldfield Corporation for many years and the first Mayor of the town in 1886, a post he held for four years. Knighted in 1892, he was appointed High Steward of the Royal Town of Sutton Coldfield in 1902. In 1895, he founded the National Photographic Record Association (photographs produced by the initiative are now held in the National Monuments Record in Swindon). In 1905–6, some of his photographs were published as a fortnightly magazine *Sir Benjamin Stone's Pictures* which made up two volumes, *Festivals, Ceremonies and Customs* and *Parliamentary Scenes and Portraits. Sir Benjamin Stone's Pictures: Records of National Life and History* was published in 1906. Appointed as official photographer to the coronation of King George V (1910). The Benjamin Stone Collection at Birmingham Central Library houses some 22, 000 examples of his work. Subjects include British customs and festivals, parliamentary portraits and topographical images and views of Europe, North and South America, Africa, India, and Australasia. The National Portrait Gallery, London holds some 2,000 photographs of people and places in and around Westminster. Stone's photographs came to contemporary attention with the publication of Bill Jay's book *Customs and Faces: Sir Benjamin Stone 1818–1914* (1972). Recent publications about Stone include *A Record of England: Sir Benjamin Stone and the National Photographic Record Association 1897–1910* (2006). Collections include the National Portrait Gallery, London, Guildhall Library, Birmingham Central Library, National Media Museum, Bradford and The Parliamentary Archives.

Clare Strand 1973–

Born in Surrey, Strand studied at the University of Brighton (1992–5), and gained a MA in Fine Art Photography from the Royal College of Art, London (1998). Recent works include *Gone Astray Portraits* and *Gone Astray Details* (2001–2), *Signs Of A Struggle* (2002–3), *The Betterment Room, Devices For Measuring Achievement* (2004–5) and *Unseen Agents* (2006–7). Solo exhibitions include *The Mortuary*, F-Stop Gallery, Bath (1997); *Seeing Red*, National Museum of Photography, Film & Television, Bradford (now known as National Media Museum) (1998); *Imago Festival*, University of Salamanca, Spain (1998); Viewpoint Gallery, Salford (1998); *Wasted*, Galleri Image, Arhaus, Denmark (2000) and *Gone Astray*, London College of Printing (2003). Selected group exhibitions include *The Dead*, National Museum of Photography, Film & Television, Bradford (now known as National Media Museum) (1995); *Look At Me*, The Kunsthal, Rotterdam (1998); *Sorted*, Ikon Gallery, Birmingham

(1998); *Modern Times*, Hassleblad Center, Sweden (1999); xpoSeptember Fotografins Hus, Sweden (2004); *Fantastic Realism,* Tallinn Town Hall, Estonia (2004); *Made in Britain*, Huis Marseille, Amsterdam (2005) and *Work*, Folkwang Museum, Essen (2005). Her photographs have appeared in numerous publications including *Vitamin Ph* (2006), *Portfolio catalogue* (issues 23 and 37) and *Photoworks* magazine (issue 4). A monograph will be published in late 2008. Collections include British Council Collection and National Media Museum, Bradford.

Wolfgang Suschitzky 1912–

Photographer, cinematographer and director and brother of Edith Tudor Hart, Suschitzky's career spans more than seventy years. He trained as a photographer in Vienna, moved to Holland in 1934, before settling in England in 1935. In 1936–8, he completed a series of photographs of Charing Cross Road, with its multitude of second-hand bookshops. He later documented London during the air raids of World War II. In 1937, he worked for Strand Films, as cameraman on the documentaries *Life Begins Again* (1942) and *Hello! West Indies* (1943). He also appears in the credits for such features as *No Resting Place* (1951), *Ulysses* (1967), *The Vengeance of She* (1968), *Ring of Bright Water* (1969) and *Living Free* (1972), as well as the gangster classic *Get Carter* (1971). In 2002, a major retrospective of his work was held at the Scottish National Portrait Gallery, Edinburgh. Collections include the National Portrait Gallery, Archives of the City of Amsterdam and Haags Gemeentemusuem, The Hague.

Frank Meadow Sutcliffe 1853–1941

Born in Leeds, son of a watercolour painter, Sutcliffe took up photography in the 1860s. From 1872–3, he photographed the castles and abbeys of Yorkshire for Francis Frith. In 1876, he opened his first photographic studio in Whitby, North Yorkshire, specialising in commercial portraiture, but also photographing landscape views, port scenes and genre scenes. By 1905 he had won numerous awards from British and International societies. He was an active writer on photography for the amateur photographic press and contributed to many journals including *Amateur Photographer*. He wrote a column for the *Yorkshire Weekly Post* for 22 years. Was the first photographer to have a solo show at the Camera Club in London (1888). He left the Royal Society in 1892 and became a founder member of the Linked Ring. He sold his business in 1922 and became curator of Whitby Library and Philosophical Society where his photographic archive is held.

Homer Sykes 1949–

Born in Vancouver, Sykes is a professional magazine photographer, working principally for national newspapers such as the *Sunday Times*, *Observer* and *Newsweek*. The first of his personal documentary projects, which he began in 1970, while a student at the London College of Printing, and finished seven years later, was published as *Once a Year: Some Traditional British Customs*. Other books include *Mysterious Britain* (1993), *Celtic Britain* (1997) and *Shanghai Odyssey* (2002). In 2002, Sykes' own publishing house, Mansion Editions, produced *On the Road Again*, which contains images from his four

American road trips, taken over thirty years, and *Hunting with Hounds* (2004), published to coincide with the British ban on hunting with dogs. Exhibitions include *Personal Views 1850–1970*, British Council, London and European tour (1970); *Traditional Country Customs* (with Sir Benjamin Stone), Institute for Contemporary Arts, London (1971); *Young British Photographers*, Museum of Modern Art, Oxford (1971); *Traditional British Calendar Customs*, Arnolfini Gallery, Bristol (1977); *Reportage Fotografen*, Museum des 20, Jahrhunderts, Vienna (1978); *A British Eye on the World*, Museum of Modern Art, Rio de Janeiro, Brazil (1986); *Shanghai Odyssey*, Open Eye Gallery, Liverpool (2003); *Shanghai Odyssey*, Festival of Photography and Contemporary Art, Biella, Italy (2005); *Viva, 1972–1982*, Jeu de Paume. Paris (2007). Collections include Government Art Collection and the British Council Collection.

Alastair Thain 1961–

Born in Germany, Thain studied photography and film at London College of Printing (1979–82). His portraits have appeared in British *Vogue, New York Times, Vanity Fair* and *The Face*. Publications include *Skin Deep* (1991), *Entrails, Heads and Tails* (1992) and *Edge of Madness* (1997). Selected group exhibitions include *Stars of British Screen*, National Portrait Gallery, London (1985); *Twenty for Today,* National Portrait Gallery, London (1985); *New Faces*, Warhol Museum, Hamburg (1988); *Shadow of a Man*, Parco, Tokyo (1994) and *Edge of Madness*, Royal Festival Hall, London (1997). In 2005, a retrospective of his work was held at Kunsthalle Mannheim, Germany.

John Thomas 1838–1905

Born in Cardiganshire, Thomas moved to Liverpool in 1853 to work in a draper's shop. In the early 1860s, he became a travelling salesman for a firm dealing in writing materials and *cartes de visite*. While working there he realised how little Welsh material there was to sell and started to take portraits. Thomas established his own photographic business, The Cambrian Gallery in 1867. He continued to live and work in Wales until his retirement. Three thousand negatives were purchased from him on retirement to illustrate future issues of the magazine *Cymru*, a publication he had contributed to for many years. The National Library of Wales holds 4,500 of his images (mostly negatives) of the people and landscapes of Wales.

John Thomson 1837–1921

Thomson was educated at the Watt Institution and School of Arts, Edinburgh. In 1862, he began travelling extensively to countries including Singapore, Cambodia, China and Cyprus, and published numerous books of his photographs from this period *The Antiquities of Cambodia* (1867), *Illustrations of China and its People* (1873–4), *Through Cyprus with the Camera* (1879) and *Through China with a Camera* (1898). He returned to England in 1875 and in 1876–7, Thomson began a series of photographs of street life in London. With accompanying essays by Adolphe Smith, this work was published in parts as *Street Life in London* (1877–8). In 1886, he was appointed Professor of Photography to the Royal Geographic Society. Thomson opened studios in Buckingham Palace

Road (1881–4), Grosvenor Street (1884–1903) and New Bond Street (1908–17). Collections include The Royal Geographical Society, The Wellcome Library, The British Library, Guildhall Library, The Rothschild Archive, London and The National Library of Scotland.

David Trainer 1954–

Trainer has observed and documented London in a number of projects exhibited at the National Portrait Gallery, London, Barbican Arts Centre and the Museum of London. He has documented people, of various ages, classes and races, who have been brought together by football matches, fairgrounds and war demonstrations. Trainer's first project, *Penny for the Guy,* was used in 2005 to mark the 400th anniversary of Guy Fawkes and the Gunpowder Plot. His work has appeared in the *Sunday Independent* magazine and the *British Journal of Photography*. Collections include the Museum of London, Imperial War Museum and Huis Marseille Museum for Photography.

Paul Trevor 1947–

In 1972, London-born photographer Paul Trevor, along with a small group of local photographers, set up the Half Moon Photography Workshop in the East End of London. Trevor formed the Exit Photography Group in 1973 with photographers Nicholas Battye and Chris Steele Perkins, their first project culminating in publication of the booklet *Down Wapping* (1974). The work led to a wider six-year project (1974–9), looking at 'inner-urban' life across the UK. Work was shown at the Side Gallery, Newcastle-Upon-Tyne (1982) and the book, '*Survival Programmes: In Britain's Inner Cities*' was published later that year. In 1976, Trevor co-created *Camerawork*, the first essential magazine of photography in Britain, remaining co-editor from 1976–80. A student of the National Film and Television School from 1982–5, his book *Constant Exposure* was published in 1987. Recent works include *Eye to I* (2000), a residency on the London Eye. *Fotomo Blues* and *In Your Face* can be viewed on the web. An ongoing major project on India led to a retrospective exhibition at the Centre for Photography as an Art Form, Bombay (1997). *Survival Programmes*, the photographs and recorded interviews are held in the archives of the London School of Economics. Trevor's work is held in public collections in Britain and abroad.

Albrecht Tübke 1971–

Born in Dalliendorf, Germany, Tübke studied at the Academy of Visual Arts in Leipzig (1997–2000) and Guildhall University of London (2000–1). Selected exhibitions include *Youth*, Dogenhaus Galerie, Leipzig (1999); *Tribe*, Rena Bransten Gallery, San Francisco (2002); *Stepping in and Out*, Victoria and Albert Museum (2002); *Citizens*, Dogenhaus Galerie, Leipzig (2002); *Portaits and Spaces*, Galeria Distrito Cu4tro, Madrid (2005); *Zeit Raum Bild*, Historisches Museum, Frankfurt (2007) and *Ortswechsel*, Atelier Frankfurt (2007). Publications include *Dalliendorf* (2000) and *Citizens* (2006). Collections include Museum Folkwang, Maison Européenne de la Photographie and the Victoria and Albert Museum.

Edith Tudor-Hart (née Suschitzky) 1908–1973

Brought up in Vienna as Edith Suschitsky (sister of Wolfgang Suschitzky). Their father, William, founded the first socialist bookshop in Vienna. She was active in student socialist groups in the early 1920s, and became a kindergarten teacher and taught in one of the first Montessori schools in Europe. She developed an interest in avant-garde music, and grew close to Schoenberg and members of the Kolisch Quartet. In 1929, she visited Paris and London and then studied at the Bauhaus Dessau, specialising in photography and studying under Walter Peterhans. She began photographing housing and living conditions and used her photographs to campaign for improvement. She met Alexander Tudor-Hart, a British doctor, in Vienna, and married in 1933, moving to London shortly afterwards. In London, she joined the Workers Camera Club and also took part in exhibitions organized by the Artists International Association. In 1934, she moved to South Wales, where Alexander Tudor-Hart worked among miners and steel workers. She worked on the book *Rich Man, Poor Man* with Pearl Binder and James Fitton (unpublished) and also contributed photo-reportage to publications including *Geographical Magazine*, *New Chronicle*, *Picture Post*, *Lilliput* and *Design for Today*. She opened a studio and made portrait and advertising photographs until beginning of World War II and continued to work in reportage. She became seriously ill in the 1940s, but continued to produce photographs, including for *Moving and Growing* in the 1950s, which remains one of the finest examples of her work. Renewed interest was shown in Tudor-Hart's work in the 1970s and 80s, and it was included in *The Other Observers: Women's Photography in Britain*, National Museum of Photography, Film & Television, Bradford (now known as National Media Museum) (1986). Publications include *Edith Tudor-Hart: The Eye of Conscience* (1987). Edith's archive is now cared for by her brother Wolfgang.

Benjamin Brecknell Turner 1815–1894

Turner is known for his topographical photographs of rural England, in particular of Worcestershire, Surrey, Yorkshire and Kent. Sixty photographs were compiled in an album, produced between 1852 and 1854, entitled *Photographic Views from Nature*. In 1849, Turner purchased a licence from Fox Talbot to practise his patented photographic process and, despite the invention of the wet collodion process, he continued to produce large-format waxed paper negatives that suited his rustic subject matter. Although he exhibited his photographs frequently with the London Photographic Society (Turner was a founder member and later Vice President of the Society) and also internationally, he remained an amateur rather than a professional. His work was shown in a retrospective at the Victoria and Albert Museum (2002). Collections include the Victoria and Albert Museum.

Keith Vaughan 1912–1977

Born in Selsey Bill, Sussex, Vaughn worked for the Unilever advertising agency, Lintas, until 1939, and served in the Pioneer Corps when war broke out. From 1941–6, he was a German interpreter in a

Prisoner of War camp in Yorkshire, when he began exhibiting his drawings and paintings. He later taught at the Camberwell School of Art, the Central School, and from 1954, as a visiting teacher at the Slade School. He exhibited widely including Whitechapel Art Gallery (1950, 1958 and 1962), the Festival organised by the Arts Council of Great Britain (1951), Royal Scottish Academy (1951), Tate Gallery (1953 and 1958), British Council touring exhibition in Australia (1958), British Art touring exhibition in China (1963). Publications include *Penguin New Writing no.26* (1945) and *no.34* (1948), *British Works on Paper 1920–1970* (1989), *Modern British Paintings* (1997) and *The London Magazine* (1962). Collections include Tate.

Tony Walker 1906–1990, Belle Vue Studio

Belle Vue Studio was opened by Sandford Walker in 1926 at 118 Manningham Lane, Bradford, where it continued to operate as a daylight studio until closure in 1975. Tony Walker joined Belle Vue in 1946, after working in the photographic trade as a door-to-door canvasser in the 1920s, and joining Will Johnson, a photographer specialising in hand colouring and retouching, in 1927. Employed at Belle Vue from c.1948, he bought the business following Taylor's death in 1953. Using a 1900 Thornton Pickard camera, Walker photographed many of the immigrant groups living and working in Bradford in the 1950s, 60s and 70s. Soon, subjects came from a wide surrounding area, as he utilised retouching skills to lighten skin tones, at his customers' request and adopted props, backgrounds and poses in collaboration with his sitters. In 1975, Walker closed Belle Vue, retiring to nurse his wife through serious illness. Many thousands of glass negatives were destroyed, and the remaining plates were stored in a cellar for over ten years. When photographer Simon Walker took over the business, he donated 150,000 glass negatives from the 1950s, 60s and 70s to the Bradford Heritage Recording Unit, and they are now conserved by the Industrial Museum in Bradford. Photographs by and interviews with Tony Walker and some of the Belle Vue portrait sitters are included in *Here to Stay: Bradford's South Asian Communities* (1994).

Agnes Warburg 1872–1953

Warburg became a member of The Royal Photographic Society in 1916 and received her Fellowship in 1939. Between 1900 and 1909, she exhibited regularly with the Linked Ring Brotherhood. In 1927, she co-founded the Royal Photographic Society Colour Group. Following the advent of the autochrome process, she experimented with new colour processes, and devised her own 'Warburytype'. Keen to further both the art and science of colour photography, she was noted for combining pictorial principles with technical proficiency. Warburg considered landscape the perfect subject for three-colour photography, providing as it did 'baffling [problems] to satisfy the most ardent worker'. Collections include The Royal Photographic Society Collection at the National Media Museum, Bradford.

Walter D. Welford

Welford operated his first studio, The Woodbine Studio, at 43 Hagley Road (1884–7), and later at 47 Hagley Road (1888–94), Birmingham. Publications include *The Photographer's Indispensable Handbook* (1887), *The Hand Camera Manual* (1893) and *The Hand Camera and How to Use It* (1899). He also wrote and directed *Repairing a Puncture* (1897) and *The Writing on the Wall* (1897). Collections include Guildhall Library.

Dorothy Frances Edith Wilding 1893–1976

After a short apprenticeship as a retoucher with Ernest Chandler Wilding, Wilding opened her first studio in 1914. Building on her success, she moved to a top-floor studio at 264 Regent Street in 1918, employing seven members of staff. At the peak of career, she was employing a staff of forty. Posterity was guaranteed by a series of royal sittings beginning in 1928 with the Duke and Duchess of Kent and leading to the official Coronation portraits of George VI (1937) and Queen Elizabeth II (1952). Wilding opened a second studio in New York (1937). Her Bond Street studio was bombed in the Blitz in 1940, destroying almost nearly all of the early negatives, prints and records. Her autobiography *In Pursuit of Perfection* was published in 1958. In 1991, the National Portrait Gallery, London showed her work with an accompanying monograph. Collections include The Royal Photographic Society Collection at the National Media Museum, Bradford; The Rothschild Archive, London and National Portrait Gallery, London.

Geoffrey N. Wright 1925–1994

Born in West Hartlepool, Wright was an English teacher in a secondary modern school in Bradford-Upon-Avon, Wiltshire, for twenty-six years. A writer and photographer, his publications include *Discovering Epitaphs* (1972), *The Yorkshire Dales* (1977), *View of Wessex* (1978), *Discovering Abbeys and Priories* (1985), *Aysgarth Falls* (1991) and *The Cotswolds* (1991). He gave guided walks in the National Park and lectured widely throughout the UK throughout his life. He was a founder member of the Yorkshire Dales Society. A large collection of his work is housed at the Hawes Country Museum, Yorkshire.

Tom Wood 1951–

Born in Mayo, Ireland. Wood studied painting at Leicester Polytechnic (1973–6), and has lived and worked in Liverpool since 1978. Solo exhibitions include International Center of Photography New York (1996); Modern Art Oxford (1998); Suermondt-Ludwig Museum, Aachen, Germany (2001) and Kunstverein Kassel, Germany (2002). Selected group shows include *Twenty Modern British Photographers*, Victoria and Albert Museum (1995); Centre National de la Photographie, Paris (2000); *The Sidewalk Never Ends*, Art Institute of Chicago (2001) and *Becks Futures*, Institute of Contemporary Arts, London (2002). Publications include *Looking for Love* (1989), *All Zones of Peak* (1998), *People* (1999), *Bus Odyssey* (2002) and *Photie Man* (2005). Collections include the International Center for Photography, New York; Museum of Modern Art, New York; Victoria and Albert Museum and the British Council Collection.

Madame Yevonde (Yevonde Middleton née Cumbers) 1893–1975

Yevonde began her career in 1911 with Edwardian portrait and society photographer Lallie Charles, and opened her first studio at 92 Victoria Street (1914) working as 'Madame Yevonde – Portrait Photographer'. In 1921, she began exhibiting her work at the Royal Photographic Society's Annual Exhibition. During the 1930s, she experimented with photographic techniques, experimenting with solarization and the Vivex tri-colour process. Her work was regularly published in *Sketch* and *Tatler*. In 1933, she moved to a new studio in Berkeley Square, and in 1935 produced a series of portraits *Godesses and Others* for which is now best known. In 1955, she moved her studio to Knightsbridge where she continued to work until her death. Her autobiography *In Camera* was published in 1940. Selected exhibitions include *Photography 1839–1937*, Museum of Modern Art, New York (1937); a group show of women photographers at the Royal Photographic Society (1958); *Some Distinguished Women* (1968) and a retrospective to celebrate her eightieth birthday at the Royal Photographic Society (1968). Posthumous exhibitions include *Fantasy and Myth*, National Portrait Gallery, London (1990) and a retrospective at The Photographers' Gallery (1998). Her work was included in *The Other Observers: Women's Photography in Britain*, National Museum of Photography, Film & Television, Bradford (now known as National Media Museum) (1986). Collections include the National Portrait Gallery, London, National Media Museum, Bradford and the British Council Collection.

List of Exhibited Works

224

FIRST MOVES: 1840–1900

Thomas Annan
The Old Closes and Streets of Glasgow 1868–71
Closed album 56 × 43 cm
Special Collections Department, Glasgow University Library

Anna Atkins
from *Algae: Cyanotype Impressions* 1843–54
Title page 'British and Foreign Flowering Plants and Ferns' 1854
Cyanotype print
34.9 × 24.9 cm
Victoria and Albert Museum, London

Anna Atkins
from *Algae: Cyanotype Impressions* 1843–54
Dandelion (Taraxacum officinale) 1854
Cyanotype print
34.8 × 24.5 cm
Victoria and Albert Museum, London

Thomas John Barnes
Barnardo Before and After Pictures c.1872
Albumen silver prints, cabinet cards
12 prints each 8.1 × 5.7 cm
Barnardo's Photographic Archive

Alexander Bassano
Queen Victoria 1882, published 1887
Albumen silver print, cabinet card
14 × 9.9 cm
National Portrait Gallery, London

Alexander Bassano
Queen Victoria and Prince Beatrice, April 1882
Albumen silver print, cabinet card
15 × 10.1 cm
National Portrait Gallery, London

Geoffrey Bevington and Sons
Neckinger Mills tanning and leather finishing factory 1861
Albumen silver print
36.8 × 41.6 cm
Victoria and Albert Museum, London

Geoffrey Bevington and Sons
Neckinger Mills tanning and leather finishing factory 1861
Albumen silver print
36.2 × 43 cm
Victoria and Albert Museum, London

Benjamin Brecknell Turner
Farmyard, Elfords, Hawkhurst 1852–4
Albumen silver print
26.5 × 36 cm
Victoria and Albert Museum, London

Benjamin Brecknell Turner
Bredicot, Worcestershire 1852–4
Albumen silver print
27 × 28.8 cm
Victoria and Albert Museum, London

Julia Margaret Cameron
Alfred, Lord Tennyson 1865
Albumen silver print
35.1 × 27.9 cm
National Media Museum, Bradford

Julia Margaret Cameron
The Mountain Nymph: Mrs Keene 1866
Albumen silver print
32.8 × 27.3 cm
National Media Museum, Bradford

Julia Margaret Cameron
My Favourite Picture of all my Works, My Niece Julia 1867
Albumen silver print
27.8 × 22.7 cm
National Media Museum, Bradford

Julia Margaret Cameron
Edward John Eyre 1867
Albumen silver print
34.2 × 25.7 cm
National Portrait Gallery, London

Julia Margaret Cameron
Thomas Carlyle, June 8, 1867 1867
Albumen silver print
35.1 × 27.9 cm
The Royal Photographic Society Collection at the National Media Museum, Bradford

Julia Margaret Cameron
The Wild Flower c.1868
Albumen silver print
29.3 × 24.4 cm
The Royal Photographic Society Collection at the National Media Museum, Bradford

Julia Margaret Cameron
Beatrice Cenci 1870
Carbon print
13.2 × 23.6 cm
National Media Museum, Bradford

Lewis Carroll (Charles Lutwidge Dodgson)
Ina Liddell holding a dog, seated, Summer 1858 1858
Albumen silver print
15 × 13 cm
National Media Museum/ National Portrait Gallery

Lewis Carroll (Charles Lutwidge Dodgson)
Edith, Ina and Alice Liddell on sofa, Summer 1858
Albumen silver print
15.7 × 17.4 cm
National Media Museum/ National Portrait Gallery

Lewis Carroll (Charles Lutwidge Dodgson)
Edith Liddell lying on a sofa, Summer 1858 1858
Albumen silver print
14.5 × 17.9 cm
National Media Museum/ National Portrait Gallery

Lewis Carroll (Charles Lutwidge Dodgson)
Xie, Herbert, Hugh and Brook Kitchin in 'St George and the Dragon' 1875
Albumen silver print
10.6 × 15 cm
Morris L. Parrish Collection, Department of Rare Books and Special Collections, Princeton Library

Lewis Carroll (Charles Lutwidge Dodgson)
Xie Kitchin as 'Penelope Boothby' 1876
Albumen silver print
15.3 × 12.4 cm
Morris L. Parrish Collection, Department of Rare Books and Special Collections, Princeton Library

Robert Thompson Crawshay
Turkish Bath c.1860
Cased ambrotype
Image 8.5 × 11 cm
Closed case 14 × 11.5 cm
Victoria and Albert Museum, London

Robert Thompson Crawshay
Turkish Bath c.1860
Cased ambrotype
Image 10.7 × 8.1 cm
Closed case 14 × 11.5 cm
Victoria and Albert Museum, London

Robert Thompson Crawshay
Turkish Bath c.1860
Cased ambrotype
Image 10.7 × 8.1 mm
Closed case 14 × 11.5 cm
Victoria and Albert Museum, London

George Davison
Portrait of a Fisherman c.1900
Gelatin silver print
21.4 × 18.7 cm
National Media Museum, Bradford

George Davison
Portrait of a Fisherman c.1900
Gelatin silver print
20.4 × 18.3 cm
National Media Museum, Bradford

Philip Henry Delamotte
The Great Exhibition 1851
Stereoscopic daguerreotype
6.8 × 6 cm
Victoria and Albert Museum, London

Philip Henry Delamotte
The Great Exhibition 1851
Stereoscopic daguerreotype
6.8 × 6 cm
Victoria and Albert Museum, London

Hugh Diamond
Photographs of Psychiatric Patients, plates I and II 1850s
Albumen silver prints
18 prints, 2 plates each mounted 91 × 70 cm
Royal Society of Medicine

W & D Downey
'Four Generations' (King George V; Queen Victoria, King Edward VII, Edward Duke of Windsor) 1894
Sepia bromide postcard
12.2 × 8.2 cm
National Portrait Gallery, London

Draycott Photo
Alfred John and John Frederick Clarke May 1892
Gelatin silver print, cabinet card
17 × 11 cm
Theatre Collections, Victoria & Albert Museum. Hippesley Cox Archive

Peter Henry Emerson
Setting the Bow Net 1886
Platinum print
16.3 × 28.8 cm
The Royal Photographic Society Collection at the National Media Museum, Bradford

Peter Henry Emerson
An Eel-Catcher's Home 1886
Platinum print
20.5 × 29 cm
The Royal Photographic Society Collection at the National Media Museum, Bradford

Peter Henry Emerson
The Poacher: A Hare in View 1888
Photogravure
28.5 × 23.6 cm
The Royal Photographic Society Collection at the National Media Museum, Bradford

Peter Henry Emerson
In the Barley Harvest 1888
Photogravure
23.4 × 24.3 cm
The Royal Photographic Society Collection at the National Media Museum, Bradford

Engler, Dresden
Amalie Jee (Tottie): Wire walker and equestrienne c.1890
Gelatin silver print, cabinet card
17 × 11 cm
Theatre Collections, Victoria and Albert Museum. Hippesley Cox Archive

Roger Fenton
Self-Portrait as Souave c.1855
Salted paper print
15 × 17 cm
Wilson Centre for Photography

Roger Fenton
Odalisque, Orientalist Series c.1858
Albumen paper print
26.5 × 28.7 cm
Wilson Centre for Photography

Roger Fenton
Spoils of Wood and Stream c.1858
Albumen silver print
34.2 × 42.7 cm
The Royal Photographic Society Collection at the National Media Museum, Bradford

Roger Fenton
Fur and Feathers c.1859
Albumen silver print
34.2 × 42.7 cm
The Royal Photographic Society Collection at the National Media Museum, Bradford

Roger Fenton
Flowers and Fruit c.1860
Albumen silver print
35.3 × 42.9 cm
The Royal Photographic Society Collection at the National Media Museum, Bradford

Roger Fenton
A Vista, Furness Abbey 1860
Albumen silver print
28.1 × 26.2 cm
The Royal Photographic Society Collection at the National Media Museum, Bradford

William Henry Fox Talbot
The Woodcutters 1843
Salt print
15.2 × 21 cm
National Media Museum, Bradford

William Henry Fox Talbot
The Open Door 1844
Salt print
14.3 × 19.3 cm
National Media Museum, Bradford

William Henry Fox Talbot
Nelson's Column under Construction c.1845
Salt print
21 × 16.9 cm
National Media Museum, Bradford

William Henry Fox Talbot
The Ladder 1845
Salt print
17 × 18.3 cm
National Media Museum, Bradford

Francis Frith
Windermere c.1865
Albumen silver print
14 × 20.2 cm
Victoria and Albert Museum, London. Given by F. Frith & Co., Ltd, 1954

Francis Frith
Mulgrave Woods, Yorkshire c.1865
Albumen silver print
15.7 × 21.5 cm
Victoria and Albert Museum, London. Given by F. Frith & Co., Ltd, 1955

Francis Frith
Bristol c.1865
Albumen silver print
17 × 21.5 cm
Victoria and Albert Museum, London. Given by F. Frith & Co., Ltd, 1957

Francis Frith
Tintern Abbey c.1865
Albumen silver print
17 × 21.5 cm
Victoria and Albert Museum, London. Given by F. Frith & Co., Ltd, 1957

Francis Frith
Stonehenge c.1865
Albumen silver print
26.5 × 33 cm
Victoria and Albert Museum, London. Given by F. Frith & Co., Ltd, 1956

Francis Frith
Rochester c.1865
Albumen silver print
15.5 × 20.5 cm
Victoria and Albert Museum, London. Given by F. Frith & Co., Ltd, 1958

Francis Frith
Cheltenham, Royal Crescent c.1865
Albumen silver print
17 × 21.9 cm
Victoria and Albert Museum, London. Given by F. Frith & Co., Ltd, 1959

Francis Frith
Mount Snowdon c.1865
Albumen silver print
20.7 × 15.7 cm
Victoria and Albert Museum, London. Given by F. Frith & Co., Ltd, 1960

Francis Frith
Canterbury Cathedral c.1865
Albumen silver print
18.6 × 22.2 cm
Victoria and Albert Museum, London. Given by F. Frith & Co., Ltd, 1961

Kate Gough
Album open at *Royal Ducks* c.1870
Collage, mixed media
12.3 × 16.5 cm
Victoria and Albert Museum, London

Stuart of Richmond, printed by Rotary Photographic Co
Queen Victoria June 1897
Sepia bromide postcard
12.4 × 8.1 cm
National Portrait Gallery, London

David Octavius Hill
Robert Adamson
The Gowan (also titled 'The Daisy') c.1840
Salted paper print
20.8 × 15.7 cm
Wilson Centre for Photography

David Octavius Hill
Robert Adamson
Five Newhaven Fisherwomen c.1844
Salted paper print
15.4 × 20.5 cm
Wilson Centre for Photography

David Octavius Hill
Robert Adamson
Newhaven Fishwife 1845
Salted paper print
19.1 × 13.8 cm
Wilson Centre for Photography

David Octavius Hill
Robert Adamson
Lady Ruthven c.1855
Carbon print
20 × 14.2 cm
Wilson Centre for Photography

Robert Howlett
The Great Eastern under Construction 1857
Albumen silver print
28.7 × 36 cm
Victoria and Albert Museum, London

Robert Howlett
Group beside stern of the Great Eastern 1857
Albumen silver print
27.7 × 35.8 cm
Victoria and Albert Museum, London

Robert Howlett
View of paddle, Great Eastern 1857
Albumen silver print
27.7 × 36.2 cm
Victoria and Albert Museum, London

Robert Howlett
The Great Eastern 1857
Albumen silver print
28.7 × 36 cm
Victoria and Albert Museum, London

Robert Howlett
Isambard Kingdom Brunel 1857
Albumen *carte-de-visite*
8.7 × 5.5 cm
National Portrait Gallery, London

Sir Henry James
Plans and photographs of Stonehenge and of Turusachan in the island of Lewis with notes relating to the druids and Sketches of Cromlechs in Ireland by Colonel Sir Henry James 1867
Albumen prints
Image 17.3 × 23.6 cm
Closed album 35 × 27.2 cm
Guildhall Library, City of London

Karoly, Birmingham
Amalie Jee (Tottie): Wire walker and equestrienne c.1890
Gelatin silver print, cabinet card
17 × 11 cm
Theatre Collections, Victoria and Albert Museum. Hippesley Cox Archive

William Edward Kilburn
Hand-tinted portrait of a woman c.1850
Daguerreotype
9.2 × 6.7 cm
Victoria and Albert Museum, London

William Edward Kilburn
Hand-tinted portrait of a woman c.1850
Daguerreotype
9.2 × 6.7 cm
Victoria and Albert Museum, London

Lafayette
Baron de Meyer dressed in costume inspired by a painting for the Devonshire House Ball 1897
Contact print on gold-toned printing out paper
35.4 × 27.8 cm
National Portrait Gallery, London

Lafayette
Lady Wolverton dressed as Britannia for the Devonshire House Ball 1897
Contact print on gold-toned printing out paper
35.4 × 27.8 cm
National Portrait Gallery, London

Lafayette
King Edward VII dressed in costume of the Grand Prior of the Order of St John of Jerusalem for the Devonshire House Ball 1897
Contact print on gold-toned printing out paper
35.3 × 27.9 cm
National Portrait Gallery, London

Lafayette
Mary Teresa ('Daisy') (Cornwallis-West), Princess of Pless dressed as Cleopatra for the Devonshire House Ball 1897
Contact print on gold-toned printing out paper
35.4 × 27.8 cm
National Portrait Gallery, London

Lafayette
Queen Victoria, 12 April 1900
Albumen cabinet card
15.1 × 10.2 cm
National Portrait Gallery, London

L Langois
Huline Brothers c.1890
Albumen silver print, cabinet card
38.1 × 53.3 cm
Theatre Collections, Victoria and Albert Museum. Hippesley Cox Archive

L Langois
Huline Brothers c.1890
Albumen silver print, cabinet card
53.3 × 38.1 cm
Theatre Collections, Victoria and Albert Museum. Hippesley Cox Archive

Richard Cockle Lucas
Richard Cockle Lucas as a Hopeful Lover; Richard Cockle Lucas as a Disappointed One c.1858
Two albumen *cartes-de-visite* in album
Each 9.2 × 6.1 cm
National Portrait Gallery, London

Paul Martin
Beaching at Yarmouth c.1892–5
Platinum print
7.5 × 10 cm
Victoria and Albert Museum, London

Paul Martin
Album open at *Punch and Judy at Ilfracombe* c.1892–5
Platinum print
Image 6.8 × 10 cm
Closed album approx 12 × 15 cm
Victoria and Albert Museum, London

Paul Martin
On Yarmouth Sands c.1892–5
Platinum print
7.5 × 10 cm
Victoria and Albert Museum, London

Paul Martin
Album open at *Bathing at Jersey* c.1892–5
Platinum print
Image 6.8 × 10 cm
Closed album approx. 12 × 15 cm
Victoria and Albert Museum, London

John Jabez Edwin Mayall
Queen Victoria; Prince Albert of Saxe-Coburg-Gotha 15 May 1860
Albumen silver print, *carte-de-visite*
8.4 × 5.5 cm
National Portrait Gallery, London. Given by W.M. Campbell Smyth, 1935

John Jabez Edwin Mayall
Prince Albert of Saxe-Coburg-Gotha; Queen Victoria 15 May 1860
Albumen, *carte-de-visite*
8.6 × 5.7 cm
National Portrait Gallery, London

John Jabez Edwin Mayall
Queen Victoria; Prince Albert of Saxe-Coburg-Gotha 1 March 1861
Albumen silver print, *carte-de-visite*
8.4 × 5.5 cm
National Portrait Gallery, London. Given by Sir Geoffrey Langdon Keynes, 1958

From the collection of Arthur J Munby
Digital scans from albumen *cartes-de-visite* and *cartes-de-visite*, shown on plasma screen
The Master and Fellows, Trinity College, Cambridge
from Album 1: Pit Bow Girls
Wigan
Robert Little/Mrs Robert Little, Wigan
Pit Bow Girl, 1867
Louisa Millard, Wigan
Title unknown
from Album 2: Pit Bow Girls
Wigan
Robert Little/Mrs Robert Little, Wigan

Title unknown
Robert Little/Mrs Robert Little, Wigan
Female Collier from Rose Bridge Pits Height c.5 feet 9 taken 10 August 1869
John Cooper, Wigan
Title unknown
Louisa Millard, Wigan
Title unknown
from Album 4: Hannah Cullwick
Fink, Oxford Street, London
Title unknown
Fink, Oxford Street, London
Title unknown
Fink, Oxford Street, London
Hannah wearing Men's Clothes, 1860
James Stodart, Margate
Hannah, 1864
James Stodart, Margate
Title unknown
James Stodart, Margate
Hannah 'in her dirt' as a maid-of-all-work, 1864
James Stodart, Margate
Title unknown
H Howle, Newport, Salop
Title unknown
H Howle, Newport, Salop
Title unknown
H Howle, Newport Salop
Title unknown
W Usherwood
Title unknown
Photographer and title unknown
from Album 5
McLean and Haes, Haymarket, London
Milkwoman, from Sim's Dairy, Jermyn Street. English: unmarried: aged about twenty seven. Taken 4 June 1864
Chamberlaine, Marylebone, London
'Young Mary,' one of Wm. Stoat's milkmaids at the Alderney Farm Dairy. Jan. 1872
Chamberlaine, Marylebone, London
Joanna, one of W. Stoat's Women: Alderney Dairy, 2 Upper Gloucester Place, N., 1872.
Chamberlaine, Marylebone, London
Mary, one of W. Stoat's Women: Alderney Dairy, 2 Upper Gloucester Place, N., 1872.
Chamberlaine, Marylebone, London
Joanna, one of W. Stoat's Women: Alderney Dairy, 2 Upper Gloucester Place, N., 1872.
Chamberlaine, Marylebone, London
One of W. Stoat's Women: Alderney Dairy, 2 Upper Gloucester Place, N., 1872. Welsh

Ornate gold locket c.1850
Mixed media
5.5 × 5.5 cm
National Media Museum, Bradford

Pendant c.1850
Mixed media
9.5 × 5.5 cm
National Media Museum, Bradford

Photographer unknown
*Casebook of London boys from the Ragged School Union admitted to a collecting centre for assisted emigrants to Canada c.*1860
Mainly salt paper prints
Image 14.5 × 11.9 cm
Closed album 27.5 × 22 cm
Guildhall Library, City of London

Photographer unknown
Alfred John and John Frederick Clarke 1892
Gelatin silver print, cabinet card
17 × 11 cm
Theatre Collections, Victoria & Albert Museum. Hippesley Cox Archive

W.W. Stephens
*Huline Brothers c.*1890
Albumen silver print, cabinet card
53.3 × 38.1 cm
Theatre Collections, Victoria and Albert Museum. Hippesley Cox Archive

Frank Meadow Sutcliffe
*Fish sellers c.*1900
Gelatin silver print
8 × 8 cm
National Media Museum, Bradford

Frank Meadow Sutcliffe
*Beach entertainment c.*1900
Gelatin silver print
7.8 × 8 cm
National Media Museum, Bradford

Frank Meadow Sutcliffe
*Children on beach c.*1900
Gelatin silver print
9.2 × 11.8 cm
National Media Museum, Bradford

Frank Meadow Sutcliffe
*Families on beach c.*1900
Gelatin silver print
9.2 × 11.8 cm
National Media Museum, Bradford

John Thomas
*Two women in Welsh national costume drinking tea c.*1875
Modern black and white print from original negative
59 × 49 cm
By permission of Llyfrgell Genedlaethol Cymru / The National Library of Wales

John Thomas
*A Welsh woman in national costume with spinning wheel c.*1875
Modern black and white print from original negative
59 × 49 cm
By permission of Llyfrgell Genedlaethol Cymru / The National Library of Wales

John Thomas
*A woman knitting in Welsh national dress c.*1875
Modern black and white print from original negative
59 × 40 cm
By permission of Llyfrgell Genedlaethol Cymru / The National Library of Wales

John Thomas
*Mary Parry, Llanfechell, wearing Welsh national dress and carrying a basket c.*1875
Modern black and white print from original negative
59 × 44 cm
By permission of Llyfrgell Genedlaethol Cymru / The National Library of Wales

John Thomson
from Street Life in London
Recruiting Sergeants at Westminster 1877
Woodburytype
11.3 × 9 cm
The Royal Photographic Society Collection at the National Media Museum, Bradford

John Thomson
from Street Life in London
Public Disinfectors 1877
Woodburytype
11.1 × 9 cm
The Royal Photographic Society Collection at the National Media Museum, Bradford

John Thomson
from Street Life in London
Covent Garden Flower Women 1877
Woodburytype
11.1 × 9 cm
The Royal Photographic Society Collection at the National Media Museum, Bradford

John Thomson
from Street Life in London
London Cabmen 1877
Woodburytype
11.4 × 8.8 cm
The Royal Photographic Society Collection at the National Media Museum, Bradford

John Thomson
Street Life in London, open at *Crawlers* 1877
Woodburytypes
Image 11.5 × 87 cm
Closed album 28 × 23 cm
Guildhall Library, City of London

Walter D Welford
[scenes at Elmwood and Haycroft Farms, Harlesden, Middlesex]
June 1888
Ye George, ye Marye, and ye Stanleye didde playe alle ye hyde and seeke rounde ye haystacke 1888
Albumen print
Image 15.4 × 20.4 cm
Page 19 × 24.3 cm
Guildhall Library, City of London

Christina Broom
Suffragette procession, London 1909
Modern gelatin silver print from original negative
25.4 × 30.5 cm
Museum of London

Christina Broom
Christabel Pankhurst at the International Suffragette Fair, Chelsea 1912
Modern gelatin silver print from original negative
25.4 × 30.5 cm
Museum of London

Richard Brown, published by Philco Publishing Co
Hettie King postmarked 1907
Bromide postcard print
13.7 × 8.6 cm
Private Collection, Surrey

Brown, Barnes and Bell, Liverpool, published by Rotary Photo Co
*Vesta Tilley c.*1906
Bromide postcard print
13.8 × 8.8 cm
Private Collection, Surrey

Brown, Barnes and Bell, Liverpool, published by Rotary Photo Co
*Vesta Tilley c.*1912
Bromide postcard print
13.2 × 8.6 cm
Private Collection, Surrey

Alvin Langdon Coburn
Leicester Square 1909
Photogravure
20 × 15.6 cm
The Royal Photographic Society Collection at the National Media Museum, Bradford

Alvin Langdon Coburn
Thames Embankment by Night 1909
Photogravure
16.9 × 16.2 cm
The Royal Photographic Society Collection at the National Media Museum, Bradford

Alvin Langdon Coburn
Trafalgar Square 1909
Photogravure
21 × 16 cm
The Royal Photographic Society Collection at the National Media Museum, Bradford

Lena Connell
Charlotte Despard 1912
Sepia-matt postcard print
13.2 × 8.3 cm
National Portrait Gallery, London

Lena Connell
Edith Craig 1912
Sepia-matt postcard print
13.5 × 8.3 cm
National Portrait Gallery, London

Lena Connell
Cicely Hamilton 1912
Matt gelatin silver print
13.5 × 8.3 cm
National Portrait Gallery, London

Surveillance Photograph issued by Criminal Record Office
Photograph of Known Militant Suffragettes 1912
Bromide print
38.1 × 30.5 cm
National Portrait Gallery, London

Surveillance Photograph issued by Criminal Record Office
Photograph of Known Militant Suffragettes 1912
Bromide print
17.4 × 21 cm
National Portrait Gallery, London

Davey Photo, published by Raphael Tuck & Sons
Mr Dan Leno. Undated
Bromide postcard print
13.8 × 8.8 cm
Private Collection, Surrey

The Draycott Galleries, published by Philco Publishing Co
*Vesta Tilley c.*1912
Bromide postcard print
19.8 × 8.8 cm
Private Collection, Surrey

Oxley Grabham
*Net showing packets for sparrows c.*1910
Gelatin silver print
9.8 × 7.3 cm
The Royal Photographic Society Collection at the National Media Museum, Bradford

Oxley Grabham
*Dancing Bear c.*1910
Gelatin silver print
7.3 × 9.7 cm
The Royal Photographic Society Collection at the National Media Museum, Bradford

Oxley Grabham
*White Whale shot in the river near York c.*1910
Gelatin silver print
7.3 × 9.5 cm
The Royal Photographic Society Collection at the National Media Museum, Bradford

Oxley Grabham
Scarecrow circa 1910
Gelatin silver print
9.5 × 7.3 cm
The Royal Photographic Society Collection at the National Media Museum, Bradford

Hana published by Rotary Photo Co
*Dan Leno as Idle Jack in the 1894 production of Dick Whittington c.*1900
Bromide postcard print
13.4 × 8.6 cm
Private Collection, Surrey

Charles Jones
*Onion Brown Globe c.*1905
Gold-toned gelatin silver print
48.5 × 35.5 cm
Sexton Collection, London in conjunction with Thames & Hudson

Charles Jones
*Celery Standard Bearer c.*1905
Gold-toned gelatin silver print
54 × 41 cm
Sexton Collection, London in conjunction with Thames & Hudson

Charles Jones
*Vegetable Marrow Long White c.*1905
Gold-toned gelatin silver print
54 × 41 cm
Sexton Collection, London in conjunction with Thames & Hudson

Charles Jones
*Bean Runner c.*1905
Gold-toned gelatin silver print
54 × 41 cm
Sexton Collection, London in conjunction with Thames & Hudson

Charles Jones
*Carrot Long Red c.*1905
Gold-toned gelatin silver print
54 × 41 cm
Sexton Collection, London in conjunction with Thames & Hudson

Charles Jones
*Potato Midlothian Early c.*1910
Gold-toned gelatin silver print
54 × 41 cm
Sexton Collection, London in conjunction with Thames & Hudson

Charles Jones
*Vegetable and Fruit Photographs open at Pear c.*1910
Gelatin silver prints
Closed album 28.3 × 39.1 cm
Victoria and Albert Museum, London

Langier, Glasgow
Dan Leno. Undated
Bromide postcard print
13.6 × 8.8 cm
Private Collection, Surrey

Otto Pfenninger
Women and Child in Boat
August 1905
Three colour carbon print (encased in glass)
5.9 × 8.4 cm
The Royal Photographic Society Collection at the National Media Museum, Bradford

Otto Pfenninger
Mother and Children Paddling
16 June 1906
Three colour carbon print (encased in glass)
6.3 × 8 cm
The Royal Photographic Society Collection at the National Media Museum, Bradford

Otto Pfenninger
Figures and nude body with supports of pier in distance August 1906
Three colour carbon print (encased in glass)
6.3 × 8.5 cm
The Royal Photographic Society Collection at the National Media Museum, Bradford

Otto Pfenninger
Figures around a boat August 1906
Three colour carbon print
(encased in glass)
13.3 × 17.5 cm
The Royal Photographic Society
Collection at the National Media
Museum, Bradford

Photographer unknown, British
Red Cross
*Legless Servicemen at Queen Mary's
Hospital, Roehampton* 1918
Modern gelatin silver print from
original negative
30.5 × 40.6 cm
Imperial War Museum, London

Photographer unknown,
British Red Cross
*Legless Servicemen fitted with
artificial limbs at Queen Mary's
Hospital, Roehampton* 1918
Modern gelatin silver print from
original negative
30.5 × 40.6 cm
Imperial War Museum, London

Photographer unknown,
published by Rotary Photo Co
Miss Hettie King postmarked 1905
Bromide postcard print
13.2 × 8.8 cm
Private Collection, Surrey

Photographer unknown,
published by Rotary Photo Co
Miss Hettie King c.1912
Bromide postcard print
14 × 8.7 cm
Private Collection, Surrey

Various postcards 1900–1918
Each 8.2 × 13.3 cm
Martin Parr

The Sassoon Family Album c.1900
Black and white photographs,
process unknown
Closed album 28 × 38 cm
Rothschild Archive, London

Norah Smyth
Mother and Child Clinic 1914
Bromide print
15.9 × 11.2 cm
Collection International Institute
of Social History, Amsterdam

Norah Smyth
*Nurse Hobbes and Malnourished
Child* 1914
Bromide print
12.5 × 17.5 cm
Collection International Institute
of Social History, Amsterdam

Norah Smyth
*Bromley Children, for the Women's
Dreadnought* 1914
Bromide print
12.1 × 17.2 cm
Collection International Institute
of Social History, Amsterdam

Norah Smyth
A Home in Bow 1914
Bromide print
10.8 × 1.5 cm
Collection International Institute
of Social History, Amsterdam

Norah Smyth
The Mothers Arms, the big nursery
1914
Bromide print
16.5 × 12.1 cm
Collection International Institute
of Social History, Amsterdam

Norah Smyth
In the Nursery 1915
Bromide print
16.5 × 12 cm
Collection International Institute
of Social History, Amsterdam

Norah Smyth
ELFS Toddlers Playing 1915
Bromide print
16.5 × 11.4 cm
Collection International Institute
of Social History, Amsterdam

Norah Smyth
ELFS Child Welfare 1915
Bromide print
15.9 × 11.4 cm
Collection International Institute
of Social History, Amsterdam

Norah Smyth
ELFS Toy Factory 1915
Bromide print
21.6 × 16.5 cm
Collection International Institute
of Social History, Amsterdam

Norah Smyth
*The Mothers Arms 438 Old Ford
Road Nursery* 1915
Bromide print
16.5 × 12.1 cm
Collection International Institute
of Social History, Amsterdam

Sir (John) Benjamin Stone
*'Horn Dance'. Abbot's Bromley.
Four of the Performers* 1899
Platinum print
24.3 × 19 cm
Birmingham Library & Archives
Services

Sir (John) Benjamin Stone
*'Horn Dance'. Abbot's Bromley.
The 'Fool' with caps and bells.
Staffordshire* 1899
Platinum print
24.3 × 19.1 cm
Birmingham Library & Archives
Services

Sir (John) Benjamin Stone
*The 'Horn Dance'. Abbot's Bromley.
'Robin Hood'. 'Hobby Horse' 11
September* 1899
Platinum print
24.3 × 19.3 cm
Birmingham Library & Archives
Services

Sir (John) Benjamin Stone
*The Harvest Home. 'Kern Baby' of
1901. Whalton, Northumberland*
1902
Platinum print
24.5 × 19.2 cm
Birmingham Library & Archives
Services

Sir (John) Benjamin Stone
*The Royal National Eisteddfod of
Wales* 1902
Platinum print
19.2 × 24.3 cm
Birmingham Library & Archives
Services

Sir (John) Benjamin Stone
*Ancient Chain Armour belonging to
the City of Lichfield being displayed
at the Court of Assaye* 1903
Platinum print
19 × 24.4 cm
Birmingham Library & Archives
Services

Sir (John) Benjamin Stone
*The Sherborne Pageant. An English
Chieftain Tribesmen and Families.*
1905
Platinum print
19.3 × 24.5 cm
Birmingham Library & Archives
Services

Agnes Warburg
Brighter, London date unknown
Three colour carbro print
18.2 × 23.3 cm
The Royal Photographic Society
Collection at the National Media
Museum, Bradford

Agnes Warburg
*Mayfield roofs from the middle
house garden* date unknown
Three colour carbro print
22.6 × 17.8 cm
The Royal Photographic Society
Collection at the National Media
Museum, Bradford

Agnes Warburg
Berkshire Cottages date unknown
Three colour carbro
14.1 × 18.2 cm
The Royal Photographic Society
Collection at the National Media
Museum, Bradford

NEW FREEDOMS IN
PHOTOGRAPHY:
1918–1945

Cecil Beaton
Edith Sitwell 1928
Gelatin silver print
23.5 × 19.2 cm
Courtesy of the Cecil Beaton
Studio Archive at Sotheby's

Cecil Beaton
Nancy Cunard 1929
Gelatin silver print
24 × 21 cm
Courtesy of the Cecil Beaton
Studio Archive at Sotheby's

Cecil Beaton
Bomb Damage 1940–1
Gelatin silver print
20 × 19.4 cm
Courtesy of the Cecil Beaton
Studio Archive at Sotheby's

Cecil Beaton
*Gallery of Church of St Vedast
Foster* 1940–1
Gelatin silver print
26.2 × 24.5 cm
Courtesy of the Cecil Beaton
Studio Archive at Sotheby's

Cecil Beaton
Bombed Church, St Lawrence
1940–1
Gelatin silver print
26.5 × 25 cm
Courtesy of the Cecil Beaton
Studio Archive at Sotheby's

Cecil Beaton
*The Western Campanili of St Paul's
Cathedral seen through a Victorian
Shop Front* 1940–1
Gelatin silver print
20.4 × 19.5 cm
Courtesy of the Cecil Beaton
Studio Archive at Sotheby's

Vanessa Bell
*Roger Fry, Duncan Grant and Boris
Anrep outside walled garden at
Charleston* 1924
Gelatin silver print
8.9 × 10.2 cm
Courtesy Tate Archive

Vanessa Bell
*Francis Partridge, Bell brothers,
Beatrice Mayer, Raymond in the
garden at Charleston* 1928
Gelatin silver print
8.9 × 10.2 cm
Courtesy Tate Archive

Vanessa Bell
*Summer School 'A Midsummer
Nights Dream'* 1928
Gelatin silver print
8.9 × 10.2 cm
Courtesy Tate Archive

Vanessa Bell
Eve Younger at Charleston 1930
Gelatin silver print
8.9 × 10.2 cm
Courtesy Tate Archive

Vanessa Bell
Angelica Bell at Charleston c.1931
Gelatin silver print
8.9 × 10.2 cm
Courtesy Tate Archive

Vanessa Bell
*Julian, Quentin and Roger Fry with
two of Quentin's statues* 1931
Gelatin silver print
8.9 × 10.2 cm
Courtesy Tate Archive
Vanessa Bell
*Frederick Ashton in the garden
at Charleston* 1932
Gelatin silver print
8.9 × 10.2 cm
Courtesy Tate Archive

Bill Brandt
Album c.1930
Closed album 21.5 × 31.5 cm
Victoria and Albert Museum,
London

Bill Brandt
London Pub c.1930
Gelatin silver print
21.6 × 18 cm
Archive of Modern Conflict

Bill Brandt
Billingsgate Fish Porter 1930
Gelatin silver print
20.7 × 15.2 cm
Archive of Modern Conflict

Bill Brandt
West End 1934
Gelatin silver print
24.5 × 19.5 cm
Private Collection

Bill Brandt
The English At Home, BT Batsford
Ltd, London 1936
Closed book 24 × 19 cm
Private Collection, London

Bill Brandt
Buskers 3 December 1938
Gelatin silver print
24.8 × 19.3 cm
Archive of Modern Conflict

Bill Brandt
Buskers 3 December 1938
Gelatin silver print
25.1 × 19.2 cm
Archive of Modern Conflict

Captain Alfred George Buckham
Ariel view of Edinburgh c.1920
Gelatin silver print
45.8 × 37.8 cm
Scottish National Portrait Gallery,
Edinburgh

Captain Alfred George Buckham
The Heart of Empire c.1925
Gelatin silver print
45.5 × 37.7 cm
The Royal Photographic Society
Collection at the National Media
Museum, Bradford

Winifred Casson
Still Life c.1935
Solarised gelatin silver print
23.8 × 23.8 cm
Private Collection, London

George Garland
A Canadian Soldier 1942
Modern gelatin silver print from
original negative
40.6 × 50.8 cm
Private Collection, London

George Garland
Miss Budd 1942
Modern gelatin silver print from
original negative
40.6 × 50.8 cm
Private Collection, London

George Garland
Duchesne Child 1942
Modern gelatin silver print from
original negative
40.6 × 50.8 cm
Private Collection, London

George Garland
Baby Grieve c.1942
Modern gelatin silver print from
original negative
40.6 × 50.8 cm
Private Collection, London

Bert Hardy
Picture Post: Fire-Fighters, Vol. 10.
No. 5, 1 February 1941
Closed magazine 35 × 26 cm
National Media Museum,
Bradford

Bert Hardy
Picture Post: A Trawler in War-Time
Vol. 14. No. 12, 21 March 1942
Closed magazine 35 × 26 cm
National Media Museum,
Bradford

Bert Hardy
Picture Post: Wartime Terminus,
Vol. 15. No. 8, 23 May 1942
Closed magazine 35 × 26 cm
National Media Museum,
Bradford

John Havinden
John Havinden 1930
Bromide print
25.4 × 20.3 cm
National Portrait Gallery, London

Percy Hennell
Probable shotgun wound of left eye which has been lost. Tissue has been replaced by a flap of skin from forehead or scalp, hence the bandage around the head where the flap was raised. Undated
Colour print from three negatives exposed synchronously in a one-shot camera incorporating trichromatic filters
19 × 14 cm
Antony Wallace Archive, British Association of Plastic, Reconstructive and Aesthetic Surgery

Percy Hennell
Right forehead shows scarring and deformity the patient has had a craniotomy and was left with a significant depression which has been reconstructed with a flap. Undated
Colour print from three negatives exposed synchronously in a one-shot camera incorporating trichromatic filters
19.3 × 15 cm
Antony Wallace Archive, British Association of Plastic, Reconstructive and Aesthetic Surgery

Percy Hennell
Probable healed burns leaving scarring of the face. Scarring has caused an ectropian of the left lower eyelid needing skin graft. Undated
Colour print from three negatives exposed synchronously in a one-shot camera incorporating trichromatic filters
25 × 19 cm
Antony Wallace Archive, British Association of Plastic, Reconstructive and Aesthetic Surgery

Percy Hennell
Healed wounds of the face, nasal deformity. Undated
Colour print from three negatives exposed synchronously in a one-shot camera incorporating trichromatic filters
16.5 × 21.4 cm
Antony Wallace Archive, British Association of Plastic, Reconstructive and Aesthetic Surgery

Percy Hennell
Shrapnel or bomb blast left side of the face and forehead. Undated
Colour print from three negatives exposed synchronously in a one-shot camera incorporating trichromatic filters
25 × 19 cm
Antony Wallace Archive, British Association of Plastic, Reconstructive and Aesthetic Surgery

Percy Hennell
Lower facial scarring from burns. 1942
Colour print from three negatives exposed synchronously in a one-shot camera incorporating trichromatic filters
25 × 19 cm
Antony Wallace Archive, British Association of Plastic, Reconstructive and Aesthetic Surgery

Percy Hennell
Airman involved in a fire on a plane. His face which was unprotected from helmet has partial thickness burns which are healing. 1943
Colour print from three negatives exposed synchronously in a one-shot camera incorporating trichromatic filters
19 × 14 cm
Antony Wallace Archive, British Association of Plastic, Reconstructive and Aesthetic Surgery

Percy Hennell
Probable gunshot wound of jaw. The patient has had skin flap repair and the jaw reconstructed and held in place with external pins and rods. 1943
Colour print from three negatives exposed synchronously in a one-shot camera incorporating trichromatic filters
25 × 19 cm
Antony Wallace Archive, British Association of Plastic, Reconstructive and Aesthetic Surgery

Percy Hennell
Subsidiary eyelashes. Scottish Nursing home. 1943
Colour print from three negatives exposed synchronously in a one-shot camera incorporating trichromatic filters
16 × 21.5 cm
Antony Wallace Archive, British Association of Plastic, Reconstructive and Aesthetic Surgery

Percy Hennell
Sustained burns of the face, some of which were full thickness. Reconstruction of the chin and the end of the nose. Skin grafting to the eyelids. 1943
Colour print from three negatives exposed synchronously in a one-shot camera incorporating trichromatic filters
25 × 19 cm
Antony Wallace Archive, British Association of Plastic, Reconstructive and Aesthetic Surgery

Percy Hennell
Probable old burn, skin flap to remove scarring of neck. 1943
Colour print from three negatives exposed synchronously in a one-shot camera incorporating trichromatic filters
25 × 19 cm
Antony Wallace Archive, British Association of Plastic, Reconstructive and Aesthetic Surgery

Percy Hennell
Wounds of the left forehead and temple and left eye. Loss of the left eye. 1943
Colour print from three negatives exposed synchronously in a one-shot camera incorporating trichromatic filters
25 × 19 cm
Antony Wallace Archive, British Association of Plastic, Reconstructive and Aesthetic Surgery

John Hinde
The control room of a civil defence centre 1944
Three colour carbro print
20.8 × 15.4 cm
The Royal Photographic Society Collection at the National Media Museum, Bradford

John Hinde
A member of the wardens service fitting a gas mask 1944
Three colour carbro print
20.8 × 15.5 cm
The Royal Photographic Society Collection at the National Media Museum, Bradford

John Hinde
A hostel for the bombed out, Scotland 1944
Three colour carbro print
20.7 × 15.6 cm
The Royal Photographic Society Collection at the National Media Museum, Bradford

John Hinde
A heavy rescue man 1944
Three colour carbro print
20.7 × 15.3 cm
The Royal Photographic Society Collection at the National Media Museum, Bradford

John Hinde
An evacuee arriving at her new temporary home 1944
Three colour carbro print
20.7 × 15.3 cm
The Royal Photographic Society Collection at the National Media Museum, Bradford

John Hinde
An ambulance attendant 1944
Three colour carbro print
20.8 × 15.2 cm
The Royal Photographic Society Collection at the National Media Museum, Bradford

John Hinde
A fire guard 1944
Three colour carbro print
20.8 × 15.2 cm
The Royal Photographic Society Collection at the National Media Museum, Bradford

John Hinde
A warden in the East End 1944
Three colour carbro print
20.7 × 15.4 cm
The Royal Photographic Society Collection at the National Media Museum, Bradford

John Hinde
Evacuees in the grounds of their hostel 1944
Three colour carbro print
20.8 × 15.4 cm
The Royal Photographic Society Collection at the National Media Museum, Bradford

John Hinde
WVS worker demonstrating how to build an emergency oven 1944
Three colour carbro print
20.3 × 15.4 cm
The Royal Photographic Society Collection at the National Media Museum, Bradford

Barbara Ker-Seymer and John Banting
Alix Strachey (née Sargant-Florence) 1930s
Bromide print
30 × 21.4 cm
National Portrait Gallery, London

Angus McBean
Frances Day 1938
Bromide print
29.3 × 24.2 cm
National Portrait Gallery, London

Edward McKnight-Kauffer
Camelia and Hand c.1935
Gelatin silver print
28.2 × 23.8 cm
Private Collection, London

Helen Muspratt
Eileen Agar c.1935
Gelatin silver print
21 × 16 cm
Private Collection, London

Photographer unknown
Kemsley House (C) Company 5th City of London Bn. Home Guard c.1940
Gelatin silver prints
6 prints, 2 mounts
each 26.5 × 33 cm
Guildhall Library, City of London

Peter Rose Pulham
Nude Study of Theodora Fitzgibbon 1942
Gelatin silver print
24.7 × 19.2 cm
Private Collection, London

Humphrey Spender
Jarrow Hunger Marchers November 1936
Gelatin silver print
16.3 × 23 cm
Estate of Humphrey Spender

Humphrey Spender
Jarrow Hunger Marchers 1936
Gelatin silver print
13.3 × 20.2 cm
Estate of Humphrey Spender

Humphrey Spender
Jarrow Hunger Marchers 1936
Gelatin silver print
16.5 × 23.5 cm
Estate of Humphrey Spender

Humphrey Spender
Jarrow Hunger Marchers November 1936
Gelatin silver print
16 × 24 cm
Estate of Humphrey Spender

Wolfgang Suschitzky
Charing Cross Road: Man looking in a Bookshop Window c.1936–7
Modern gelatin silver print from original negative
41.4 × 39.6 cm
Courtesy of the artist

Wolfgang Suschitzky
Charing Cross Road: Man having his shoes shined c.1936–7
Modern gelatin silver print from original negative
37.6 × 28.7 cm
Courtesy of the artist

Wolfgang Suschitzky
Charing Cross Road: Two men talking, Lyons Tea House c.1936–7
Modern gelatin silver print from original negative
36 × 29.6 cm
Courtesy of the artist

Wolfgang Suschitzky
Charing Cross Road: Man reading c.1936–7
Modern gelatin silver print from original negative
38.5 × 28 cm
Courtesy of the artist

Wolfgang Suschitzky
Charing Cross Road: Man outside pub c.1936–7
Modern gelatin silver print from original negative
37.8 × 27.7 cm
Courtesy of the artist

Edith Tudor-Hart
Children in Mining Village, Tyneside 1930s
Gelatin silver print
19.2 × 24.2 cm
National Media Museum, Bradford

Edith Tudor-Hart
Kensal House, Kindergarten 1930s
Gelatin silver print
30.2 × 24.9 cm
National Media Museum, Bradford

Edith Tudor-Hart
London Family 1930s
Gelatin silver print
19.6 × 24 cm
National Media Museum, Bradford

Edith Tudor-Hart
Gee Street, Finsbury 1936
Gelatin silver print
19.2 × 24.2 cm
National Media Museum, Bradford

Keith Vaughan
Dick's Book of Photos: Young Man 1939
Gelatin silver print
23.7 × 30.3 cm
University of Wales, Aberystwyth

Keith Vaughan
Dick's Book of Photos: Young Man 1939
Gelatin silver print
23.7 × 30.3 cm
University of Wales, Aberystwyth

Keith Vaughan
Dick's Book of Photos: Young Man 1939
Gelatin silver print
16.5 × 21.4 cm
University of Wales, Aberystwyth

Keith Vaughan
Dick's Book of Photos: Young Man 1939
Gelatin silver print
24.1 × 29.8 cm
University of Wales, Aberystwyth

Keith Vaughan
Dick's Book of Photos: Young Man
1939
Gelatin silver print
25.3 × 29.2 cm
University of Wales, Aberystwyth

Keith Vaughan
Dick's Book of Photos: Young Man
1939
Gelatin silver print
25.2 × 28.5 cm
University of Wales, Aberystwyth

Dorothy Wilding
Helen Wills Moody 1928
Chlorobromide silver print
28.7 × 20.6 cm
National Portrait Gallery, London

Dorothy Wilding
Pola Negri 1929
Chlorobromide print
22.9 × 16.5 cm
National Portrait Gallery, London.
Given by the photographer's
sister, Susan Morton, 1976

Dorothy Wilding
Florence Desmond 1930s
Chlorobromide silver print
29.2 × 20.5 cm
National Portrait Gallery, London

Dorothy Wilding
Gladys Cooper 1933
Cream-toned bromide print
27.6 × 19.2 cm
National Portrait Gallery, London.
Given by the photographer's
sister, Susan Morton, 1976

Dorothy Wilding
Diana Wynyard 1937
Chlorobromide print
43.3 × 33.3 cm
National Portrait Gallery, London.
Given by the photographer's
sister, Susan Morton, 1976

Madame Yevonde (Yevonde
Middleton)
*Lady Balcon Photographed as
'Minerva'* June 1935
Vivex colour print
34.2 × 27 cm
National Portrait Gallery, London.
Given by Madame Yevonde, 1971

Madame Yevonde (Yevonde
Middleton)
*Mrs Richard Hart-Davis
photographed as 'Ariel'* 1935
Vivex colour print
36.6 × 29.3 cm
National Portrait Gallery, London.
Given by Madame Yevonde, 1971

Madame Yevonde (Yevonde
Middleton)
*Mrs Donald Ross photographed as
'Europa'* 1935
Vivex colour print
37 × 25.1 cm
National Portrait Gallery, London.
Given by Madame Yevonde, 1971

Madame Yevonde (Yevonde
Middleton)
Mrs Edward Mayer as Medusa 1935
Vivex colour print
36.2 × 29.7 cm
The Royal Photographic Society
Collection at the National Media
Museum, Bradford

Madame Yevonde (Yevonde
Middleton)
The Machinist in Summer 1937
Dye transfer print
52.1 × 32.1 cm
The Royal Photographic Society
Collection at the National Media
Museum, Bradford

Madame Yevonde (Yevonde
Middleton)
Edwardian Girl, advertising shot
c.1938
Dye transfer print
43 × 31.8 cm
The Royal Photographic Society
Collection at the National Media
Museum, Bradford

Madame Yevonde (Yevonde
Middleton)
Still Life with Head of Nefertiti 1938
Dye transfer print
42.8 × 31.8 cm
The Royal Photographic Society
Collection at the National Media
Museum, Bradford

Madame Yevonde (Yevonde
Middleton)
*Advert for Christy's Lanolin
Cream* c.1939
Dye transfer print
42.7 × 31.9 cm
The Royal Photographic Society
Collection at the National Media
Museum, Bradford

Madame Yevonde (Yevonde
Middleton)
*Advert for Glyco-Thymoline
medicine* c.1939
Vivex colour print
42.8 × 31.8 cm
The Royal Photographic Society
Collection at the National Media
Museum, Bradford

Madame Yevonde (Yevonde
Middleton)
Self portrait with image of Hecate
1940
Dye transfer print
52.1 × 32.1 cm
The Royal Photographic Society
Collection at the National Media
Museum, Bradford

THE NEW BRITAIN: 1945–1969

Eve Arnold
Untitled c.1965
Fibre-based print
16.6 × 25 cm
Eve Arnold/Magnum Photos

David Bailey
A Box of Pin Ups 1965
36 gelatin silver prints
Each 36.9 × 32 cm
Martin Parr

Shirley Baker
Hulme, 1965 1965
C-type print
approx. 25.4 × 20.3 cm
Courtesy of the artist

Shirley Baker
Hulme, 1965 1965
C-type print
approx. 25.4 × 20.3 cm
Courtesy of the artist

Shirley Baker
Hulme, 1965 1965
C-type print
approx. 25.4 × 20.3 cm
Courtesy of the artist

Shirley Baker
Hulme, 1965 1965
C-type print
approx. 25.4 × 20.3 cm
Courtesy of the artist

Shirley Baker
Hulme, 1965 1965
C-type print
approx. 25.4 × 20.3 cm
Courtesy of the artist

Shirley Baker
Hulme, 1965 1965
C-type print
approx. 25.4 × 20.3 cm
Courtesy of the artist

Dorothy Bohm, Studio Alexander,
Manchester
Erica 1942
Gelatin silver print
25 × 20 cm
Dorothy Bohm Archive

Dorothy Bohm, Studio Alexander,
Manchester
A Manchester Girl 1947
Hand-tinted gelatin silver print
25.2 × 19.8 cm
Dorothy Bohm Archive

Dorothy Bohm, Studio Alexander,
Manchester
Igor 1947
Gelatin silver print
21 × 16 cm
Dorothy Bohm Archive

Dorothy Bohm, Studio Alexander,
Manchester
Girl with Pearl Necklace 1947
Gelatin silver print
21.2 × 16 cm
Dorothy Bohm Archive

Camerawork
*Lewisham: What are you taking
pictures for?* Publishing project
Half Moon Photography
Workshop, London November
1977
closed magazine 30.5 × 21.5 cm
Private Collection, London

Country Life
*Picture Book of the Lake District in
Colour,* Country Life Ltd London,
first published 1961
open at:
Elterwater Village Green by
Edward Bowness, Plate 8
Colour reproduction
Catbells and the Vale of Newlands
by Geoffrey N Wright, Plate 23
Colour reporoduction
Bowness on Windermere by
Kenneth Scowen, Plate 41
Colour reproduction
Four books, closed 29 x 24.2 cm
Private Collection, London

Euan Duff
How We Are c.1965
Layouts by Duff prepared during
the making of the *How We Are*
book
Bromide prints
Closed concertina approx.
27.4 × 18.2 cm
Mass Observation Archive at the
University of Sussex Library

Euan Duff
How We Are, Allen Lane The
Penguin Press, London 1971
Closed book 28 × 18.5 cm
Private Collection, London

Leonard Freed
Theatre Zoo, London c.1960
Gelatin silver print
38.2 × 25.9 cm
Leonard Freed/Magnum Photos

Bert Hardy
A Ghost Strayed from Old Greece
November–December 1948
Gelatin silver print
25.4 × 21 cm
On loan from the Cuming
Museum, London Borough of
Southwark, purchased with the
aid of a grant from the National
Art Collection Fund.

Bert Hardy
The Horse Dealers
November–December 1948
Gelatin silver print
25.4 × 21 cm
On loan from the Cuming
Museum, London Borough of
Southwark, purchased with the
aid of a grant from the National
Art Collection Fund and
MLA/V&A Purchase Grant fund.

Bert Hardy
At the Market
November–December 1948
Gelatin silver print
24 × 16 cm
On loan from the Cuming
Museum, London Borough of
Southwark, purchased with the
aid of a grant from the National
Art Collection Fund and
MLA/V&A Purchase Grant fund.

Bert Hardy
The Man who Dresses the Elephant
November–December 1948
Gelatin silver print
24 × 16 cm
On loan from the Cuming
Museum, London Borough of
Southwark, purchased with the
aid of a grant from the National
Art Collection Fund and
MLA/V&A Purchase Grant fund.

Bert Hardy
*Picture Post: Around the Elephant
and Castle, Cockney Life,* Vol. 42.
No. 2, 8 January 1949
Closed magazine 35 × 26 cm
National Media Museum, Bradford

Nigel Henderson
Wig Stall, Petticoat Lane 1952
Gelatin silver print
20.2 × 25.6 cm
Mayor Gallery, London

Nigel Henderson
Petticoat Lane Market 1952
Gelatin silver print
20.3 × 25.5 cm
Mayor Gallery, London

Nigel Henderson
Bag-wash 1949–53
Gelatin silver print
20.1 × 25.4 cm
Mayor Gallery, London

Nigel Henderson
*Heads seen through Pub Window,
East End* 1949–53
Gelatin silver print
21.2 × 25.4 cm
Mayor Gallery, London

Percy Hennell
British Women go to War, with text
by J.B.Priestley, Collins, London
Undated
Digital scans from book, shown
on plasma screen

Percy Hennell and Geoffrey
Grigson
An English Farmhouse, Max Parrish
& Co Ltd, London 1948
Closed book 23.5 × 17.5 cm

John Hinde
Baking tray with six baked apples
c.1945
Made during the production of
*The Small Canteen: How to Plan and
Operate a Modern Meals Service,*
Oxford University Press, 1947
Page proof (four colour block
proof)
13.5 × 18 cm
The Royal Photographic Society
Collection at the National Media
Museum, Bradford

John Hinde
*Pasty with potatoes and assorted
vegetables* c.1945
Made during the production of
*The Small Canteen: How to Plan and
Operate a Modern Meals Service,*
Oxford University Press, 1947
Page proof (four colour block
proof)
13.6 × 18 cm
The Royal Photographic Society
Collection at the National Media
Museum, Bradford

John Hinde
Pink blanc mange with fruit in bowl
c.1945
Made during the production of
*The Small Canteen: How to Plan and
Operate a Modern Meals Service,*
Oxford University Press, 1947
Page proof (four colour block
proof)
14 × 18 cm
The Royal Photographic Society
Collection at the National Media
Museum, Bradford

John Hinde
*Plate with fish surrounded with
vegetables* 1945
Made during the production of
*The Small Canteen: How to Plan and
Operate a Modern Meals Service,*
Oxford University Press, 1947
Page proof (four colour block
proof)
13.6 × 18 cm
The Royal Photographic Society
Collection at the National Media
Museum, Bradford

Eric Hosking
Barn Owl 1948
Gelatin silver prints
10 prints, each 25.4 × 20.3 cm
Eric Hosking Charitable Trust

W.G. Hoskins
The Making of the English Landscape, Hodder & Stoughton Ltd, London 1955
Closed book 22.5 × 18.2 cm
Private Collection, London

David Hurn
Hostess in a Men's Drinking Club, London 1965
Gelatin silver print
32.9 × 21.2 cm
David Hurn/Magnum Photos

Harry Jacobs
Harry Jacobs Studio, London
Anonymous portrait photograph mid 1960s–mid 1970s
Gelatin silver print
20.8 × 15.7 cm
London Borough of Lambeth, Archives Department

Harry Jacobs
Harry Jacobs Studio, London
Anonymous portrait photograph c.1970
Gelatin silver print
20.8 × 16 cm
London Borough of Lambeth, Archives Department

Harry Jacobs
Harry Jacobs Studio, London
Anonymous portrait photograph c.1970
Gelatin silver print
20.5 × 15.5 cm
London Borough of Lambeth, Archives Department

Harry Jacobs
Harry Jacobs Studio, London
Anonymous portrait photograph c.1970
Gelatin silver print
20.8 × 15.9 cm
London Borough of Lambeth, Archives Department

Sergio Larrain
London, Great Britain 1959
Fibre-based print
26.7 × 18 cm
Sergio Larrain/Magnum Photos

Roger Mayne
Southam Street 1957
Gelatin silver print
36 × 25.2 cm
Victoria and Albert Museum, London

230

Roger Mayne
Southam Street 1957
Gelatin silver print
36 × 27 cm
Victoria and Albert Museum, London

Roger Mayne
Southam Street 1957
Gelatin silver print
36 × 27.5 cm
Victoria and Albert Museum, London

Roger Mayne
Southam Street 1957
Gelatin silver print
36 × 27.2 cm
Victoria and Albert Museum, London

Roger Mayne
Southam Street 1957
Gelatin silver print
36 × 27.2 cm
Victoria and Albert Museum, London

Observer magazine
The Blacks: A Negro's frank report on the lives and thoughts of Britain's coloured people 10 January 1965
Closed 30.5 × 24.4 cm

Norman Parkinson
Wenda Rogerson, for British Vogue, *1950* 1950
Gelatin silver print
30.6 × 22.8 cm
Courtesy Eric Franck Fine Art

Norman Parkinson
Della Oake, for British Vogue, *1951* 1951
Gelatin silver print
37.4 × 29.3 cm
Courtesy Eric Franck Fine Art

Norman Parkinson
Wenda in a hand-knit cashmere twinset, the public bar, Hobnails Inn, Wasbourne 1951 1951
Gelatin silver print
37.7 × 28.8 cm
Courtesy Eric Franck Fine Art

Norman Parkinson
Scotland, for Vogue 1953 1953
Gelatin silver print
24.2 × 30.6 cm
Courtesy Eric Franck Fine Art

Norman Parkinson
Scotland, for Vogue 1953 1953
Gelatin silver print
31.2 × 24.5 cm
Courtesy Eric Franck Fine Art

Norman Parkinson
Royal Exchange from the Mansion House, for British Vogue, 1955 1955
Gelatin silver print
35.5 × 29.1 cm
Courtesy Eric Franck Fine Art

Charlie Phillips
Shy Dred 1963
Modern gelatin silver print scanned from the original vintage print
30 × 41 cm
Courtesy of the artist and Akehurst Creative Management

Charlie Phillips
Notting Hill Couple 1967
Modern gelatin silver print scanned from the original vintage print
30 × 41 cm
Courtesy of the artist and Akehurst Creative Management

Charlie Phillips
Outside the Piss House Pub, Portobello Road 1968
Modern gelatin silver print scanned from the original vintage print
30 × 41 cm
Courtesy of the artist and Akehurst Creative Management

Charlie Phillips
The Piss House Pub 1969
Modern gelatin silver print scanned from the original vintage print
30 × 41 cm
Courtesy of the artist and Akehurst Creative Management

Photographer unknown
Souvenir photographs from Butlins Hlliday Camp, Filey mid-1950s
5.1 × 7.6 cm
Private Collection, London

Photographer unknown
Floral Clock, New Brighton c.1955
Postcard
9 × 14 cm
Private Collection, London

Photographer unknown
Floral Clock, Edinburgh c.1955
Postcard
10.5 × 15 cm
Private Collection, London

Photographer unknown
Floral Clock, Bridlington c.1955
Postcard
9 × 14 cm
Private Collection, London

Photographer unknown
Collonades NS Blackpool by Night c.1955
Postcard made from a hand-tinted original print
9.1 × 14.2 cm
Private Collection, London

Photographer unknown
The Tower and Promenade, Blackpool Illuminations c.1955
Postcard made from a hand-tinted original print
8.9 × 13.6 cm
Private Collection, London

Photographer unknown
Illuminated Archway Promenade, Blackpool c.1955
Postcard made from a hand-tinted original print
9 × 14 cm
Private Collection, London

Photographer unknown
Galbot Square, Blackpool by Night c.1955
Postcard made from a hand-tinted original print
9.1 × 14 cm
Private Collection, London

Photographer unknown
Daily Herald Archive: Trevor Howard as Lieutenant Commander Hugh Frazer in The Gift Horse (Glory At Sea) 1951
Gelatin silver print
24.1 × 18.7 cm
National Media Museum, Bradford

Photographer unknown
Daily Herald Archive: Margaret Rutherford in The Importance of Being Earnest 1952
Gelatin silver print
24.2 × 18.9 cm
National Media Museum, Bradford

Photographer unknown
Daily Herald Archive: Frankie Howerd c.1955
Gelatin silver print
24 × 18.7 cm
National Media Museum, Bradford

Photographer unknown
Daily Herald Archive: Audrey Hepburn 1957
Gelatin silver print
23.8 × 19.3 cm
National Media Museum, Bradford

Photographer unknown
Daily Herald Archive: Dirk Bogarde leaves for Paris 30 November 1957
Gelatin silver print
9.9 × 11.2 cm
National Media Museum, Bradford

Photographer unknown
Daily Herald Archive: Bruce Forsyth 1958
Gelatin silver print
22 × 18.9 cm
National Media Museum, Bradford

Photographer unknown
Daily Herald Archive: Diana Dors 1958
Gelatin silver print
12.8 × 28.3 cm
National Media Museum, Bradford

Photographer unknown
Daily Herald Archive: Terry Thomas 1958
Gelatin silver print
26.7 × 20.2 cm
National Media Museum, Bradford

Photographer unknown
Daily Herald Archive: Kenneth More in We Joined the Navy 1960
Gelatin silver print
24 × 19.3 cm
National Media Museum, Bradford

Photographer unknown
Daily Herald Archive: Pat Phoenix 1961
Gelatin silver print
20.3 × 14.1 cm
National Media Museum, Bradford

Photographer unknown
Daily Herald Archive: Peter Sellers (The Goons are back) 1963
Gelatin silver print
21.2 × 27.5 cm
National Media Museum, Bradford

Photographer unknown
Daily Herald Archive: Hattie Jacques 1963
Gelatin silver print
24.4 × 18.8 cm
National Media Museum, Bradford

Photographer unknown
Daily Herald Archive: Barbara Windsor c.1965
Gelatin silver print
25.1 × 19.5 cm
National Media Museum, Bradford

Photographer unknown
Daily Herald Archive: Peter O'Toole as Lord Jim from the 1965 film of the same name
Gelatin silver print
25.3 × 20.5 cm
National Media Museum, Bradford

Photographer unknown
Daily Herald Archive: Rex Harrison and Samantha Eggar watching the World Cup Final 1966
Gelatin silver print
19.2 × 23.6 cm
National Media Museum, Bradford

Photographer unknown
Daily Herald Archive: Elizabeth Taylor and Richard Burton 1966
Gelatin silver print
18.9 × 24.1 cm
National Media Museum, Bradford

Photographer unknown
Daily Herald Archive: Darling Julie back from Hollywood 1966
Gelatin silver print
25.6 × 20.1 cm
National Media Museum, Bradford

Photographer unknown
Daily Herald Archive: Sean Connery and Maureen O'Hara 1967
Gelatin silver print
25.3 × 20.3 cm
National Media Museum, Bradford

Photographer unknown
Daily Herald Archive: Tommy Cooper and Ronnie Corbett 1969
Gelatin silver print
25.3 × 18.9 cm
National Media Museum, Bradford

Photographer unknown
Daily Herald Archive: Michael Caine and Geraldine Moffatt in Get Carter 1971
Gelatin silver print
28.6 × 19.7 cm
National Media Museum, Bradford

Photographer unknown
Good Housekeeping Colour Cookery, Ebury Press, London, 1967 and 1971
10 book plates
Closed book 24.5 × 19 cm
Private Collection, London

Walter Arthur Poucher
Untitled. Undated
Hand-coloured colour print
20 × 20.1 cm
The Royal Photographic Society Collection at the National Media Museum, Bradford

Walter Arthur Poucher
Torridon – Beine Eigha from Loch Conlin May 1977
C-type print
24.7 × 37.8 cm
The Royal Photographic Society Collection at the National Media Museum, Bradford

Tony Ray Jones
Glyndebourne 1967
Gelatin silver print
17.5 × 26.4 cm
National Media Museum, Bradford

Tony Ray Jones
Beauty Contest, Southport 1967
Gelatin silver print
13.9 × 20.8 cm
National Media Museum,
Bradford

Tony Ray Jones
The City, London 1967
Gelatin silver print
17.3 × 25.9 cm
National Media Museum,
Bradford

Tony Ray Jones
Eastbourne 1968
Gelatin silver print
17.7 × 26.7 cm
National Media Museum,
Bradford

Tony Ray Jones
Bournemouth 1969
Gelatin silver print
17.3 × 26 cm
National Media Museum,
Bradford

Grace Robertson
Mother's Day Off, Picture no.3 1954
Gelatin silver print
37 × 29.1 cm
National Media Museum,
Bradford

Grace Robertson
Mother's Day Off, Picture no.4 1954
Gelatin silver print
37 × 29.1 cm
National Media Museum,
Bradford

Grace Robertson
Mother's Day Off, Picture no.9 1954
Gelatin silver print
29 × 36.8 cm
National Media Museum,
Bradford

Grace Robertson
*Mother's Day Off, 'We all get
together at the local'* 1954
Gelatin silver print
29 × 37 cm
National Media Museum,
Bradford

George Rodger
London Pub 1969
Gelatin silver print
35 × 26.5 cm
George Rodger/Magnum Photos

The Rose Annual, The Royal
National Rose Society, St Albans,
Hertfordshire, exhibited editions
1965, 1968 and 1969
Each closed approx. 21 × 14.5 cm

Edwin Smith
*Sissinghurst Castle Gardens, The
White Garden* 1953
Gelatin silver print
25.3 × 20.3 cm
Edwin Smith/RIBA British
Architectural Library Photographs
Collection

Edwin Smith
*Castle Gardens, The gatehouse seen
from the cottage* 1962
Gelatin silver print
25.3 × 20.3 cm
Edwin Smith/RIBA British
Architectural Library Photographs
Collection

Edwin Smith
*Tresco Abbey Gardens, Isles of Scilly,
"Dasylirion"* 1962
Gelatin silver print
25 × 20 cm
Edwin Smith/RIBA British
Architectural Library Photographs
Collection

Edwin Smith
*Stowe, Temple of British Worthies
from the Temple of Ancient Virtue*
1963
Gelatin silver print
25.3 × 20.3 cm
Edwin Smith/RIBA British
Architectural Library Photographs
Collection

Edwin Smith
*Great Dixter, View of the Oast House
from the Topiary Garden* 1963
Gelatin silver print
25.2 × 20.2 cm
Edwin Smith/RIBA British
Architectural Library Photographs
Collection

Edwin Smith
Amesbury Abbey, Gay's Cave 1967
Gelatin silver print
25.3 × 20.3 cm
Edwin Smith/RIBA British
Architectural Library Photographs
Collection

Robert Smithies
The Modists c.1967
Gelatin silver print
32.5 × 21.3 cm
Robert Smithies / The Guardian

Robert Smithies
The Modists c.1967
Gelatin silver print
33.6 × 21.4 cm
Robert Smithies / The Guardian

Robert Smithies
The Modists c.1967
Gelatin silver print
21.2 × 32.8 cm
Robert Smithies / The Guardian

Robert Smithies
The Modists c.1967
Gelatin silver print
21 × 34.5 cm
Robert Smithies / The Guardian

Robert Smithies
The Modists c.1967
Gelatin silver print
21.5 × 34.2 cm
Robert Smithies / The Guardian

J.A. Steers and J.K.S. St. Joseph
*The Coast of England & Wales in
Pictures*, Cambridge University
Press, Cambridge, first edition
1948, exhibited edition 1960
Closed book 28.8 × 20.4 cm
Private Collection, London

Sunday Times Magazine
Who Works today? 5 December
1971
Closed 30 × 25 cm
Private Collection, London

Tony Walker, Belle Vue Studio,
Bradford
A Wrestler with his Winnings 1950
Modern gelatin silver print from
original negative
25.4 × 20.3 cm
Bradford Museum, Galleries and
Heritage

Tony Walker, Belle Vue Studio,
Bradford
Family Portrait 1950
Modern gelatin silver print from
original negative
25.4 × 20.3 cm
Bradford Museum, Galleries and
Heritage

Tony Walker, Belle Vue Studio,
Bradford
Young Men in their Best Suits 1950
Modern gelatin silver print from
original negative
20.3 × 25.4 cm
Bradford Museum, Galleries and
Heritage

Tony Walker, Belle Vue Studio,
Bradford
Young Nurse in her Uniform 1950
Modern gelatin silver print from
original negative
25.4 × 20.3 cm
Bradford Museum, Galleries and
Heritage

THE URGE TO DOCU-
MENT:
1970–1990

Keith Arnatt
Pictures from a Rubbish Tip 1988
C-type print
50.5 × 61 cm
Courtesy of the artist

Keith Arnatt
Pictures from a Rubbish Tip 1988
C-type print
50.5 × 61 cm
Courtesy of the artist

Keith Arnatt
Pictures from a Rubbish Tip 1988
C-type print
50.5 × 61 cm
Courtesy of the artist

Keith Arnatt
Pictures from a Rubbish Tip 1988
C-type print
50.5 × 61 cm
Courtesy of the artist

Jane Bown
from Greenham Common
TV Crew 1984
Gelatin silver print
20 × 30 cm
Jane Bown/Observer

Jane Bown
from Greenham Common
Impasse 1984
Gelatin silver print
23.5 × 29.7 cm
Jane Bown/Observer

Jane Bown
from Greenham Common
After the eviction 1984
Gelatin silver print
19.9 × 29.9 cm
Jane Bown/Observer

Vanley Burke
Alter Call, Austin Road Church
c.1970
Modern gelatin silver print from
original negative
50.8 × 60.9 cm
Courtesy of the artist

Vanley Burke
Boy with Flag c.1970–6
Modern gelatin silver print from
original negative
50.8 × 60.9 cm
Courtesy of the artist

Vanley Burke
Tek Mi Picture 1970s
Modern gelatin silver print from
original negative
50.8 × 60.9 cm
Courtesy of the artist

Vanley Burke
Day Trip to Skegness 1970s
Modern gelatin silver print from
original negative
50.8 × 60.9 cm
Courtesy of the artist

Vanley Burke
*Men outside George Street Church,
Lozells* 1972
Modern gelatin silver print from
original negative
50.8 × 60.9 cm
Courtesy of the artist

Vanley Burke
Lozells Riots c.1985
Modern gelatin silver print from
original negative
50.8 × 60.9 cm
Courtesy of the artist

Stephen Dalton
*Brown rat (Rattus norvegicus)
leaping from dustbin* 1983
Modern r-type print from
original negative
30.3 × 47 cm
Stephen Dalton/NHPA/Photoshot

Stephen Dalton
*Hedgehog (Erinaceus europeus) on
lawn at twilight* 1990
Modern r-type print from
original negative
37.5 × 31.3 cm
Stephen Dalton/NHPA/Photoshot

Stephen Dalton
*Red fox (Vulpes vulpes) raiding
dustbin* 1991
Modern r-type print from
original negative
31.8 × 45 cm
Stephen Dalton/NHPA/Photoshot

Stephen Dalton
*Badger (Meles meles) wandering
down garden path* 1993
Modern r-type print from
original negative
37.8 × 31.5 cm
Stephen Dalton/NHPA/Photoshot

John Davies
*Agecroft Power Station, Salford,
1983* 1983
Gelatin silver print
25.7 × 36.7 cm
Courtesy Michael Hoppen
Contemporary

John Davies
*Allotments, Easington Colliery, Co.
Durham 1983* 1983
Gelatin silver print
25.9 × 37.2 cm
Courtesy Michael Hoppen
Contemporary

Exit Photography Group,
Paul Trevor
from Survival Programmes in
Britain's Inner Cities
*Christmas Day, Petrus Community
Hostel, Everton, Liverpool* 1974
Gelatin silver print
23.5 × 53.5 cm
Side Photographic Gallery,
Newcastle Upon Tyne

Exit Photography Group,
Nicholas Battye
from Survival Programmes in
Britain's Inner Cities
*Play Space, Condemned House,
Handsworth, Birmingham* 1975
Gelatin silver print
23.7 × 35.5 cm
Side Photographic Gallery,
Newcastle Upon Tyne

Exit Photography Group,
Nicholas Battye
from Survival Programmes in
Britain's Inner Cities
*Squatters Action Meeting, Welbie
House, Hornsey Rise, London* 1976
Gelatin silver print
23.9 × 35.3 cm
Side Photographic Gallery,
Newcastle Upon Tyne

Exit Photography Group,
Chris Steele Perkins
from Survival Programmes in
Britain's Inner Cities
*Outside the White Hart, Tottenham,
London* 1977
Gelatin silver print
23.6 × 35.4 cm
Side Photographic Gallery,
Newcastle Upon Tyne

Exit Photography Group,
Paul Trevor
from Survival Programmes in
Britain's Inner Cities
*Anti Racism sit down protest,
Bethnal Green, London* 1978
Gelatin silver print
23.9 × 35.4 cm
Side Photographic Gallery,
Newcastle Upon Tyne

Exit Photography Group,
Chris Steele Perkins
from Survival Programmes in
Britain's Inner Cities
*Marathon Disco, Turf Lodge, Belfast,
Northern Ireland* 1978
Gelatin silver print
23.4 × 35.4 cm
Side Photographic Gallery,
Newcastle Upon Tyne

Anna Fox
from Workstations
*Fortunes are being made that are in
line with the dreams of avarice* 1988
C-type print
45 × 55.5 cm
Courtesy of the artist (originally
commissioned by Camerawork
and the Museum of London)

Anna Fox
from Workstations
*Typical Female workers rabbiting
away* 1988
C-type print
45.5 × 55 cm
Courtesy of the artist (originally
commissioned by Camerawork
and the Museum of London)

Anna Fox
from Workstations
Strength, stamina and precision that kept him at the top 1988
C-type print
45.5 × 55 cm
Courtesy of the artist (originally commissioned by Camerawork and the Museum of London)

Anna Fox
from Workstations
If we don't foul up nobody can touch us 1988
C-type print
45.5 × 55 cm
Courtesy of the artist (originally commissioned by Camerawork and the Museum of London)

Anna Fox
from Workstations
5.30pm 1988
C-type print
27.5 × 35.5 cm
Courtesy of the artist (originally commissioned by Camerawork and the Museum of London)

Anna Fox
from Workstations
Celebrating the Killings 1988
C-type print
45.5 × 55 cm
Courtesy of the artist (originally commissioned by Camerawork and the Museum of London)

Paul Graham
from A1 The Great North Road
Plate 1, Young Executives, Bank of England, London November 1981
Colour coupler print
19.4 × 24.2 cm
The artist, courtesy of Anthony Reynolds Gallery

Paul Graham
from A1 The Great North Road
Plate 20, Interior, Blyth Services, Blyth, Nottinghamshire June 1981
Colour coupler print
19.4 × 24.3 cm
The artist, courtesy of Anthony Reynolds Gallery

Paul Graham
from A1 The Great North Road
Plate 29, Burning Fields, Melberby, North Yorkshire September 1981
Colour coupler print
19.4 × 24.5 cm
The artist, courtesy of Anthony Reynolds Gallery

Paul Graham
from A1 The Great North Road
Plate 36, Looking North, Newcastle By-Pass, Tyne and Wear November 1981
Colour coupler print
19.5 × 24 cm
The artist, courtesy of Anthony Reynolds Gallery

Paul Graham
from A1 The Great North Road
Plate 3, Woman at Bus Stop, Mill Hill, North London November 1982
Colour coupler print
19.4 × 24.2 cm
The artist, courtesy of Anthony Reynolds Gallery

Paul Graham
from A1 The Great North Road
Plate 11, Cafe Waitress, John's Cafe, Sandy, Bedfordshire May 1982
Colour coupler print
19.4 × 242 cm
The artist, courtesy of Anthony Reynolds Gallery

Paul Graham
from A1 The Great North Road
Plate 12, Little Chef in Rain, St Neots, Cambridgeshire May 1982
Colour coupler print
19.1 × 24.1 cm
The artist, courtesy of Anthony Reynolds Gallery

Paul Graham
from A1 The Great North Road
Plate 23, Ferrybridge Powerstation, West Yorkshire November 1982
Colour coupler print
19.2 × 23.7 cm
The artist, courtesy of Anthony Reynolds Gallery

Nancy Hellebrand
Delia Whittaker, Housewife, West Hampstead 1973
Gelatin silver print
30 × 29.8 cm
Hellebrand Collection courtesy of the National Portrait Gallery, London

Nancy Hellebrand
John Farrell, building worker, West Hampstead 1973
Gelatin silver print
35 × 30 cm
Hellebrand Collection courtesy of the National Portrait Gallery, London

Nancy Hellebrand
Marion in a Bed Sitter, Marion Reck, Shoot Up Hill 1974
Gelatin silver print
30 × 30 cm
Hellebrand Collection courtesy of the National Portrait Gallery, London

Chris Killip
Youth, Jarrow 1977
Gelatin silver print
20.1 × 25.5 cm
Victoria and Albert Museum, London

Chris Killip
The Angelic Upstarts at the Barbary Coast Club, Sunderland, during a Miners' Strike Benefit Dance c.1984
Gelatin silver print
47.7 × 57 cm
Victoria and Albert Museum, London

Chris Killip
Bever, 1977–1985 c.1985
Gelatin silver print
40 × 50.2 cm
Victoria and Albert Museum, London

Daniel Meadows
The Free Photographic Omnibus 1973–4
Digital scans from 120 roll film negatives, shown on plasma screen
Courtesy of the artist

Peter Mitchell
from A New Refutation of the Viking 4 Space Mission
Plumbers, Crown Street, Leeds 1974
Modern c-type print from original negative
50.8 × 40.6 cm
Courtesy of the artist

Peter Mitchell
from A New Refutation of the Viking 4 Space Mission
Opticians, West Hendon Broadway, London 1975 1975
Modern c-type print from original negative
50.8 × 40.6 cm
Courtesy of the artist

Peter Mitchell
from A New Refutation of the Viking 4 Space Mission
Mrs. McArthy & her daughter. Saturday 7 June 75. Noon. Sangley Road, London 1975
Modern c-type print from original negative
50.8 × 40.6 cm
Courtesy of the artist

Horace Ové
Windrush Generation 1971
Modern giclee print from original negative
40.6 × 61 cm
Courtesy of the artist

Horace Ové
Multicultural London 1971
Modern giclee print from original negative
40.3 × 61.3 cm
Courtesy of the artist

Horace Ové
Walking Proud 1971
Modern giclee print from original negative
44 × 61 cm
Courtesy of the artist

Horace Ové
Sagaboy 1976
Modern giclee print from original negative
61.2 × 49 cm
Courtesy of the artist

Martin Parr
from The Cost of Living 1986–9
Private View
C-type print
42.5 × 52 cm
Martin Parr/ Magnum Photos

Martin Parr
from The Cost of Living 1986–9
Laura Ashley, Worcester
C-type print
42.5 × 52 cm
Martin Parr/ Magnum Photos

Martin Parr
from The Cost of Living 1986–9
Conservative 'Midsummer Madness' party, Bath, Avon
C-type print
42.5 × 52 cm
Martin Parr/ Magnum Photos

Martin Parr
from The Cost of Living 1986–9
Garden Open Day
C-type print
42.5 × 52 cm
Martin Parr/ Magnum Photos

Martin Pover
Harold Hill 1987
C-type prints
50.8 × 40.6 cm
Courtesy of the artist

Martin Pover
Harold Hill 1987
C-type prints
50.8 × 40.6 cm
Courtesy of the artist

Martin Pover
Harold Hill 1987
C-type prints
50.8 × 40.6 cm
Courtesy of the artist

Paul Reas
from I Can Help
Rubber Baby, B&Q. Cwmbran. South Wales 1988
Modern c-type print from original negative
50.8 × 60.9 cm
Courtesy of the artist

Paul Reas
from I Can Help
Military Wall Paper, B&Q. Newport, South Wales 1988
Modern c-type print from original negative
50.8 × 60.9 cm
Courtesy of the artist

Paul Reas
from I Can Help
Buying Trees, Garden Centre. Newport, South Wales 1988
Modern c-type print from original negative
50.8 × 60.9 cm
Courtesy of the artist

Paul Reas
from I Can Help
Pig Motifs, Merthyr Tydfil, South Wales 1988
Modern c-type print from original negative
50.8 × 60.9 cm
Courtesy of the artist

Derek Ridgers
Club and Street Portraits c.1985

Myra Clare White Trash 1981
Leicester Square 1983.
Bonner, Kings Road 1982.
At Sacrosanct 1986.
Boy George, Wardour Street 1980.
Cerith, Blitz Club 1980.
Crytale, Skin Two Club 1983.
Martin and Steve, Kings Road 1980.
Letty, Kings Road 1984.
Jock, Park Lane 1983.
Jo, Kings Road 1984.
Kings Road, June 1983.
Derek, Heaven 1981.
Flanagan, Kings Road 1983.
Shoreditch 1979.
Smiler, Kings Road 1984.
Susie, Kings Road 1982
Steve and friend, Billy's 1978.
Stuart and Angela, Zeeta's 1986.
Yasmin, Kings Road 1984.

Digital scans from original negatives and 35mm transparencies, shown on plasma screen
Courtesy of the artist

Paul Seawright
from Sectarian Murders
Tuesday 3 April 1973: 'Late last night a 28 year old man disappeared from a pub. It was until this morning that his body was found abandoned in a quiet park on the coast.' 1988
C-type print
50.8 × 50.8 cm
Courtesy of the artist and Kerlin Gallery, Dublin

Paul Seawright
from Sectarian Murders
Sunday 9th July 1972: 'The 31 year old man was found under some bushes in Cavehill Park. He had been shot dead. The police believe it to have been a sectarian murder.' 1988
C-type print
50.8 × 50.8 cm
Courtesy of the artist and Kerlin Gallery, Dublin

Paul Seawright
from Sectarian Murders
Friday 25 May 1973: 'The murdered man's body was found lying at the Giants ring Beauty spot, once used for pagan rituals. It has now become a regular location for sectarian murder.' 1988
C-type print
50.8 × 50.8 cm
Courtesy of the artist and Kerlin Gallery, Dublin

Paul Seawright
from Sectarian Murders
Saturday 9th June 1973: 'A Sixty year old man was found shot three times in the head in Ballysillan Playground. The area showed no signs of a struggle.' 1988
C-type print
50.8 × 50.8 cm
Courtesy of the artist and Kerlin Gallery, Dublin

Homer Sykes
from Once a Year
The Burry Man, South Queensferry, Lothian 1971
Gelatin silver print
30.4 × 40.6 cm
Courtesy of the artist

Homer Sykes
from Once a Year
Britannia Coconut Dancers, Bacup, Lancashire 1972
Gelatin silver print
30.4 × 40.6 cm
Courtesy of the artist

Homer Sykes
from Once a Year
The Ripon Sword Dance Play, Ripon, Yorkshire from Once a Year series 1972
Modern gelatin silver print from original negative
30.4 × 40.6 cm
Courtesy of the artist

Homer Sykes
from Once a Year
Caking Night, Dungworth, Yorkshire 1974
Gelatin silver print
30.4 × 40.6 cm
Courtesy of the artist

Tom Wood
from Looking for Love 1985–6
Moves Closer
Modern C-type print from orginal negative
39.4 × 58.4 cm
Courtesy of the artist and the Approach, London

Tom Wood
from Looking for Love 1985–6
Not for Nothings
Modern C-type print from orginal
negative
39.4 × 58.4 cm
Courtesy of the artist and the
Approach, London

Tom Wood
from Looking for Love 1985–6
*Like Hanson, Bow Lips and Man Ray
Mouth*
Modern C-type print from orginal
negative
39.4 × 58.4 cm
Courtesy of the artist and the
Approach, London

Tom Wood
from Looking for Love 1985–6
Bottletopnose
Modern C-type print from orginal
negative
39.4 × 58.4 cm
Courtesy of the artist and the
Approach, London

**REFLECTIONS ON A
STRANGE COUNTRY:
1990S-2006**

Douglas Abuelo
Where they Sleep 2006
Gelatin silver print
15.2 × 10.2 cm
Courtesy of the artist

Douglas Abuelo
Where they Sleep 2006
Gelatin silver print
15.2 × 10.2 cm
Courtesy of the artist

Stephen Bull
Meeting Hazel Stokes 1993–

Matthew Kelly Meeting Hazel Stokes
Alvin Stardust Meeting Hazel Stokes
Neil Buchanan Meeting Hazel Stokes
Richard Briers Meeting Hazel Stokes
Janet Dibley Meeting Hazel Stokes
Liza Tarbuck Meeting Hazel Stokes
*Stratford Johns Meeting
Hazel Stokes*
*Simon Williams Meeting
Hazel Stokes*
*Jonathon Morris Meeting
Hazel Stokes*
Lewis Collins Meeting Hazel Stokes
Adam Faith Meeting Hazel Stokes
*Nigel Davenport Meeting
Hazel Stokes*
Lionel Blair Meeting Hazel Stokes
Joe Pasquale Meeting Hazel Stokes
*Sophie Lawrence Meeting
Hazel Stokes*
*Duncan Preston Meeting
Hazel Stokes*
Julian Clary Meeting Hazel Stokes
June Brown Meeting Hazel Stokes
Gordon Kaye Meeting Hazel Stokes
Brian Murphy Meeting Hazel Stokes
Colin Baker Meeting Hazel Stokes
Shane Ritchie Meeting Hazel Stokes
David Soul Meeting Hazel Stokes
*Ardal O'Hanlon Meeting
Hazel Stokes*
Peter Duncan Meeting Hazel Stokes
*Daniel MacPherson Meeting
Hazel Stokes*
Henry McGee Meeting Hazel Stokes
Peter Noone Meeting Hazel Stokes

Harry Hill Meeting Hazel Stokes
*Nickolas Grace Meeting
Hazel Stokes*

Digital scans from c-type and
digital c-type prints, shown on
plasma screen
Courtesy of the artist

Elaine Constantine
Mosh 1997
Digital scans from c-type prints,
shown on plasma screen
Courtesy of the artist

Jason Evans
Strictly 1991
C-type print
19 × 19 cm
Photograph by Jason Evans,
styling by Simon Foxton

Jason Evans
Strictly 1991
C-type print
19 × 19 cm
Photograph by Jason Evans,
styling by Simon Foxton

Jason Evans
Strictly 1991
C-type print
19 × 19 cm
Photograph by Jason Evans,
styling by Simon Foxton

Flickr launched 2004
www.flickr.com
Photosharing website

Chris Harrison
from Sites of Memory
*Picardy and Bapaume Avenue,
Belfast.* 1995–6
Cibachrome print
76.2 × 152.4 cm
Imperial War Museum.
Gift of the artist, 2000

Chris Harrison
from Sites of Memory
Sheerness, Kent. 1997
Cibachrome print
76.2 × 152.4 cm
Imperial War Museum.
Gift of the artist, 2000

Fergus Heron
Ivy Drive, Lightwater, Surrey, 2004
2004
C-type print
50.8 × 61 cm
Courtesy of the artist

Fergus Heron
*Bosman Drive, Windlesham,
Surrey, 2005* 2005
C-type print
50.8 × 61 cm
Courtesy of the artist

Fergus Heron
*Robin Hill Drive, Camberley,
Surrey 2007* 2007
C-type print
50.8 × 61 cm
Courtesy of the artist

Fergus Heron
*Hawkesworth Drive, Bagshot,
Surrey, 2007* 2007
C-type print
50.8 × 61 cm
Courtesy of the artist

Dan Holdsworth
from A Machine for Living
Untitled 1999
C-type print
92.5 × 114.5 cm
Tate. Purchased 2001

Dan Holdsworth
from Machine for Living
Untitled 1999
C-type print
92.5 × 114.5 cm
Courtesy of the artist and Store,
London

Tom Hunter
Travellers No. I 1996–8
Cibachrome print
61 × 50.8 cm
Courtesy of the artist

Tom Hunter
Travellers No. II 1996–8
Cibachrome print
61 × 50.8 cm
Courtesy of the artist

Tom Hunter
Travellers No. VII 1996–8
Cibachrome print
61 × 50.8 cm
Courtesy of the artist

Penny Klepuszewska
Living Arrangements No. 4 2006
Digital c-type print
55.9 × 86.3 cm
Courtesy of the artist

Penny Klepuszewska
Living Arrangements No.18 2006
Digital c-type print
55.9 × 86.3 cm
Courtesy of the artist

Penny Klepuszewska
Living Arrangements No. 1 2006
Digital c-type print
55.9 × 86.3 cm
Courtesy of the artist

Penny Klepuszewska
Living Arrangements No.3 2006
Digital c-type print
55.9 × 45.7 cm
Courtesy of the artist

Clive Landen
Familiar British Wildlife 1994

*talpa europaea B4521
fringilla coelebs gengleri A466
strix aluco sylvatica A465
corvus corone corone A46
mustela erminea stabilis A48
columba palumbus palumbus B4231
meles meles meles A48
oryctolagus cuniculus B4221
erithacus rubecula melophilus B4293
delichon urbica urbica A40
phasianus colchicus A38
mustelidae A48
bufo bufo B4151
vulpus vulpes crugigera B4509
ardea cinerea cinerea M50
erinaceus europaeus B4234*

Digital scans from c-type prints,
shown on plasma screen
Courtesy of the artist

Grace Lau
Archive of Hastings, Summer 2005
2005
C-type print
60.9 × 60.9 cm
Courtesy of the artist

Grace Lau
Archive of Hastings, Summer 2005
2005
C-type print
60.9 × 60.9 cm
Courtesy of the artist

Grace Lau
Archive of Hastings, Summer 2005
2005
C-type print
60.9 × 60.9 cm
Courtesy of the artist

Grace Lau
Archive of Hastings, Summer 2005
2005
C-type print
60.9 × 60.9 cm
Courtesy of the artist

Susan Lipper
from Bed and Breakfast
Untitled 1998
C-type print
21.1 × 25.9 cm
Courtesy of the artist
Commissioned by Photoworks UK

Susan Lipper
from Bed and Breakfast
Untitled 1998
C-type print
21.1 × 25.9 cm
Courtesy of the artist
Commissioned by Photoworks UK

Susan Lipper
from Bed and Breakfast
Untitled 1998
C-type print
21.1 × 25.9 cm
Courtesy of the artist
Commissioned by Photoworks UK

Susan Lipper
from Bed and Breakfast
Untitled 1998
C-type print
21.1 × 25.9 cm
Courtesy of the artist
Commissioned by Photoworks UK

Susan Lipper
from Bed and Breakfast
Untitled 1998
C-type print
21.1 × 25.9 cm
Courtesy of the artist
Commissioned by Photoworks UK

Zed Nelson
from Love Me
Miss Southampton 2006
C-type print
73.5 × 60.5 cm
Courtesy of the artist

Zed Nelson
from Love Me
Miss Lincolnshire 2006
C-type print
73.5 × 60.5 cm
Courtesy of the artist

Zed Nelson
from Love Me
Miss Portsmouth 2006
C-type print
73.5 × 60.5 cm
Courtesy of the artist

Simon Norfolk
Military Landscape 2006
Digital c-type print
101.6 × 127 cm
Courtesy Bonni Benrubi Gallery,
New York

Simon Norfolk
Military Landscape 2006
Digital c-type print
101.6 × 127 cm
Courtesy Bonni Benrubi Gallery,
New York

Jonathan Olley
Sea Walls: Flooded Suburbia 2003
Lambda print
60.8 × 77 cm
Courtesy of the artist

Jonathan Olley
*Sea Walls: Caravan holiday park
and gasworks from the sea wall.
Canvey Island, Essex,
England UK* 2003
Lambda print
60.8 × 77.5 cm
Courtesy of the artist

Jonathan Olley
*Sea Walls: Traffic cone on Sea Road.
Cliff erosion. Happisburgh, Norfolk,
England UK* 2003
Lambda print
60.9 × 75.6 cm
Courtesy of the artist

Eileen Perrier
*Untitled from Red, Gold and Green
series* 1997
C-type print
30.5 × 40.6 cm
Courtesy of the artist
Commissioned by Autograph ABP

Eileen Perrier
*Untitled from Red, Gold and Green
series* 1997
C-type print
30.5 × 40.6 cm
Courtesy of the artist
Commissioned by Autograph ABP

Eileen Perrier
*Untitled from Red, Gold and Green
series* 1997
C-type print
30.5 × 40.6 cm
Courtesy of the artist.
Commissioned by Autograph ABP

Sarah Pickering
from Public Order series 2002–5
High Street Barricade 2002
C-type print
76 × 94.3 cm
Courtesy Daniel Cooney Fine Art,
New York

Sarah Pickering
from Public Order series 2002–5
Dickens - High Street 2003
C-type print
76 × 94.3 cm
Courtesy Daniel Cooney Fine Art,
New York

Sarah Pickering
from Public Order series 2002–5
Flicks Nightclub 2004
C-type print
30 × 37 cm
Courtesy Daniel Cooney Fine Art,
New York

Sarah Pickering
from Public Order series 2002–5
Garden School Road 2005
C-type print
76 × 94.3 cm
Courtesy Daniel Cooney Fine Art,
New York

Richard Primrose
The NightBus Project
Elephant Vanishes NightBus Film
(October 2005 duration
6 minutes 31 seconds)
Trafalgar Square NightBus Film
(November 2005 duration
12 minutes 33 seconds)
Colour photographs with
soundtrack by Richard Primrose,
designed to be played on an iPod
Courtesy of the artist

Nigel Shafran
*All aboard charity shop, West
Hampstead* 2001
C-type print
58 × 72 cm
Courtesy of the artist

Nigel Shafran
*Relief Fund for Romania charity
shop, Kilburn* 2002
C-type print
58.5 × 74 cm
Courtesy of the artist

Jem Southam
*The Pond at Upton Pyne, December
1996* 1996
C-type print
95 × 113 cm
Courtesy of the artist

David Spero
*Emma and John's, Tir Ysbrydol
(Spiritual Land), Brithdir Mawr,
Pembrokeshire. October
2004* 2004
C-type print
58.4 × 74 cm
Courtesy of the artist

David Spero
*'The Longhouse' communal space and
new kitchen, Steward Community
Woodland, Devon, November 2004*
2004
C-type print
58.5 × 74.1 cm
Courtesy of the artist

David Spero
*Merlin, Becky and Rowan's. Steward
Community Woodland , Devon,
November 2004* 2004
C-type print
58.5 × 74.1 cm
Courtesy of the artist

David Spero
*Mary and Joe's, Tinker's Bubble,
Somerset, June 2004* 2004
C-type print
58.5 × 74.1 cm
Courtesy of the artist

Clare Strand
Gone Astray 2002
Gelatin silver print
124.5 × 114.3 cm
Courtesy of the artist

Clare Strand
Gone Astray 2002
Gelatin silver print
124.5 × 114.3 cm
Courtesy of the artist

Alastair Thain
Marines 2006
Digital c-type print
300 × 200 cm
Courtesy of the artist

Alastair Thain
Marines 2006
Digital c-type print
300 × 200 cm
Courtesy of the artist

Alastair Thain
Marines 2006
Digital c-type print
300 × 200 cm
Courtesy of the artist

David Trainer
*Wanstead Flats London Easter
Funfair* 1991
Gelatin silver print
37 × 37 cm
Courtesy of the artist

David Trainer
Cambridge Midsummer Fair 1994
Gelatin silver print
37 × 37 cm
Courtesy of the artist

David Trainer
The Epsom Derby 1995
Gelatin silver print
37 × 37 cm
Courtesy of the artist

Albrecht Tübke
Citizens 2003
C-type print
47 × 38 cm
Courtesy Dogenhaus Galerie,
Leipzig

Albrecht Tübke
Citizens 2003
C-type print
47 × 38 cm
Courtesy Dogenhaus Galerie,
Leipzig

Albrecht Tübke
Citizens 2003
C-type print
47 × 38 cm
Courtesy Dogenhaus Galerie,
Leipzig

Albrecht Tübke
Citizens 2003
C-type print
47 × 38 cm
Courtesy Dogenhaus Galerie,
Leipzig

Information is provisional and subject to change

Acknowledgements

Nicky Akehurst; Melanie Aspey; Martin Barnes; David Bonney; Toni Booth; Keith Bonnick; Camilla Brown; Stefanie Braun; Michael Carey Burke; Fiona Cairns; Michael Callaghan; Tamara Carlier; Harmeet Chagger; David Chandler; Robin Christian; Neil Colquhoun; Constantine Ltd; Fiona Courage; Lorna Crabbe; Juliet Creosole; Alan Dein; Luke Dodd; Elizabeth Edwards; Peter Ellis; Robert Elwall; John Fisher;

Jane Fletcher; Anna Fox; Eric Franck; Clare Freestone; Eva Fuchs; Philippe Garner; Clare Grafik; Violet Hamilton; Roger Hargreaves; Tim Harris; Janice Hart; Louise Hayward; Mark Haworth-Booth; Denny Hemming; Rachel Hewitt; Neil Holland; John Hoole; Michael Hoppen; David Hosking; Ruth Hibbard; Neil Holland; Peter James; Kate Jones; Matt Jones; Indra Khanna; Conor Kilroe; Brigitte Lardinois;

Melissa Larner; Sophie Leighton; Brian Liddy; Joanna Ling; MC Designers Ltd; Gordon MacDonald; David McNeff; Robert Meyrick; Jake Miller; Brian Morgan; Andrew Murray; Museums and Archives Council; Sandy Nairne; Jon Newman; Dr Alistair O Neill; Eimear O'Raw; David Packer; Terence Parris; Nick Pavey; Terence Pepper; Ian Peppiatt; Robert Perks; Dean Phipps; Stephen Pover; Ben Primer; Bob Pullen; Brett

Rogers; Brian Roberts; Fiona Rogers; Marjolaine Ryley; Sharon Scarmazzo; Nicole Schulz; Peter Scott; Michael Seaborne; Henrietta Shirley; Elizabeth Smith; Roger Smither; Patrick Sutherland; Roger Taylor; Jaimie Thomas; Vicki Thornton; Willeke Tijssen; Sharon Tuff; Victoria Volkman; Antony Wallace; Nigel Warburton; Simon Watney; David Weston; Hugh Williams; Nicola Wood; Philippa Wright; Sophie Wright

Lenders to the Exhibition

PUBLIC COLLECTIONS

Antony Wallace Archive,
British Association of Plastic,
Reconstructive and Aesthetic
Surgery, London
Archive of Modern Conflict,
London
Barnardo's Photographic Archive,
Ilford
Birmingham Library & Archives
Services, Birmingham
Bradford Industrial Museum,
Bradford
The Cecil Beaton Studio Archive at
Sotheby's, London
Cuming Museum, London
The Eric Hosking Charitable Trust,
Suffolk
Guildhall Library, London
Imperial War Museum, London
International Institute of Social
History, Amsterdam
Lambeth Archives, London
Llyfrgell Genedlaethol Cymru,
The National Library of Wales,
Aberystwyth
London Borough of Lambeth,
Archives Department, London
The Master and Fellows, Trinity
College, Cambridge

Museum of London, London
National Gallery of Scotland,
Edinburgh
National Media Museum, Bradford
National Portrait Gallery, London
Newsroom, Guardian and Observer
Archive and Visitor Centre,
London
Norman Parkinson Archive, London
Princeton University Library,
Princeton
Rothschild Archive, London
Royal Institute of British Architects,
London
The Royal Society of Medicine,
London
School of Art Museum & Gallery,
Aberystwyth
Tate, London
Theatre Collection, Victoria and
Albert Museum, London
University of Glasgow Library,
Glasgow
University of Sussex, Brighton
Victoria and Albert Museum, London
Wilson Centre for Photography,
London

PRIVATE COLLECTIONS

Douglas Abuelo
Keith Arnatt
Eve Arnold/Magum Photos,
London
Shirley Baker
Dorothy Bohm Archive, London
Jane Bown/Observer, London
Stephen Bull
Vanley Burke
Cecil Beaton Studio Archive at
Sotheby's, London
Elaine Constantine
Stephen Dalton/NHPA/Photoshot,
London
Daniel Cooney Fine Art, New York
John Davies
Dogenhaus Galerie Leipzig, Leipzig
Eric Franck Fine Art, London
Jason Evans
Flickr
Anna Fox
Leonard Freed/Magnum Photos,
London
Paul Graham courtesy of Anthony
Reynolds Gallery, London
Fergus Heron
David Hurn/Magnum Photos,
London
Tom Hunter
Penny Klepuszewska
Clive Landen
Sergio Larrain/Magnum Photos,
London
Grace Lau
Susan Lipper
Mayor Gallery, London

Daniel Meadows
Michael Hoppen Contemporary,
London
Peter Mitchell
Zed Nelson
Simon Norfolk
Jonathan Olley
Horace Ové
Martin Parr / Magnum Photos,
London
Eileen Perrier
Charlie Phillips and Akehurst
Creative Management
Sarah Pickering
Martin Pover
Richard Primrose
Paul Reas
Derek Ridgers
George Rodger/Magnum Photos,
London
Paul Seawright, courtesy of Kerlin
Gallery, Dublin
Sexton Collection, London in
conjunction with Thames &
Hudson, London
Nigel Shafran
Side, Newcastle Upon Tyne
Jem Southam
Estate of Humphrey Spender
David Spero
Store, London
Clare Strand
Wolfgang Suschitzky
Homer Sykes
Alastair Thain
David Trainer
Tom Wood, courtesy of the
Approach, London

And other private lenders who
wish to remain anonymous

Index

Page numbers in *italic* type refer to main biographical entries.

A

About Britain Guides 108–9
Abuelo, Douglas 162, 194, *209*; no.120
Adamson, Robert *see* Hill & Adamson
advertising 81, 82
aerial photography 196; nos.57, 81
agencies 110
albumen prints 26, 64; nos.2, 4–10, 12–13, 19, 22, 23
Alexandra, Queen 65
ambrotype ; no.32
Anderson, Benedict
 Imagined Communities 11
Annan, T.& R. and Sons
 Old Closes and Streets of Glasgow 26; no.24
Annan, Thomas 26, 27, *209*
Arbus, Diane 20
Archer, Frederick Scott 26, 200*n*
Arnatt, Keith 139, *209*; no.114
Arnold, Eve 107, *209*
Arts Council of Great Britain 139
Atkins, Anna 25, 203*n*, *209*; no.1
autochrome process 63

B

Bailey, David 107, 196, *209*; no.86
Baker, Shirley 107, 194, *209*; no.72
Barnack, Oscar 204
Barnardo, Dr 17–18, 25, 194; no.9
Barnes, Thomas John 25; no.9
Barthes, Roland 191
Bassano, Alexander *209*
Batsford books 108
Battye, Nicholas 137, *210*
Beard, Richard 199
Beaton, Cecil 81, 193, *210*; no.58
Bedford, Francis 13
Bell, Angelica 19
Bell, Vanessa 19, 65, 81, 195, *210*; no.49
Belle Vue Studio (Bradford) 19, 107, *222*; no.90
Bevington, Geoffrey *210*; no.23
blog websites 206
Bloombury set 65; nos.49, 52
Bohm, Dorothy *106*, 107, *210*
books, photographically illustrated 26, 82, 107, 108, 199–200, 203, 205; nos.73–6, 78
Bown, Jane 138, *210*; no.116
Bowness, Edward Alan 109, *210*
Brandt, Bill 82, *210*
Brecht, Bertolt 193
Brewster, Sir David 201
bromide prints nos.25, 35–6, 52, 56
Broom, Christina 64, *210–11*; no.46

Brunel, Isambard Kingdom 11, 27, 193; no.22
Buckham, Captain Alfred George *80*, 196, *211*; no.57
Bull, Stephen 163, *211*; no.137
Burke, Vanley 138, *211*; no.100
Butlin's holiday camps 109; no.79

C

cabinet cards 14, 64
calotype 26, 199–200, 200*n*
Camerawork magazine 137
Cameron, James 205*n*
Cameron, Julia Margaret 25, 195, *211*; no.5
carbon-printing process 26; no.43
Carbro process 83
Carroll, Lewis 16, 195, *211*; no.12
cartes-de-visite 26, 64, 200; no.21
Cartier-Bresson, Henri 110
Casson, Winifred 81, *211*; no.67
chlorobromide prints no.66
Christian, Ray
 Old English Customs 20
cinema 204
circus performers 18, 64, 196; no.17
Clark brothers 64, 196; no.17
Claydon, W. 25
Coburn, Alvin Langdon 62, 63–4, *211*; no.44
Cohen, Albert A.
 Delinquent Boys 110
collotype 203
colour photography 82–3, 107, 137, 138–9, 205; nos.60, 62, 83
colour supplements 107, 110, 205
Connell, Lena 19, 64, *211*; no.48
Constantine, Elaine 161, *211*; no.122
contact print no.20
cookery books 107; no.76
Cooper, Tommy 22, 108
Country Life Picture Books 108, 109; no.74
Crawshay, Robert Thompson *211–12*; no.32
Criminal Records Office 64; no.45
Crystal Palace 13; no.31
cyanotype no.1

D

Daguerre, Louis Jacques Mandé 14, 199
dagurreotype 14, 26, 199, 200, 200*n*, 201; nos.30–1, 33
Daily Herald 108; no.87
Dalton, Stephen 139, *212*; no.113

Davey Photo no.36
David & Charles 108
Davies, John 137, *212*; no.115
Davison, George *212*; no.15
Delamotte, Philip Henry *212*; no.31
Diamond, Hugh Welch 18–19, 26, *212*
 Photographs of Psychiatric Patients; no.10
digital camera 205–6
Disdéri, André Adolphe Eugène 200
documentary photography 137, 138–9
Dors, Diana 22
Downey, W. & D. *212*
Draycott Galleries no.35
dry plate gelatin process 201–2
Dufay process 82
Duff, Euan 107, *212*; no.92
Duxachrome 83

E

Eastlake, Lady Elizabeth 198
Eastman, George 202
Edward VII, King 195; no.20
Emerson, Peter Henry *212*; no.27
émigré photographers 81
enprint 205
environmental issues 161
Evans, Jason 22, 161, *212*; no.123
Evans, Walker 198
Exit Photography Group 137–8, 194; no.109

F

The Face magazine 139, 161
fashion photography 22, 81, 107, 110, 139, 161
Fenton, Roger 25, 203, *212–13*; no.2
Festival of Britain 191
Fisher, James 109
folk music 20
Forsyth, Bruce 22, 196; no.87
Fox, Anna 138, *213*; no.102
Fox Talbot, William Henry 26, 199, 200, 203*n*, *213*; no.3
Foxton, Simon 22
Frank, Robert 20
Freed, Leonard *213*; no.88
Frith, Francis 27, 196, *213*; no.25

G

gardening, images of 107, 196–7
Garland, George 81–2, *213*; no.50
Gilpin, William 13
Gough, Kate E. 25, *213*; no.14

Grabham, Oxley 63, *213*; no.37
Graham, Paul 138, 139, *213*; no.108
Grant, Duncan 19
Great Exhibition 201
Grigson, Geoffrey 109
 An English Farmhouse and its Neighbourhood 108; no.78
Guardian 110
Gunn and Stuart 14, *214*

H

Half Moon Photography Workshop 137
Hardy, Bert 82, 205*n*, *214*; no.70
Harrison, Chris 163, *214*; no.125
Haviden, John 81, 82, *214*; no.56
Haworth-Booth, Mark 139
Hellebrand, Nancy 137, *214*; no.99
Henderson, Nigel Graeme 107, *214*; no.85
Hennell, Percy 19–20, 83, 109, *214*; no.60
 British Women Go to War 83; no.59
 An English Farmhouse and its Neighbourhood 108; no.78
Heron, Fergus 161, *214*; no.140
Hill & Adamson 27, *214*; no.16
Hill, David Octavius *see* Hill & Adamson
Hinde, John 81, 83, 107, *214*; no.62
Hoggart, Richard 22
Holdsworth, Dan *160*, 161–2, *214–15*; no.130
Hopkinson, Tom 205, 205*n*
Hosking, Eric *215*
 Barn Owl series 109–10; no.82
Hoskins, W.G. *215*
 The Making of the English Landscape 108–9; no.73
Howerd, Frankie 22, 108
Howlett, Robert 27, 193, *215*; no.22
Hudson, Derek 10
Huline brothers 21, 27, 196; no.19
Hulton, Edward G. 205*n*
Hulton Picture Library 205*n*
Hunter, Tom 162, *215*; no.127
Hurn, David 107, *215*
Hutton, Kurt 204*n*

I

i-D magazine 22, 139, 161
immigrant population, images of 19, 107, 138; nos.90–1
Industrial Revolution 13
Ingram, Herbert 203
Ives, Frederick Eugene 203

J

Jacobs, Harry 19, 107, 138, *215*; no.91
Jacques, Hattie 22, 108
James, Colonel Sir Henry *215*; no.6
Jarrow Hunger Marches 82
Jennings, Humphrey
 Family Portrait 191
Jones, Charles 63, 197, *215*; no.40

K

Ker-Seymer, Barbara 81, *215–16*;
 no.52
Kersting, A.F. 109
Kilburn, William Edward D. *216*;
 no.33
Killip, Chris 138, 161, 194, *216*;
 no.110
Klepuszewska, Penny 163, *216*;
 no.139
Kodak 65, 202

L

Lafayette Studios 27, 195, *216*; no.20
Landen, Clive 161, *216*; no.141
landscape photography 108–9, 137,
 139, 162, 196; no.83
Larrian, Sergio *216*
Lau, Grace 162, *216*; no.136
Left Book Club 82
Leica 204
Leno, Dan 21, 64, 196; no.36
Lipper, Susan 162, *216*; no.138
Little, Richard no.21
Lorant, Stefan 204
Lucas, Richard Cockle *216*; no.8

M

McBean, Angus 81, 195, *216–17*;
 no.65
McColl, Ewan 20
McKnight-Kauffer, Edward 197, *217*;
 no.68
Maddox, Dr Richard Leach 202
magic-lantern 13
Magnum Photos 110, 137
Mann, Felix *204n*
Marlow, Peter 137
Martin, Paul Augustus *217*; no.28
Mass Observation 194
Mayall, John Jabez Edwin 200, *217*;
 no.7
Mayne, Roger 107, 194, *217*; no.89
Meadows, Daniel *217*
 Free Photographic Omnibus 21,
 138; no.98
miniature camera 82
Mitchell, Peter 137, *217*; no.107
modernism 81
Munby, Arthur J. 12–13, 18, 25, 194,
 217; no.21
music hall 20–1, 64, 196; nos.19, 35–6
Muspratt, Helen 81, 82, *217*; no.55

N

Nash, Paul 108
national identity, sense of 11, 191–2
National Photographic Record
 Association 14–15
Nelson, Zed 162, *217–18*; no.133
New Society magazine 110
Norfolk, Simon 163, *218*; no.131
Nottage, George Swan 201

O

Observer magazine 107, 110, 138
Olley, Jonathan 162, *218*; no.124
Orwell, George
 'The Lion and the Unicorn'
 191–2, 196
Ouzery no.19
Ové, Horace 138, *218*; no.111

P

Paget process 83
Pankhurst, Christabel no.46
Parker, Charles 20
Parkinson, Norman 107, *218*; no.96
Parr, Martin 138, *218*; no.104
Perrier, Eileen 162, *218*; no.132
Pfenninger, Otto 63–4, *218*; no.43
Phillips, Charlie *218*; no.94
phone camera 206
photogravure 203; no.44
photojournalism 82, 83, 110, 137–9,
 161, 204
Pickering, Sarah 163, *218–19*; no.129
Pictorialists 63–4
picture essay 204
Picture Post magazine 82, 204–5, *205n*
Piper, John 108
platinum prints nos.27–8, 34
politically-motivated subjects 82, 137
postcards 64, 203–4; nos.41, 80
Poucher, Walter Arthur 109, *219*
Pover, Martin 18–19, *219*; no.106
poverty, images of 192–5
Priestley, J.B.
 British Women Go to War 83
Primrose, Richard 162–3, *219*; no.135
propaganda, photography as 25
Pulham, Peter Rose 81, *219*; no.54

R

Ragged School Album 24, 26; no.11
Ramsey, Lettice 82
Ray-Jones, Anthony 20, 107, *219*;
 no.95
Raydex process 63
Reas, Paul *136*, 139, *219*; no.103
Reynolds, Revd George 18
Ridgers, Derek 21, 139, 161, *219*;
 no.101
Robertson, Grace 107, *219*; no.84
Rodger, George *219*
Rolleiflex *204n*

romanticism 13, 107
Rose Annual 107, 197; no.75
Rothschild Collection 65
Royal Photographic Society 63
rural imagery 13

S

St Joseph, J.K.S. *219*
 The Coast of England and Wales 109
salt print nos.3, 16
Sarony, Oliver François Xavier 200
Sassoon family album 65; no.42
Scowen, Kenneth 109, *220*
Seawright, Paul 139, *220*; no.105
Seeger, Peggy 20
Seten-Watson, Hugh 11
Shafran, Nigel 162, *220*; no.128
Smith, Adolphe 26
Smith, Edwin 108, 197, *220*; no.77
Smithies, Robert 110, *220*; no.93
Smyth, Norah 64, 194, *220*; no.38
snapshot photography 65
sociology 110
solarisation 82; no.67
Southam, Jem 162, *220*; no.117
Spencer, Dr D.A. 82
Spender, Humphrey 82, 194, *220*;
 no.64
Spero, David 161, *220*; no.126
Spring Rice, Margery
 Working Class Wives 82
Spry, Constance 107
Steele Perkins, Chris 137, *220–1*;
 no.109
Steers, J.A. 109
stereoscopic photography 26, 201
Stone, Sir Benjamin 14–15, *221*
 Festivals and Customs 17, 20, 63,
 195; no.34
Strand, Clare 162, *221*; no.118
Studio Alexander 107
studio portraits 81, 82, 107, 162, 199
stylists 161
Suffragette movement 19, 64;
 nos.45–6
Sunday Times magazine 107, 110,
 137–8
surveillance photography 64; no.45
Suschitzky, Edith *see* Tudor-Hart,
 Edith
Suschitzky, Wolfgang 81, *221*; no.69
Sutcliffe, Frank Meadow 27, *221*;
 no.29
Sykes, Homer *221*
 *Once a Year: Some Traditional
 British Customs* 17, 137, 195;
 no.97

T

television 205
Thain, Alastair 163, 193, *221*; no.121
Thames & Hudson 108
Thomas, John 18, 27, 195, *221*; no.18

Thomson, John *221–2*
 Street Life in London 26; no.26
Tilley, Vesta 20, 64, 196; no.35
tourism 64, 108, 109
Trainer, David 161, *222*; no.119
tranny 205
Trevor, Paul 137, *222*
Tübke, Albrecht 162, *222*; no.134
Tudor-Hart, Edith 81, 82, *222*; no.63
Turner, Benjamin Brecknell 13, *222*;
 no.31
Turner, J.M.W. 13

V

Valentine, James, and Sons 64, 203–4;
 no.80
Vaughan, Keith *222*
 Dick's Book of Photos 81; no.51
Victoria, Queen 14, 200, 201; no.7
Vivex process 82–3; no.53
Vogue magazine 107

W

Walker, Tony 107, *222*; no.90
Warburg, Agnes 63, 196–7, *222*; no.39
Weight, Geoffrey N. *223*
Welford, Walter D. *223*; no.13
wet-plate collodion process 26, *200n*,
 201–2
Wilding, Dorothy Frances Edith 81,
 223; no.66
wildlife photography 109–10, 139;
 nos.83, 113
Wilmott and Young
 Family and Kinship in East London
 110
Winogrand, Gary 20
Wisdom, Norman 108
Wittgenstein, Ludwig 191
Wood, Tom 138, *223*; no.112
Woodburytype 26, 203; no.26
Woolf, Virginia 65
Workers' Film and Photo League 82
World War I 65; nos.38, 47
World War II 19–20, 81, 82, 83;
 nos.57–62
Wright, Geoffrey N. 109

Y

Yevonde, Madame 64, 81, 82, *223*
 Goddesses and Others 81, 195;
 no.53

Z

Zwemmers' bookshop 81

238

Credits

240